RADICAL CONTEMPORARY THEATRE PRACTICES BY WOMEN IN IRELAND

RADICAL CONTEMPORARY THEATRE PRACTICES BY WOMEN IN IRELAND

Edited by Miriam Haughton and Mária Kurdi

CARYSFORT PRESS

A Carysfort Press Book

Radical Contemporary Theatre Practices by Women in Ireland

Edited by Miriam Haughton and Mária Kurdi
First published in Ireland in 2015 as a paperback original by
Carysfort Press, 58 Woodfield, Scholarstown Road
Dublin 16, Ireland

ISBN 978-1-909325-75-3
©2015 Copyright remains with the authors

Typeset by Carysfort Press
Cover design by eprint limited
Printed and bound by eprint limited
Unit 35
Coolmine Industrial Estate
Dublin 15
Ireland

This book is published with the financial assistance of
The Arts Council (An Chomhairle Ealaíon) Dublin, Ireland

Foreword

Garry Hynes, Druid Theatre, 2015

Being a woman in Irish Theatre is still difficult. I was lucky with Druid and got to make theatre on my own terms and I was years into my career before I even realized that it was–at the time–unusual for women to be directors. But as I moved beyond Druid, I quickly came up against the realities for women. Radical as the changes have been since I started out–changes to which this volume ably attests–radical action is still needed. This year Druid will stage a gender-blind production of a cycle of Shakespeare's history plays. It will be a challenge in the rehearsal process and, later, with audiences. My hopes for this production are for the women in the company as much as anything else–that their contribution will be responded to honestly. While I might be apprehensive about this, and this volume gives me to know why, I entertain no such doubts for this present volume. I fully expect it to inspire women to bring their vital energies to all corners of Irish theatre and to create productions of ever greater ambition, complexity and beauty. I, for one, find in its publication grounds for celebration.

Contents

List of Illustrations

Cover Image: *The Rain Party* by junk ensemble. Image by Fionn McCann. Jessica Kennedy, Megan Kennedy.

Fig.1 *Laundry* (2011) by ANU. Image by visual artist Owen Boss courtesy of ANU. Performer Laura Murray.

Fig.2 *The Rain Party* (2007), junk ensemble. Image by Fionn McCann. Performers Jessica Kennedy, Megan Kennedy.

Fig.3 *In My Bed*. The Shed, Temple Bar, Dublin Fringe Festival. September 2011. Image by Marlijn Gelsing. Image reproduced by kind permission of the artist Veronica Dyas.

Fig.4 *Medea* (2001). Courtesy of Amanda Coogan.

Fig.5 *Bird with boy* (2011), junk ensemble. Image by Luca Truffarelli. Performer Liv O'Donoghue.

Fig.6 *Dusk Ahead* (2013), junk ensemble. Image by Luca Truffarelli. Performers Zoe Reardon, Jaiotz Osa, Miguel do Vale, Ramona Nagabczynska, Ryan O'Neill.

Fig.7 Beckett's *Ghosts* at Project Arts Centre, by kind permission of Ros Kavanagh.

Fig.8 *Laundry* (2011) by ANU. The former Magdalene Laundry where *Laundry* was staged on Lower Seán McDermott Street, Dublin, 16 February 2012. Photograph supplied by Miriam Haughton.

Fig.9 *The Fountain* (2001). Courtesy of Amanda Coogan.

Fig.10 *all that signified me...* Project Arts Centre, Dublin, January 2013. Image by Naomi Goodman. By kind permission of the artist Veronica Dyas.

Acknowledgements

We are enormously grateful to a host of scholars and artists both in Ireland and internationally who provided unwavering support in bringing this collection to fruition. It is impossible to name each and every person, so we shall avoid this failure altogether by issuing a collective declaration of gratitude, sprinkled with a few essential nods.

In particular, our colleagues, students and friends at the institutions where we are based, the University of Pécs and NUI Galway, have contributed intellectual debate, rigour and an experimental laboratory where many of the collection's ideas were first tested and then retested. Our thanks indeed.

To Garry Hynes, who has provided her thoughts from decades of making work; her honesty and reflection enriches the collection greatly, illuminating the road from her first production to current work. To Megan and Jessica Kennedy of junk ensemble, this collection is strengthened and excited by your words, and indeed, your work. Congratulations on the first decade of innovative dance theatre, and we look forward to marking the next decade.

We express our gratitude to *Modern Drama* for their permission to reproduce parts of Miriam Haughton's article, 57.1 (2014), for this collection.

Carysfort Press and the Arts Council have once more created a vital space for academic and artistic knowledge to collaborate, as they should. The result is a much-needed documentation and analysis of major theatre practices and ideologies dominating recent decades. Our thanks for your support of this collection.

Finally, we hope that this collection plays an important role in acknowledging and interrogating the interventions of contemporary theatre practices by women in Ireland at the present moment. Our aim

is to understand, document and value the radical content and form that is shaping practices in theatre venues and spaces of performance throughout the thirty-two counties of Ireland, and the radical cultural, social, and political climate that women in contemporary Ireland live and work in. These essays provide a collage of such experiences, marking the complex, contradictory and potent cultural moment that has produced such intense theatre and creativity in this country. We salute the artists, scholars, audiences and all who enter into these debates. This present collection is dedicated to those who speak out and lean in, and the narratives of those who could not.

Introduction

Miriam Haughton and Mária Kurdi

This collection is the result of a simultaneously coherent and complex objective: to document the interventions of radical theatre-making achieved by female practitioners in contemporary Ireland through an analytical lens. No doubt the actualities of foregrounding such a mission statement assume much, and are inherently problematic and complicated. Firstly, terms such as radical and contemporary maintain an arbitrary, subjective and shifting scope, which this introduction unpacks and positions according to the limits of the particular enquiry the collection offers. Furthermore, there should be no associative conflation between work led by women and the ensuing form or content deemed as "radical" directly emanating as a result of their involvement. In truth, at the present moment, the traditional hierarchies of theatre-making such as the established roles of playwright, director, performer, designer and producer are situated alongside more fluid and potentially collaborative working relationships. Consequently, untangling the work of a particular female maker from her male collaborator is a complicated task and not always appropriate. Yet this collection is ready not only to critique, acknowledge and celebrate certain individuals and companies, but to safeguard against former ideological and material discriminatory habits from making a furtive return to prominence. Ultimately, it aims to provide an essential and overdue microscopic view of groundbreaking and provocative achievements led by female practitioners, which maintain a relationship with the scope of the term "radical" in motive, theme, form, and affect.

The scope of the term radical, however, stretches a distance indeed. The proximity in this collection's title between "radical" and "women"

may conjure up resonances from the histories of radical feminism most pervasive in North American culture during the "second wave" of feminisms in the 1960s and 1970s, also referred to as cultural feminism, though the terms maintain different remits of focus and meaning. In the second edition of her landmark book *The Feminist Spectator as Critic*, feminist theatre scholar Jill Dolan summarizes that at

> the start of the second wave of American feminism in the late 1960s and early 1970s, radical feminism was based in a theoretical struggle to abolish gender as a defining category between men and women. Cultural feminism, on the contrary, bases its analysis in a reification of sexual difference based on absolute gender categories. (5)

However, it is vital to clarify and confirm from this collection's outset that its call did not privilege scholarship regarding feminist theatre practice. Rather, it seeks to convey how in contemporary Irish theatre-making, much of the radical productions and affective theatrical experiences circulating currently stem from productions led by female practitioners. This cannot be a coincidence. Indeed, Dolan notes that in the US, many prominent female practitioners would not identify their work as feminist or radical. Here also, many of these makers shy away from these labels, and at times, directly refuse them. Yet, by choosing a path away from the patriarchal heritage of realism, one can identify a common thread of attraction to alternative forms of making work and a diversity of themes relating to female experience.

Dolan details that "[t]he fact that women now direct so many postmodern, experimental theatre companies–Anne Bogart (the SITI Company), Elizabeth LeCompte (the Wooster Group), Marianne Weems (the Builders Association), among others–indicates that women artists, too, use alternative forms and genres to tell stories and practice their craft" (xxxiii). At the same time Dolan releases the disclaimer that "[f]orm, style, and genre never automatically forecast radical content" (xxxiii). In Ireland, this community of female practitioners and their radical produce is the hard-won result of feminisms in Ireland and internationally, as well as a response to the multiple crises of power and institutionality that are ongoing. These structures and systems, now mid-collapse, were created from and developed through patriarchal ideologies made manifest through law and policy, supported by some communities, and contested by others. As we write at the point of their disgrace, the shift in the exercise of power and social expectation paves the way for newly emerging agendas. This moment of change does not constitute advocacy for the replacement of one form of constrictive

control with another, but offers individuals and institutions the space that is required for positive regenerative change.

One could argue that dedicating a collection to women's creativity in theatre is inherently part of the third wave materialist feminist project whether this is directly embedded in the collection's intentions or not. This collection acknowledges that the socially imposed divisions of patriarchal governance and ideology, social and religious, both limited and prescribed contributions from female theatre artists in industry at times throughout modern Ireland. Part of this culture ensured that the works led by women during several decades were also subject to discriminations in critical thinking and its print manifestations. Consequently, this collection is an act of resistance to those dynamics, destabilizing their assumed power. While the dominant patriarchal culture of theatre practice has greatly improved, it is not a wholly historical narrative even today.

The feminisms and increasing agency of women in all parts of public life have witnessed major successes in the workplaces and cultural spheres of Ireland, including the arts, but there is still a road not yet travelled. There is still a glass ceiling in some rooms. Assessments of women's creative work in the theatre, such as this collection, intend to position themselves in the direction of that road, with the desire of illuminating those glass ceilings when they appear. Unconscious and subconscious attitudes and habits are not easy to challenge and re-inscribe. The exercise of power is often silent and invisible, its effects trickling into daily life, which are then glossed over as natural and spontaneous activities rather than vested and strategic. If collections, institutions, programming and policies do not make the effort to identify and quantify the contributions of women directly, there remains the danger that they become sidelined to the shadows in the national and international consciousness once more. James Joyce's warning that those who do not learn their history are thus doomed to repeat it lurks behind every decision to act and react. It remains the responsibility of politicians, academics, artists and all communities as well as individuals to resist the traditions of old, where patriarchal and male-dominated power structures reproduce patterns of thinking and doing which ultimately ensure rigid gender roles underlying the performance of art and gender in public life.

The female practitioners at the heart of these essays and interviews do not face the same kind of gender inequality as they did in the previous century. Indeed, inequalities can be specific and yet similar and relational. As the writings will detail however, issues of inequality

and gender politics are embedded in the culture and industry of theatre-making in contemporary Ireland. The theatre, performance and dance artists in this collection stand strong in themselves. Yet at what cost? Had the public eye not followed the breakthrough political achievements of former Presidents Mary Robinson and Mary McAleese, what would be the relationship between expectations of female leadership, visibility, authorship of ideas, and the "national" consciousness, in contemporary Ireland? At this time of writing, the country has not yet witnessed a female Taoiseach nor Minister for Finance; two of the most powerful and influential government positions. What message does this send about the value of women and associated opportunities in public life?

To what extent did Ireland's membership of the EU (then EEC) in 1973 impact and intervene in Irish laws, policies, customs and ideologies relating to public life? Does Ireland still need international political intervention to legislate fairly for women? Savita Halappanavar suffered gross wrongdoing while miscarrying her pregnancy in 2013, directly as a result of Irish state and society's refusal to face pressing issues on termination, the Constitution and religion. Had her tragic experience not been met by international media attention and political condemnation, would the state have put the "Protection of Life During Pregnancy Bill 2013" into law? When will women in Ireland possess full legal rights to the dominion of their own bodies, regardless of religious convictions and antiquarian laws? How have the sporting triumphs of 2012 Olympic gold medallist Katie Taylor and the media frenzy of Ireland's foremost drag queen, Panti, in 2014, renegotiated concepts of femininity, power and heroism in Irish cultural dialogue? In summary, what are the links between the agency and visibility of women in Ireland in general–in politics, economics, religion, media, sport–and the agency and visibility of women in theatre in Ireland? This relationship provides the landscape from which these theatre and performance artists work, the attitudes they encounter, and the challenges that remain and appear throughout the motives and content of much of these makers' work. Thus, it is crucial to analyze the context to achieve any fair understanding or evaluation of the artists' work and contributions.

From the 1990s onwards there have emerged many female voices in Irish theatre practice who are intent on making theatre in new and exciting ways. The current plethora of works achieved by women question and undermine the constructs and conventionally drawn borders of personal and communal identities, rigidified views on

femininities and masculinities as well as the established hierarchies of power in national institutions and traditional beliefs. Also, they bring to the fore the alternative social experiences which arise from time-space compressions in a globalized and digital cultural climate, while discovering suppressed narratives in the official patriarchal discourses of modern Ireland for a renegotiation of the value systems related to gender, sexuality, class, ethnicity and different concepts of multiculturalism and interculturalism.

This collection includes theoretically grounded essays and praxis-oriented reflections and interviews, in one case a combination of the two, which survey, analyze and discuss the role of women in the changing shifts across the field of contemporary Irish theatre-making, South and North. The fourteen contributions included here focus on innovative theatre by women in the respective work of practitioners, directors, designers, collaborative groups and performance artists, providing also visual illustrations to the works under scrutiny. Most appropriately, the collection is opened by the foreword of Garry Hynes, the first woman in the world to win the Tony Award for Best Director in 1996. Referring to her own positive experiences with women theatre makers, Garry Hynes offers encouragement by expressing her belief that the volume will have an energizing influence on women's production for the stage. The contributions to follow are headed by a piece of writing which provides an insight into the world of artists' experience and self-reflection, which is often sidelined by external views of what becomes public of their work. Concurrently, this leading piece also marks a special anniversary. "Collective junk: Moving Through a Decade of Dance Theatre" by twin sisters Megan and Jessica Kennedy, who established the company in 2004, is mapping the history, goals, multiple challenges, awards, international successes and even the possible future of junk ensemble more than ten years after its birth. The specific genre of their work, dance theatre, is largely a female terrain, where the body is the primary locus of the joint effects of self-expression and aesthetic creation in performance. Megan and Jessica Kennedy place a great emphasis on the imaginative qualities and spatial consciousness of this branch of physical-cum-visual art and the liberating need to have an on-going, fruitful collaboration with other practitioners and representatives of other disciplines. In 2008 Bernadette Sweeney could still write that "[t]he repression of the body has been evidenced in the creation of meaning at all levels of the theatrical process in Ireland. The work of playwrights whose work (even unknowingly) subscribes to this repression of the body is more visible

in the Irish theatre canon" (8). During recent years the significant and rapid development of dance theatre, in which junk ensemble hold a leading role, has been an inspiration for the increasing acceptance of and respect for the body and its identity-forming potential in Ireland. By its remarkably vivid tone, added to its informational value, Megan and Jessica Kennedy's words about their art strike several cords that have their due echo in the analytical methods, critical attitudes, shared and overarching themes as well as gender-related concerns that occur throughout the present volume and make it unique.

The structural arrangement of the material across the volume corresponds to the similarities in the main focus of individual contributions, which appear in three groups. Under the title "Embodying the Radical; Radical Revisions in Performance" the first section brings together papers which argue their subject by foregrounding the diverse, unconventional roles the body can take in performance staged by and about women. In "Olwen Fouéré's Corpus: The Performer's Body and her Body of Work," Shonagh Hill claims that the 2010 production *Sodome, my love*, a French play by Laurent Gaudé, witnessed two of Ireland's eminent female theatre practitioners collaborating: Rough Magic director Lynne Parker and actress Olwen Fouéré. Fouéré, also the translator of the piece, played Lot's wife, who has been preserved (while also silenced and paralyzed) in salt for thousands of years and in the drama awakens to tell her story by reshaping the myth of Sodome and her own female experience related to it. Fouéré's performance with its heightened corporeality is discussed in the paper in the context of her other work on the stage, often concerned with the liminal state between life and death as in Marina Carr's *Woman and Scarecrow* (2006). By exploring the limits and freedoms of reperforming and "exscribing" (exceeding the inscription of) myths of femininity through the body, Fouéré's performance is related in the essay to the construction of identity as an embodied, thus potentially resistant process. Issues of representation are also touched on by Hill, who concludes that in *Sodome, my love*, Fouéré's performance highlights that the female body can become the author (and remain no longer the passive object) of its own representation. Written by Cathy Leeney, the essay "Second Skin: Costume and Body: Power and Desire" addresses the issue of representation in an even more radical way, by examining *Sodome, my love* alongside another 2012 Rough Magic production, a new version of *Phaedra* with music by Ellen Cranitch and Hilary Fannin, drawing inspiration from Racine's *Phèdre* (1677) and Rameau's opera *Hippolyte et Aricie* (1733). Both

pieces, Leeney argues, re-stage female bodies known from ancient myths as central to the action and narrative, who express intense sexual desire which challenges the normative positioning of women as mere objects of desire. Furthermore, the essay poses questions about revisioning theatre semiotics in the productions, and in answer reveals the appearance of a crisis in the representation, a kind of "visual aporia" to convey the "ambivalence of third wave feminism." Leeney's investigation is largely concerned with costuming, the role of vestiary codes in articulating and enhancing the disruptive potential of the performing body along with semiotic excesses added to the images of female agency to suggest its instabilities set against the agenda of third wave- or post-feminism.

The next two essays address the liberating effects of bodily enactment in productions that share features of documentary theatre. "From Laundries to Labour Camps: Staging Ireland's 'Rule of Silence' in ANU Productions' *Laundry*" by Miriam Haughton analyzes a 2011 site-specific work which offers a shocking immersion into the infamous past of Irish social morality. Directed by Louise Lowe, *Laundry* uses the Convent building attached to a former Magdalene laundry in Dublin, drawing on historical record as well as testimonies of penitents who were forced to work there like slaves. The audience, thus, was introduced to the painful, yet for a long time hidden aspects of the nation's history. Combined with its documentary nature, *Laundry* proved to be an example of experiential theatre by employing strategies, the essay discusses, which made a complex verbal, visceral, and haunting impact on the audience. In fact, it radically intervened in conventional audience habits to watch a performance as an outsider by involving them in the humiliating and unhealthy routines of the "Maggies," the incarcerated victims of the system. Quoting Michel Foucault and Peggy Phelan, Haughton analyzes the performance in detail through her own personal exposure as an audience member to a sensual, performative experience of what it was like being locked up, silenced and erased as individuals by Church and State in such a laundry for the "crimes" of the body. In addition to writing about the postdramatic aesthetics of the performance, the essay stresses its revelatory socio-cultural values in the context of publishing the "Report of the InterDepartmental Committee to establish the facts of state involvement with the Magdalen Laundries" in 2013, and the mixed reactions that followed.

The essay "The Fetishization and Rejection of Womanhood in the Performance Works of Áine Phillips" by Caitriona Mary Reilly discusses

the art of Áine Phillips, whose work, the author argues, draws on the artist's own autobiographical details to interrogate and critique respective manifestations of the postindependent and postfeminist Irish idolization of womanhood and motherhood. In her performance work Phillips probes into contemporary issues like abortion, reproductive freedom and female sexuality, often making use of the grotesque mode to highlight an alternative view of pregnancy, maternity and a woman's right to ownership of her body. Grounding her essay in aspects of Irish history, social discourses, movements and documents crucial for women, Reilly takes a critical interest in particularly three of the artist's works, and through these analyzes how Phillips uses her physicality and personal experiences coupled with a provocative visual imagery as the means of radically subverting idealized notions of the female body and its expected roles. In the part about *Sex, birth & death* (2003), the author cites Peggy Phelan's ideas about fetal imagery and discusses the performance also as an act of challenging the mystique of breastfeeding. *Harness* (2007-2011) is a "narrative re-enactment" of Phillips' experiences of disability and concomitant family relationships, through which, Reilly argues, the performance destabilizes "the fetishization of postfeminist motherhood and femininity by drawing attention to the difficulties of motherhood as well as the limitations of the human body." Finally, Phillips's *Emotional Labour* (2012), is looked at as a contribution to a collaborative performance work, *Labour,* a piece of radical, politically sensitive performance which physically illustrates the painful sides of women's work, subverting the "image of the dutiful housewife." The essay discusses how Phillips, in her own part of the series, evokes the lasting effect of abuse and stigmatization both on the bodies of individual women and the social body of the nation parallel with ANU's *Laundry* and drawing on the experiences of the unseen and silenced women incarcerated in the Magdalene Laundries.

The fictionalized documentary is also an element of the last essay featured in the section. Sam Yates's "'We Will Be Seen': Documenting Queer Womanhood in *I (Heart) Alice (Heart) I*" draws primarily on Janelle Rienelt's ideas on documentary theatre when exploring the strategies contemporary Irish playwright and performer Amy Conroy has developed to create a "dramaturgy of the real" in her 2010 mock-documentary play *I (Heart) Alice (Heart) I*. Conroy's play, in Yates's interpretation, interrogates representational visibility and complexities of the queer narrative which fuses the intimate experience of personal identity with social commentary. With the Alices' intimacy in focus,

Yates explores the ways in which Conroy's work reflects changing experiences of queerness and gender identity in Irish society, queer people's resolution of "their conflicted relationships with masculinity" as well as the potential empowerment through their non-normative identification. A "series of memories connected by [the] interrelated dialogue" of the two Alices, Yates writes, combine in Conroy's work lived experiences as an authentic basis and theatrical performance to interrogate the contestatory role of gender and sexual power in the discourse on contemporary national identity. Conroy also investigates, according to Yates, how femininity and queerness strengthen each other to offer alternatives to the male-based dominance in the Irish and even broader cultural context. Repressed gender positions can enter the public imaginary and establish a new consciousness and feminine space there through the medium of performance. Also, the play is considered to be ground-breaking here for reconciling queerness with Catholicism through the representation of Irish queers as ordinary people who strive to define their complex relationship to religion.

The second section of the volume under the title "Performing Woman in Contemporary Ireland" includes essays that focus on the empowering effects of female solo performance. Emma Creedon's "Performative Reappropriation: A Case Study of *Taking Back Our Voices*" interrogates a production staged at the Abbey Theatre in 2012 and directed by the Abbey's Resident Assistant Director Oonagh Murphy. Here Creedon explores the ways in which theatre is able to challenge contemporary social misconceptions about prostitution and the commercial sexual exploitation of women. The piece was developed using the personal testimonies of victims about the harsh realities of prostitution. Therefore, it urges the critic to look at it from the angle of documentary theatre and evoke the false and humiliating ways in which prostitutes were represented in the male-dominated theatre (for instance in O'Casey's *The Plough and the Stars*) and their still ambiguous treatment in contemporary social discourses and debates. Creedon's paper considers the ethical aspects of the process of this kind of theatre-making along with the socio-political and emotive implications it carries through the embodiment and live re-enactment of trauma. Performing the traumatized self in theatre, Creedon argues, makes it possible to take back their voice and reclaim control of the narrative by counteracting stereotypical notions about the "oldest profession," leading to the re-empowerment of women debased by sexual exploitation. "'The Horror, The Horror': Performing 'The Dark Continent' in Amanda Coogan's *The Fountain* and Samuel Beckett's

Not I" by Brenda O'Connell draws on the theories of Julia Kristeva and Luce Irigaray to argue that Amanda Coogan's performance deploys a unique female language mediatized through the corporeal body "as a site of communication." By taking *The Fountain* (2001) as the centre of analysis, the essay underscores an intertextual relation between this piece and Beckett's *Not I*, finding that in both works the female abject is foregrounded, disrupting conventional patriarchal notions about and treatment of the feminine. Coogan displays her genitalia while urinating in the performance, and Billie Whitelaw's performance of Mouth in *Not I* evokes the image of the vagina, acts which, in their own way, O'Connell claims, are not only provocative but also challenge Freud's blindly simplifying identification of female sexuality as the Dark Continent by posing danger to the phallogocentric system. In the case of Coogan, the author of the essay refers to the radically transgressive features of the artists' other works which, "silent [and] durational," have a shocking effect on the audience.

The next two papers are concerned with the highly experimental work of two female performance artists and the ways in which these encourage audience participation and even radically revise the theatre and spectator relationship. The subject of "Blurring Boundaries and Collapsing Genres with Shannon Yee: Immersive Theatre, Pastiche, and Radical Openness in the North" by Fiona Coffey is the work of Shannon Yee, a queer, Chinese-American immigrant playwright with an acquired brain injury, which the author discusses in the context of new developments in the theatre life of post-Troubles Northern Ireland. The artist, Coffey claims, "uses her multiple minority identities to tackle difficult and taboo subjects in non-traditional ways." Two of Yee's performance pieces, *Trouble* (2013) and *Recovery* (2012) are addressed by Coffey, pinpointing that they experiment with a pastiche-like blend of techniques in their act of defying conventional art forms. With both, the essay demonstrates, "Yee creates individualized and interactive performances for her audience members ... to engender compassion, empathy, and understanding for those who identify outside of traditional identity politics in the North." Flanking this essay Kasia Lech's contribution opens her critique of and interview with theatre artist Stefanie Preissner by contextualizing the increasing presence of rhyme in the contemporary performing arts through reference to recent examples, which received both critical and popular acclaim. She concludes from this that, "rhythmical language seems to facilitate well the voices of artists that emerged during the last decade. Secondly, rhythmical language appears to have an increasing appeal for various

contemporary audiences." Lech relates this prevalence of form directly to the impact of the Celtic Tiger crises, as its energies seem to facilitate artists with a "response to the trauma of instability and change." Focusing attention on two of Preissner's productions in particular, *Our Father* (2011) and *Solpadeine is My Boyfriend* (2012), both written and performed by Preissner during two consecutive Absolut Dublin Fringe Festivals, Lech employs the theories of Bert O. States concerning the actor and the persona, and Jerzy Limon's consideration of audience perception of actor and character speech, to query how these works function and impact their audiences. While the content and themes of these performances move in different directions, Lech notes important consistencies in form and intent, particularly in relation to the role and impact of rhyme. Lech argues that, "such strong introductions of rhyming patterns may from the very beginning highlight the issue of Preissner's multiple identities. This is central for her performance of rhymes as an escape and her use of rhymes as an expression of pain."

Embedding an interview, Lech's contribution prepares the way for the third part of the collection, which is titled "Reflections on and Interviews with Radical Theatre Makers" and is headed by Charlotte Headrick's essay "Lynne Parker: 'Radical' Director. Reflections of a Fellow Director." To a large extent it is based on the author, a fellow director's direct observations of Parker's work and personal talks with her. As an artistic director of Rough Magic, Headrick argues, Parker is radical for several reasons: because of the rich array of her work, her commitment to discovering and helping especially young women writers, her continued ambition to challenge audience expectations with, among others, radical adaptations of some Irish and non-Irish classics. The article emphasizes that Lynne Parker has worked together with actresses of Charabanc and directed plays not only in Ireland but in London and the United States as well. Headrick refers to several of her groundbreaking productions, including O'Casey's *The Silver Tassie* at the Almeida in London (1995), a new, all-women version of *Phaedra* (2010) with Rough Magic and a 2012 re-staging of Shakespeare's *Macbeth* for the new Lyric Theatre in Belfast. Highlighting the most innovative elements and techniques deployed by the productions, Headrick is building up a consistently authentic, highly appreciative picture of Parker. The article concludes with the well placed words of a kind of tribute: "[a]s the artistic head of Rough Magic, she has done more than any other artistic head in Ireland to promote writing by women and to open the door for young directors through the SEEDS program."

An interview with directors follows in the collection: Matt Jennings talks to four of Northern Ireland's leading theatre directors, all female– Emma Jordan (Prime Cut), Paula McFetridge (Kabosh), Caitriona McLaughlin (Freelance), and Zoe Seaton (Big Telly). This gender dynamic is not an isolated incident, as Jennings details that "Nine of the fifteen producing theatre companies in receipt of annual funding from the Arts Council of Northern Ireland (ACNI) 2014-2015 are led by female executive or artistic directors." Nor is it a coincidence as the ensuing dialogue attests. Jennings rightly declares it is a unique cultural phenomenon that requires further study, particularly as it unfolds in a place where the politics of gender have generally been treated as subordinate to, and separate from, questions of national identity. Debating the term "radical," this cohort consider it not only in terms of the form and content of their work, but also of the industry pressures within which they must work. While noting the privileged position they feel they have reached by being in receipt of public funding, concerns are also expressed regarding the limits to their rehearsal and development processes. These practical frameworks hugely impact their productions. Significantly noticeable regarding this interview is the warmth of the environment and dialogue among the directors. Directing theatre is a punishing task, and a competitive profession. In this interview, these tensions seem to produce a climate of camaraderie and support. The histories and audience expectations of the places where they produce work, including Belfast, Derry and Portstewart, inscribe their work from concept to creation. Paula McFetridge considers the nuances of and between being a political artist and an activist, claiming that

> I think artists, by their very nature, live on the fringes of society –
> maybe because the rest of society thinks that what we do isn't a
> proper job; or that we are quirky and bohemian and they can't
> quite put us in a box. So inevitably, if you're on the outside looking
> in, there's something a bit different about you. There is something
> radical, changing, whatever it is. But I do think that all art, by its
> very nature, is political–with a small 'p'. I think that the question
> is between being active or passive.

The entirety of this collection seeks to unpack these questions of politics and theatre guided by a big "P" and a little one, and indeed, how the continuum of active and passive impact and inspire theatre artists and their audiences.

Another interview in the section, "HERE AND NOW, There and Then: An Interview with Veronica Dyas" by Karen Quigley, provides an

illuminating and thought-provoking talk with contemporary Irish theatre artist Veronica Dyas, regarding two specific shows she has developed, *In My Bed* (2011), and *HERE & NOW* (2012). Dyas pithily summarizes the reaction that most of the theatre artists documented in this collection reveal in response to the association of themselves and/or their work as "radical," musing that "[r]adical is a hard word, and it feels, from a certain perspective, like a strange compliment." However, the term "radical" does ring true in her case. *In My Bed* is a site-responsive piece, staged in the location where Dyas' grandmother was married, and throughout the performance, she narrates between two periods of time in Ireland spanning fifty years; her grandmother's social experience and her own. Thus, similarly to some other contributions in the collection regarding both form and content, Dyas' work testifies that the history of female experience is impacting radical contemporary Irish theatre-making as social histories of silence break through to centre stage theatrical performances. The second performance Quigley interrogates, *all that signified me...* is part of the ongoing practical project *HERE & NOW*, and also stems from contemporary crises in Ireland, chiefly, the extremity of the Celtic Tiger economy on mind, body, and soul. Quigley's reflective and analytical critique regarding the interview considers the ways in which Dyas' work addresses histories of abuse and recovery on the individual and national levels.

Next Noelia Ruiz provides both a review of seminal Irish lighting designer and co-founder of Pan Pan, Aedín Cosgrove, as well as an interview with her. Noting that Cosgrove founded Pan Pan with Gavin Quinn in 1991, and has since worked on their productions as well as independently, the interview highlights one of the primary motives of this collection—that there exists a wave of female theatre artists creating groundbreaking work in Ireland in recent years and throughout previous decades. However, there is a lack of critical attention and celebration devoted to their work and achievements. Ruiz's insightful and comprehensive contribution addresses this imbalance. Ruiz firstly reviews Cosgrove's career, from Pan Pan's recent major Beckettian triumphs at the Edinburgh International Festival 2013, but also returns to Cosgrove's initial influences from theatre and aesthetics. Cosgrove's early engagement with the ideas of Adolphe Appia, the avant-garde, symbolism and futurism led her to explore ideas of the postdramatic. These conceptual and theatrical histories maintain a role in the aesthetics of Pan Pan's significant body of work totalling twenty-six productions, and as Ruiz comments, establishes Pan Pan as "the

longest-running experimental theatre company in Ireland and arguably the most recognized internationally, especially in the festival circuit." As a woman involved in the technical side of theatre-making since the 1990s in Ireland, Cosgrove comments on her awareness of her gender in a male-dominated profession. She reflects on how her role as a lighting designer was unusual at that time, but also, she questions whether it was as noticeable among her male colleagues as it was in her own consciousness. She details that "[i]t was very hard because if you made a mistake or you wanted to make a considerable change it was more of a big deal ... Maybe it would have been the same for a young man. It is always difficult for everybody to be in charge of a team."

As the last piece, Tanya Dean's interview with producer Anne Clarke tells of a career trajectory that is a source of inspiration for both emerging and established theatre-makers. Beginning with the basic of administrative duties in the Gate Theatre from 1984, Clarke tells of how a "significant birthday" empowered her to take the leap from her established position as Deputy Director at the Gate–a venue she cites as maintaining the joys of a loyal audience and, for programming, certain creative flexibilities. Exploring the "three legs to the stool" that interested her, including casting, touring and producing, Clarke built her new home in Landmark Productions in 2003, a company she founded and is led by a Producer–herself. A decade later, Landmark has arrived at a point of critical and popular acclaim through following a model of art-led and commercial-led productions. Achieving acclaim from both popular audiences and pundits is a major success in itself, but perhaps what we could argue is most radical regarding Clarke's work is how she nurtured her company financially to the benefit of artistic aims, so that it was born and grew outside of total or near-total dependence on the Regularly Funded Organisations grants provided by the Irish Arts Council. Not receiving Arts Council support for their first production, David Hare's *Skylight* (2004) at Project Arts Centre acted as a sharp shock. This shock resulted in her awareness that such financial vulnerability would not sustain her long-term motivations, and henceforth she engaged with funders to produce a body of work that has toured Ireland, London and New York. While the binary of art-led and commercial-led works presents many distinctive works for Landmark, there is an organic guiding sensibility that is key to Clarke's company and work ethic. She acknowledges, "There are just stories that need telling, and there are different spaces that are right for different stories. And finding the right way to tell the story in the best possible way is what's really exciting. That's the great gift of being an

independent producer, of finding something that you feel you absolutely *have* to get on the stage." Indeed, with Clarke at the helm, audiences in Ireland and internationally can anticipate further productions from Landmark which both challenge and delight, and without doubt, inform generations of artistic organizations and theatre productions regarding the making of work in contemporary context, whether boom or bust.

Considering the rich variety of essays and interviews we have been lucky to include in the present collection, Melissa Sihra's thoughts on Marina Carr from 2007, although written about a theatre more traditional in form, seem to be relevant to close this introduction with. Sihra maintains that, "in a society where historical processes of female oppression have only begun to be seriously acknowledged in the social, political and academic fora of the last decade or so, painful narratives need to be addressed before transformations can occur" (214). This is precisely what the very recent theatrical pieces and performances discussed in the essays and interviews published here are undertaking, and their efforts well deserve being made known to a wider public through specific critical treatment and multivalent reflection. As editors we express our warm thanks to the authors of the essays and the theatre makers interviewed by the authors. Also, we express gratitude to eminent director Garry Hynes and the representatives of junk ensemble for their introductory words and insights, a fine prelude to the material that follows. Further, we thank all the scholars who agreed to become involved in the peer-reviewing process of the papers and offered the authors and editors valuable advice or suggestions on why and how to carry out revisions where it seemed necessary. Finally, we are extremely grateful to Carysfort Press and to the Arts Council Ireland/An Chomhairle Ealaíon for their kind assistance and generous support that made the publication of this collection possible.

Works Cited

Dolan, Jill. *The Feminist Spectator as Critic.* 2nd ed. Ann Arbor, MI: U of
 Michigan P, 2012. Print.
Sihra, Melissa. "A House of Woman and the Plays of Marina Carr." *Women
 in Irish Drama: A Century of Authorship and Representation.* Ed.
 Melissa Sihra. London: Palgrave Macmillan, 2007. 201-18. Print.
Sweeney, Bernadette. *Performing the Body in Irish Theatre.* Houndmills,
 Basingstoke: Palgrave Macmillan, 2008. Print.

1 | Collectable junk: Moving through a Decade of Dance Theatre

Jessica Kennedy, Megan Kennedy
junk ensemble

junk ensemble

junk ensemble was established by joint Artistic Directors Megan Kennedy and Jessica Kennedy in 2004 with a commitment to creating works of brave and imaginative dance theatre. Winners of Best Production Award 2011, Culture Ireland Touring Award in 2008, Excellence and Innovation Award in 2007 and listed as a Sunday Times Highlight in 2011, junk ensemble's work continues to tour nationally and internationally. Their productions are often created in collaboration with artists from other disciplines to produce a rich mix of visual and performance styles that seeks to challenge the traditional audience-performer relationship. This approach has led to productions being created in non-traditional or found spaces as well as in more conventional theatre spaces.

junk ensemble were Artists in Residence at Tate Britain, London (2012) and Fingal County Council (2010/11) and Artistic Directors of Drogheda Youth Dance (2007). Productions include *Dusk Ahead* (Dublin Theatre Festival 2013/Kilkenny Arts Festival 2013), *The Falling Song* (UK and National Tours 2014/Belfast Festival 2012/Dublin Dance Festival 2012), *Bird with boy* (Dublin Theatre Festival 2012/Dublin Fringe Festival 2011), *Five Ways to Drown* (Irish Tour 2012/Dublin Dance Festival 2010), *Sometimes we break* (Tate Britain 2012), *Pygmalion Revisited* (Áix-en-Provence commission 2010), *Drinking Dust* (2008), and *The Rain Party* (2007). junk ensemble are Associate Artists at Project Arts Centre, Dublin.

Introduction: The Spark

The spark for junk ensemble's formation occurred when Megan was in the midst of writing her dissertation at Queen Margaret University in Edinburgh in 2003. This led to working with Jessica and another dancer/choreographer, Matthew Spencer, for the practical element of her thesis. Jessica was working in London at the time with various dance companies. The piece was called *Chocolate Rhino*, based on Ionesco's *Rhinoceros*. It was the first time we had created a piece of choreography together as a piece of theatre, containing a loose narrative. We capitalized on the fact that we are identical twins, and as a result, realized we could create an embodied aesthetic in performance that is unique to our individual and shared identity. *Chocolate Rhino* was programmed in the Edinburgh Fringe Festival in 2003 and therein began our interest in creating work together.

The company name for the Edinburgh Fringe show (a double-bill with another company and therefore a shared name) was "Stage Junket." When we thought about names for our own company we wanted to hold onto the word *junk*, as it represented so many different ideas to us. We liked the feeling that the company was a creation of eclectic ideas, objects, and remnants of histories, which remain scattered in the present. Also, it is part and parcel to our collaborative ethos and the reason we included *ensemble*.

We both returned to Dublin and formed junk ensemble in 2004. Our desire to start the company came from wanting to create work that we had not seen in Ireland before, and to collaborate with other artists. The visual aesthetic created through our shared performance style–near identical in our appearance and movement–is generally well received. We had just spent a summer watching many dance theatre pieces in the Edinburgh Fringe Festival and came across wonderful and strange Russian work: *Derevo* (Islands in the Stream), *Do Theatre* (Birds-Eye View), and *Akhe* (White Cabin). We wanted to make work in a similar vein in Ireland. We also were influenced by the work of Pina Bausch (1940–2009), the founder of TanzTheater Wuppertal, who remains a staunch inspiration to us both. Filmmakers such as Roy Andersson, David Lynch, and Alfred Hitchcock continue to have an effect on our work. When we started to make work, male choreographers and directors heavily populated the Irish contemporary dance scene, with very few female choreographers working in the field. Yet the crafted work of Liz Roche spoke to us and helped mark a strong female stamp on the current dance scene.

In some ways, the identity of junk ensemble has been firmly realized since the company's inception. However, we now have a body of work, and through reflection, we recognize the patterns in our practice. This may be because we are naturally closely linked and have similar histories, training, and exposure to much of the same work, all of which have formed us. Nevertheless, the identity of junk ensemble has unquestionably been shaped by collaborations with other artists. We have created three pieces with Scottish theatre maker, Jo Timmins. From our early work to current we have a strong creative bond with Jo; she sees things we do not always see, and has an acute sense of the visual. We also have an affinity with visual designer Aedín Cosgrove; we have a similar approach to work as Aedín and she can be a bit anarchic about theatre, like us. Another influence on our work is our continued collaboration with Brokentalkers (Ireland), which began in 2005.

junk's Body of Work: Collaboration and Growth

We began creating duets using pre-existing music by composers and experimenting with visual and lighting design ourselves. We created three duet pieces over the course of four years, which we performed nationally in Ireland and to Germany as small, inexpensive, compact pieces–essentially the two of us and a bag of props and costume. The three pieces were *Watch Her Disappear* (2004), *Circus Freak* (2005) and *The Rain Party* (2007). *Watch Her Disappear* began with our fascination with split personality and schizophrenia. As twins, we were intrigued to research these disorders. Identity was something we were interested in at the start of our collaboration together and the research we did for the work struck a chord with us regarding this theme.

We received our first commission from Project Arts Centre in 2007 for our third piece called *The Rain Party*. At that time, Willie White was the Artistic Director at Project and invited us into their Associate Artist scheme. Project Arts Centre has been instrumental in our development as artists and as a company. They showed an interest in us as young artists and continue to support us with enthusiasm and pragmatism to help realize our creative aims. Our interest in site-responsive work began with *The Rain Party*; it was first performed in a garden centre in Temple Bar and subsequently toured to various outdoor spaces, including a Diocese in Sligo, Christ Church Cathedral in Dublin and university gardens in Erlangen, Germany. We collaborated with Jo Timmins in making the piece, who we have since worked with on *Bird with boy* and *Sometimes we Break* (Tate London). *The Rain Party* won the Excellence and Innovation Award at Dublin Fringe Festival 2007.

We received our first Arts Council funding award in 2008 for *Drinking Dust*, another site piece. We collaborated with Feidlim Cannon and Gary Keegan from Brokentalkers and focused on abandonment in the city, stolen memories and the idea of a strange and broken family pushed together in one space. We separated the audience into two and reunited them for the final part of the show. For *Drinking Dust* we worked with an older actor (Daniel Reardon) and a 6-year-old girl (Juno Kostick). It was our first piece working inter-generationally, and carved the way for many more to come.

For *Drinking Dust*, we were interested in working with non-dancers/non-professionals and continued this process in many of our other shows, notably *Five Ways to Drown* (2010), *Bird with boy* (2011) and *The Falling Song* (2012). We were awarded the Culture Ireland Touring Award at Dublin Fringe Festival 2008 for *Drinking Dust*. We toured the piece throughout Europe and performed it again in Ireland as part of Dublin Dance Festival 2009.

We were awarded Best Production at Dublin Fringe Festival 2011 for *Bird with boy*. We made the piece on a small grant from Dublin City Council and a huge amount of generosity and goodwill from highly skilled professionals (dancers, musicians, visual artists, theatre makers) and arts spaces (DanceHouse Dublin, Project Arts Centre, Dance City Newcastle). It was certainly tricky to make a show with very little funding but we wanted to create work instead of sitting tight so we forged ahead. We were invited to perform the piece the following year in Dublin Theatre Festival 2012 and this allowed us to pay all of the artists that had worked on the original production.

2012 was a busy and productive year for junk ensemble. We created two new shows (one for Tate London and one for Dublin Dance Festival); one production toured nationally and another was re-staged in Dublin Theatre Festival. Our biggest and lengthiest tour to date has been with *The Falling Song* in 2014. We toured the work to eight venues in the UK and four venues in Ireland. The UK tour garnered large audiences and excellent reviews.

We have been critically noticed since 2007, however after *Bird with boy* and *Dusk Ahead* were programmed in the Dublin Theatre Festival, a larger pool of critical attention and exposure to our work emerged. A large breadth of reviewers and presenters attend Dublin Theatre Festival every year and this is advantageous for us regarding international acknowledgement of our work.

To date, we have worked with younger children in four productions and with older performers in two productions. It is the "realness" of

young performers that attracts us: their vulnerability, brightness, insecurity and innocence. We are interested in the human condition and finding a way to place that in our work, to tell a story in non-linear form without a large amount of text, and often incorporating song and live music. Essentially we make dance stories. We think this constitutes one of the strongest ways to hear a story. It is more instinctive for us to read someone's body language or physical language than to decipher it through text, which can conceal the emotion.

We try to tell stories through the body in ways we have not seen or heard before. We search for the raw emotion, the violence, the fragility, the destruction and beauty, and try to demonstrate it physically. It is a tall order, but we attempt to create brave theatre, without it feeling contrived or forced. Attachment and mortality are other themes that recur in our work. We had various physical constraints of attachment in *Dusk Ahead* (2013), whereby two dancers were attached at the lip, one to a chair, one to someone's back, and two female performers attached by their hair. These tasks created an interesting and restricted way of moving but also described the various dynamics of relationship, the dichotomy of needing someone or something and the stubborn refusal to split.

We make the work we want to make, the work that feels right for us, and we hope that it will feel this way for others too. Working with artists in other disciplines is key for us and our long term collaboration with composer Denis Clohessy and Aedín Cosgrove have in turn helped inform the work to great benefit. Working with designer Sabine Dargent on *Dusk Ahead* opened the door to a huge amount of research material we had not previously considered. We work with visual artists as often as we can and find that this collaboration is particularly successful with site work. We enjoy the different perception a visual artist has to a "set" designer; the thought that space and its atmosphere are mutable and easily adapted.

In recent years we have begun our research process in residence at Dance City in Newcastle, by disappearing out of Dublin to work without distraction. In residence, we look over old and new photography books, watch films that might be relevant to the piece, discuss and devise images and movement ideas from talking through everything we've watched and looked at. We often try out our ideas in the studio before taking them back to the cast. For instance, in *Dusk Ahead* the cast begin blindfolded and attempt to navigate the stage's obstacles following the sound of a bell. We spent a day in the rehearsal studio completely blind, bumping into the mirrors and into each other. We also stayed stock-still

and tried spinning for endless minutes, which in turn allowed us a sensitivity when asking the performers to try this difficult task.

Negotiating the Terrain: Challenges

It has often been a challenge to secure arts funding for our work over the years. We tried various formats and proposals for some years and we were eventually successful with the Arts Council in 2008. This was by no means a guarantee for future projects and we continue to be in an unstable funding situation, particularly with the recent cuts to dance project funding. These cuts make it difficult for us to make work. Creating one production a year is no longer possible at this time. There were a few times when we alternately became fed up with it all and declared we were moving to New York or the south of France. One such example of frustration led to us doing *Bird with boy* with very little money involved. Ultimately, it is more important for us to create something out of nothing than create nothing at all.

There is something special and liberating when finances are limited. The work is being made for ourselves, exactly as we want it, with full creative control. Designing and lighting a space from found objects and house lamps forces us to be extremely resourceful and inventive. Although we continue to take on such projects for the adventure of creative activity, we also sustain ourselves by freelancing as choreographers and performers, working with a host of theatre and opera companies and regularly collaborating with Brokentalkers.

After our initial research period, we work with the cast in studio for approximately six weeks before going into production. In an ideal world, we would work longer than this as the ideas need time to develop and the work to settle but the current funding status is limited. Rehearsals can often be challenging for the performers because of the movement tasks we ask of them. It is physically draining and mentally frustrating to spend an entire day attached to someone else's lip; the end product shows a history of this: the time and perseverance that was given to the idea and the strength of the performers to first handle the challenge, and eventually to own the material.

There have been difficult moments in rehearsals between us. Not only are we family, we are twins working together six days a week. We are not always well mannered or considerate to each other when we feel strongly about something and our disagreements are not particularly pleasant for other people in the rehearsal room, although we have perfected the art of hushed arguing. Denis Clohessy (who also is an identical twin) once said to us: "You should be sent to polite school."

Ultimately we want the same things in our work and are in agreement about the big things, nonetheless, the little things can sometimes dominate. It took some time to figure out a less complicated, healthier way of working together. We are still learning but our working method improves with every project.

junk's work does not directly set out to make a statement about gender identity or inequality or sexual politics. However, we often collaborate with female designers and a female production team. The female performers in our work appear confident, unfazed, in control, and sometimes fierce. This is an unspoken decision between us. We do, however, acknowledge the challenges that women face in Ireland in the present day. We enjoy working with strong women and with strong men. We work with performers that will take risks and push themselves hard, physically and mentally, for the work. We expect the female performers to match the strength of the male performers. Certainly, gender discussions arise in the work, particularly with *The Falling Song*, which is performed by an all-male cast yet choreographed by two women. We were interested in the challenges of this process and eager to learn more about what it is to be a man and how to represent it accurately.

Imagined Futures

We reached our ten-year anniversary in 2014 and only realized this when our father mentioned it. It feels odd to have reached ten years; there is something vaguely bittersweet about the milestone. We have achieved quite a lot in that time, and yet we have so much more to do. The ten years mostly makes us look forward in anticipation to all the artists we have yet to work with and all the work we have yet to make.

In ten years from now we believe junk ensemble will still be creating work. We hope to have longer working periods in 2024 with more time for research and development, which might not necessarily lead into one big production. We will reach 2024 if we keep challenging ourselves and keep trying to do new things with dance. We might fail some of those times but at least we will be pushing ourselves and not worrying if we land on ground or in water.

The impact of dance is fast developing in Ireland. It was a slow burner to begin with but the importance of dance is growing and there is a palpable interest in movement. There are various independent dance artists in Ireland making interesting work and many of them are being supported by Dance Ireland, our national dance agency. Dance theatre is also evolving, as are its audiences. There is a better

understanding and appreciation of physicality and dance as an art form. Audiences are more educated in contemporary theatre and contemporary dance, and do not necessarily require an explanation at every turn or a verbal roadmap to find their way. However, there does seem to be a lingering fear in Ireland surrounding the notion of the body and its language, perhaps from the centuries of body repression.

There is no professional dance training in Ireland. This applies across all the dance forms including contemporary and ballet. If one wants to train professionally then the only option is to train abroad, which is a considerable challenge, particularly financially. If one decides to train abroad, further issues arise for the ecology of dance in Ireland. As is often the case after training abroad, the dance artist will create contacts and find work in that particular country and remain there, which is unfortunate for the dance sector in Ireland. Often a dance artist or company will work with international dancers because of the scarcity of dancers based in Ireland. We have done this for many of our productions and it can become both costly and tricky to find the right performers. The lack of professional dance training in Ireland is a roadblock for the arts and needs to be addressed.

On the other hand, there *are* increased opportunities for dance artists in Ireland such as regional dance artist-in-residence schemes, Dance Ireland and Dance Limerick opportunities, the Step Up programme, and Arts Council bursaries for dance. There is a recent influx of trained Irish dancers who have returned to Ireland with an interest to join the dance scene and have stayed in the country because of opportunities of dance work. Now we need them to tell their friends.

Embodying the Radical:

Radical Revisions in Performance

2 | Olwen Fouéré's Corpus: The Performer's Body and her Body of Work

Shonagh Hill

A whispering voice emerges from the darkness: "You pass and you do not see me" (Gaudé 1). In the opening moments of *Sodome, my Love* the audience is made aware of the shadowy presence of a stooped figure sitting on a bench. A poetic monologue written by Laurent Gaudé and translated and performed by Olwen Fouéré, the play draws on the Biblical story of Lot but focuses on his wife's account as she emerges from her centuries-long burial under mountains of salt.[1] In the opening tableau, Fouéré's physical posture is stiff, her head is bowed down, she is leaning her weight on one arm, and has one leg awkwardly straightened; this tension is further compounded by the script's emphasis on the cloying atmosphere of the city of Sodome and descriptions of the sweaty clammy bodies of its inhabitants. Lot's wife slowly materializes from this deadening space: "I feel the bite of the salt in my veins" (1). The sharp bite awakens her body and story, and her return to life is manifested through both narrative and corporeal presence. The salt marks the anxiety of this retelling: it both preserves and denies life, connoting the possibilities for, and limits placed on, female bodily expression.

[1] Laurent Gaudé. *Sodome, my Love*. Trans. Olwen Fouéré. Dir. Lynne Parker. Perf. Olwen Fouéré. Designer. John Comiskey. Costume. Monica Frawley. Music and sound. Denis Clohessy. Rough Magic in association with TheEmergencyRoom. Project Arts Centre, Dublin. 16-27 Mar. 2010. My performance analysis is based on my viewing of the play on 23 March, as well as the DVD recording held by Rough Magic. I would like to thank Rough Magic for allowing me access to the recording.

The opening moments of *Sodome, my Love* encapsulate the aspects of Olwen Fouéré's substantial body of work with which this article is concerned: how her distinctive and vigorous physical performance style underscores the ways in which limiting myths of femininity are inscribed on, and resisted by, the embodied experiences of women. Her performance exposes the disparity between the fixity of mythic "woman" and the complexity of actual women: "Thus, as against the dispersed, contingent, and multiple existences of actual women, mythical thought opposes the Eternal Feminine, unique and changeless" (De Beauvoir 283). Fouéré has undertaken a marked number of roles which draw explicitly on myth: *Salomé* (Gate Theatre, 1988); Yeats's *Kathleen ní Houlihan* and *The Cuchulain Cycle* (Abbey Theatre, 1989-1993); the title roles in Marina Carr's *The Mai* (Peacock Theatre, 1994), Hester Swane in *By the Bog of Cats...* (Abbey Theatre, 1998), and Woman in *Woman and Scarecrow* (Peacock Theatre, 2007); Vincent Woods's *A Cry from Heaven* (Abbey Theatre, 2005); Fabulous Beast Dance Theatre's *The Bull* (Dublin Theatre Festival, 2005) and *The Rite of Spring* (London Coliseum, 2009); *Medea* (Dublin Fringe Festival, 2010); *Sodome, my Love* and, most recently, Anna Livia Plurabelle in *riverrun* (Dublin Theatre Festival, 2013). Fouéré's performances thus intervene in a body of cultural myths which depend on repetition to achieve their force and perpetuate their meanings; meanings which are inscribed on and silence female bodies.

This article will focus on *Sodome, My Love*, in order to address Fouéré's authorship and dismantling of myths of femininity through both script and body. I will firstly address the cultural myths of femininity with which Fouéré's work engages before looking to the female body as a site of resistance. Discussion of Fouéré's physicality and presence will serve to highlight the unacknowledged creativity of bodies, stifled by the imposition of limiting myths of femininity and through the lack of documentation of female bodies on the Irish stage. I will then turn to Jean-Luc Nancy's notion of exscription in *Corpus* which addresses an outer edge beyond language which exceeds inscription. This will facilitate discussion of the possibilities for, and difficulties of, documenting the body. Nancy's exploration of the anxious relationship between body and discourse enables examination of that which is beyond inscription: the excluded creative female body as the other edge of signification. Following analysis of Lot's wife's writing-body, I will close by speaking to Fouéré's body of work as a document of corporeal resistance to myths of femininity.

The Inscription of Myths of Death and Femininity

Sodome, my Love intervenes in an existing body of cultural myths which silences women through the association of female sexuality with death. Simone De Beauvoir's study of myths of femininity in *The Second Sex* outlines the ambivalent status of the virgin-whore dichotomy of the Eternal Feminine and woman's resultant connection with both fertility and decay:

> woman is at once Eve and the Virgin Mary. She is an idol, a servant, the source of life, a power of darkness; she is the elemental silence of truth, she is artifice, gossip, and falsehood; she is healing presence and sorceress; she is man's prey, his downfall, she is everything that he is not and that he longs for, his negation and his *raison d'être*. (175)

Thus, cultural myths of death and femininity function as a means of removing female autonomy of expression, and of effacing the threat of death and desiring female bodies:

> The aesthetic of death and femininity asserts the womb-tomb matrix of Western cultural iconography; a conflation which attempts to neutralize the threat of death and female sexuality: representations of death may seek strategies to stabilize the body, which entails removing it from the feminine and transforming it into a monument, an enduring stone. Stable object, stable meanings: the surviving subject appropriates death's power in his monuments to the dead. (Bronfen and Webster Goodwin 14)

Throughout the play, Lot's wife's postures and movements veer between seduction and petrification to create an uncertainty and instability which is heightened by the central motif of the salt which both strips life away and preserves it. Sodome is a city characterized by profligate passions and bodies, and Lot's wife is the threatening remains of that excess; as she warns us in the opening section of the play: "I am here,/ Amongst you. I am the last daughter of Sodome" (2). The contagion which ravages the city is introduced by a male ambassador from Gomorrhe but culpability is shifted to the women of Sodome: Lot's wife reveals that the armies of Gomorrhe wanted to destroy "Us, the women... Our smiles of seduction" (12). Thus, the women of Sodome, and Lot's wife as the last daughter of Sodome, epitomize the fearful union of death and femininity: "the beauty of Woman is conceived as a mask for decay, and the sexual relation with her as a form of death rather than conception" (Bronfen 67). The ambivalent representation of Lot's wife is compounded by her decision to wreak a "voluptuous revenge" (20) on those who inflicted her

punishment. She will employ an arsenal of contagion and sexuality, as made clear when she places an opened lipstick on the bench and states: "That is the weapon I will use" (20).

Lot's wife's vengeful declaration precedes the last section of the play in which she puts on her femme fatale attire of trench-coat and high heels before delivering her final lines in front of a montage of images which flashes up on the screen behind her, including images circulating within popular culture of runway models and pop singers like Beyoncé. Neoliberal and postfeminist discourses of bodily self-fashioning offer the illusion of female power through the accrual of economic and cultural value, but this is potentially countered and exposed in *Sodome, my Love*. Through a process of self-sculpting, Fouéré's performance attends to the visceral effects of myths of femininity and their inscriptions on the female body, as well the risks of inhabiting, and the possibilities for questioning, these myths. The exploration of the threshold between death and life, which in turn explores the body in the process of representation, is familiar terrain for Fouéré who, in 2007, played Woman in the Irish premiere of Marina Carr's *Woman and Scarecrow*; a performance in which, as I have argued elsewhere (Hill 235-51), the sculptural qualities of the staging highlighted Woman's reshaping of her dying body to refuse the fixed moment of idealization.

In the Biblical story, Genesis 19, the city of Sodome's enjoyment of sinful pleasures results in disaster so angels help Lot and his family to flee. They are warned not to look back but Lot's wife does and she is turned into a pillar of salt, thus it is possible to read this as punishment for her desiring backwards glance at the iniquitous city. The myth of Lot's wife silences the desiring female body and she is stabilized as mythic icon but in *Sodome, my Love* she is reawakened; Lot's wife tells her story through her body's revival. The limits inflicted on her corporeal being and expression are felt throughout the opening sections of the play in which we see her tense body slowly, and almost imperceptibly at first, return to life. Fouéré has described the importance of "finding your stillness so that movement can come out of stillness" (*"Conversation"* 156); in *Sodome, my Love* this stillness intensifies the audience's awareness of every movement she makes and thereby heightens the expressive potential of the body. Furthermore, it highlights the constraints placed on the articulation of an embodied female subjectivity, and the tension between the reality of women's lives and limiting myths of femininity.

The Female Body as Site of Resistance

The physicality of Fouéré's performance in *Sodome, my Love,* as well as her other mythic roles, has been crucial in highlighting how limiting myths of femininity are not just discursively imposed but viscerally lived, and thereby interrogated. Olwen Fouéré is described as an actor who "has been a creative force in Irish theatre, bringing a keen physicality to her work inside and outside the mainstream" (Sweeney 45). This "keen physicality" is central to Fouéré's radical contribution to Irish theatre in its engagement with corporeal means of expression; with reference to her 1999 collaboration with composer Roger Doyle, *Angel/Babel,* Fouéré describes how "(m)y own need to dissolve disciplinary boundaries and articulate a performance-based theatrical language was growing, in resistance to the inherent traditions of a predominantly literary Irish theatre" (*Operating Theatre* 115). Within the Irish literary theatre tradition, women's contribution has been marked by iconicity, most famously as the mother-nation figure in Yeats's and Gregory's *Kathleen ní Houlihan.* Much crucial work has been done to retrieve and assert female playwrights' contribution to the history of Irish theatre, and this edited collection of essays broadens the scope of female authorship in its address of women theatre makers. Furthermore, the association of woman with the body has heightened the effects of a critical neglect of bodies within a theatre tradition which affords prominence to the literary text. Understanding the performing female body as a lived body which is fundamental to experience and the production of knowledge enables exploration of the creativity of the female body.

Attending to the female body as a site of struggle in *Sodome, my Love* facilitates consideration of the ways in which limiting myths of femininity are inscribed on and through the body; as Elizabeth Grosz explains: "Far from being an inert, passive, noncultural and ahistorical term, the body may be seen as the crucial term, the site of contestation, in a series of economic, political, sexual, and intellectual struggles" (19). Irish theatre studies has looked to the body with renewed interest in recent years; for example, in *Performing the Body in Irish Theatre* Bernadette Sweeney re-examines five Irish plays which have "been suppressed in some way by the dominant discourse of dramatic, textual analysis" (2). In her discussion of the Irish independent theatre sector, Anna McMullan notes "the emergence of theatre practices which foreground performance: the visual, kinesic and the corporeal as major means of expression and signification" (30). Counter to the dominance

of the writer's text, McMullan highlights Yeats's and Beckett's awareness of the "expressive potential of the actor's body" (32). In *Dance Theatre in Ireland: Revolutionary Moves,* Aoife McGrath explores the body's potential to generate meaning, and it is both this renewed critical engagement with, and return of agency to, the body which Fouéré's work highlights: alerting the audience to the expressive potential and creativity of the corporeal. It is perhaps no surprise that Fouéré has engaged with dance theatre, most recently with choreographer-director Michael Keegan-Dolan (Fabulous Beast), as dance offers: "(t)he possibility of a body that is written upon but that also writes. It asks scholars to approach the body's involvement in any activity with an assumption of potential agency to participate in or resist whatever forms of cultural production are underway" (Foster 15). Susan Leigh Foster's "claim for a writing-dancing body" (19) enables examination of Fouéré's corporeal intervention in the cultural production of myths of femininity.

In an interview, Fouéré notes that, "what fascinated me about theatre was what was underneath the text; the whole things about presence and performance and the whole non-verbal world..." ("Conversation" 155). This non-verbal world is a threshold between music, voice and body as evidenced in Fouéré's work with Operating Theatre (1980-2006), as well as her most recent performance, *riverrun.*[2] The sound design of *riverrun* responds to Fouéré's performance and is mixed live to seamlessly merge with Fouéré's own articulate and inarticulate soundscape, beyond language. Furthermore, Fouéré's movements were indistinct from this soundscape and embodied the text. *Sodome, my Love* offers a more traditionally recognizable narrative than these other performances, but it also utilizes an affective soundscape of city noise and electronic reverberations, as well as delighting in the sensuous nature of language through bodily movement. Rather than thinking about the non-verbal as what is "underneath the text," implying a hierarchy, I will explore the expressive potential of the actor's body in *Sodome, my Love* in order to access what performance conveys and which language cannot articulate: the excluded creative female body as the other edge of signification. This enables exploration of the possibilities for female

[2] James Joyce. *riverrun.* Adapt. Dir. and Perf. Olwen Fouéré. Co. Dir. Kellie Hughes. Sound Design. Alma Kelliher. Lighting Design. Stephen Dodd. Costume. Monica Frawley. TheEmergencyRoom and Galway Arts Festival. Druid Theatre, Galway. 18-27 Jul. 2013.

authorship which question the dominance of a text-focused performance tradition. Furthermore, shifting the emphasis from the body as bearer to maker of meaning rewrites the corporeal realm which woman has traditionally been aligned with; resisting the inscription of silence and passivity on woman and the body.

Touching on a Female Writing-Body

Through discussion of the challenge of documenting women's bodies in theatre, Anna Cutler outlines a hierarchy of documentation: the Proper (traditional and literary forms), the Processual (which emerge from processes of production), and the Residual, "the area of work which represents lots of doubtfully or mis-remembered memories, smells, bodily scars, and movement memory" which "actually communicate more directly the moment of performance" (113). Cutler argues that "women's performance work, which uses the female body as the primary text" (113) has been excluded from the realm of the Proper and more often resides in the Residual. The differences between Cutler's Proper and Residual performance documentation are also addressed by Joseph Roach's concept of "genealogies of performance" which focuses on how history and memory are enacted on and remembered through the body, thus shifting the emphasis from discursively documented history. These genealogies are described as "counter-memories" which expose "the disparities between history as it is discursively transmitted and memory as it is publicly enacted by the bodies that bear its consequences" (Roach 26). Tracing these genealogies of performance is vital in exposing how women's bodies bear the consequences of the imposition of myths of femininity. Though working from her own translation of Gaudé's script, I would argue that in *Sodome, my Love* Fouéré uses the female body as the primary text in order to uncover the inscription of bodies, as well as the bodily meanings which exceed inscription.

Cutler looks to the ways in which the Residual elements of performance may be attended to through address of a Potential Body which "holds the many histories and inscriptions of ourselves but is also open to new possibilities" (115). Fouéré's performance in *Sodome, my Love* offers a Potential body: inscribed by an archive of myths of femininity but also generating other possibilities. Cutler advocates *écriture féminine* as a means of documenting the Potential Body, whereby "the written landscape becomes the performance landscape" (117). Through the process of "writing the body" *écriture féminine* aims to return ownership of female bodies to women: "By writing her self,

woman will return to the body which has been more than confiscated from her, which has been turned into the uncanny stranger on display" (Cixous, qtd. in Cutler 118). In *Sodome, my Love* Lot's wife returns to her body in order to author her story and articulate an embodied subjectivity. *Ecriture féminine* risks advocating a return to an originary pre-inscribed female body, unless it addresses the economic and historical conditions which shape the cultural inscription of gender. In order to avoid reasserting an inflexible idealized representation of woman which fails to acknowledge how sexual difference is reinscribed through biological discourse, the body needs to be understood as a "site of contestation": a Potential Body which is inscribed, yet also in process and thus exceeds inscription.

In the opening section of *Sodome, my Love* the audience witness the slow revival of the residues of Lot's wife's life, and thus our attention is drawn to the ways in which bodies come to life and are full of potential, yet are simultaneously fragmented, limited and inscribed. Lot's wife's whispered voice and body emerge from the darkened stage to mark her presence and following these initial moments, a large close-up of her face is projected on the mirrors stage right; a face which echoes the stillness of Lot's wife as its eyes remain closed. She asks us, "Do you feel?" (1) as raindrops start to fall, slowly at first, on the projected face whose mouth opens in response. Then Lot's wife starts to move, almost imperceptibly, as she is revived by the sensuousness and fertility of the rain: "The first drop is for me./ It falls on my lips with the weight of a cherry" (2). Her physical and onscreen presence draws our attention to the ways in which our bodies are inscribed by our experiences: the falling rain leaves tracks on the projected face as she tells us, "I let the rain scar my face" (2). This section of the play closes with the sound of falling rain becoming increasingly loud, almost threatening to drown out Lot's wife's assertion that "I am coming back to life" (3). She tilts her head back and releases the hand which she has been sitting on; lifting her claw-like hand to catch the raindrops. Her bodily tension conveys the traces of her petrification, frozen in salt and time, but now she is revived by the rain and we witness her gradual release.

The inability to articulate fully the bodily meanings generated in performance, of only touching on their residues and of exceeding inscription, resonates with Jean-Luc Nancy's sense of the withdrawal connoted by touch. Susan Leigh Foster discusses the "possibility of a scholarship that addresses a writing body as a well as a body written upon" (12) and Nancy's work in *Corpus* broaches the gap between body and text through his exploration of the tactility of writing: the creation

of a corpus of tact and the attendant anxiety. In *Corpus* Nancy evokes the womb-tomb matrix which I am arguing *Sodome, my Love* resists: "skulls with staring eye-holes, castrating vaginas, not openings, but evacuations, enucleations, collapses..." (75). However, his understanding of the anxious relationship between body and discourse has huge potential for feminist critique of performance, particularly in his notion of exscription which addresses that which is beyond inscription.

"The Law of Touching is Separation"

Nancy's philosophy of the body in *Corpus* potentially resonates with a feminist project of reclaiming the female body; a body which inhabits the space outside of the symbolic and is therefore denied representation: "We lose our footing at 'the body'. Here, non-sense doesn't mean something absurd, or upside-down, or somehow contorted ... It means, instead: no sense, or a *sense* whose approach through any figure of 'sense' is absolutely ruled out. Sense making sense where sense meets its limit" (13). Thus, for Nancy, "the fragmentation of writing ... responds to the ongoing protest of bodies in–against– language" (21). However, unlike the essentialist female body of *écriture féminine*, Nancy's body is one defined by uncertainty. In the opening sentence of *Corpus,* Nancy invokes the Eucharistic phrase *Hoc est enim corpus meum* ("This is my body") to invoke the performative of Christian ritual which brings the body and God into presence. However, crucially for Nancy, this presence is also marked by the absence that is felt: "The presentified 'this' of the Absentee par excellence: incessantly, we shall have called, convoked, consecrated, policed, captured, wanted, absolutely wanted it" (3). Just as the body invokes presence and absence, touch is, for Nancy, defined by anxiety, namely between contact and separation: "From one singular to another, there is contiguity but not continuity. There is proximity, but only to the extent that extreme closeness emphasises the distancing it opens up. All being is in touch with all being, but the law of touching is separation ..." (qtd. in McMahon 15).

The repetition of Lot's wife's reawakening, as she relives her story and her salty incarceration in the final sections of the play, underlines the impossibility of fully touching on another's embodied experiences. As her narrative comes full circle, she is petrified before our eyes, "I had become a statue" (18), and she adopts the same posture which closed the opening section of the play: sitting with one arm outstretched to catch the rain, while the projected face appears once more and opens its

mouth to taste the raindrops. The reassertion of the myth through its cyclical retelling, and its inhibition of Lot's wife's corporeal expression, ensures that the audience are acutely aware of the ways in which myths are repeatedly inscribed on and lived through the body. However, Lot's wife resists the imposition of silence and she reminds us that while her killers grew old and died, she lived on: "I was nothing more than a salty residue of life/ But I endured" (19). Her enduring presence is marked not just by her verbal retelling of her experiences but by the recreation of her embodied experience. She may have been merely a residue, but her traces cannot be erased and the repetition of her opening posture and gestures serves as a "countermemory" which reasserts her presence. However, though Lot's wife's performative writing of her body and life strives to bring her presence into being, it simultaneously marks the felt absence: "But we certainly feel some formidable anxiety: 'here it is' is in fact not so sure, we have to seek assurance for it" (Nancy 5).

We seek this assurance through touch which "challenges, allays all our doubts about appearances" (5). Nancy utilizes the notion of tactility through writing, "the page itself is a touching (of my hand while it writes, and your hands while they hold the book.) ... you read me, and I write you" (51). If we extend this tactile relationship to performance, we can address how the writing-body touches the performance space and audience. Nancy's touch confers distance, thereby addressing the limits of our ability to share another's embodied experiences, and the impossibility of fully returning an authentic body to these female mythic icons: "Writing touches upon bodies *along the absolute limit* separating the sense of the one skin from the skin and nerves of the other. Nothing *gets through,* which is why it touches" (11). In the context of a discussion of the appropriation of women as mythic icons, understanding the anxiety of Nancy's sense of touch offers the possibility of exploring how female bodies resist silence through the reassertion of their materiality.

The Exscribed Body, "Outside the Text"

In order to address the limits of touch and the withdrawal connoted, Nancy introduces his concept of exscription: "We have to begin by getting through, and by means of, the *exscription* of our body: its being inscribed-outside, its being placed *outside the text* as the most *proper* movement of its text; the text *itself* being abandoned, left at its limit" (11). Cutler's Potential Body can be thought of as exscribed: the cultural inscriptions on the body are acknowledged, but so too is that which is

on the outer edge of language and the body. The Potential and exscribed body is turned outside, to reveal the body as "being-exscribed" (19). This broaches the gap between the narrative of *Sodome, my Love* and the bodily meanings generated by Fouéré's performance; her movements indicate how myth is not just inscribed on the body, but how bodies open out to undo myth. Attending to the bodily meanings generated in performance exposes myth's apparent fixity and authority, and enables us to touch on the exscribed edge of Lot's wife's body, beyond the limits and silence of mythic iconicity.

Prior to Lot's wife's second reawakening at the end of the play, she describes how she hid herself in an attempt to survive the city's massacre. She is discovered by the last of the enemy and she begs him to kill her, but instead is condemned to her fate: to be buried alive in salt. It is through the very limits of Fouéré's corporeality that she expresses Lot's wife's experience: she lies on her front on the bench with one arm trailing on the floor, however her splayed hand pushes against the ground, her tension pre-empting the pain of her incarceration in salt, subject to the exertion of this man's power: "I can still remember his hand gripping my arm,/ The vice of power in his hand./ I knew the agony that was to come" (15). Stark white light drenches the stage as Lot's wife describes how she could hear the mountains of salt being dragged into the city. She describes her screams as she feels the "bite" of the salt as each shovelful is poured on her. However, she is soon exhausted, and her presence is silenced by the salt, "no sound of a pulse in my veins" (17). The section closes with the words, "Nothing else./ Nothing" (17) and she once more adopts the seated, and still, position of the opening of the play. Her incarceration imposes silence and language collapses temporarily, yet her body presents her exscribed-being: "And a twofold failure is given: a failure to speak about the body, a failure to keep silent about it. A double-bind" (Nancy 57).

Fouéré's performance in *Sodome, my Love* realizes the potential of the anxiety of touch: of the instability and possibility of the space between touch/ separation and presence/ absence. Lot's wife's body resides in this between space: "The created body is there, meaning *between* here and there" (Nancy 99). Between-bodies and Potential Bodies are marked by process and occupy the space of the Residual; they are haunted by that which is unnameable, namely the "intimate self-texture" (Nancy 75) of the body. Thus what is exscribed through the performance of *Sodome, my Love* is the embodied experience of a mythic icon, Lot's wife; a statue who comes to life to assert her presence

and story, and in this process articulates the tensions of female embodied experience within patriarchal society, as both mythic object and embodied subject, as well as the anxiety of touching upon this experience.

Corpus–The Body of Work

Nancy looks to between-bodies and between spaces as anxious realms of touch and separation, and applies this to the body of language:

> Exscription is produced in the loosening of unsignifying spacing: it detaches words from their senses, always again and again, abandoning them to their extension. A word, as long as it's not absorbed without remainder into a sense, *remains* essentially extended between other words, stretching to touch them, though not merging with them: that's language as *body*. (71)

The creation of a body of language that extends "between other words" suggests the fragmentary assemblage that defines Nancy's understanding of a corpus; a corpus which would outline a body of work, or genealogy of performance, invigorated by the traces of bodily meanings which extend between one another. Thus, Nancy's writing catalogues "A corpus of tact: skimming, grazing, squeezing, thrusting, pressing, smoothing, scraping, rubbing, caressing ..." (93), and the list continues. The creative space between-bodies generates a body, just as the tactility of the page, of the hands that wrote on it and the hands that hold it, creates the tactile body of work: "you read me, and I write you" (51).

Between the bodies of Fouéré's performances, a body of work is created which serves as a document of corporeal resistance to myths of femininity. The mythic women of Fouéré's performances touch on and write one another to suggest a "corpus of tact" which creates resonances and residues which attend to the visceral experience of female embodiment in tension with limiting myths of femininity. Fouéré's description of her performance as *Kathleen ní Houlihan* resonates with the other mythic women whom she has played, from Salomé, through Carr's work, to *Sodome, my Love*, who counter the feminine ideal with their desiring bodies: Fouéré states that it is "(f)ascinating to subvert the long-suffering image we have inherited of her [Kathleen ní Houlihan]. To unleash the seductive, manipulative queen with predatory desires running through the country of her body" ("Afterword" 220). Fouéré's mythic women become powerful forces as she explores their exscribed-being, their writing body, and intervenes in the performative reassertion of limiting myths of femininity which

silence a desiring and creative female corporeality. Fouéré's corpus draws attention to the process of writing the body and of self-sculpting, thereby exploring the inscription of meaning on the body, as well as the potential for resistance. The fragments and residues of Fouéré's "corpus of tact" attest to the exscribed edge of language to open out the bodies of these female mythic icons and in the process undo the myths.

In *Sodome, my Love* the female body is not silent and inscribed but is the author of its own representation and documentation. Just as Lot's wife intends to spread the contagion in revenge for her fate, she warns that her corporeal presence will be embodied by all who come into contact with her: "I will be carried by the breath,/ By the hand,/ By the eyes" (22). Furthermore, the play ends with Lot's wife's refusal to be silenced as mythic statue: she walks out past the audience and through their exit to enter the real world. Lot's wife makes clear that these corporeal traces are unsettling: "I am entering your cities and I will leave the unknown scent of Sodome in my wake./ First it will intrigue you, then it will disturb you" (19). We, the audience, will bear the bodily traces and residues of performance, and facilitate the contagion's spread; a contagion which draws on myths of woman and death in order to enable the re-emergence of a female corpus which has been repressed by myth and Proper theatre documentation: her embodied subjectivity, and her body of work.

Works Cited

Bronfen, Elisabeth. *Over Her Dead Body: Death, Femininity and the Aesthetic*. Manchester: Manchester UP, 1992. Print.

---, and Sarah Webster Goodwin, "Introduction." *Death and Representation*. Ed. Elizabeth Bronfen and Sarah Webster Goodwin. Baltimore and London: The John Hopkins UP, 1993. 3-28. Print.

Cutler, Anna. "Abstract Body Language: Documenting Women's Bodies in Theatre." *New Theatre Quarterly* 14.2 (May 1998): 111-18. Print.

De Beauvoir, Simone. *The Second Sex*. Trans. H. M. Parshley. 1953. London: Vintage, 1997. Print.

Foster, Susan Leigh. *Choreographing History*. Bloomington: Indiana UP, 1995. Print.

Fouéré, Olwen. "Afterword: The Act and the Word." *Women in Irish Drama: A Century of Authorship and Representation*. Ed. Melissa Sihra. Basingstoke: Palgrave Macmillan, 207. 219-20. Print.

---. *Olwen Fouéré*. Web. 20 Oct. 2013. <http://www.olwenfouere.com/>

---. "Olwen Fouéré in Conversation with Melissa Sihra." *Theatre Talk: Voices of Irish Theatre Practioners*. Ed. Lilian Chambers, Ger Fitzgibbon, and Eamonn Jordan. Dublin: Carysfort Press, 2001. 155-66. Print.

---. "Operating Theatre and *Angel/Babel*." *The Dreaming Body: Contemporary Irish Theatre*. Ed. Melissa Sihra and Paul Murphy. Gerrards Cross: Smythe, 2009. 115-24. Print.

Gaudé, Laurent. *Sodome, ma Douce*. Trans. Olwen Fouéré. Unpublished, May 2010. Print.

Grosz, Elizabeth. *Volatile Bodies: Towards a Corporeal Feminism*. Bloomington: Indiana UP, 1994. Print.

Hill, Shonagh. "Female Self-Authorship and Reperformance of the 'Good Death' in Marina Carr's *Woman and Scarecrow*." *Staging Thought: Essays on Irish Theatre, Scholarship and Practice*. Ed. Rhona Trench. Oxford: Lang, 2012. 235-51. Print.

McGrath, Aoife. *Dance Theatre in Ireland: Revolutionary Moves*. Basingstoke: Palgrave Macmillan, 2013. Print.

McMahon, Laura. Cinema and Contact: The Withdrawal of Touch in Nancy, Bresson, Duras and Denis. London: MHRA and Maney, 2012. Print.

McMullan, Anna. "Reclaiming Performance: The Contemporary Irish Independent Theatre Sector." *The State of Play: Irish Theatre in the Nineties*. Ed. Eberhard Bort. Trier: Wissenschaftlicher, 1996. 29-38. Print.

Nancy, Jean-Luc. *Corpus*. Trans. Richard A. Rand. New York: Fordham UP, 2008. Print.

Roach, Joseph. *Cities of the Dead: Circum-Atlantic Performance*. New York: Columbia UP, 1996. Print.

Sodome, my Love. By Laurent Gaudé. Trans. Olwen Fouéré. Dir. Lynne Parker. Perf. Olwen Fouéré. Rough Magic in association with TheEmergencyRoom. Project Arts Centre, Dublin. 23 Mar. 2010. Performance.

---. By Laurent Gaudé. Trans. Olwen Fouéré. Dir. Lynne Parker. Perf. Olwen Fouéré. Areaman Productions, March 2010. DVD.

Sweeney, Bernadette. *Performing the Body in Irish Theatre*. Basingstoke: Palgrave Macmillan, 2008. Print.

3 | Second Skin: Costume and Body: Power and Desire

Cathy Leeney

Introduction

The history of women in relation to clothing has been a problematic adventure in aesthetics, control and resistance. In theatre, costume has a particular significance in the interrogation of representations of female power and desire. This essay aims to investigate how powerful women characters are costumed in contemporary performance, through focus on two productions from Rough Magic Theatre Company, a prestigious independent company founded in Dublin in 1984.

In 2010 Rough Magic produced two major works at Dublin's Project Arts Centre. Firstly, *Sodome, My Love*, translated and adapted from Laurent Gaudé's French original by Olwen Fouéré, renowned Irish performer who also played the sole role in the piece and whose company The Emergency Room co-produced. For the Dublin Theatre Festival in October of 2010, Ellen Cranitch and Hilary Fannin wrote a new version, with music, of *Phaedra*, setting their Irish-inflected interpretation in the present day.[3] They were inspired by Racine's

[3] The story of Phaedra is set on the Troezen shore, during the prolonged absence at war of her bullying husband Theseus. Phaedra is his second wife, and she is tortured by her desire for Hippolytus, Theseus' son by his first marriage. Phaedra's transgressive love is nurtured in her by her attendant Enone, to the point where Phaedra declares her passion to the young man. But Hippolytus loves Aricie and she returns his passion although her father was murdered by Theseus. When Hippolytus rejects Phaedra, in fury and humiliation she accuses him of rape. Theseus

Phèdre (1677) and by Rameau's opera *Hippolyte et Aricie* (1733), both of which were drawn in turn from Euripides' *Hippolytus*. Seneca's *Phaedra* served as an intertext. Although widely different in genre and staging (*Sodome* is a one-person show while *Phaedra* has a cast of seven, plus three singers and four musicians) the productions had certain creative contributors in common: both were directed by Lynne Parker, artistic director of Rough Magic, and lighting and settings were designed by John Comiskey. Costume design for *Sodome* was by Monica Frawley and for *Phaedra* by Bláithín Sheerin. Both productions were very well received and between them received no less than six nominations for Irish Times Theatre Awards for 2010.

What connects the two shows however, for the purposes of this essay, is the representation in both of female characters who are central to the action and narrative, and who express intense sexual desire which threatens the normative placing of women as, exclusively, objects of desire. In Gaudé's piece the protagonist is a survivor of the cursed city of Sodome, her voice an echo of Lot's wife, turned to a pillar of salt as she looks back at her city burning. Her passionate memories of life there comprise the early part of the performance, as she evokes a lost world loosed from sexual inhibition, a society of utopian eroticism in which the expression of pleasure is a social bond, floating free from corrupting power relations, and gendered manipulation, into pre-lapsarian joy and bodily fulfilment. Between the pleasure gardens and terraces of Sodome, where desire flows like wine, and the troubled shore where Phaedra's exiled soul writhes in the grip of her unruly passion, is a chasm of moral judgement. Through Euripides and Racine, Theseus' wife has become a theatrical and cultural icon of woman's guiltiness for sexual longing and the inevitable tragedy that comes in its wake. Anne Ubersfeld describes how Racine's play is "[i]n the history of the classical theatre ... a sort of blind spot, an obscure *calling into question of classical representation* [emphasis in original]" (209). Ubersfeld sees in the play a challenge to the form of the space of performance, but also to the representation of the body. A larger point is being argued by Ubersfeld relating to Racine's "non-place" of tragedy (209), the "progressive void" (210) in his *Phèdre,* in which she identifies a Jansenist suspicion of the representation of the world. The body, and especially the desiring woman's body, is part of an unease, a negotiation

returns and banishes Hippolytus, whose body is torn apart by a sea monster as he flees. Phaedra takes her own life.

with what representation fears, the female subject outside the bounds of passivity and objecthood.

To return to the productions in question here, both posed questions concerning a post-feminist reclamation of glamour as power; both created images of female bodies bearing the signs of hyper-femininity in uneasy relation to the gaze of the audience, which was invited to assess the empowerment or disempowerment of the character in the narrative of each play. Were audiences witnessing a third wave feminist strategy to reclaim the semiotics of woman as sexual object, of woman as social (read patriarchal) construction? Or was a crisis in representation revealed, a visual aporia at the margins of the symbolic economy of gender?

Alisa Soloman comments that "femininity is always drag" (145) in recognition of the long-standing idea that to be a woman, on or off stage, is the performance of a lifetime. Before an audience, how is the performance of femininity de-naturalized? Can women in performance threaten what Judith Butler calls the obligatory repetition of hegemonic gender identity? What theatrical strategies are available to interrogate the central women characters in each of these Rough Magic productions, and in the layered and complex signs that are at play in these performances for an audience, what is revealed of the ambivalence of third wave feminism? I will, in what follows, attempt to touch on these questions primarily in relation to *Phaedra*, and to a lesser extent in *Sodome, My Love*. To begin I will set out the analytical and theoretical coordinates for my argument.

Costume in Performance

Costume in performance is not often the core concern of critics or commentators and it seems useful to explore some of the grounding ideas about its analysis. It is not possible to dissociate costume from its wider staging context, involving scenographic issues of space, light, and composition as well as dramaturgical issues of narrative function and character. In contemporary production, the designer of costumes creates a signifying system which, as Patrice Pavis remarks, "is valid in its own right," even if, as he goes on to say "it also constitutes a sonic echo, an amplifier with implications for the rest of the performance" (172). In semiotic terms Pavis sees costume as one of many elements in performance: "both a signifier (pure materiality) and a signified (an element integrated into a system of meaning)" (174).

The intimate and dynamic relation between costume and the body of the performer, makes complex and enriches this dual semiotic role; as

Pavis points out, a "body is 'worn' and 'carried' by a costume as much as the costume is ... by the body" (175). This was Oskar Schlemmer's insight into the inseparable phenomena of body and costume, and points to further dimensions in the layering of the material and the fictional, the "alive-in-time" body of the performer wears the fictional costume of the character (25). Roland Barthes, examining how costume may reveal social processes, proposes that costume is part of "social gestus, the external, material expression of the social conflicts to which it bears witness" (41). His idea extends the power of costume to analyze the social world of the performance for the audience. Thus, from the audience's point of view, the costume may both define character and simultaneously disappear into the character/role/performer nexus. It has the power to collapse the distance between the social world of the play and the performance in relation to the world of the audience. Through the notion of costume as a "shifter vector" Pavis reveals how costume works to enable transitions between stage and auditorium, between fictional and real time, between actor/role/character and audience (180). An example of such a transition operates in *Phaedra*, where the abandoned queen of Colchis is dressed in the style of a Celtic Tiger yummy mummy. In *Sodome, My Love*, the performance moves towards a defining transformation that brings the survivor from the mythic city into the midst of contemporary urban experience. However, such transitions can be freighted with an excess of semiotic consequences, due to the expressive power of vestiary codes, and the "networks of strictly codified signs" (Pavis 180) that circulate between the spaces of performance and the spaces of social processes, culture, the body, and fashion. This excess of meanings is a key question in the analyses that follow.

Part of costume's function in shifting the audience from the fictional stage world towards an awareness of its own vestiary idiom derives its power from the world of fashion. Marvin Carlson traces the history of costuming in European theatre as it came under the influence of the romantic/realist movement. Within that period an earlier tradition of "recycling" costumes and other stage materials, from one production to another, was rejected in favour of individual and specific designs for each production of a play. Costumes were made especially, to reflect the overall staging of the play, with the set designer often taking on costume design too. "The reform sought by the romantics was long in being generally accepted" though, Carlson argues (124). The recycling of costume never really disappeared and it has more recently gained a new lease of life through a postmodern understanding of every

performance "as existing in and best understood through a web of intertextual relationships" (Carlson 126); this may be a visual web, involving costume contextualized by the entire mise en scène.

Costume, Body and Fashion

Carlson's argument concerns theatre as a place of haunting. Every play might be titled "Ghosts" he suggests, quoting Herbert Blau's observation that performance carries an uncanny sense of repetition, of "seeing what we saw before" (Carlson 1). Carlson examines how the elements of production themselves carry ghostly meanings and associations from their prior stage lives. But Carlson's poetic and engaging thesis also offers a way of thinking about the relationship between costume in performance and fashion. This is a two-way street of influence, as Elaine Showalter has shown in her revealing analysis of the history of Ophelia's role in *Hamlet*. Representations of Ophelia on stage reflected beliefs about women's lives and desires, and in turn influenced ideas about women's lives and desires, sometimes with real consequences. Ophelia's costuming both reflected social attitudes to women and in certain cases contributed to real women's understanding of ways to be a woman, to be in grief, and to be mad. Where performers are dressed in contemporary clothes (whether those clothes have been designed specifically for the production, or have been bought in the high street) their appearance is haunted by these two-way laws of fashion, the performance of the body as fashion, and "the many complex social dimensions of fashion" (Entwistle & Wilson 3).

Even the most cursory consideration of fashion semiotics reveals the body's immediate and defining participation in its images and symbolic economy. The shifting laws of fashion are the laws of gendered embodiment. Philosopher Kate Soper, to whom I will return later, wryly comments that "Vivienne Westwood may be right in her suggestion that fashion in dress is about eventually being naked ..." (19). In immediate and concrete ways, costuming in this context reveals how bodies of women and men are framed and inscribed in the Foucauldian sense. Women's problematic history of restraint by and prohibition through clothing has fuelled their efforts to resist vestiary disempowerment. The patriarchal drive to control femininity, to define it as other, as secondary, as essentialized identity, is often materialized in clothing and fashion. So, what is the form taken by the drive to disrupt and resist the inscriptions that these gender definitions operate on woman as desiring subject, as determined participant in power, conventionally defined in phallogocentric terms?

From Gianni Versace's 1992 "bondage" collection, to the work of Vivienne Westwood, Betsey Johnson and Alexander McQueen, contemporary high fashion purveys powerful images of women appropriating the semiotics of fetish and Sadean victim/aggressor relationships. High street fashion follows in its wake, moderated, but often bearing significant traces of designers' extremity. Through a dialogue with the circulation of fashion images, theatrical costume works to connect the spectator into the performance or to estrange him/her. The semiotic vocabulary of designers like Westwood and McQueen operates between hyperfemininity and phallocentrism, playing with the tropes of femme fatale (deadly female sexuality) and Sadean woman (Marcusean release of sexuality from the order of procreation—see Herbert Marcuse, *One Dimensional Man*). Relative to more conservative haute couture designers, their images are a challenge to high street trends; the extremity of their vision is diluted to a great degree in order to become wearable for the person in the street. However, their images have been absorbed to a surprising degree into normalized images of woman as aggressively sexual, disabled by dizzyingly high heels, and sporting the chains, straps and other signs of sado-masochist erotics.

In performance, costume may define, mask, entrap or liberate the body of the performer; as part of the dynamic of scenography, costume in a sense *is* the body of the performer, just as the naked performer wears the "costume" of nakedness on stage. Angela Carter, in Foucauldian spirit, writes, "our flesh comes down to us through history" (qtd. in Evans 212); one might extend her observation to propose that our flesh comes down to us through the history of fashion. Thus, costume and body are intimately connected at every level of meaning, and the regulatory systems applying to clothing are visible also in theatre as inscriptions on the body of the performer as part of the cultural and fashion context of the production.

Third Wave Feminism

"Feminism has operated for several decades on an ethic of powerlessness and we need to investigate an ethics of power ... In the twenty-first century you cannot pretend anymore that no women have power " (Gillis and Munford, "Interview" 61-62). Showalter's comment focuses on third wave feminism's negotiation with certain (limited) successes of feminisms' earlier battles in the Western world. Sometimes labelled "post-feminism," the third wave is often presented as implying that feminisms are outdated. This view is severely limited both in its

occlusion of women's subordinated legal and social situations in most parts of the world, while it normalizes the circumstances of privilege within which a minority of women are empowered to fulfil their talents and ambitions, through hard-won equal opportunity. The notion of post-feminism as back-lash acknowledges the regressive potential in proposing that both the battle and the war are over. Between this paradox of victory and defeat, the periodization of women's efforts to live fully may appear as a discourse of superfluity on the one hand (no longer needed), and failure on the other (so much gender inequality remaining unaddressed). Within this contradictory position the disruptive potential of appropriation continues however;[4] fetishized representations of the performance of femininity, of woman as phallic signifier, holder of de-othered power, become a ground for a take-over, an appropriation.

The "identifiable position from which one speaks," as Margaret Shildrick argues, is "both undecidable and subject to iteration, ... [and] is *at the same time* endlessly transformative" (69, emphasis added). Hyper-iterated images of woman as sexual object of male desire contain the potential to be transformed into images of power as agency, even if only the agency of appropriation. Or do they? Within this tension both Fannin's and Cranitch's Phaedra and Gaudé's survivor of Sodom return to the stage from the troubled gallery of Classical Greek and Judeo-Christian icons of womanhood. They bear excessive passions, demand a confrontation with their rejection of limits and conventions. The staging of their excess requires to be communicated to twenty-first century audiences in terms of the unresolved questions of feminism's third wave. But as theatrical revenants, to come back to Carlson's idea, they fracture diachronic time and suggest that women's excess is a recurring energy, that the nexus of woman, power and desire is both polyvalent and unstable. I hope to show how both productions, each

[4] The energy of post-feminist appropriation is evidenced in publications such as Elizabeth Wurtzel's *Bitch: In Praise of Difficult Women* (New York: Doubleday, 1998) and in civic actions such as so-called "Slutwalks," where women have taken to public spaces wearing whatever clothes they wish, to challenge the view that women, on account of their perceived lack of modesty in dress, are responsible for being the victims of attack by men. The first "Slutwalk" is said to have taken place in Toronto in 2011, but was surely based on earlier feminist actions which took place under the slogan "Reclaim the Night" in the late twentieth century. "Slutwalks" achieve the added and controversial reclamation of "slut."

through contrasting narratives, and through different staging and design strategies, interrogate the vexatious issue of woman's subversive agency and how this may be imaged.

Phaedra/Phaedra

The Irish post-Celtic Tiger context for Rough Magic's 2010 *Phaedra*, text by Hilary Fannin and music by Ellen Cranitch, portrayed the shore of Troezen in a ruefully dark-comic mood that overlaid the classical world of Racine/Rameau with post-Freudian analysis of uncontainable desires and futile efforts to escape them through drug, psycho- or body therapies.[5] Undoubtedly the House of Helios creates a bitterly ironic palimpsest for this twenty-first century dysfunctional household and the personal indulgences accessible to an élite during the economic boom years in Ireland before the so-called crash. Imagery of the sea (evoked through John Comiskey's abstract lighting) together with the instrumental and sung music materialized a force, overwhelming any mere individual, expressive of elemental longing, beyond what is sayable (Fannin et al. in *Phaedra* Programme). The singers (named as the gods that Euripides associates with the action in his extant version: Artemis, Poseidon and Aphrodite) counter-point dialogue that is aggressive, funny and cutting. These supernatural figures frame the mortal characters as venal animals gripped by history, vanity and desire.

The play follows the outline of Racine's version of Phaedra's story in general terms. Emphasis grows, however, on Hippolytus and Aricia as the innocent victims of a corrupted parental generation, and Phaedra's obsession with her step-son is paralleled in an interesting reading of Theramenes as a psychiatrist struggling to control his attraction to the young man who is his patient. Hippolytus then is desired by Phaedra, by Theramenes and by Aricia, is admired by Ismene, and becomes an almost parodic icon of sexual allure. Phaedra's longing is overwhelmed and finally falls into secondary place amidst this web of yearning.

The scenic space, also designed by Comiskey, held five musicians in a shallow pit up stage centre, split by a central staircase; downstage a

[5] *Phaedra* by Hilary Fannin; music by Ellen Cranitch, at Project Arts Centre, Dublin, 3-10 Oct. 2010. Produced by Rough Magic Theatre Company for Dublin Theatre Festival; directed by Lynne Parker; Design and Lighting by John Comiskey; Costumes by Bláithín Sheerin. Phaedra: Catherine Walker; Theseus: Stephen Brennan; Enone: Michèle Forbes; Ismene: Sarah Greene; Teramenes: Darragh Kelly; Hippolytus: Allen Leech; Aricia: Gemma Reeves. Viewed 7 Oct. 2010.

central platform, a self-conscious stage-within-the-stage accommodates core scenes of intimate dialogue, and of troubled family gatherings. Two lateral platforms rise steeply to face the audience on either side, and a startling luminous-blue panel, angled over the scene, increases the sense of confrontation and immediacy between the space and the tiered ranks of audience.

The action opens with Phaedra (Catherine Walker) turning before a distorting full-length mirror, in which her magnified image is reflected, then projected onto the surface of the mirror to play back her gaze. The mirror captures the dominant culture of surfaces, vanity and self-obsession, while it is also an ironic sign of Phaedra's failed self-reflection. As Sara Keating comments in her review of the production, Fannin has re-imagined the space of the play as "a cynical, corrupt place ... [with] familiar resonances with modern Ireland ... [including] the hyper-sexualisation of women ... and a real anger at the status of women in this amoral world." Enone (Michèle Forbes) watches Phaedra; the uneasy relationship between the two stresses Enone's authoritative but parasitic manipulation of her mistress, her vicarious engagement with the younger woman. Power-costumed in a double-breasted coat-dress and court shoes, Enone presents as an aspirational, bourgeois feminist of the 1980s, a kind of wanna-be top girl.

Manipulation of body image and victimization coincide neatly in Phaedra's account of a woman's body washed up on the shore: "It was a long time in the water" (Fannin, *Phaedra* [2010]), and identifiable only by the serial numbers on her implants. This image is repeated and emphasized musically. Ubersfeld argues that, in Racine's version of the story, representation of the body as a unity is challenged; "Phaedra's body appears twice as a unity" she points out, but otherwise is fragmented and dispersed: hands, eyes, mouth and so on. For Ubersfeld, Racine's *Phèdre* is a confluence of spatial and bodily dispersal; its location in a "non-place, a concrete non-picture" (209). Phaedra's body is rendered unified by suffering and passion, but is shattered into isolated parts expressing the failure of the body's analogous meaning as an image of totality. Hippolytus' death, his body broken into pieces, clearly figures this theme of fracture, and the sense of dispersal runs deeper in the structure of the narrative. In Fannin's and Cranitch's version this unity or integrity of body is shown to be already an impossibility. What results is a performance of the void that rips out the inner site of desire from its corporeal seat, and casts it homeless, adrift. Fragmentation is framed as commodification of the female (and male) body, a punishing and even deadly process. Phaedra

deliberately cuts her wrist on the edge of the mirror in the first scene; her gesture distils women's self-punishment in an economy of body regulation, passive objecthood and woman's entrapment in being the desired, but not the desirer.

Overall, costuming by Bláithín Sheerin operates on two intersecting levels: the off-the-peg style of clothing of the mortal characters, contrasted with the three singers, each dressed elaborately, bearing ritual elements such as feathers, martial collars and armlets, ceremonial objects, and with faces masked with bronze or gold paint. While the street clothes work as connector vectors to link the audience and the contemporary dialogue to the mythic action, the gods are a "sonic echo" of tragic fatefulness; they re-orientate the gestus of the performance (Pavis 172, 175) and its relationship between the performance and the social world of the audience. The semiotic excess of the combined costume sign systems reflects the instabilities of the tragic anti-heroine as third wave feminist subject.

One scene that effectively stages how Phaedra is trapped by the contradictory demands of her own emotions and the cliché-ridden image of female attractiveness is where she, believing that Theseus is dead, confronts Hippolytus with her desire. The encounter is staged in the centre of the scenic space, made self-consciously performative through its self-consciously "theatrical" positioning. Phaedra wears a grey silk dressing gown, her hair down. When she is assured that Hippolytus, now orphaned, does not see her as his [step] mother, she removes her dressing gown, supposedly to try on a range of dresses to wear to Theseus' funeral. She reveals a conventional image of the sexualized woman: décolleté black basque, black suspenders, black stockings and high heels. The sleek silhouette of the performer's body adds to the image of fashionable seductiveness. Fashion's paradox though, "that it presents itself as a means of self-realization but only on condition that you submit to the dictate of a collectivity" (Soper 27) is materialized in what follows. If, as Barthes writes "good costume clarifies gestus" (42) then this scene traps Phaedra in the desperation of her desire. She embodies the contradictions of her (simultaneous) freedom to express herself, while the image she chooses places her as passive object of the male gaze. Her conformity with objectification runs side by side with her appropriation of the potential power of that objectification, to win what she wants. But the narrative is set against her empowerment. She is rejected by Hippolytus and gains only his temporary pity. The scene ends with her suffocated collapse. She clings piteously yet deliberately to Hippolytus, her humiliation overtaken by a

retreat into vulnerable passivity. Her putting to use of familiar expectations of feminine weakness only subverts her status as a tragically misguided figure and opens a way for her betrayal of honour under the malign influence of Enone. When she realizes the catastrophic consequences of her lie to Theseus (that Hippolytus raped her) it is Aphrodite (Cathy White) who helps her to swallow the overdose that causes her suicide. In the final scenes she wears a silver sequined dress, shattering reflected light in a spectacle of bodily and moral fragmentation, each particle of sequin a tiny shard dispersing her image into an impossibility of completion.

Lynne Parker stages this with fine balance between dignity and hopeless despair; Phaedra crosses the front of the stage left to right, blindly, as if held in tensile relation to Aphrodite, who crosses up stage from right to left. As Phaedra reaches the window structure, represented down stage right in a form that closely echoes the mirror mentioned earlier, she falls softly to the ground and is visible to the audience only through the disturbing distorting glass that shields her. The gestus of her death is a surrender. In contrast to Seneca's version where Theseus orders that Phaedra be buried, it is implied alive,[6] Phaedra here acts to bring on her own death. She must embrace defeat. Fannin, Cranitch and the production stage for the twenty-first century the damaging and unrelenting agon of woman's self-fulfilment, the irony of her agency against herself.

Sodome, My Love

In a shallow arena bordered by tall screens and furnished only with two bench structures, Laurent Gaudé's survivor of Sodom returns to us from her sleep in salt.[7] The audience see her first in close-up, her sleeping face, flaked with salt, projected on the screens; the floor of the stage is harsh with saline crystal. We hear the voice and breath of the nameless woman, "the world groans and moves around me ... the salt sticks to my skin" (Gaudé). Slowly the still figure is revealed on stage, head down, long pale hair, seated, barefoot. Olwen Fouéré's body

[6] "THESEUS. ... As for that woman–bury her" (38). Seneca, *Phaedra. Six Tragedies*. Trans. Emily Wilson. Oxford: Oxford UP, 2010.1-38.

[7] Laurent Gaudé, *Sodome My Love*. Translated from French by Olwen Fouéré, at Project Arts Centre, Dublin, Premiered 16 March 2010. Co-Produced by Rough Magic Theatre Company and TheEmergencyRoom; directed by Lynne Parker; design and lighting by John Comiskey; costumes by Monica Frawley; sound composition and design by Denis Clohessy. Performed by Olwen Fouéré.

appears whitened, her skin bearing residues of salt, her movements expressive of long stasis finally broken. She is costumed in a sleeveless white shift, a shroud of silk-like fabric.

In this staging at Project Arts Centre the screens are used to point towards the off stage world of the protagonist, an alienating and alienated place of technologized anonymity, but they also present the audience with larger-than-life access to the detail of the performer's facial expressions and states of mind. In this way the screens extend the scale of the presence and location of the woman; she is present physically and is also out there, uncanny, amongst us, within us. On the screen close-up, her face runs with drops of water, the mouth open. She welcomes "rain for which I have waited centuries." Lights are flickering vertically now on the screens stage right, with images of hard urban energies, time passing, anomie. Comiskey conceives a space for the survivor of aeons, a revenant who "comes back and demands attention" (Warner, *Sodome* Programme 4). Its emptiness isolates her while her discourse fills the void with images of the excess of her life in the ancient city which she invites the audience to imagine. She is the mythic figure "confronted with extreme tragedy" that George Banu identifies with Gaudé's work (Banu, *Sodome* Programme, 3).

The story of Sodom emerges as the figure becomes more powerfully revived, gradually gaining in animation as she recounts the pleasures of her city, the shared erotic joy of its citizens. Her images are orgiastic, superabundant, uncompromised by any sense of surfeit. Then her narrative turns. She tells of a woman who comes to the city gates: "then she said that word 'contagious'." This is the first warning of what is to follow. A harbinger of death then comes in the shape of a beautiful ambassador, who "plunged into a passionate embrace with every woman and man who came to him." Ominous sounds of heavy rain are heard and images of streaming water are projected over the screens: "Sodome killed by one man with a clear countenance and a perfect body." Screen images of water are replaced by plumes of smoke, while the sound of rain becomes the sound of burning, the destruction of the city.

The simple costume of the performer does not allow us to identify it as anything more than a covering for her nakedness. As the scene turns red she tells of the deathly invasion of the city, of her burial alive in salt. She is determined to endure: "the happiness of our lives survived in me." The victim/survivor is not to be pitied however: "For a long time I thought about my revenge." Angela Carter writes that "a free woman in an unfree society will be a monster" (27). The woman exhorts the

audience to beware: "you will get the taste ... you will think of nothing but that. ... You will be possessed by horror and by sensuality. Do you remember–contagion ... I will stalk your cities until everything is driven wild." The screens show images of city neon, the gloom and glare of nightclub dissipation and the sound swells into a din of sirens, traffic and nightlife as the figure begins to transform. Beginning with lipstick she dresses herself : glamorous flowing coat, high strapped shoes, cigarette, dark glasses, something approaching the uniform of the phallic hyper-feminine woman, a post-feminist femme fatale, "no longer depicted as an object of fear, rather she [becomes] a frightening subject" (Evans 204). The challenge for the designer of costume is to find an image for this manifestation of erotic threat. Olwen Fouéré remembers that a number of possible solutions were tried. The choice of "iconic haute couture, which carries its own unreadable mysteries" as Fouéré puts it, was made, but was felt finally to be "still too specific" (Fouéré, e-mail). When the production was invited to play at the 2010 Ohria Festival in Macedonia, simpler solutions were tested; Fouéré wore no make-up, she put on an old mackintosh, smoked a cigarette, and at the end, wearing high-heeled shoes, walked out of the performance space onto the street. Closure bears the weight of resolution and definition of what has gone before. Once she moves out of history and into the present, the challenges posed by Fouéré's woman of Sodome bear the pressure of current anxieties about woman as commodity, woman as powerful, woman as desiring.

Conclusion

Both these productions dramatized women's resistance to naturalized gender expectations of passivity in desire. Both showed the difficulty of finding strategies to image women's sexual desire alongside resistance to hegemonic gender iteration. In *Phaedra*, design excess and spatial manipulation through mediatized images on stage showed the anti-heroine as a potentially powerful site of desire diverted and destroyed by fractured self-image, trapped in the paradoxes of appropriating hyper-femininity, and struggling to maintain tragic status. Fouéré embodied a more sustained threat to patriarchal control of desire, but in the Dublin performance, her appropriation of haute couture power dressing begged the question of being within the walls, yet being bent on their destruction. Images of Phaedra and the survivor of Sodome "gesture towards moments of a cultural [and gender] trauma which we can only begin to describe" (Evans 212). They explore the limits around the appropriation of objectifying images of woman as a feminist

strategy, while both productions also point towards a longed-for escape into an "other" territory, a city of "Zenophilia."

Works Cited

Banu, Georges. "Laurent Gaudé: A Theatre of Excess." Trans. Aoife Spillane-Hinks. *Sodome, My Love* Programme. 3. Print.

Barthes, Roland. "The Diseases of Costume." *Critical Essays*. Trans. Richard Howard. Evanston, Ill.: Northwestern UP, 1972 (1964). 41-50. Print.

Blau, Herbert. *The Eye of Prey*. Bloomington, Indiana: Indiana UP, 1987. Print.

Carlson, Marvin. *The Haunted Stage: Theatre as Memory-Machine*. Ann Arbor: The U of Michigan P, 2001. Print.

Carter, Angela. *The Sadeian Woman*. London: Virago, 1979. Print.

Entwistle, Joanne, and Elizabeth Wilson. "Introduction." *Body Dressing*. Ed. Joanne Entwistle and Elizabeth Wilson. Oxford: Berg, 2001. 1-12. Print.

Evans, Caroline. "Desire and Dread: Alexander McQueen and the Contemporary Femme Fatale." Entwistle and Wilson 201-14. Print.

Fannin, Hilary. *Phaedra*. Unpublished text.

---, Lynne Parker, Ellen Cranitch, and Maureen White in Conversation: "It All Starts With the Sea." Programme for *Phaedra*. Dublin Theatre Festival, 2010. Print.

Fouéré, Olwen. E-mail to the author. 1 Dec. 2011.

Gaudé, Laurent. *Sodome, Ma Douce*. Paris: Actes Sud, 2009. Print.

---. *Sodome My Love*. Trans. Olwen Fouéré. Unpublished text.

Gillis, Stacy, and Rebecca Munford. "Interview with Elaine Showalter." *Third Wave Feminism: A Critical Exploration*. Ed. Stacy Gillis, Gillian Howie, and Rebecca Munford. Basingstoke: Palgrave, 2004. 292-97.

Keating, Sara. "*Phaedra*." www.irishtheatremagazine.ie/Reviews/Ulster-Bank-Dublin-Theatre-Festival; accessed 28 Nov. 2011. Web.

Marcuse, Herbert. *One Dimensional Man*. Boston, Mass.: Beacon, 1964. Print.

Pavis, Patrice. *Analyzing Performance*. Toronto: U of Toronto P, 2003.

Schlemmer, Oskar. "Man and Art Figure." *The Theater of the Bauhaus*. Ed. Walter Gropius and Arthur S. Wensinger. Baltimore: Johns Hopkins UP, 1996. 17-48.

Shildrick, Margaret. "Introduction: Sex and Gender." Gillis, Howie, and Munford 67-71. Print.

Showalter, Elaine. "Representing Ophelia: Women, Madness and the Responsibilities of Feminist Criticism." *Shakespearean Tragedy*. Ed. John Drakakis. Harlow: Longman, 1992. 280-95. Print.

Soper, Kate. "Dress Needs: Reflections on the Clothed Body, Selfhood and Consumption." Entwistle and Wilson 13-32. Print.

Ubersfeld, Anne. "The Space of Phèdre." *Poetics Today* 2.3 (Spring 1981): 201-10. Print.

Warner, Marina. "Hearing the Revenant." *Sodome, My Love* Programme. 4. Print.

4 | From Laundries to Labour Camps: Staging Ireland's "Rule of Silence" in ANU Productions' *Laundry*[8]

Miriam Haughton

> "On the subject of sex, silence was the rule." (Foucault, *The History of Sexuality 1*, 3)

Please remember these names: Margaret Blanney, Gertrude Craigh, Mary Fagan, Christina Green. These are four names selected at random from the 1911 Irish Census. The women to whom these names belonged resided, according to the census, at the Magdalene Laundry run by the Sisters of Our Lady of Charity of Refuge on Seán MacDermott Street (formerly Gloucester Street) in Dublin's north city centre until 1996. It was at this address that these names, and hundreds of others, were finally given voice during ANU Productions' site-specific performance *Laundry*[9], directed by Louise Lowe in 2011, a century after that census was held. Gloucester St was located in the "Monto" (abbreviation for Montgomery Street, now Foley Street) region of Dublin, part of a north inner-city slum and Europe's largest red-light

[8] This essay has been previously published in *Modern Drama*, 57:1 (2014): 65-93.

[9] *Laundry* was premiered as part of The Ulster Bank Dublin Theatre Festival 2011. Creative Producer Hannah Mullan, Designer Owen Boss, Lighting Design Sarah Jane Shiels, Sound Design Ivan Birsthistle and Vincent Doherty, Choreographer Emma O'Kane. Cast includes Úna Kavanagh, Sorcha Kenny, Catriona Lynch, Niamh McCann, Stephen Murray, Bairbre Ní Chaoimh, Peter O'Byrne, Robbie O'Connor, Niamh Shaw and Zara Starr. Community cast includes Martin Collins, Stephen Duigenan, Paddy Fitzpatrick, Tracey McCann, Laura Murray, Eric O'Brien, Fiona Shiel and Lauren White. *Laundry* won "Best Production" at the Irish Times Theatre Awards 2012.

district of the early twentieth century. This act of remembrance reflects one of the scenes or "moments of communion" (Lowe, Personal Interview) in ANU Productions' site-specific postdramatic performance located in the Convent building attached to the former laundry. In this encounter, the names of these enslaved women were read out, and each audience participant was given four names in particular to repeat and remember. The issues of naming, identity, presence, absence, freedom, remembrance and criminality were at the heart of this performance as they are at the heart of Magdalene history and Irish social history.

Laundry signalled, through a gentle performance with a troubling impact, the stakes at play for the Irish state, its citizens and its "official" history. On 5 February 2013, the "Report of the InterDepartmental Committee to establish the facts of state involvement with the Magdalen Laundries" was published, eighteen months after it began its enquiry. This state inquiry into state involvement commenced following an urgent recommendation from the United Nations Committee Against Torture (UNCAT) in 2011, though the Irish state had previously argued the women entered these institutions voluntarily and were managed by the religious orders without state involvement. This report acknowledges significant state involvement from 1922 (when the Irish Free State was established as a dominion of the British Empire under the Anglo-Irish Treaty), with 26.5% of referrals made by state authorities. Yet, An Taoiseach (the Prime Minister), Enda Kenny, failed to apologize in full on behalf of the Irish state to the remaining survivors and the families of its victims on its publication. Instead, the apology came weeks later as intense international public pressure mounted. Following the McAleese report, two nuns who remained anonymous gave a radio interview broadcast on Raidió Telifís Éireann (RTÉ), the national broadcaster ('The God Slot', RTÉ 1, 2013). They defended the Church's role in Magdalene history, refusing to apologize and reminding listeners that it was the families who put them there, adding that during those times Ireland was a "no welfare state." Since then, the four Orders which ran the laundries in the Republic of Ireland have refused to contribute to the Redress Scheme set up by the Irish government in the wake of the Report (this scheme was confirmed after much delay and initial hesitancy to do so).

This current crisis results from eighteenth, nineteenth and twentieth-century Irish history when "outcast" women were sent to Convent-run, state-supported laundries for "penance" and "protection." In her ground-breaking book on the laundries, *Do Penance or Perish* (2001), Frances Finnegan's research declares that these outcast women

included prostitutes, unmarried mothers, orphans transferred from industrial schools, women prosecuted by the courts (using the laundries instead of a prison), women with intellectual and physical disabilities, and women considered "objects of temptation." Justice for Magdalenes (JFM), a survivor advocacy group seeking justice and redress for these victims, estimate that approximately thirty thousand women were sent into the laundries in Ireland, though an exact figure cannot be confirmed (Steed). The recent problematic state report finds approximately ten thousand women entered the laundries between 1922-1996, though the first laundry opened in 1767 (Finnegan 8). Many who entered these places never left them, but died in forced slavery and incarceration, unaware they had the right to leave. Some were buried on Convent grounds in mass graves without public ceremony (Raftery). Their identities were removed on arrival, as was their freedom and if pregnant, eventually, their babies.

This article critiques certain scenes from *Laundry* (2011), considering how the performance staged and disrupted "The Rule of Silence" (Finnegan 23-24); an official policy implemented in Irish Convents throughout the twentieth century to control and subjugate Magdalene "penitents." Through employment of the theoretical hypotheses of Michel Foucault and Peggy Phelan, this study will interrogate the performance of silence and representation as strategies of power in ANU's *Laundry*. This silencing of "outcast" women aided the representation of pure Irish womanhood that is critically bound up with the representation of the Irish state. Analysis of this landmark Irish performance will also convey how this rule of silence dominated the wider public and private spheres of modern Irish society, ensuring their complicity in the discrimination, slave labour and forceful imprisonment of these vulnerable women.

Context: Artistic, Political, Critical

Part of *Laundry*'s potency lies in the staging of testimonies and recovered histories in the very building in which those experiences were contained. This renegotiates the "suspension of disbelief" often assumed to underlie the theatrical event; the re-presentations were drawn from historical record, and the setting was a functioning laundry. This also renegotiates the rules governing Magdalene experience in Irish society. Thus, rather than the women's silence, the performers spoke directly to audience participants. Instead of the women's absence and invisibility, they were seen, acknowledged and they offered physical contact. Significantly, rather than a concrete

barrier separating the women from public life such as the high walls which typically surround these laundries, members of the public crossed this threshold and entered them, contesting the boundary between public citizens and hidden citizens. Institutions espoused as charitable by a multitude of authorities and wider society, through the experience of *Laundry*, were exposed as prisons and labour camps. For a brief time, audience participants were positioned to consider consciously, and feel, a lifetime of stripped constitutional freedoms, silence, slavery and isolation. As an Irish audience member, I entered the convent building as a consumer who bought a theatre ticket as part of The Ulster Bank Dublin Theatre Festival 2011, and exited it as a citizen, confused and horrified by my shared history with a regime characterized by such unjust despair to the weak and struggling members of Irish society.

This article observes that these laundries operated as labour camps, where women were forcefully incarcerated and imprisoned, many to their deaths, for the commercial and ideological profit of the Roman Catholic Church in Ireland and the Irish State, hegemonic forces which tightly managed and monitored Irish society with their similar policies on sex and society. Both spiritual and secular rule in Ireland have injected the role of womanhood in Irish society with mythological and symbolic functions, further established (and often contested) by Irish theatre historiography, to the detriment of material womanhood in Ireland. Cultural, political and religious shaping of gender roles has resulted in a normalization of the subjugation of women in Irish public life throughout the twentieth-century.

Magdalene history will continue to haunt Irish and international memories (as questions regarding Magdalene laundries in the UK, the US, and Australia increase at this time of writing), through both its presence and absence. Indeed, the recent confirmation by state authorities of an investigation into widespread illegal adoptions in Ireland as recently as the 1970s (though no prosecutions have occurred due to lack of evidence [O'Brien]), ensures this complex history is scratching its way to the surface of Irish politics, demanding action. Various forces vie for dominion of the female body and its fruit once more, to regulate its territory and write its history. James M. Smith details in *Ireland's Magdalen Laundries And the Nation's Architecture of Containment* (2007) that "The first asylum for fallen women in the United States, the Magdalen Society in Philadelphia, was founded in 1800 and closed its doors in 1916" (Smith xv). In Ireland, those doors closed in 1996, except for the remaining women (approximately one

hundred) who currently remain in residence in Convents with the Sisters (JFM).

Consequently, this visual, visceral and embodied experience of *Laundry* is of elevated social importance as well as of major artistic merit. The continual post-performance efficacy experienced by *Laundry*'s audience ensures that while the actual performance may be ephemereal, the memory and consequence of this performance lives on. My experience cannot be universal nor my report wholly objective, as I will detail my subjective experience of this production. Regardless, it is not entirely exclusive either, and reviews, commentary and continued debate regarding the impact of this production provide this assurance. Indeed, one cannot deny a history of trauma enacted in front of one's eyes. One cannot forget the poisonous smell of carbolic soap (distributed to the penitents) that infiltrates the senses the moment the front double doors are shut and bolted. One cannot rebuff the unexpected grief and guilt that bubbles up from an overpowering experience of silence and isolation in performance. One cannot help but shudder while gasping for fresh air in a building locked tight which forbids open windows and bright light, observing the shadowy and ghostly movements behind sturdy doors. Most significantly, one cannot release the emotional connection that is forged between audience participant, performer and history. In this context, thus, the unacknowledged crimes of the Irish authorities, spiritual and secular, transfer to the negligence and complicity of Irish society. While the laundries did close throughout the late twentieth-century, the dominant reason is attributed to the commonplace arrival of washing machines in the domestic sphere, not a public outcry of injustice (Finnegan 2).

Magdalene history began on the island of Ireland in 1767. It has crept in and out of official narratives since, though in sombre and hushed dialogues, as the shame of fallen and outcast women became more suitable to public silence than discourse. In 2011, *Laundry* created a space for audience participants to witness, acknowledge, engage with, and feel, the shame of particular Irish histories and certain oppressive ideologies, which resulted in slavery, incarceration, premature death and lost children in an unknown, and unquantifiable, magnitude.

Laundry: The Performance

Laundry attempted to re-present the daily routine of the lives of the women who lived and worked in that particular laundry. The action was not theatrical in any traditional sense but the performance remained

dramatically powerful due to where it was taking place. ANU researched historical accounts of these women and developed each performance according to personal testimonies detailed in the JFM archives they were given access to, oral histories retrieved from the local community where Lowe was raised, and histories documented by a local historian, Terry Fagan. The production focused on witnessing the female body in a closed punitive space in a quiet and constrained manner, reinforcing the sense of tragedy inherent in this situation. It reinstated the reality that the women's lives were quiet hidden lives with no access to political power or opportunities to communicate. The last women were admitted to the Gloucester St. Laundry in 1995 and the building was closed in 1996.

Lowe argues vehemently, "It should matter that you are there," (Synge Summer School 2012). Noting that the role and experience of the participant is central to the artistic and personal experience of the performance resonates with Peggy Phelan's claim that "[p]erformance implicates the real through the presence of living bodies" (148). However, Lowe not only considers the living bodies which perform but the living bodies traditionally seated en masse covered by darkness, away from all but visual contact with the stage. By renegotiating the relationship between performer and participant through including the participant in the performance, and staging the performance not in a commercial theatre venue but in a haunting historical landmark, Lowe urged each participant to realize the importance attached to *their* presence at this event. If Magdalene history could not enter the public sphere due to the lifetimes of silence which locked it up, then the public will have to enter Magdalene history.

From my experience, a total of fifteen mini-performances took place from when I arrived at the site of performance to when I left. To remain within the appropriate space for this essay, I will analyze some but not all of the encounters.

Performance One: I consider arriving at the venue and waiting to enter the building the first part of the performance. I waited on a seat outside and observed other audience members exit the building approximately every five minutes, carrying linen in the company of a Maggie and being pushed into a waiting taxi as the Maggie attempted escape. At the same time, local residents watched the waiting participants as we watched them. In this way, the social history of the area was as performative as the performance proper taking place inside the convent building. Foucault argues that by analyzing how space has been organized, categorized, managed and encoded, one could "write

the whole history of a country, of a culture, of a society" ("The Stage of Philosophy" 4). Observing the history of this space indeed details the history of hidden and hushed up Irish culture. Tattered buildings, litter and graffiti surrounded the laundry, not ocean views, Gaelic Athletic Association (GAA) clubs or shopping chains; and as such situated the laundry and the penitents' lives in a neglected and forgotten place, outside the main focus of national activity and representation.

Observing such direct close contact with the performers and realizing I would be pushed into a car travelling to an unknown venue certainly heightened my critical interest but also signalled this was not a performance I could necessarily control my participation in. There were no fixed seats, dimmed lights and camaraderie with other patrons. In this instance, the number of performers would be greater than the number of audience members and not due to a "poor house" but to ensure this was a uniquely personal experience for each person. Consequently, it arguably would become a performance never forgotten by the few who saw it, which is precisely the political issue at stake by representing the Maggies, hidden for decades. Irish authorities and society tried to deny and forget their incarceration. Forgetting these people, for some, may be easily done; as the women entered the laundries they were re-named.

Performance Two: Daylight disappeared as the heavy bolted doors opened and the two other participants and I were ushered into the dark reception hall with an extremely distinctive and overbearing smell (later to be identified as the carbolic soap distributed to the women in the laundries). They were immediately directed to small rooms right and left of the first entrance hall while I waited for approximately ten minutes in silence with a young man tending to the front door. Cold tiles, an extremely pungent smell of carbolic soap, a high ceiling, whispered sounds and shadowy movements taking place behind the faded glass double doors leading to the rest of the building created an overwhelming sense of darkness and dread. For the many Irish citizens who have been educated in Catholic institutions, entering such a building could be simultaneously familiar and alien. The design and atmosphere immediately evokes the memory of my own convent education and yet it is a system many can no longer connect with in the wake of such major failures in pastoral care, religious guidance, gender discrimination and outdated totalitarian rule. Standing still in that front foyer while waiting to enter the other rooms facilitated an encounter with walls, locked doors, and silence. Ten minutes of "real" time became distorted and heavy. It brought the realization that as a

participant in this production, I was acting as witness to a history of human torture and despair. Before he re-opened the doors to the rooms he spoke, "People said they didn't know what was going on. Would you have done anything?" Hence, I was no longer a spectator in a theatrical imagined performance but a complicit member of Irish society, asked to consider the limits of my own social responsibility and intervention.

Performance Five: I was directed to the second reception hall where a young "Maggie" listed the names of two hundred and twenty-five Magdalene penitents listed as resident in this laundry in the 1911 Irish Census and instructed me on four particular names I had to remember. Each participant was given four different names of Magdalene women to remember and repeat out loud, incorporating the act of remembrance into the act of witnessing. Indeed, one participant heard the name of her birth mother being read out during this scene (Lowe, Personal Interview). Once the names were listed and repeated, I was directed to an old filing cabinet which contained extra bars of soap and clips of human hair; I was instructed to look through it and invited to leave some of my own. Sifting through the human hair, in remembrance of those who had lived their lives in a place of punishment, neglect and slave labour, ensured my personal connection and thus personal responsibility for their memory was tightening.

Naming is an essential component in strategies of control. Naming has been an integral part of the numerous regenerations projects related to Monto, as it has been an integral part of Irish history and politics. From a colony of the British Empire to a dominion of the Commonwealth as The Irish Free State to the present day Republic of Ireland, naming has cost the Irish nation terror, trauma and human life. Magdalene penitents were called promiscuous, sinful, whores, shameful, and worse. Their children were called illegitimate, orphans, bastards and in the end, children for export to the UK, America, Australia and many other places. *Laundry* exposes another conflict of naming and identity; Gloucester St became Séan McDermott St and World End's Lane became Liberty Corner. Yet each regeneration attempt of this area has failed and as Lowe describes her home-place, "It's a pocketplace, insular, shut off from the hub" (Interview). If the experience of humanity can inform a place, and possibly leave a trace through objects, memory and DNA, then perhaps the history and trauma of this area is too inscribed in its bricks, mortar and energy. Moreover, perhaps this locale still suffers from discrimination in official discourse and social investment to enter any phase of transformative renewal, while the ghosts and histories resident there remain contained

within its urban coordinates, and not fully accounted for in the established discourses of national history.

Performance Six: As I was instructed to enter the room right of the second reception hall, another audience participant exited it crying. In this room another young Maggie was performing her daily ritual; bathing. It was a bath of cold water mixed with what appeared as breast milk, expressed by her leaking breasts. From ANU's research, the team learned that hundreds of women had died from mastitis, an infection that occurs in the breasts and can be treated with antibiotics. I was instructed by her, not through dialogue but her hand gestures, to unwrap the cloth that covered her chest and help her into the bath where she shivered and quietly wept. I then helped her to get out of the bath and re-wrap her chest. Being faced with a shivering naked vulnerable body and instructed to wrap and cover her breasts symbolizes the fragility of these women in this repressive place and the policy to deny evidence of their motherhood. Silently but steadfastly observing this interaction was a stage manager, dressed similarly to a nun, sitting on a stool while reading a book and eating an apple. Upon reflection, there is a tragically ironic connection in this encounter between the British Empire's colonization and oppression of the island of Ireland, re-naming the landscape and controlling social movement and the Irish authorities colonizing these women, denying their identities, controlling the landscape of their bodies and removing them from free society.

Performance Eight: This performance foregrounded the act of visibility and invisibility. Both performances required the spectator to participate from another foyer area. Performance eight, "Alice through the looking-glass" as Lowe calls it, was devised from the memories of Lowe's friend and neighbour Sandra Walsh. Sandra's aunt Alice Walsh lived with her family directly across the road from the Gloucester Street laundry in the 1960s and tried to hide her pregnancy from her family. At approximately six months pregnant her father discovered her secret and forced her to enter the laundry. Local testimony declares that Alice had fought him every step of the way, kicking and screaming through the streets and into the convent (Interview). Approximately four years later, her brother Noel Walsh returned from work on a building site in Birmingham and learned of his sister's fate. He tried to retrieve her from the laundry, but was informed by the nuns there was no record of her entry or any child. Alice had disappeared. In Finnegan's research, she discusses convent literature where the policy of keeping good workers is outlined, "This distasteful practice of retaining 'hard

workers' in the laundries and discouraging their departure—even from short-term Homes—is referred to frequently in the literature" (35). Perhaps Alice was a hard worker.

The participant sat on a chair and observed a wall of mirror constructed from perspex facing them. However, one's reflection in this mirror began to fade and one could see a young woman behind this "wall." She moved painstakingly slowly toward the mirror-wall, stretching out her arm as if to touch you and opening her mouth in an effort to speak or scream. As she moved an eerie blue light shone behind her. The crackle and hum of washing machines interrupted the otherwise resounding silence. The mirror-wall alternated between reflecting the participant's reflection to revealing this trapped person behind the wall.

Performances Ten, Eleven and Twelve: These all took place in the Church part of the building at the back of the laundry. They were the final performances to occur within the building. For performance ten, a widowed Maggie "Pauline" sat in a pew and asked each participant to sit with her for a while and hold her hand as she gently explained her circumstances. She had been married for years but as her husband grew ill he was afraid she would not cope living independently and urged her to enter a laundry for protection and comfort in her later years. She had a bag of sweets in her hand and offered one to her listener while shooting critical glances at another Maggie passing by, clearly on the run. This performance was devised from a testimony where "Pauline" had been grateful for the sanctuary of the laundry and the company of the other women. Pauline had been raised in the laundry after attacking a local Madam who had fostered her. She left the laundry when she married. Before her husband died he told her "You have been a good girl and a good wife" and instructed her to return to the laundry after his death (Interview). She initially tried to live alone in their apartment but barricaded the door every night in a constant state of fear. She eventually returned to the laundry which she felt was a haven and also, a place where she would be remembered by the others after her death.

Pauline instructed me to enter the confessional at the end of our conversation and as I let go of her hand I knew I did not want to enter the confessional, even more so than usual. Waiting there was a young vivacious Maggie with her boots kicked off and making a poor attempt at scrubbing the walls. She informed me how she had always been told whistling attracted the devil, and so, she whistled and smiled. She reminisced on a dance she had attended many years ago where she wore a beautiful dress with a strap here, a hem like this and a neckline

like so, and she took my arms and we waltzed in the small room, dimly lit by candles. Evidently, the tragedy here was that she would never wear another beautiful dress or dance again and her vivacious spirit would eventually fade as she scrubbed her days until death. Before I exited the confessional, she reaffirmed her defiance against her confinement by whispering her "real" name in my ear, "Christine."

I was then directed towards a small room to the left of the pulpit and on this journey one's eyes are immediately drawn to the figure of Christ hanging from up high, observing everyone below. In *Discipline and Punish*, Foucault's research concerning the spread of panoptic control from prison architecture to all social spaces is immediately applicable. In essence, the power of the panoptic structure is its gaze, "inspection functions ceaselessly. The gaze is alert everywhere" (195). Foucault concludes that since the late eighteenth century, modern western civilization has witnessed "the disappearance of torture as public spectacle" (7). His claim outlines while the body remains the instrument on which official power networks inscribe their law, the mode of regulating the body has shifted from physical punitive methods to observation of the body in a panoptic infrastructure associated with prison architecture. This development was in accordance with the evolution of social power dynamics taking place on a globalized front, propelled by capitalism's imperial power. The operation of power with regard to the social body then became a question of production output and societal discipline, rather than a display of official authority as embodied by the public torture event. It is this political technology of the body that Foucault argues acted as the driving impetus in this significant evolution of official punitive and regulative measures. Indeed, this is an apt assessment for the development and commercial success of Magdalene laundries in twentieth-century Ireland.

Through this door one met the Maggie trying to get out, but to do this, she required help. "Just act natural ok, just act natural" she warned me, and begged me, filling my arms with laundry and looking out the window and back door to see who was present. The front door would be her best bet she decides, and she grabs my arm as we re-enter the Church, only pausing to bow before Our Lord in his Holy House, before exiting the three foyers I had previously travelled, and out the front door. She pushed me and the laundry into a taxi which sped away, while she ran. This performance was devised from a testimony of a lady who escaped frequently, once seriously injuring herself from doing so. However, she had formed a close bond with a ninety-four year old penitent at the laundry who she referred to as "Granny" and so she

returned after each escape in the evening to see her. After the death of "Granny," she escaped and did not return.

Performance Thirteen: In performance thirteen the taxi driver cheerfully introduced himself as "Den Den" and explained we were going to the new laundry not far away. It was not a convent but the place that opened with the arrival of washing machines. As he drove, clad in his Dublin GAA jersey, he told his story. He used to deliver milk to the laundry at approximately six in the morning every day. At this time of day, the Maggies were allowed out in the back courtyard and would sing Ave Maria; after this time they had to remain indoors. He fell in love with one of them and they wed in the Church in the laundry. Soon after their marriage she told him she was going to the shop to purchase milk, and never returned. The drive took us through the streets of "Monto" and the view was of high-rise council apartments, littered streets and homeless people slouched in doorways (for most of the earlier performances, this taxi-drive would have incorporated performance from *World End's Lane* which was taking place en route. Performers from *World End's Lane* would stop and enter the taxi, asking questions of the participant inside it). He brought me to the front door of the laundry and promised he would return shortly to collect me.

Performance Fifteen: When the taxi driver returned, he drove the two other participants and me (who had entered the laundry at the same time) back to "point zero," outside the laundry doors, where the performance had originated. Before we exited the taxi he gave us each a wrapped bar of soap, the same soap with the intense and distinctive smell that first assailed the senses as one entered the building, returning me to the moment I entered it. On the soap was a label with my name, and the date. The performance had indeed ended, but it became clear then, to a certain extent, it had never begun. This experience was very much a reality for thousands of Irish women, their families and friends, and their adopted children who live both on the island and throughout the world. By staging *Laundry*, ANU Productions urged each participant, as a spectator and citizen, of whatever country, to bear witness to this hidden and denied trauma by remembering these women and their families.

Once indicted to a sentence of unknown duration in a Magdalene Laundry there was little opportunity for escape; unlike a prison sentence for murder or rape for which the state dictates a specific number of years, as well as a process of trial and appeal. For these women, a life sentence could mean death. Perhaps a brother would

come to claim his sister but she no longer officially existed. Every day signalled another test in mental, emotional and physical endurance, while every locked door and high wall were testament to the shame the established religious, political and social ideologies declared they deserved. If the production of *Laundry* has conveyed any clear message, it is not the story of fallen women but of a fallen state and church, and a complicit society. While the state previously denied involvement, these denials were rebuffed by those who documented evidence. Smith devotes the second chapter of his book to confirming the relationship of support and complicity between the Irish State and the Catholic Church in the management of these institutions. He outlines:

> The state also provided the religious orders with direct and indirect financial support [...] This partnership between church and state encouraged a transformation in Ireland's Magdalen asylums: they adopted a punitive and recarceral function that increasingly upplanted their original rehabilitative and philanthropic mission. (Smith 47)

Until a policy of full openness by the convents, state and society informs the former report and subsequent investigations, the state continues to fall and the Irish theatrical community continues to stage this journey, responding to urgent social crisis as their dramatic ancestors did almost a century ago at the dawn of the Irish "Free" State.

Conclusion

To conclude, *Laundry* is fundamentally concerned with the politics and consequences of difference. To understand how difference can be identified, one must first understand how the act of representation is political, layered and often misleading. Phelan notes the often reductive interpretation of the relationship between representation and power: "If representational visibility equals power, then almost-naked young white women should be running Western culture. The ubiquity of their image, however, has hardly brought them political or economic power" (10). As such, to put faith in the totality of representation is naïve. Catholic institutions in Ireland, supported by the founding nationalist ethos, declared Irish society noble and religious, and Ireland's women virgins and virtous mothers. Yet the hidden narratives exposed by *Laundry* and Magdalene history signal religious institutions were not faithful to their *own* claims of morality and compassion. One must consider what is facilitated through representation, and significantly,

the representation of absence. Who do we hide from the dominant hegemonic imagery and discourse?

Phelan expands "Representation is almost always on the side of the one who looks and almost never on the side of the one who is seen" (25-26). Irish society has been conditioned to look and see a limited range of predetermined female roles that operate according to a basic binary division–good women/bad women. In *The Death of Character* (1996), Elinor Fuchs outlines how female characters have been constructed according to their heterosexual sexual conduct–again, good women and bad women. In the performance of this region throughout modern Irish history, it seems this extremity of limited female character and role were hidden here, from prostitutes to nuns. However, as Raftery exposed, there were unfortunate similarities between the scruples of the Madams and the Sisters of Charity.

Both Irish constitutional rights and international human rights have been shunned through Magdalene history. They continue to be shunned through the McAleese report; an inquiry which took place only due to urgent and repeated recommendations from the United Nations Committee Against Torture, not from a willingness within the Irish government, or, pressure from an angered Irish society. While we wait for state and wider society to catch up with its artists' willingness to explore these narratives, we can only try and assist this process through discourse, protest and remembrance–so please, observe these names once more: Margaret Blanney, Gertrude Craigh, Mary Fagan, Christina Green.

Works Cited

ANU Productions. *Laundry*. Dir. by Louise Lowe. Magdalene Laundry, Seán McDermott Street, Dublin, September 29-October 15 2011. Performance.

Collins, Stephen, and McGee, Harry. "Kenny criticised for failure to issue Magdalene apology", *Irish Times*, 6 February 2013. Web. <http://www.irishtimes.com/newspaper/breaking/2013/0206/breaking 5.html>

Ferriter, Diarmaid. *Occasions of Sin: Sex and Society in Modern Ireland*. London: Profile, 2009. Print.

Finnegan, Francis. *Do Penance or Perish: A Study of Magadalen Asylums in Ireland*. Oxford: Oxford UP, 2001. Print.

Foucault, Michel. *Discipline and Punish: the Birth of the Prison*. Trans. Alan Sheridan. London: Penguin, 1991. Print.

---. *The History of Sexuality 1: The Will to Knowledge*. Trans. Robert Hurley. London: Penguin, 1998. Print.

---. Madness and Civilization: A History of Insanity in the Age of Reason. Trans. Richard Howard. London: Routledge, 2009. Print.

---. "The Stage of Philosophy: A Conversation Between Michel Foucault and Moriaki Wotanabe." *New York Magazine of Contemporary Art and Theory Scenes of Knowledge* 1.5 (1978): 1-21. Print.

Keating, Sara. Review of *Laundry*. *Irish Theatre Magazine*, 29 September 2011. Web. <http://www.irishtheatremagazine.ie/Reviews/Ulster-Bank-Dublin-Theatre-Festival-2011/Laundry >

Lehmann, Hans-Thies. *Postdramatic Theatre*. Trans. Karen Jürs-Munby. London: Routledge, 2006. Print.

Long, Samantha. "A Life Unlived: 35 Years of Slavery in a Magdalene Laundry" *The Journal*, 30 September 2012. Web. < http://www.thejournal.ie/magdalene-laundry-true-story-margaret-bullen-samantha-long-614350-Sep2012/>

Lowe, Louise. "Interview with Miriam Haughton." Dublin, 15 May 2012. Unpublished.

---. "Justice for Magdalenes" Survivor Advocacy Group. Web. <http://www.magdalenelaundries.com>

McGee, Harry. "Nuns Say They Will Not Pay Magdalene Compensation." *The Irish Times*, 16 July 2013. Web < http://www.irishtimes.com/news/politics/nuns-say-they-will-not-pay-magdalene-compensation-1.1464737>

O'Brien, Carl. "Up to 100 Illegal Adoptions Uncovered." *The Irish Times*, 12 January 2013. Web <http://www.irishtimes.com/newspaper/frontpage/2013/0112/1224328 743265.html>

O'Keefe, Donal. "Mass grave 'filled to the brim with tiny bones and skulls.'" *The Journal*, 31 May 2014. Accessed 2 June 2014. Web < http://www.thejournal.ie/readme/mass-grave-galway-tuam-1494001-May2014/>

Phelan, Peggy. *Unmarked: The Politics of Performance*. London: Routledge, 1993. Print.

Raftery, Mary. "Ireland's Magdalene laundries scandal must be laid to rest." *The Guardian*, 8 June 2011. Web <http://www.guardian.co.uk/commentisfree/2011/jun/08/ireland-magdalene-laundries-scandal-un>

Sihra, Melissa. "Figures at the Window." *Women in Irish Drama: A Century of Authorship and Representation*. Ed. Melissa Sihra. Basingstoke: Palgrave, 2007. 1-22. Print.

Smith, James M. Ireland's Magdalen Laundries: And the Nation's Architecture of Containment. Indiana: U of Notre Dame P, 2007. Print.

Steed, Mari. "Email correspondance with Miriam Haughton." 18 September 2012.

The Department of Justice and Equality website. <http://www.justice.ie/en/JELR/Pages/MagdalenRpt2013 > Web

5 | The Fetishization and Rejection of Womanhood in the Performance Works of Áine Phillips

Caitriona Mary Reilly

Introduction

Many recent performances address issues associated with gender inequality and as such incorporate elements of feminist activism whether intentionally or indirectly. Áine Phillips is a contemporary of other performance/visual artists such as Amanda Coogan, Sandra Johnston and Kira O'Reilly.[10] Phillips was born in Dublin in 1965 and grew up in an Ireland blighted and repressed by Catholic ideology. Phillips' live performance and video works reflect her own autobiographical details in the context of a repressive Irish State. She is described as a visual artist whose work "aims to link autobiographical themes, actions and images with wider social and political realities" (Barrett and Coogan, *Labour: A Live Exhibition*). Phillips seeks to undermine idealized femininity and motherhood as well as raise consciousness on other contested issues, such as women's access to abortion and justice for women formerly incarcerated in the Magdalene laundries. Rather than privilege the popular postfeminist incarnations of women as highly sexualized, feminine objects, Phillips' artistic works

[10] Notable works by Amanda Coogan include *The Madonna Series* (2000-2010) and *The Yellow Series* (2008-2010) which features a range of live performances, videos and photographs. Coogan has explored the role of motherhood in *The Madonna Series*. Sandra Johnston transcends the limitations of the body in pain in performances such as *Articles of (faith)* (2010) and *Even Now* (2012). Kira O'Reilly's work invokes controversy. In the performance series *inthewrongplaceness* (2005-2009) she performed with the corpse of a pig.

give much needed visibility to the problems of representation of femininity, womanhood and motherhood in contemporary Irish culture.[11] Her work interrogates and critiques both the postfeminist and Irish idolization of womanhood and motherhood, as once depicted in the Irish Constitution. Through the analysis of Phillips' performance works including *Sex, birth & death* (2003), *Harness* (2007-2011), and *Emotional Labour* (2012), this essay addresses how Phillips uses her physicality, personal experiences and graphic imagery to radically subvert the idealized notions of womanhood as associated with the female body, femininity, and motherhood.

The historical treatment of women, particularly in roles of the wife and mother, is still haunting Ireland today. As the Irish State distances itself from Catholic ideology which so often impacted its legislation, wider social attitudes towards women have changed.[12] In Ireland heterosexist ideology is reflected in The Irish Constitution of 1937 wherein Article 41.2 declares that, "the State recognises that by her life within the home, woman gives to the State a support without which the common good cannot be achieved" and the State shall therefore "endeavour to ensure that mothers should not be obliged by economic necessity to engage in labour to the neglect of their duties in the home" (Bunreacht na hÉireann 162). Article 41.2 reinforces traditional and conservative models of femininity, presuming that "woman" and "mother" exist only in heterosexual relationships. It implies that women are more suited to life in a domestic setting and should not feel pressured to undertake employment outside of the marital home. As Stacy Gillis and Joanne Hollows argue, ideologies of domesticity "played a crucial role in reinforcing the association between femininity and the home and in convincing women that their 'natural' duties were domestic, naturalizing the association between home and femininity"

[11] Rosalind Gill refers to several features which "constitute a postfeminist discourse" (149). These include the "notion that femininity is a bodily property"; "a focus upon individualism, choice and empowerment"; "a marked sexualisation of culture"; and "an emphasis upon consumerism and the commodification of difference." Gill argues that postfeminist media culture has an "obsessive preoccupation with the body" (149).

[12] In 2013, the Constitutional Convention accepted the proposed recommendations of "Amending the clause on the role of women in the home" and "Encouraging greater participation of women in public life and increasing the participation of women in politics" (The Convention of the Constitution 4). Advocacy groups such as National Women's Council of Ireland and Women for Election contributed to the submissions and presentations to the Convention.

(4). The Irish Constitution helped normalize domestic femininity and encouraged women's dependence on male citizens under the guise of supporting married mothers.

Within Irish society institutions such as the Catholic Church have demonized women who challenged patriarchal ideals and Catholic morality whilst privileging the married mother. The first Irish Magdalene Asylum opened in 1767 and was situated in Lower Leeson Street in Dublin. The Female Penitentiary Movement in Ireland and The Good Shepherd Sisters were committed to "the reform of fallen women" (Finnegan 26). The last Irish Magdalene laundry closed in 1996 and whilst "fallen" women were no longer segregated from the rest of society, attitudes towards the containment of women and female sexuality remain contentious. The current feminist debate surrounding women's reproductive rights in Ireland is at odds with the depiction of the Irish Madonna. Abortion remains a highly contested issue in Ireland both North and South of the border. The Irish attitude to abortion draws parallels to what Simone de Beauvoir argued of French society in the late 1940s. De Beauvoir argued that there are "few subjects on which bourgeois society exhibits more hypocrisy: abortion is a repugnant crime to which it is indecent to make an allusion" (537). Despite the secularization of contemporary Irish society, traces remain of Catholic conservatism in its attitudes towards women's reproductive choice and freedom. Women who do not challenge maternal identities are normalized and idolized whilst women who do not conform to the Catholic, virginal embodiment of womanhood and motherhood, are socially shamed. For example, the shaven headed musician, Sinead O'Connor, receives much negative attention for her opinionated views on everything from the Catholic Church to pop star Miley Cyrus. In contrast RTÉ broadcaster, Miriam O'Callaghan, is an idealized and much more attractive version of the Irish mother. She is pretty, successful, and has eight children. She does not appear as offensive as O'Connor. The social shaming of women once occurred with the institutionalization of women in the Magdalene laundries and it still occurs today within the pro-life movement led in Ireland by groups such as Youth Defence and the Iona Institute.

Since 2012 the issue of a woman's right to reproductive choice has been directly visible in the public consciousness following the death of Savita Halappanavar.[13] The death of Mrs Halappanavar prompted a

[13] Savita Halappanavar arrived at University Hospital Galway on 21 October 2012 with back pain, where she was found to be "miscarrying" at 17

fierce backlash to the Irish government regarding Irish abortion laws. The *Oireachtas* Committee on Health and Children met in January 2013 to discuss legislating for abortion in accordance with the infamous X case: that is, they addressed situations where the life, as opposed to the health of the mother, is at risk. In 2013 the Protection of Life During Pregnancy Act came into effect. It is described as an Act "to protect human life during pregnancy; to make provision for reviews at the instigation of a pregnant woman of certain medical opinions given in respect of pregnancy; [and] to provide for an offence of intentional destruction of unborn human life ..." (*Protection of Life During Pregnancy Act* 7). The Act explains the limited circumstances in which abortion is permitted and aims to clarify these circumstances for medical practitioners. The attitudes and issues surrounding women's reproductive choice, specifically the right to abortion, raises awareness to the paradox of being a woman in contemporary Irish society.

Abortion and the Grotesque in *Sex, birth & death*

Phillips' 2003 performance, *Sex, birth & death*, depicts her personal conflict of having an abortion and therefore rejecting premature motherhood. As well as referring to her past experience of termination, the performance reveals the paradoxical representations of the female body. Phillips' work characterizes the conflicted ways in which the female body is seen as "impure and dangerous and provokes corruption" as well as being "sacred, nurturing, and asexual" (Frueh 578). She corrupts and deconstructs the "Mother-Whore" ideology using provocative conceptual imagery. In *Sex, birth & death*, Phillips juxtaposes the feminine maternal body with abortion imagery to interrogate the validity of abortion in Ireland. In this performance Phillips uses graphic imagery in the form of a "baby cake" and is rigged up to "medical latex tubes" which propel liquid to pour out at her nipples. She is the "Other" mother who rejects the Irish maternal martyr image.[14] She displaces the idealized feminine body to adopt a

weeks; she died on October 28th. Reports describe how Savita asked several times over a three-day period that the pregnancy be terminated, "given that she was in pain and was miscarrying" yet this request was refused by medical staff who said they could not do anything because there was still a "foetal heartbeat."–"Tánaiste seeks 'clarity' on abortion after Savita death." *The Irish Times* 15 Nov. 2012. Web. 18 Nov. 2012.

[14] The "Other" is a "differently embodied reproduction of the Self" (Suchman 121). Imogen Tyler discusses Julia Kristeva's theory of the abject. The abject is a force which "disrupts social order" (79). Tyler also

grotesque female body. The depiction of the grotesque pregnant body is the antithesis to the Irish realization of woman as mother and carer. Phillips has spoken openly about her own experience of travelling to England as a young woman to have an abortion thus emphasizing the impact of the personal and political in her performance (Glynn and Phillips, "Live Art Symposium"). As Phillips' performances are informed by her personal experiences, she is able to confront her audience with the reality that there are other women still travelling afar to access abortion. Her experiences inform her work in equally personal and political ways.

Sex, birth & death, is described as a work "expressing the subjective womanly experience of maternalism and eroticism" and as identifying issues such as "birth and abortion" alongside "sexual desire and the complexity of our gendered identity" (Phillips, *"Sex, Birth & Death*, 2003"). Phillips' overview of the performance provides insight into her delight in performing the grotesque:

> I deliver a spoken monologue, a series of poem-like texts dealing with the subjective experience of maternal loss, erotic love and an enduring condition of desire. I stand before a small table upon which is placed a 'baby cake'. It is a rich fruit cake, iced with almond paste and fondant icing in the shape of a [foetus]. All the ingredients are organic ... and it is delicious! ...

Part two is a declaration of love and loss, illustrated by the issuing forth of milk streams from my breasts ... Standing before the audience, rigged up to medical latex tubes through my dress, I pick up two squeezy bottles of milk and propel the liquid through the tubes to pour out at the nipples. Two streams of milk flow down my dress ... The piece ends with this image of maternalism and eroticism combined (Phillips, *"Sex. Birth & Death*, 2003").

During the performance, Phillips draws attention to the female body with conflicting images of both the maternal and anti-maternal. She plays the role of a monstrous woman attacking an unborn child and thus purposely complicates the relationship of the female body to the maternal. The image of milk spewing from her breasts asserts her as the maternal mother whilst she also becomes the grotesque Medea-creature

highlights different interpretations of the "maternal abject" which identify the "maternal (and feminine) body" as a "primary site/sight of cultural disgust" (82). The "Other" Mother then is the maternal abject or "maternal other" (Tyler 83).

rejecting motherhood.[15] The action of cutting and eating the "delicious" foetus cake only adds to Phillips' creation of sadistic abortion imagery. She visually assaults her audience and invokes her right to speak about her personal abortion experience. The performance is not about Phillips' shame of having an abortion; rather it confronts the audience with their own expectations regarding the female body as well as the ethics of abortion and reproductive choice. Pro-life groups such as Youth Defence use graphic images of the foetus to shock and imply abortion is a sadistic act. Phillips subverts the use of such images and instead her performance becomes an ironic attack on the use of such imagery in pro-life campaigns.

Within the performance, Phillips becomes a feminized cyborg, adopting technology and tubes to physically alter and manipulate the natural female body. Anne Balsamo discusses how, despite the "technological possibilities of body reconstruction," in the discourse of "biotechnology" the female body is "persistently coded as the cultural sign of the "natural," the "sexual," and "the reproductive," so that the womb, for example, continues to signify female gender in a way that reinforces an essentialist identity for the female body as the maternal body (9). Scientific and medical advancements have opened up new possibilities and types of femininities with the Pill helping many women avoid unwanted pregnancies and plastic surgery offering people the opportunity to physically "improve" or "enhance" themselves. Phillips complicates notions of biology and science where the use of latex tubes draws parallels with IVF and the creation of a "test-tube" baby (Balsamo 91). This type of reproductive control, manufacturing and manipulation allows Phillips to convey what may be her critique of the scientific control and adaptation of the organic female body. By managing the stream of pouring milk, Phillips regains control of her bodily functions (albeit through technology) and thus creates a type of "queer breastfeeding" (Longhurst 102). Images of milk spewing from her breasts should assert Phillips as the maternal mother; however the use of medical latex tubes also suggests a technological rejection of motherhood. Robyn Longhurst describes breastfeeding as a "sacred maternal performance" which is undone "when men breastfeed" and

[15] In Euripides' *Medea*, Medea kills her own children as vengeance for her ex-husband's betrayal and abandonment. Matthew C. Reid and Grant Gillet use the classic text of Medea as an example in their argument of "fetal-maternal conflicts" relating to the moralistic dilemmas in the termination of pregnancies (19). Medea becomes the maternal other when she kills her children. Infanticide is one example of an abject act.

"when breastfeeding is incorporated into people's sex lives" (114). In Phillips' case, the mystique of breastfeeding is undone through her use of the tubes and violent imagery. She sacrifices the maternal as the act of breastfeeding becomes mechanically sterilized and denaturalized as well as grotesque.

Further to the medical latex tubes, Phillips' rejection of motherhood is evident in the disturbing abortion imagery, identified through the cutting and eating of a "delicious" foetus cake. Her unapologetic destruction of the cake shocks the spectator as it suggests violence towards the "innocent" foetus. Peggy Phelan argues:

> Fetal imagery, a persistent and ubiquitous focus in the abortion debates, is important because it upsets the psychic terrain that formerly located all reproductive visibility on the body of the pregnant woman. Fetal imagery locates reproductive visibility as a term and an image independent of the woman's body. Once that independence is established, the uses of fetal imagery become vulnerable to all the potential manipulations of any sign system. (386)

Given the use of fetal imagery in the abortion debate, Phillips is provoking the audience for their perceptions and opinions. She is deliberately trying to upset the association of the female body with pregnancy as well the relationship of the pregnant body to the foetus. In some instances, such as in pro-life documents, the foetus is given more privilege than the pregnant woman. Rather than discussing the experience of the pregnant woman, the manipulated image of the foetus is prioritized. Different modes of "foetal iconography" (Smyth 27) have perpetuated the postfeminist privilege of reproduction.[16] However, feminist discourses may see representations of the foetus as separate from representations of motherhood. As Phelan implies, the foetus becomes a separate entity from which the mother is invisible. Rather than perpetuating motherhood, foetal iconography alienates and detaches the woman from the unborn child. Phelan argues that detached from the pregnant woman, "the fetal form has become a sign that is already powerfully implicated in the political economy of capitalism and patriarchy" (387). Through the use of foetal iconography

[16] Referring to a "postfeminist lifecycle," Diane Negra argues that mainstream popular culture "frequently equates motherhood with full womanhood" and "pregnancy becomes 'exemplary time' when women look, feel, and are their best" (63). She describes how the pregnant female body has "lost its taboo status and is being subject to new forms of fetishization and eroticization" (Negra 63).

Phillips disassociates her body from all reproductive visibility. She distinguishes her performing female body as separate from the female body associated with womanhood and motherhood. Whilst the focus on the foetus and fetal imagery may be important to invoking support for pro-life lobbies, Phillips returns focus to the grotesque female body devoid of all association with motherhood. She defends a woman's right to responsibility and ownership of her body which is often unfairly discredited and undermined by pro-life campaigns.

Foetus imagery is powerful and controversial hence why it has been adopted by many pro-life campaigners. In Ireland pro-life groups such as Youth Defence operate many well-funded campaigns and protests to invoke tensions surrounding abortion. In their use of intense campaign advertisements these groups use foetus imagery to intimidate and/or educate people about abortion. Often these images are grotesque, invoking disgust amongst those who witness them. Describing the use of images of the foetus in such campaigns Phelan argues, "[t]he innocent image works to induce sympathy and protection while the mutilated one is a call for outrage and outrageous action" (386). Whilst pro-life groups may use fetal imagery to guilt women out of proceeding with terminations, Phillips' use of fetal imagery is defiant. Her defiance and lack of shame are evident in the performance's poem-like texts which deal "with the subjective experience of maternal loss." The emphasis on the subjective implies Phillips' acute certainty and acceptance of her personal feelings. Her tone is also humorous as she describes the cake as being "delicious!" There is no sense of regret as Phillips takes responsibility for her actions although her humour may be initially mistaken for flippancy. The artist's personal experience informs the understanding of S*ex, birth & death* with Phillips attempting to discourage the audience from developing empathy and sympathy for her. By offering her audience a piece of the foetus cake, Phillips attempts to turn her audience into actors who are in collusion with the "morally corrupt" abortionists. By taking a piece of foetus cake, the audience are as culpable as Phillips.

Martyrdom and the Destabilization of the Female Body in *Harness*

In addition to *Sex, birth and death*, *Harness* conveys the complexity of womanhood through the depiction of Phillips' experiences and familial relationships. *Harness* is a twenty-minute "narrative re-enactment" of Phillips' experience growing up with a brain-damaged brother as well as the experience of her daughter who was born with dislocated hips

(Phillips, "*Harness* 2007-2011"). In this work Phillips wishes to "show the vulnerability of wholeness, the purpose of love & union in extreme human experience and how the personal becomes political" ("*Harness* 2007-2011"). Whilst the performance concentrates on the realization of the physical and emotional constraints her brother and daughter experienced as an effect of their disability, the performance also gives visibility to Phillips' experience of mother-daughter relationships. Through the representation of disability and family relationships, Phillips destabilizes the human (female) body and maternal identities.

In *Harness*, Phillips avoids the fetishization of postfeminist motherhood and femininity by drawing attention to the difficulties of motherhood as well as the limitations of the human body. Where postfeminist motherhood presents the "exhibitionist terms of pregnancy" and the "pregnant (white) woman's current position as the exemplar of idealized femininity" (Negra 63), Phillips presents an alternative, problematic maternal and feminine identity. She deglamorizes the role of woman as mother and instead presents her and her daughter's body as fragile and vulnerable. Phillips describes her performance in *Harness* as follows:

> The duration of the piece is 20 minutes and I use a series of actions and gestures derived from my own life (I sit up on a 'potty' chair, a commode chair that is modified with an incandescent neon tube. I wash my eyes 'to clean what I have seen ...'. I strap myself into a harness, a replica of the one my daughter wore). A video piece plays for the duration, showing a climb I made in the summer of 2006 up the famous pilgrimage mountain Croagh Patrick 'The Reek' in Mayo. In this arduous ascent I am accompanied by the same daughter (of the harness) and we both disappear into a white mist at the summit. A soft, haunting sound track is played behind my spoken delivery (of the script), it is the very elongated, slowed down resonance of a glass shattering. ("*Harness* 2007-2011")

Wearing the blue uniform of a nurse, Phillips adopts a personification of womanhood through the role as a nurse. As a nurse she becomes someone who looks after the ill and vulnerable, drawing parallels with traditional representations of women and mothers as feminized caregivers and nurturers. Despite being critical of Catholic ideologies, Phillips uses the religious imagery of the holy mountain to invoke a sense of martyrdom and the virginal qualities of the Irish mother. She uses the juxtaposition of the video recording and her live performance to contrast the images of the woman as the caring, innocent mother and woman as martyr. Speaking against the video

recording whilst the image of the mountain ascent plays, Phillips says, "I am my own self at twenty one; a care nurse on a locked ward of vivid human creatures" (Phillips, *Live Autobiography*). She demonstrates the difficulties of motherhood through the representation of her mental and physical exhaustion as depicted in the wearing of the harness and the arduous ascent on the holy mountain. Despite adopting the caring maternal role, Phillips again disrupts the postfeminist envision of perfected maternity, femininity and womanhood.[17] Referring to her daughter she says, "I am my own child who is born and five days later is strapped into traction for the sake of completion, for the sake of non-injury and repair, for the sake of restoration and return, for the sake of lavishment of love, for the sake of climbing a holy mountain" (Phillips, *Live Autobiography*). Wearing a harness allows Phillips to share the burden of her daughter's pain and physical disability. Sitting in the potty chair, Phillips is humiliated as she adopts an imperfect body which is often critiqued in postfeminist culture. The declarations of, "My existence is disability; the way you know ability" (Phillips, *Live Autobiography*) imply the monotony and constant agony of living with a physical disability. These performed inner thoughts demonstrate the raw emotions of Phillips, highlighting her own imperfections and feelings of personal guilt as she cannot otherwise alleviate her daughter's discomfort.

Harness allows Phillips to question her relationship to her mother and daughter as well as her own experience as a mother. Here there are echoes of *Sex, birth & death* with her melancholic reminiscing of a failed/passed upon motherhood. The mountain in the video installation reveals an aspiration to personal and emotional betterment. In the audio recording we hear Phillips say, "I keep thinking of meeting my mother, at the top of the mountain, of my own daughter becoming me, of me becoming my own mother and of meeting myself" (Phillips, *Live Autobiography*). *Harness* is a radical performance in how it addresses the stigma of disability as well as reflecting on female identity and female relationships. Phillips destabilizes her own emotions and utilizes her personal experiences to inform her work. By doing this she confronts social stigmas creating a visceral and emotive experience for the audience.

[17] Diane Negra discusses the "fetishization and eroticization of pregnancy" (63) as well as the "postfeminist celebration of mothering" in the media whereby motherhood "redeems," "transforms," "enriches," and "elevates" (65).

Asylums and Female Punishment in *Redress: Emotional Labour*

In *Redress: Emotional Labour* Phillips uses religious imagery to reflect the virginal ideals of Irish motherhood. Despite the Irish State upholding the importance of a woman's role within the home and as Mother, the State constitution disregarded the role or existence of unmarried mothers. The Irish State ignored many destitute women and instead left them to punishment and penance by religious orders. Conservative attitudes in Ireland and elsewhere implied that any sexual act was to be confined to the marital bed; hence women who had children out of wedlock were stigmatized. Motherhood was "overtly idealized and venerated in its social and religious aspects, but also ruthlessly demonized if it occurred outside the legalities and control of church and state" (Meaney 10). The Irish Catholic values of chastity, celibacy and virginity were held in such impossible esteem that it would be difficult for any unmarried woman to be respected. Gerardine Meaney discusses the "derealization of motherhood in the ideology of the southern Irish state, the often-violent rejection and repression of the maternal body as such and the extent to which that body became a spectre, haunting national consciousness" (10). In *Emotional Labour*, Phillips brings to life the spectres of the Magdalene women whose stories and experiences have been ignored by the historical narratives of the Irish State and culpable religious orders.

Labour is an important example of radical contemporary performance in Ireland today. Not only does it incorporate the talents of multiple female performance artists, but it deals specifically with the female experience. Irish (female) performance art is at odds with the theatrical Irish canon and the "dramatic tradition of almost exclusively male playwrights" (Sihra 9). Melissa Sihra argues that it is important to consider the "ways in which canon-formation enables an implicit set of cultural norms and standards to materialize, which perpetuate hegemonic structures, and which are based upon historically contingent values" (9). *Labour* offers an alternative to these hegemonic historical and theatrical structures. The *Labour* exhibition formed the second part of a two-day event at The LAB (Dublin) for International Women's Day in March 2012, and subsequently toured to London and Derry. *Labour* was an inherently political performance which incorporated the energies of eleven Irish based female artists, namely: Phillips; Michelle Browne; Chrissie Cadman; Amanda Coogan; Pauline Cummins; Ann Maria Healy; Frances Mezzeti; Áine O'Dwyer; Anne Quail; Elvira

Santamaria Torres; and Helena Walsh. The artists performed over an eight-hour period with each performance referencing separate interpretations of women's work and labour. The eight-hour duration was to mark the average working day for women. In *Labour* the artists use their bodies to physically illustrate the pain and endurance of women's work and labour. The audience do not witness the image of the dutiful, domestic housewife but rather the reality of stress, monotony, and the difficulty of work within a suggested industrial and domestic frame. The performances of Chrissie Cadman and Michelle Browne exemplify how *Labour* physically illustrated women's work. Cadman's performance, *World's End Lane*, was one of the most physically demanding as she spent the entirety of the performance outside lathering and washing the exterior windows of The LAB. Browne's performance *The Grace of God* acknowledged the work carried out by women in the Magdalene laundries as she silently made small navy pinafores with the use of an old sewing machine.

Like Michelle Browne, Phillips also drew inspiration from the Magdalene laundries for her performance. The performance draws on the experiences of women who were formally incarcerated in the Magdalene laundries/asylums in Ireland. Whilst it may be believed that the Irish State martyred the "woman as mother," unmarried mothers and their illegitimate children faced indiscriminate abuse and stigmatization both at the hands of the Irish State and Church. The Magdalene asylums were conceived to deal with the unwanted visibility of unmarried women and illegitimate children. They became a place for ostensibly uncouth women, a place of punishment and penance run by religious orders. James M. Smith discusses how the Irish Free State worked with the Catholic hierarchy to establish a "two-tiered, institutional response to the 'problem' of the unmarried mother and her illegitimate child" (48). For Smith this institutional system was conceived so as to "effect absolute segregation between two classes of fallen women–those deemed 'first offenders' and thus open to spiritual reclamation and those deemed 'hopeless cases' and perceived as sources of moral contagion" (48). Within *Emotional Labour*, Phillips attempts to personify both these types of "fallen" woman.

Like other contemporary performances such as ANU's *Laundry*, *Emotional Labour* engages with the experience of women in the Magdalene asylums. Both performances attempt to raise consciousness of the unjust experiences of women in the laundries. Justice for Magdalenes (JFM) is a survivor advocacy group who campaign for the State and Church to accept responsibility for what happened to women

within the Magdalene asylums. JFM seek to promote and represent the "interests of the Magdalene women"; "respectfully promote equality and seek justice for the women formerly incarcerated"; as well as seek the "establishment and improvements of support as well as advisory and re-integration services provided for survivors" ("About Justice for Magdalenes"). In their political campaign, JFM had two main objectives: to bring about an official apology from the Irish State and establish a compensation scheme for all Magdalene survivors ("Press Release," 17 May 2013). JFM's decision to end their political campaign in May 2013 was as a result of the Irish State's apology and agreement to a compensation scheme for the Magdalene women. On 19th February 2013, Taoiseach Enda Kenny officially apologized and acknowledged the State's involvement in incarcerating women to Magdalene asylums:

> Therefore, I, as Taoiseach, on behalf of the State, the government and our citizens deeply regret and apologise unreservedly to all those women for the hurt that was done to them, and for any stigma they suffered, as a result of the time they spent in a Magdalene Laundry. (Houses of the Oireachtas, "Statements on the Magdalene Laundries report")

The Taoiseach appeared to be emotionally moved towards the end of his statement but his apology is still greeted with much scepticism. Although it is more than a year since this apology and since plans for a redress scheme, no payments have been made. The Report of the Inter-Departmental Committee to establish the facts of State involvement with the Magdalene Laundries (more widely referred to as the McAleese Report) sought to "establish the facts of State involvement with the Magdalene Laundries" (*Department of Justice and Equality* 1). The report has been criticized by JFM who refute "the government's most recent assertion that the McAleese Report is 'a comprehensive and objective report of the factual position' and that it establishes 'the facts of the Magdalene Laundries'" ("Press Release," 28. Nov. 2013). They also highlight how the Report "offers a narrative–partial and incomplete–of State involvement only" ("Press Release," 28. Nov. 2013). One of the major issues of contention is that the testimonies of women incarcerated in the laundries have been omitted from the report and ignored as a source of primary evidence, being referred to instead as "stories." Although Phillips' performance took place a year before the Government apology and publishing of the McAleese Report, the performance still resonates and highlights the injustice and silencing of Magdalene women. Unlike the McAleese Report, Phillips uses firsthand

accounts of women's experiences in the laundries demonstrating her empathy for the incarcerated and forgotten women.

The *Labour* programme acknowledges the relationship and impact of the laundries on Phillips' performance stating: "At the centre of women's history in Ireland are the notorious Magdalene Laundries where countless women were confined up to 1996 and subjected to unpaid hard labour for the crimes of unmarried pregnancy, being in moral danger or precocity" (Barrett and Coogan, *Labour: A Live Exhibition*). The programme describes how Phillips always felt she would have ended up in a Magdalene Laundry if she had been "born some years earlier." Phillips' imagined incarceration is alluded to through her choice of white pinafore (similar perhaps to the grey pinafores worn by women in the laundries), and later the black fishing net in which she is entangled. Attached to her white pinafore dress is a small speaker. Barely audible Phillips relays women's experiences of the Magdalene laundries. She states:

> In this work, I aim to retrieve the discarded and disregarded stories from women on whom silence had been imposed. In the performance I carry their stories on my body in the form of vocal recordings made from Evelyn Glynn's compilations of the testimonies of Magdalene laundry survivors of Limerick's Good Shepherd Laundry. The recordings play from a hidden speaker under my dress: the listener must come close to hear. My dress is 'speaking' the narratives that have been suppressed in our culture and history. (Phillips, "*Emotional Labour* 2012")

Phillips actively approaches spectators so as to share the unheard stories of the Magdalene women. As she crawled towards spectators, she would stop and touch an item of their clothing so to create an intimate connection. The close proximity forced the spectator to lean towards Phillips and listen to the whispered vocal recordings of the histories of the women. The performance was a public and shared experience for the audience and performers. The spectator was offered a moment of reflection and shared compassion with the artist as together they shared the experience of listening to the Magdalene women's experiences.

Emotional Labour is divided into two distinct sections marked by Phillips changing from an outfit of pristine white to black. Phillips' white dress suggests a virginal innocence and purity whilst her hair is kept in a neat up-do. The white dress may draw on the symbolism of the Catholic Sacraments such as baptism, the Eucharist and matrimony whereby babies are dressed in white on their baptism; girls wear white

dresses for their First Holy Communion; and brides traditionally wear white on their wedding day. Over the eight hour duration, Phillips tars her dress with black polish. She initially appears ethereal, moving slowly throughout the gallery space, however as she begins to slowly soil her white dress, she deliberately destroys the virginal imagery. In one moment, Phillips stands silently holding her hands as if in prayer thus creating an image reminiscent of the Madonna. She purposely seeks to disturb multiple popular representations of Irish culture and identity. Phillips wears hard Irish jig shoes which have had glass inserted into the soles. These force her to drag herself and crawl along the floor. The movements have similarities to a child learning to crawl but they also insinuate something more primitive and animalistic. Considering the international popularity of Riverdance, jig shoes and Irish dancing are synonymous with Irish culture. Phillips is aware of the international fetishization of Irish culture and traditions and so seeks to undermine it with her grotesque embodiments of Irish femininity and womanhood.

Conclusion

Phillips draws attention to issues concerning the right to reproductive choice, freedom and control in Ireland whilst also critiquing the ways in which the Irish State continues to dictate and shame the reproductive female body. She plays with religious imagery to undermine the concept of the Irish Madonna and satirizes Catholic morality. She creates a visceral experience which sometimes shocks her spectators but at other times allows them to develop empathy and compassion for both herself and those such as the Magdalene women who had otherwise lost their voices. *Sex, birth & death* addresses the issue of reproductive control, abortion and motherhood; *Harness* realizes non-normative femininities, female relationships and the stigma of disability; and *Emotional Labour* draws on the experiences of the unseen and untold stories of women formerly incarcerated in the Magdalene Laundries. The performances realize the Irish fetishization of womanhood and Phillips' rejection of this ideal. Phillips' performances confront and provoke the spectator to think about the State and society's culpability regarding the treatment and internment of women in Ireland today. The performances force the spectator to think about their own embodiment and attitude to womanhood, motherhood and femininity. Considering the changes to the Irish State's legislation surrounding abortion laws and the Taoiseach's apology to Magdalene survivors, it remains to be seen what the wider connotations and impact will be for

the rest of Irish society. Regardless, artists such as Phillips will continue to create radical performance works which interrogate and undermine national stereotypes of womanhood.

Works Cited

"About Justice for Magdalenes." *Justice for Magdalenes*. Web. 23 Nov. 2012.

---."Press Release: Justice for Magdalenes to end its political campaign." 17 May 2013. Web. 30 May 2013.

---. "Press Release: JFM Research welcomes UNCAT list of issues, citing grave concerns about Magdalene Scheme." 28 Nov. 2013. Web. 19 Jan. 2014.

An Coinbhinsiún ar an mBunreacht: The Convention on the Constitution. *Second Report of the Convention on the Constitution*. May 2013. Web. 16 Jan. 2014.

Balsamo, Anne. *Technologies of the Gendered Body: Reading Cyborg Women*. Durham and London: Duke UP, 1997. Print.

Barrett, Sheena, and Amanda Coogan, eds. *Labour: A Live Exhibition*. Dublin: Dublin City Arts Office/the LAB, 2012. Print.

Bunreacht na hÉireann: Constitution of Ireland. Dublin: The Stationary Office, 2012. Print.

De Beauvoir, Simone, *The Second Sex*. Trans. Constance Borde and Shelia Malovany Chevallier. London: Vintage, 2010. Print.

Department of Justice and Equality. "Report of the Inter-Departmental Committee to establish the facts of State involvement with the Magdalene Laundries: Executive Summary." 5 Feb. 2013. Web. 19 Jan. 2014.

Finnegan, Frances. *Do Penance or Perish: Magdalene Asylums in Ireland*. Oxford: Oxford UP, 2001. Print.

Frueh, Joanna. "'Feminism' (1989)." *Feminism-Art-Theory: An Anthology 1968-2000*. Ed. Hilary Robinson. Oxford: Blackwell, 2001. 578-84. Print.

Gill, Rosalind. "Postfeminist media culture: Elements of a sensibility." *European Journal of Cultural Studies* 10.2 (2007): 147-66. Print.

Gillis, Stacy, and Joanne Hollows. "Introduction." *Feminism, Domesticity and Popular Culture*. Ed. Stacy Gillis and Joanne Hollows. New York and London: Routledge, 2009. 1-14. Print.

Glynn, Evelyn, and Áine Phillips. "Live Art Symposium: Evelyn Glynn & Aine Phillips presentation." *Vimeo*. 9 March 2012. Web. 15 May 2012.

Houses of the Oireachtas: Tithe an Oireachtais. "Statements on the Magdalene Laundries report." 19 Feb. 2013. Web. 5 March 2013.

"In full: Enda Kenny's State apology to the Magdalene women." *TheJournal.ie*. 19 Feb. 2013. Web. 5 March 2013.

Longhurst, Robyn. *Maternities: Gender, Bodies and Space*. New York and London: Routledge, 2008. Print.

Meaney, Gerardine. *Gender, Ireland, and Cultural Change: Race, Sex, and Nation*. New York and London: Routledge, 2011. Print.

Negra, Diane. *What a Girl Wants?: Fantasizing the Reclamation of Self in Postfeminism*. London and New York: Routledge, 2009. Print.

Phelan, Peggy. "White Men and Pregnancy: Discovering the Body to Be Rescued." *Acting Out: Feminist Performances*. Ed. Peggy Phelan and Lynda Hart. Ann Arbor: The U of Michigan P, 1993. 383-401. Print.

Phillips, Áine. "*Emotional Labour* 2012." *Áine Phillips*. Web. 18 Oct. 2013.

---. "*Harness* 2007-2011." *Áine Phillips*. Web. 28 May 2013.

---. "*Sex, Birth & Death* 2003." *Áine Phillips*. Web. 23 Feb. 2012.

Phillips, Áine, perf. *Live Autobiography*. Live Art Development Agency, 2010. DVD.

Protection of Life During Pregnancy Act. 30 July 2013. Web. 16 Jan. 2014.

Reid, Matthew C., and Grant Gillett. "The case of Medea—a view of fetal-maternal conflict." *Journal of Medical Ethics* 23 (1997): 19-25. Print.

Sihra, Melissa. "Introduction: Figures at the Window." *Women in Irish Drama: A Century of Authorship and Representation*. Ed. Melissa Sihra. Hampshire: Palgrave Macmillan, 2007. 1-22. Print.

Smith, James M. Ireland's Magdalen Laundries and the Nation's Architecture of Containment. Manchester: Manchester UP, 2007. Print.

Smyth, Lisa. Abortion and Nation: The Politics of Reproduction in Contemporary Ireland. Aldershot: Ashgate, 2005. Print.

Suchman, Lucy. "Subject objects." *Feminist Theory* 12.2 (2011): 119-45. Print.

"Tánaiste seeks 'clarity' on abortion after Savita's death." *The Irish Times*. 15 Nov. 2012. Web. 18 Nov. 2012.

Tyler, Imogen. "Against abjection." *Feminist Theory* 10.1 (2009): 77-98. Print.

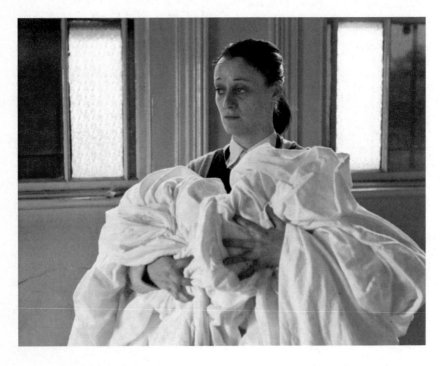

Fig. 1 *Laundry* (2011) by ANU. Image by visual artist Owen Boss courtesy of ANU. Performer: Laura Murray.

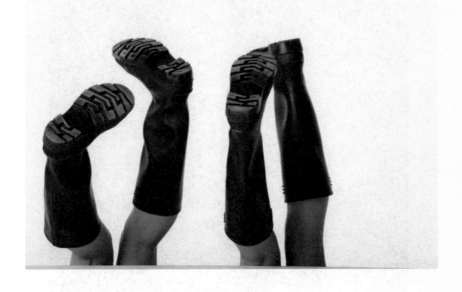

Fig. 2 *The Rain Party* (2007). Image by Fionn McCann. Jessica Kennedy, Megan Kennedy.

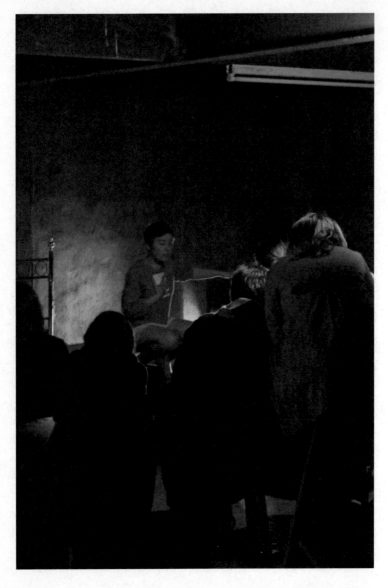

Fig. 3 *In My Bed*. The Shed, Temple Bar, Dublin Fringe Festival.
September 2011. Image by Marlijn Gelsing.
Image reproduced by kind permission of the artist.

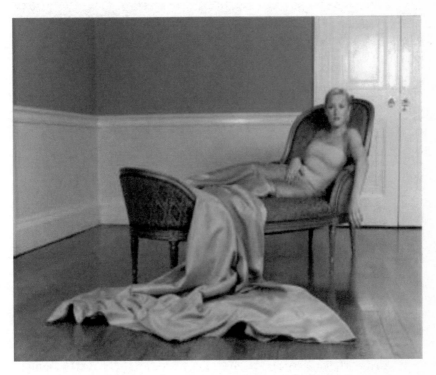

Fig. 4 *Medea* (2001). Courtesy of Amanda Coogan.

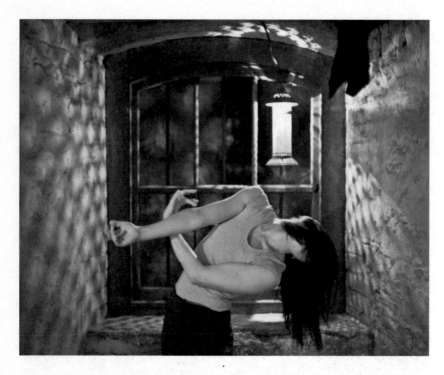

5: *Bird with boy* (2011). Image by Luca Truffarelli. Liv O'Donoghue.

Fig. 6 *Dusk Ahead* (2013). Image by Luca Truffarelli. Zoe Reardon, Jaiotz Osa, Miguel do Vale, Ramona Nagabczynska, Ryan O'Neill.

Fig. 7 Project Arts' Beckett's *Ghosts*, by kind permission of Ros Kavanagh.

Fig. 8 *Laundry* (2011) by ANU. The former Magdalene Laundry where *Laundry* was staged on Lower Seán McDermott Street, Dublin, 16 February 2012. Photograph supplied by Miriam Haughton.

Fig. 9: *The Fountain* (2001). Courtesy of Amanda Coogan.

10: *all that signified me...* Project Arts Centre, Dublin, January 2013.
Image by Naomi Goodman, reproduced by kind permission of the artist.

6 | "We Will Be Seen": Documenting Queer Womanhood in Amy Conroy's *I (Heart) Alice (Heart) I*

Samuel Yates

Amy Conroy's *I (Heart) Alice (Heart) I*, a dialogue with two married middle-aged women in their modest Dublin home, was conceived as an intimate comedy. Once Conroy began to develop the piece, however, the production's roots quickly took hold as a documentary-style play. Conroy felt traditional dramatic modes would be a "false frame" for portraying the show's protagonists, Alice Slattery and Alice Kinsella, so she conducted interviews and sourced material from her own life to widen the narrative focus beyond the conventional LGBTQ politics and examine a more quotidian existence for queer women in Ireland. *I (Heart) Alice (Heart) I* debuted in the 2010 ABSOLUT Fringe Festival, picking up two Fringe awards as well as the Fishamble New Writing Award. It was subsequently remounted for Irish audiences in the 2011 ReViewd series for the Dublin Theatre Festival, as well as the Spring 2012 tour beginning on the Abbey's Peacock Stage; that tour included an engagement at the Irish Arts Centre in New York City. In February 2013 *Alice* toured Australia with engagements at the World Theatre Festival in Brisbane, the Auckland Arts Festival, and the Ten Days on the Island of Tasmania series. *Alice*'s positive reception and multiple engagements is a testament to the play's skillful navigation of the oft-invisible reality of queer Irish women.

Theatre has the unique capacity to reshape history by illuminating the unseen in real-time shared space and, by doing so, generates audience empathy and social commentary. Conroy's explicit rejection of the literary tradition of canonical writers such as Yeats, O'Casey, and

Synge as an inadequate framework for queer women begs inquiry into her framing choices, as her artistic process intentionally counters the assumptive heteronormativity in traditional Irish drama (Conroy, Personal Interview). In *Alice*, Conroy challenges the conventional Irish canon and the socio-cultural mores and norms it embodies, and moves beyond more contemporary artists like Emma Donoghue, who explores lesbianism and female persuasion in *I Know My Own Heart* (2001). Slattery and Kinsella detail the mundane and extraordinary of their lives and, in doing so, demonstrate the heterosexual/homosexual binary coded into everyday social functions. By attending to their outings for groceries or feelings of exclusion from religious spaces, audiences become the curious public about which the Alices speak; safe in the anonymity of a darkened theatre, spectators are free to take in–or stare at–the women. This invitation to judgement would not be radically different from other documentary or fictional plays, if these women were indeed plainly real or fictionalized.

Thus, the historical and cultural problem surrounding the publication becomes, what is the appropriate way of representing *Alice* as a fictional or factual account? And, for audiences, this is also a problem of collective subject formation: how does our approach to, and use of, the story of these women transform our relationship to the material? By considering how the portrayal and performance of Alice Slattery and Alice Kinsella is managed in *Alice*, the artistic choices structuring the production allow us to more freely consider what the role the play itself is made to enact–as a composite historical narrative, as a piece of activism, as art–for contemporary audiences. The effort of this paper, then, is to think through how *I (Heart) Alice (Heart) I* frames queer Irish women as a piece of art and social commentary. I specifically want to explore how the play apes elements of documentary theatre that situate the work as "authentic" in a manner that downplays its fictional theatricality to service a wider commentary on reconciling queerness with Catholicism.

"Framed by deliberations on authenticity," documentary theatre productions advance the long-established project of interrogating identity politics through theatre (Butler 97). Although I borrow language from Judith Butler's meditation on the media representation of war, the issue of authenticity is at the forefront of Conroy's artistic practice. Rather than the necessary definition and reinforcement of a central and cohesive personal (or national) identity, Conroy's theatrical performances open space for the public's acknowledgment and discussion on alternative modes of sociality and personal identification.

Tropes of documentary theatre serve as a natural evolution for a dramatic custom that has, as Susan Cannon Harris notes, "traditionally been one area in which public battles [... of] culture have been fought" (3). Conroy calls attention to these battles primarily in context of the status of gender and sexuality in a similar way to Harris, but it is important to note that the material sourced from actual persons is not directly translated onstage in *Alice*. The fictionalization of the material challenges the stereotypical frame that has come to serve as the footing, if not for practiced documentary performance, then certainly for its language of authenticity.

A scholar of documentary theatre such as Janelle Rienelt maintains that "public life's theatricalization is no longer a contested issue," and although *Alice* does not utilize many of the structural trappings of documentary drama its rhetoric on performance is helpful (28). Understanding the conception of performance as an unreal or an artificial that helps audiences process contemporary public life, Reinelt lays the groundwork for theatre's capacity to "[create] a new real, making manifest the real, embodying the real within the realm of images and sensation as well as the realm of discursivity" (71), and as Rokem points out, performing versions of "history" enables us to "overcome both the separation and the exclusion from the past, and create a community where the events from this past will matter again" (xii). The invisibility of queer women, arguably, never ceased to "matter" in contemporary history since their plight has been at the forefront of international LGBTQ efforts, but the expansion of their narratives into the Irish imaginary via *Alice* creates a new relationship between the women Conroy imagines and the present historical moment.

Fictionalizing Documentary Theatre

Standing at the edge of the stage, wringing hands and sharing nervous glances, two Alices share their innermost fear–and greatest joy–of participating in Amy Conroy's *I (Heart) Alice (Heart) I*: "We will be seen" (8). This simple statement is the binary that strikes at the heart of all queer performance, the fear of "coming out" to an unreceptive public. Alice Kinsella, who has lived almost all her adult life as a self-identifying lesbian, describes the end-result of her *Alice* performance as "a testimonial" (9). Alice Slattery, an over-cautious widow who has only experienced same-sex attraction to Kinsella, calls the project "dangerous" (9). The gulf between these two viewpoints makes the central issue plain: there is too much ground, too many aspects of the

Alices' lives inextricably linked to their relationship and sexuality, to cover with a guise of subscription to heteronormative culture. Slattery knows this, even as she attempts to maintain appearances, saying, "People don't see the life I've lived … They just see an unassuming older lady. Well, I don't like scones, and I don't drink tea. I wonder would that shock them?" (10). She is acutely aware of her paradoxical identity, feeling uncomfortable showing public displays of affection or attending Pride parades, even as she knows that she must expand her personal boundaries to achieve the requisite social visibility needed to establish placement in mainstream society.

Queerness itself is not the emotional or intellectual focal point in Conroy's work, but it is the cornerstone experience upon which *Alice* was created. As the first production for Conroy's theatre company, HotForTheatre, *Alice* can be seen as a guide to the artistic director's personal aesthetic. Established in 2010, HotForTheatre operates under the tagline "Big, Bold, Edgy," and markets that "theatre should provoke, move and delight in equal measure" ("About HotForTheatre"). This provocation upends eroticism and plays with the sexual preferences of both the company members and audiences by indicating their arousal (or being "Hot") as a result of participating in theatre. In its displacing normative sexual objects for art, the company queers all participants by bringing them into the fold of a social Other–if only for a few hours. Although the company's later successes, *Eternal Rising of the Sun* (2011) and *Break* (2013), eschew central narrative arcs explicitly linked to sexuality, Conroy's HotForTheatre productions continue to queer everyday life by denaturalizing the familiar onstage. Attempts to distance herself from *queer* or *gay* labels only take Conroy so far, as the playwright made a conscious choice to portray a queer couple within the documentary genre with *Alice*, citing visibility for "real" people as a driving impetus for the creation of her work.

Conroy's emphasis on authenticity shares a common concern of documentary theatre practices: a presentation of balance within the narrative. The documentary genre has long been associated with queer performance as the latter has strong roots in boundary-pushing presentations of non-fictions; such work manifests in a multitude of forms, including multimedia integration, found texts, and personal storytelling. *Alice*'s script epitomizes this style through the stringing together of a series of memories connected by interrelated dialogue. Bearing witness to a kaleidoscope of personal experiences, one cannot overlook the presumed redaction of personal memories that comprise a final performance, giving rise to concerns of narratorial veracity.

Slattery and Kinsella are supported reliable characters through their presentation as a pair. Having two actors onstage allows the audience the benefit of receiving accurate, detailed, alternative information about each character from her scene partner, and also prevents the development of an overly skewed or falsified worldview given by unreliable narrators.

In *Alice*, this device is obvious. Alice Slattery and Alice Kinsella, set opposite each other, deliver a rapid-fire list of intimate and ordinary details from their daily lives:

> A KINSELLA. She tuts when people drop litter. *(A Slattery tuts)*
> A SLATTERY. She expects people to move out of her way.
> A KINSELLA. I often say 'ahh that's bass.'
> A SLATTERY. I watch Nationwide and think Michael Ryan is handsome. (3)

By not shying away from these small and potentially embarrassing facts, the audience comes to understand that these are women largely unworried about presenting pristine portrayals of themselves. Their delivery of mundane information in such a casual repartee builds rapport with the audience, generating openness and trustworthiness with the performers onstage. More important, however, is that the ripostes the Alices exchange clearly convey that neither Alice will allow the other to lie to the audience; each acts as both conscience and counterbalance to the other. It was Conroy's "immense intention" to present an evenhanded piece, so her writing process took into consideration that "every character had to be balanced on her own, they had to balance each other, [and] the Alices' journey had to balance on both their start point and their end-point" (Conroy, Personal Interview).

Alice presents a complex case study in the revelation of a social void regarding queerness and interrogates the link between representational visibility and power for dramatic representations of "coming out" by playing off conflicting elements of the LGBTQ narrative: the intimate experience of personal identity and feelings of public dissent, joined with a need to express one's disparate position. In doing so, the play illustrates an experience of queer womanhood in Irish society and its success demonstrates how a repressed position can gain social currency with audiences through performance media. For Conroy, troubling the perception of "real" people onstage gives unparalleled precedence to the contestation of gender identities in public forums.

Conroy "never doubted the power of documentary theatre," as it lets the artist choose the limits of her own boundaries, much like the Alices'

own decision to participate in *Alice*. Even so, her work is balanced by severe reservations about using the documentary form to reveal intimate aspects of the self, given that the work can fail if not approached for the "right reasons" (Conroy, Personal Interview). Citing experiences of watching documentary theatre with non-performers baring their souls in service of the directing artists rather than for themselves, Conroy began writing *Alice* to challenge perceptions and uses of the documentary genre. *Alice* stands apart in its attempt to convince audiences that the performers–the Alices–are real women that Conroy happened to see kiss in a grocery store. In reality they are two actors, one being Conroy herself. The production notes establish this frame clearly, articulating, "The show is fictional but presented as a documentary piece. Both of the 'Alices' have been working with the director for nearly a year ... They are not actors, so performing live is a huge challenge for them" (Conroy, *Alice* 2). Experiencing stage fright, the two Alices stutter, stammer, and stumble through their story, occasionally referencing a map on the back wall, to create an effect of untrained actors onstage.

While the device of "real" women delivering *Alice* is well played, the revelation of the Alices' true identities jeopardizes the audience's relationship with the women and their story. Having reached the end of the script, Alice Kinsella (Conroy herself) removes her wig and proclaims: "... thank you for sharing the journey of these remarkable women. Alice and Alice could not be here tonight ... because Alice and Alice are not real, but does that really matter? There are Alices out there, full of love, strength, courage and pride, so we don't believe we've misled you. What you feel, that's what's real" (27). Despite Conroy's insistence that the audience has not been "misled," *Alice*'s manipulation of reality complicates conceptions of authenticity within the documentary form. Here the playwright's intention is not to represent "truth" as such onstage, but instead elicit an authentic emotional reaction from the viewer. Displeasure with the deception is indexed in early reviews of the show that called the "reveal" of the Alices' identities as "confrontational" and "unnecessary," even though the play achieved critical and commercial success (Ní Chinnéide). These achievements, however, underscore the question of whether or not it matters that Slattery and Kinsella are *not* real, especially when situated alongside documentary pieces that chronicle lived events. Conroy's choice to unravel her constructed world literally queers the audiences' perceptions of their emotional investments, now made strange and foreign.

Crafted with a dedication to "duty" and "care" in Conroy's selection, judicious editing, and a small amount of purposed obfuscation, the ending paradigm of the play becomes the pinnacle of visibility through its very erasure (Conroy, Personal Interview). When the original script debuted in the 2010 Dublin Fringe, it contained a near-same version of Kinsella's final disclosure as detailed above. Conroy's description of this final speech as a "tag" reveals much about the playwright's own anxiety regarding its belonging in the script, and indeed, not every performance of *Alice* has explicitly revealed its conceit at the end (Conroy, Personal Interview). The tag remained during the production's autumn 2011 revival and Irish tour, and also through its February 2012 run on the Abbey's Peacock stage. Significantly, the decision to officially remove it from performances happened, not in Ireland, but in America during *Alice*'s residency at the New York City Irish Arts Centre (IAC) in March 2012. The New York ending was performed throughout the production's 2013 Australian tour. "Constantly in flux," the ending remains mutable as Conroy seeks "what best serves the piece, and serves the audience" (Interview). Admitting that she needed it during *Alice*'s first run because she "deliberately misled people to serve the piece," Conroy is now comfortable with the story itself doing the significant emotional work, ending the play with the Alices' kiss, "and then we leave it, and let people have it at that" (Interview). Such reasoning comes from the hope that the bracket that these women are *not* real is no longer necessary to critically engage with an audience. If the conceit becomes obvious and gratuitous then the erasure of the ending becomes necessary, as the queer protagonists of the play will have achieved the social visibility Conroy aimed to create. Despite this newfound confidence the tag technically still remains in the script, a conditional marker of the queer community's social advancement. Regardless, the tag locates *Alice* in a landscape of queer being that is, if not factually verbatim, emotionally accurate.

Reconciling Queerness and Catholicism

With elements of documentary theatre establishing rapport with the Alices, the play is able to engage audiences with Conroy's more contentious commentary on being a queer woman in Ireland. One sphere of Conroy's cultural exegesis is a refusal of peace with the Catholic Church; her characters self-authorize and comfort with a distinctly feminine, maternal resolve rather than seeking support within an institution inextricably linked to patriarchy, religion, and duty. For the theatremaker, "When you're Irish, and of a certain age,

the religious mindset is just a fabric of your being. It's never *not* been there" (Conroy, Personal Interview). Through the juxtaposition of religious participation and gender or sexual identification, Conroy underscores how Ireland's theatrical practices have historically assisted in the codification and reinforcement of Christian heteronormative ontology through notions of maleness and exertions of masculine power. Not only have these convictions hindered secular developments in Ireland's socio-cultural sphere, but they also have repressed the public expression of alternative modes of identity construction. We can see this violence enacted through the familiar tropes of family and nation that are built upon a patriarchal order ingrained in Irish culture through years of close affinity with Christianity. Thus, patriarchy, as Eamonn Jordan observes, "has both prescribed and fictionalized societal, gender, class and race relations, and it has also, to a considerable extent, fashioned and fabricated the dramaturgical practices of Irish theatre in term of how plays are written, programmed, directed, produced, marketed and consumed" ("Meta-Physicality"130). Conroy's pairing of lived experiences with theatrical performance not only asks what gender roles and sexual power have to do with discovering a contemporary national identity, but also how femininity and queerness might radically collude to offer viable alternatives to patriarchal Catholicism.

Rather than re-inscribing lines in the battle on intellectual inheritances between feminist and queer ideologies, we can see Conroy's style of cultural production as reconciling these traditions by drawing on her experiences as a woman and lesbian to critique society. In this way, *Alice* sits easily alongside work of activist scholars like Janice McLaughlin, who calls for a reconciliation of the radical separation between gender and sexuality argued for in the early nineties by Gayle Rubin, E.K. Sedgwick, and others (1-18). Despite the play's articulation of its leads as "real" women being a theatrical device and marketing coup, the queer sexuality performed in *Alice* undermines the "incommensurability between genetic and erotic logics [that] suggests that queerness ... and gender can never be brought into parallel alignment," as Michael Warner submits in his introduction to *Fear of a Queer Planet* (xvii). Inequities in sociopolitical status between queer-identifying persons and cis-gendered heterosexual individuals does not negate the linked nature of these categories in Ireland, nor does it diminish theatre's ability to demonstrate performances of queer identity as being parallel to, or greater than, formative social experiences defining expected gender associations. The queer project in

particular sets itself as speaking out against the current normative mode, whatever that is at the time; thus, queerness is paired with non-patriarchal lifestyles by circumstance, not nature. Under such reasoning, it is not difficult to imagine an inverse institutional structure, where women enjoy cultural dominance and heterosexual relationships are the queer Other.

By viewing the artistic project of *Alice* as an almost ethnographic documentation of queer life in Ireland, we are able to see the play perform the delicate work of bringing gender and sexuality towards each other, and situate these experiences alongside wider social institutions. Doing so allows us to look beyond Conroy's archival practices and reflect on what the recorded material reveals. *Alice* gives the documented lives of Kinsella and Slattery as a "true" record of experiences, demonstrating an array of ways in which queer people resolve their conflicted relationships with masculinity and find empowerment through their identification as queer, Other, non-normative. Refusing the social stereotypes and conditions fashioned in patriarchal conditions, this queerness is located in womanhood and the feminine. The protagonists of *Alice* consequently determine their own situation between a personal and social identity and, in doing so, find themselves in conflict over one of Ireland's predominant power structures–the Church.

Instead of finding comfort or support with a male religious system, the protagonists in *Alice* explore alternatives to the presupposed norm. *Alice* does not explicitly encroach upon ecclesiastical power, but instead takes up Warner's question, "What do we do with our [sexual] shame?" (*Normal* 3). As queer women, Kinsella and Slattery attempt to rid themselves of the sexual shame imposed on them by the very religious communities they seek entry to. Conroy, like Warner, seeks a positive, productive acknowledgment of personal identity, instead of hiding a supposed deviance. Furthermore, she pushes against the "antiquity of [hetero]sexual norms" blindly obeyed by society, and challenges a past "morality of patriarchs and clansmen, souped up with Christian hostility to the flesh ('our vile body,' Saint Paul called it)" (*Normal* 5). For Conroy, the body is a site of transgression, absolved by defining one's own relationship with religion and spirituality.

The Catholic Church's longstanding influence over Irish society's attitudes on gender and sexuality has garnered much attention in the past twenty years, particularly given the series of high profile debates on divorce referenda, the 2009 release of the Ryan Report, and abortion rights. Women and queers alike have thusly been viewed

through the prism of cultural Catholicism, but rarely are the two looked at in tandem, and almost never as a means of intervention towards the male enclosure of Christianity in Ireland. A notable exception to this is Michael Harding's *Sour Grapes* (1997), in which an aspiring priest named Peter tells the Virgin Mary, instead of the male Jesus or Father, his "secret" of loving men (8). Feeling betrayed by the male system that promised him guidance, he turns to the Virgin Mother, establishing femininity as a source of refuge and guidance for queers. Harding, alongside Friel's gay characters in *The Gentle Island* (1971) and McGuinness's *Observe the Sons of Ulster Marching Towards the Somme* (1985), anticipates Conroy's work by situating queerness against rigid conceptualizations of masculine identity. *Alice* demonstrates a refusal of religious patriarchy by reinforcing institutional constructions of manliness that are, as George Mosse writes, motors that "drive" the nation and society at large as "positive stereotypes" intended for emulation (3). Joseph Nugent similarly connects the praxis of this mode of thought as central to Ireland's national formation during the twentieth century, when mingling secular European models of manliness such as the warrior with moral templates necessary for guiding the aspirations of the Irish under the rubric of a distinctive cultural order (589-92).

Alice chronicles the fear and anger associated with the loss of a community place presumably bound foremost by faith in a higher power, God. The women depict two oppositional experiences of religion and a relationship with the divine—one devout, the other atheist—and both Alices struggle to reconcile their homosexuality with the Church. Cognizant that all handling of religious material is inherently personal, Conroy's characters acknowledge their disagreement in free discourse and, finding their positions irreconcilable, table the issue for love's sake. Kinsella, having acknowledged her lesbianism at an early age, comes to view religion as systemically "offensive" in its preclusion of queer acceptance by religious congregations. Slattery, in contrast, is a practicing Catholic who comes to their relationship as a widow from a Church-sanctioned marriage. Extending from these positions, we can view Kinsella as the queer-identifying person's way into the play and Slattery as the corresponding conduit for people subscribing to more heteronormative ideals. This construction speaks to the effort towards "balance" the playwright inlaid throughout the work and the also inescapable contention of religion. For Conroy every Irish person has to define their relationship with God and the Church because "[it's] never *not* been there," and indeed, "particularly when you're Irish ... the

religious mindset is just a fabric of your being" (Conroy, Personal Interview). The solution presented by the two Alices is not to "stop being gay" in a system that disallows their love, but rather, a finding "peace with that discord" (Conroy, Personal Interview).

Questions of belonging, above concerns of sin or morality, are the apex of the religious experience represented in *Alice*. Even as Conroy wrote Kinsella's religious criticisms to mirror her own, a "weird fascination and deep respect for people's faith" informed *Alice*. Drawn to "something about the rituality, the communality" of church-going experiences, Conroy's play operates from her belief that "[there's] something in that communality that is really beautiful and moving, based on what it *should* be. But religion isn't that" (Interview). Kinsella registers her disabuse of the community-building project of religious institutions in her refusal of the centerpiece of Catholic culture, the communion: "I refused to receive communion at a wedding, years ago. We didn't speak for about a week. I wasn't trying to upset her, I just ... I just couldn't do it any more. I couldn't pretend to go along with something that offends me for posterity's sake. I had just had enough" (14). Feeling the gesture to be empty, Kinsella marks her definitive split from the Church community not only as a disinclination toward participation to fulfill social expectations, but also as one that separates her from the multi-generational "posterity" of the Irish Catholic tradition. This sense of lost community is powerfully central to *Alice*'s representation of religion and Irish queerness, as Conroy herself was raised in a religious environment that left her not as much displaced as "*non*placed" (Conroy, Personal Interview). Entrenched in a narrowly specific cultural narrative, the trauma born from growing into a person no longer recognized within that system forces Kinsella "to eke out [her] own relationship with God [and] question everything, and work out [her] relationship with this entity, being, void, whatever, that society says won't accept [her] anyways" (7). When Kinsella speaks to the audience she underscores that "it's not God, but the church that I have a problem with" (Conroy 14). Her recognition that Slattery (here representing wider society) often conflates God and Church, a manmade institution, directly challenges audiences to reflect if these two facets of faith are intermingled in their own minds.

Hoping that audiences will see that "neither Alice is wrong in her approach, and no one is calling the audience a fool for their beliefs," Conroy wrote *Alice* to appeal to a broad cross-section of society and stymie the polemical divide religion and queerness often presents (Conroy, Personal Interview). Slattery's devout faith could easily be

rendered as a scapegoat against Kinsella's own convictions, but here it is used to underscore feelings of fear and guilt implicit to belonging in a religious group. Effectively problematizing the idea that queerness is inherently oppositional to Christianity, we see the fear that being "gay" casts the women out of their community. Slattery's admittance, "I was scared we were going to hell," lays out the extreme social ostracism– eternal damnation–and obliquely referencing the moral aspersions queers are subjected to (Conroy 18). Her aggrandizing worry is born from attempts to reconcile her personal experiences with a discordant social narrative. The Alices' fear of social excommunication is yoked with a sense of self-reproach for continually seeking entry into a system that denies admittance (or rather, offers it conditionally) and guilt for abandoning the institution in which they were raised. Despite Conroy's articulation of a specifically queer experience in *Alice*, the complex set of emotions she brings onstage are applicable to a broader experience of disillusionment with faith and religion in Ireland: "Then there's guilt for rejecting it, and not believing in God or participating in the Church, because deep down you feel like you should–it's how you were raised, it's in the fiber of your being" (Conroy, Personal Interview). This ongoing cycle of guilt is a routine that Slattery and Kinsella break from, and offer alternatives to, by retooling the ideas of religion that seem most apropos to their worldview.

Split on issues of faith as they are, Slattery and Kinsella proffer an imperfect solution for how to reconcile the beliefs on religion as queer women: material re-appropriation, self-respect, and silence. These three elements work in tandem to reconstitute the feelings of congregation and ritual that both Alices mark as important to a religious experience, bridging the chasm between their polar stances. Slattery takes the words of the Bible as authorization enough for her own lifestyle: "'Follow the way of love.' Corinthians Chapter 14, Verse 1. I've made peace with myself. I know God loves me, as I am" (Conroy, *Alice* 18). Her referencing a foundational text of Christianity in support of homosexuality impugns the systemic power of the Church, highlighting the hypocrisy of the conditional application of scripture to create dictums in contemporary culture. Furthermore, Slattery's selection of Corinthians 14:1 demonstrates a new confidence in her own self-worth. At peace with herself and her relationship with God, Slattery's contentment in her relationship with Kinsella negates the need for wider social acceptance outside of themselves. The two, then, constitute their own community, replete with their own unique observances. When Slattery goes to Church on Sunday mornings,

Kinsella does the morning's shopping. The Alices then have a "re-morning" after both have finished, repeating their Sunday morning household activities without acknowledging religion–a secular ritual to "bring [them] back together" (Conroy 14). Slattery and Kinsella's silence on the contentious topic removes religion from a discursive space in a similar way to the Church's own obviation of queerness; though it does not offer a progressive solution, it is necessary for their peaceful coexistence. By submitting this impasse for audience consideration Conroy disputes homogenous portraits of the devout Irish, laying the groundwork for the reappraisal and inclusion of subaltern lifestyles within a culturally Catholic society.

Conclusion

In the preceding pages I have attempted to demonstrate the strategies Conroy has employed towards creating a "dramaturgy of the real"; subverting heteronormative narratives through the documentation of queers onstage and refiguring the relationship that gender and sexual identities play in modern Ireland.[18] Finding strength in queerness and the feminine, Conroy archives a liberative potential against what fellow theatremaker Neil Watkins calls the "deep stain of years of Catholic conservative anti-pleasure fuck-uppery influencing [Ireland's] mindset" (qtd. in Shaw).

The limitations of this brief essay–particularly the focus on Dublin productions and narrative tools–leave much room for further inquiry. Issues such as the construction of a liminal physical performance space and the international reception of this work have gone unmentioned; the discussion would also benefit from positioning Conroy's subsequent work as a theatre maker in dialogue with *Alice*. These shortcomings notwithstanding, we can see *Alice* as a successful realization of an authentic experience of queerness in modern Ireland. Rather than understanding Conroy's work as a brazenly concrete resistance against popular social regimes, we should view *Alice* as a new position in the process of identity disclosure, subverting patriarchal norms within Irish social structures.

Carol Martin shows us that while postmodern assertions continually destabilize the idea of authenticity, "most people live guided by convictions what they believe to be true. It's this world–the world

[18] I borrow this apt phrase from Carol Martin's edited collection, *Dramaturgy of the Real on the World Stage*. Ed. Carol Martin. Basingstoke and New York: Palgrave Macmillan, 2009.

where truth is championed even as we experience our failure to ever know it with absolute finality–that theatre of the real attempts to stage" (3-4). Much like Todd Barry's consideration of how society might change if queerness were to ascend to the central interpretive lens of culture rather than that of heteronormativity, *Alice* questions how a queer vantage might be employed to re-imagine and heal fractures in Ireland's identity by its provision of an alternative narrative of belonging and personal identity (155). Such an understanding expands the boundaries of Irish theatre and society, as Martin articulates, by "[using the theatrical] frame not as a separation, but as a communion of the real and simulated; not as a separation, but as a distancing of fiction from nonfiction, but as a melding of the two" (2). The application of a queer lens would overturn social pressures to accept a stable category of gender identity, with fixed sexual attractions, allowing for a protean construction of masculinity and femininity alike; foreclosing stable reifications of queerness, *Alice* indexes the emergence of a new consciousness around who and what a queer individual might be. Amy Conroy's work presents the opportunity to regularize queer within the larger socio-cultural discourse without discrimination or fetishization by showcasing Irish queers as everyday people. This is largely due to the fact that, twenty years after the legalization of homosexuality in the Republic of Ireland, both the theatre community and broader society are still navigating identity politics situated against stereotypes of Irishness that nonetheless inform the national imagination. Indeed, contemporary queer theatre in Ireland has only recently begun to explicitly strive for a reclassification of a non-heteronormative sexual identity as a socio-cultural norm, let alone political equality.

Artistic conversations normalizing queer persons or gender identities can only be successful if foregrounded with interrogative dramas like *I (Heart) Alice (Heart) I* in the social milieu. Creating productions that function as a performative ethnography of queer experiences in modern Ireland reminds us of the way in which gender is a relatively neutral surface on which culture acts, as Elaine Aston's articulates: "Gender is not to culture as sex is to nature [... it is] also the discursive/cultural means by which 'sexual nature' or 'a natural sex' is produced and established as 'prediscursive' prior to culture" (8). Helping audiences reshape their perceptions of "natural" order subverts social pressures to accept stable gender categories with specific sexual preferences, allowing for the categories of *woman, feminine*, and *queer* to be adopted or rejected by personal choice–but if adopted, then shouldered as a mantle of power rather than a stigma. Though Conroy

generates the Alices' identities within a matrix of gendered norms, her "[choice] to become about the politics of sexual identity, not sex" ensures that Kinsella and Slattery "can never really escape ... reliance on a sex public, nor the loathing that continues to be attached to any explicit or publicly recognized sex" (*Normal* 40). Until the personal discovery and process of identification of queer sexuality is no longer considered groundbreaking in the social discourse of a comparatively traditionalist twenty-first century Ireland, theatre documenting the Irish queer's experience continues to be necessary.

Works Cited

Aston, Elaine. *An Introduction to Feminism and Theatre*. London: Routledge, 1995. Print.

Barry, Todd. "Queer Wanderers, Queer Spaces: Dramatic Devices for Re-imagining Ireland." *Deviant Acts: Essays on Queer Performance*. Ed. Cregan, David. Dublin: Carysfort Press, 2009. 151-69. Print.

Butler, Judith. *Frames of War*. London and New York: Verso, 2011. Print.

Conroy, Amy. *I (Heart) Alice (Heart) I*. Dublin: Conroy, 2010. Print.

---. Personal Interview with Samuel Yates. 7 June 2012. 1-8 Unpublished.

Harding, Michael. *Sour Grapes. New Plays from the Abbey Theatre*: Volume Two, 1996-1998. Ed. Judy Friel and Sanford Sternlicht. Syracuse, NY: Syracuse UP, 2001. 3-58. Print.

Harris, Susan Cannon. "Watch Yourself: Performance, Sexual Difference, and National Identity." *Genders*. Vol. 28. 1998. Last Updated 1998. Web. 28 May 2013. http://www.genders.org/g28/g28_watchyourself.html

Irish Theatre Institute. "HotForTheatre." *PLAYOGRAPHY Ireland*. Irish Theatre Institute. Last Updated 19 July 2012. Web. 19 July 2013. http://www.irishplayography.com/company.aspx?companyid=462

Jordan, Eamonn. "Meta-Physicality: Women Characters in the Plays of Frank McGuinness." *Women in Irish Drama: A Century of Authorship and Repression*. Ed. Melissa Sihra. New York: Palgrave Macmillan, 2007. 130-43. Print.

Martin, Carol, ed. "Bodies of Evidence." *Dramaturgy of the Real on the World Stage*. Basingstoke and New York: Palgrave Macmillian, 2009. 17-26. Print.

---. "Introduction: Dramaturgy of the Real." Martin 1-14. Print.

McIvor, Charlotte. "'Crying' on 'Pluto': Queering the 'Irish Question' for Global Film Audiences." Cregan 171-87. Print.

Mosse, George L. *The Image of Man*. Oxford: Oxford UP, 1996. Print.

Ní Chinnéide, Fíona. "Review: I [heart] Alice [heart] I." *Irish Theatre Magazine*. Updated 22 September 2012. Web. 24 June 2013. http://www.irishtheatremagazine.ie/Reviews/Dublin-Fringe.aspx?review=38.

Nugent, Joseph. "The Sword and the Prayerbook: Ideals of Authentic Irish Manliness." *Victorian Studies* 50.4 (Summer, 2008): 587-613. Print.

Reinelt, Janelle. "Towards a Poetics of Theatre and Public Events: In the Case of Stephen Lawrence." *TDR* 50.3 (Autumn, 2006): 69-87. Print.

Rokem, Freddie. *Performing History: Theatrical Representations of the Past in Contemporary Theatre*. Iowa City: Iowa UP, 2000. Print.

Shaw, Andrew. "The Year of Magical Wanking." *Gay News Network*. 10 January 2012. Web. 12 January 2013. http://gaynewsnetwork.com.au/feature/ft-victoria/4044-the-year-of-magical-wanking.html.

Sierz, Alex. "Enda Walsh in an interview with Alex Sierz." *Theatre Voice*. Web. 23 June 2013. www.theatrevoice.com/listen_now/player/?audioID=627.

Warner, Michael. "Introduction." *Fear of a Queer Planet: Queer Politics and Social Theory*. Minneapolis: U of Minnesota P, 1993. vii-xxxi. Print.

---. The Trouble with Normal: Sex, Politics, and the Ethic of Queer Life. Cambridge, MA: Harvard UP, 1999. Print.

Performing Woman in Contemporary Ireland

7 | Performative Reappropriation: A Case Study of *Taking Back Our Voices*

Emma Creedon

The staging of *Taking Back Our Voices* (2012) at the Abbey Theatre, Dublin, followed a six-month gestation period that saw six professional actors meet with women who had been involved in prostitution. The intention of these encounters was to form "personal and honest" relationships and explore any dramatic material that might emerge. This intention is difficult to qualify as the Abbey Theatre's partnership with Ruhama (and hence its related political motives) could be interpreted as at odds with this alleged "personal and honest" objective. The performance was commissioned by the Abbey Theatre's Community and Education Department and developed in collaboration with Ruhama, a Dublin-based NGO, who work with women whose lives have been affected by prostitution.

Taking Back Our Voices strove to challenge what Ruhama consider to be contemporary misconceptions concerning the commercial sexual exploitation of women, notably that their involvement in prostitution is consensual and that prostitution should be legalized. However, by aligning themselves with Ruhama who, within the context of global debates on the issue, promote a radical feminist viewpoint, the Abbey Theatre was taking a distinct political stance and promoting the theatre as in favour of the criminalization of prostitution.

The purpose of this chapter is not to interrogate or speculate on the Abbey Theatre's political leanings on the subject of prostitution as it was not their intention to create a piece of political propaganda. Rather, as I shall reveal, the intentions of this chapter are to consider from an aesthetic posture, how *Taking Back Our Voices* utilized the topic of prostitution as a synecdoche for wider gender injustices still endemic in

society today. This chapter will analyze how the production drew connections between prostitution and other types of labour from the perspective of women's rights and roles. Thus, in its focus on female objectification and gender discrimination within the workplace, the aims of this production were best served by portraying prostitution as humiliating and degrading. This representation thus worked to de-glamourize, diffuse and re-appropriate the falsified eroticism of the commercial sex industry.

An Overview of the Production

As the performance began, the audience heard footsteps and then a female voice. At the back of the stage, Justine Reilly, who has worked as a prostitute in Dublin, read a poem in the darkness, referencing O'Casey's *The Plough and the Stars* (1926), as though addressing a client. Resurrecting the words of O'Casey's infamous prostitute Rosie Redmond, Reilly read: "You louse/you louse, you're no man/you're no man, I'm a woman anyhow." The lights then rose on a table, horizontal to the audience, around which four women in tracksuits were seated. Niamh Shaw started to read from a report on epigenetics that gauges how an unborn child can be affected by the trauma of the mother whilst in the womb. The other characters were uninterested and when the phone rang Caitríona Ní Mhurchú answered in a demure voice. They had a client. A series of "auditioning" ensued against the soundtrack of *Pretty Woman*. The four actors posed in a parodic display of sexiness, as though they were preparing for battle. In the background Reilly emerged in full dominatrix garb as the omniscient surveyor of the upstage action, sitting spread-eagled on a chair. The effect, according to Reilly, was so that the audience could see the woman first and then the prostitute-stereotype second as an act, as masquerade. In conversation, Shaw also drew comparisons between this "auditioning" required of prostitutes in the selection process for a client and the actor, waiting for the phone to ring, powerless in her career. During the performance, the characters posed upstage, alongside polished images of their professional headshots, advertisements of themselves suggestive of the commodification of selfhood within the acting profession. In conversation, Reilly questioned whether men are forced to endure the rigorous dissection of their physicality that female actors are subject to when being considered for their suitability to certain roles.

Taking Back Our Voices did contain first-hand testimonies from women whose lives have been affected by prostitution in Ireland. However, these were delivered by the actors via off-stage monologues

and, in performance, this theatrically alluded to a sense of disembodiment. Thus the testimonies were exploited for their artistic potential rather than their emotive resonance. In the first monologue, the speaker recalled a sexual encounter in a car with an overweight client, describing "the smell of genitals that haven't been exposed to the air in a long time." "I don't want to get any closer to it," the speaker admits, "but now I'm expected to put it in my mouth." Meanwhile the other three actors put on deodorant, cleaned themselves with baby wipes and performed other banal self-grooming tasks at the upstage table. The phone rang again and to Caitríona's prompt of "client!" the "prostitutes" were again expected to perform. The character played by Sorcha Kenny read aloud the services she is willing to provide: "A level (5 Star Escort), BJ (Blow-Job), BBJ (Bare Back Blow-Job), CID (Come in Deep), DFK (Deep French Kissing), Doggy-Style (From Behind), GFE (Girl Friend Experience), Anal Sex, HJ (Hand Job)" The other characters joined in and, as their voices overlapped, the character played by Ní Mhurchú repeatedly stated "I can be your fantasy." Shaw's ensuing monologue chronicled another appointment with a "client," delivered as an almost scientific cataloguing of events so that the de-sensitised tone of the delivery clashes with the explicit nature of the content of her speech:

> stupid sweat/ moaning and groaning/ rip condom with your teeth/ tease top of penis/ sucking penis and putting it in your mouth as far as you can without gagging/ I could be thinking of what I'm going to wear Saturday night/ straddle him and slowly push his penis on to me so that only the tip goes into my vagina ... horrible disgusting gasp as he comes/ pig-like moan into your ear/ flops on top of you for a few seconds to catch his breath.

Following this, Úna Kavanagh and Kenny read a role-play charting an encounter between a submissive female and a chauvinistic male. Ní Mhurchú enacted this role-play by simulating oral sex on Kavanagh in the role of the man. Firstly standing with her mouth wide open, her discomfort by the time she is forced on her knees was palpable. Ní Mhurchú began to gag and tears streamed from her eyes; she is only given relief when the phone rings again; she answers the "client" demurely, "performing" her role for her client and ignoring her bodily discomfort.

The performance posited that prostitution can perpetuate sexual objectification and this was given further visual countenance in this performance when the characters played by Kavanagh and Kenny proceeded to touch Shaw inappropriately while she stood passively.

Deriding her, they groped her groin, fondled her breasts, put their fingers in her mouth, smelled her crotch and asked her if she is clean. By presenting prostitution as degrading and debasing, *Taking Back Our Voices* demonstrates the power of live action to disrupt narrative. This physically invasive action ensured that the production did not replicate the aesthetics of pornography for the function of critique. The sense of humiliation was exacerbated when Kavanagh's character forced Kenny to wear a bondage mouth-gag, literally rendering her speechless, as the other characters teased and laughed at her. Each of the women was subsequently subjected to ridicule. "Does your son know you're a cunt?", Kavanagh's "prostitute" asked Ní Mhurchú. Adding to the testimonial essence of the theatre piece, *Taking Back Our Voices* ended as Reilly, "performing herself," took back her voice. During a staged conversation with Shaw, Reilly signalled to society's antagonistic perception of the two women: "You're up here and I'm down there. The worldview is that here's Niamh the scientist and actress and here's Justine, the ex-prostitute. I'm dirt. I'm scum." Reilly continued: "When you're working as a prostitute your awareness is heightened. You bring that with you. I could point out any man who pays for sex." With that, the lights went up and Reilly, along with the four professional actors, came to the front of the stage and returned the audience's gaze.

National Debates Concerning Prostitution

The criminalization of prostitution is presently, both globally and nationally, a highly contentious issue. According to Joyce Outshoorn

> Prostitution is a specially interesting case for studying the relationship between the women's movement and women's policy agencies, as women's movements are deeply divided over the issue. Although theoretically as many as four positions can be distinguished in feminist debates on prostitution ... the major divide is between those feminists defining prostitution as sexual domination and the essence of women's oppression ... and those who maintain prostitution is work that women can opt for, the sex work position. (9)

Taking Back Our Voices was developed in collaboration with Ruhama who espouse the former view that prostitution perpetuates the oppression of women. Ruhama is a core member of the Turn Off the Red Light Campaign (TORL), a campaign to end prostitution and sex trafficking in Ireland by criminalizing the purchase of sex. This campaign is presently supported by sixty-eight organizations including

the Irish Medical Organisation, the Irish Congress of Trade Unions, SIPTU and the National Women's Council of Ireland. However, the TORL campaign is vehemently opposed and challenged by Sex Workers Alliance Ireland who advocate a harm reductionist approach and argue that criminalization of the purchase of sex will simply drive the industry underground and provide less support to those working in prostitution. Additionally, they consider such campaigns as based on purely moralistic issues that are pitched along a clear morality spectrum of good versus evil. Moreover, Dr Eilis Ward, a lecturer at NUI Galway on international relations, politics and women's studies, argues that the TORL campaign

> conflates many different phenomena–the reality of sex trafficking, smuggling, undocumented migration–with all aspects of sex work. It's a highly ideological position, and public policy should not be based on ideological positions ... We have to conceive the sex trade on a continuum of exploitation, and public policy should reflect that reality. This black-and-white definition of the sex trade that promotes criminalisation does not reflect the reality ... [D]isempowering myths have emerged in Ireland that function to silence and disqualify and shame (qtd. in Holmquist)

Additionally, the anthropologist and author of *Sex at the Margins: Migration, Labour Markets and the Rescue Industry* (2007) Laura Augustin shares this viewpoint. Augustin considers the campaign toward criminalization a "civilising movement by developed countries to save people from themselves." In a lecture at University College Dublin on 4th April 2013, Augustin spoke against the term "trafficked," an expression she argues that has become synonymous with slavery; she considers "trafficking" a security, authoritarian issue rather than a human rights one. Outshoorn writes that this debate

> influences the way migration of women in sex commerce is viewed. "Trafficking of women" emerged as a political issue in the 1880s, and was then called "white slavery." As it was defined in criminal law as the forced transfer of women across (inter)national borders for the purposes of prostitution, it was intrinsically linked to prostitution ... In the sexual domination view, trafficking of migrant sex workers is always seen as against their will; they are by definition victims of trafficking ... For those adhering to the sex work position, women can be victims of trafficking, but not all women sex workers migrating are victims of forced prostitution. (9)

According to Augustin, "migration policy and employment policy are where the problems lie and not with women being exploited for sex." Furthermore, she considers the TORL campaign to be indicative of neo-colonialism, a "media-blackout" demonstrative of "the rescue industry" from which, she argues, many prostitutes do not want to be "saved" (Augustin).

Augustin posits that the voices of women selling sex have been "disqualified" from the debate on prostitution in Ireland and that their voices "have been taken by the feminists and are now in a feminist debate." This, she conceives, ensures that the "marginalised remain so." *Taking Back Our Voices* had the explicit aim of reclaiming this narrative. Reilly, who had worked in Dublin as a prostitute for nearly twenty years, joined four professional actors–Kavanagh, Kenny, Ní Mhurchú, and Shaw–on the Abbey stage in a theatrically self-reflexive Brechtian move. A founding member of Space International (Survivors of Prostitute Abuse Calling for Enlightenment), Reilly dismisses suggestions that prostitution is the oldest profession in the world, compounding it with the gender injustices still endemic in Western society. "Prostitution," she argues, is not the oldest profession but the oldest form of oppression." "As a prostitute I was a human toilet into which men emptied themselves daily, washing any trace of me from their bodies afterwards." Reilly believes that while working in prostitution, she was forced to mentally invest in the myths on which it relies–that she was in power, that her involvement in prostitution was consensual–purely in order to survive. Whilst working as a prostitute, Reilly was repeatedly raped and physically and emotionally abused. She describes her experience as one of enslavement with psychic disassociation as an inevitable survival technique. Such degradation, Reilly says, attacks the soul, leading to inexorable perceptual disembodiment. Once the mind and the body are irretrievably fragmented, life becomes an out-of-body experience and s/he is constantly cut-off from his/her surroundings. "I lived on adrenaline," Reilly recounts, "wondering when I would be raped again, whether the next men who came in the door would attack me wearing balaclavas." Reilly compares the psychic countenance demanded of her in prostitution to the de-sensitization required of soldiers in battle, "in the army, soldiers are trained to hide their souls." According to Reilly, "sex and prostitution are not the same thing. Prostitution is analogous to control and power." Reilly depicts life working as a prostitute as sexually and morally debasing and her comments about her psychic

conditioning as a survival technique suggest that women working in prostitution who do not consider it to be exploitative are disillusioned.

A Contextualization of *Taking Back Our Voices* and Prostitution

Taking Back Our Voices was the Abbey Theatre's Community and Education Department's first major project since it reopened in 2011. It was performed for two nights only in November 2012, directed by the Abbey's Resident Assistant Director, Oonagh Murphy. According to Phil Kingston, Community and Education Manager for the Abbey Theatre, the theatre never intended *Taking Back Our Voices* to be a piece of political propaganda yet its partnering with Ruhama suggested a particular political stance. However, the Community and Education Department found it difficult to get responses from the liberal feminist side of the argument. All the collaborators on the project were in support of the criminalization of prostitution, thus it seems, almost by overwhelming veto by all involved, that one particular side of the debate dominated. When Kingston researched the issue further, he found that "the percentage of women who consented to working in [the industry] was so small that to promote [prostitution] as a choice would be deceptive." This does seem to equate the debate about prostitution in Ireland solely with issues of consent. Yet, rather than a conscious evasion of issues in the on-going global arguments concerning prostitution, it appears that an unbiased representation of both sides of the debate by Ireland's National Theatre would be recalcitrant to the aims of the production which, as this chapter posits, were aesthetic rather than political. Kingston is keen to emphasize that the Abbey's primary intention was not to offer therapy, but to create a work of art, one that would embody contradictions and would make a significant impact as a theatrical performance. Rather, *Taking Back Our Voices* sought to exploit the topic of prostitution as "the ultimate emblem" (Murphy) of an exploitative capitalist culture.

Prostitution and the Abbey Theatre

The opening lines of the Abbey Theatre's production of *Taking Back Our Voices* (2012), read by Reilly from the back of a blackened stage, ensured that the performance was intertextually positioned within a traditional dramatic lineage of representing prostitution on Ireland's national stage. Resurrecting the words of Seán O'Casey's infamous prostitute Rosie Redmond, *Taking Back Our Voices* belongs to a

theatrical trajectory of representing the perceived realities of prostitution on the Abbey stage, and Reilly's words demonstrated that *Taking Back our Voices* was consciously contributing to this tradition, indeed one that stems back to the staging of O'Casey's play. Back in 1926, the playwright was forced to defend his characterization of the prostitute Rosie Redmond against audience accusations that there were no prostitutes in the country at the time. George O'Brien, one of the Abbey's directors and a government appointee, wrote to W.B. Yeats, suggesting that scenes that emphasized Redmond's profession be removed from the play, an advice that Yeats eschewed (Welch 95). Thus O'Casey's representation of a prostitute on the Abbey stage could be read as an attempt to de-fictionalize the audiences' perceptions of the realities of the sex industry in Ireland.

Historically, Brendan Behan's *An Giall (The Hostage)* (1957) was set in a Dublin brothel and caused consternation in its suggested feminization of Ireland as a whore. On the other hand, plays such as Tom Murphy's *The Morning After Optimism* (1971) and Sebastian Barry's *White Woman Street* (which appeared at the Peacock in 1992), have also historically depicted prostitution on the National stage. Christopher Murray interprets Murphy's play as indicative of the "challenge to puritanism" (172) that was a pervasive feature of Irish drama in the 1960s and 1970s. Murray notes, however, that at this time "the empowerment of women in Irish drama was from a male point of view" (173) with Murphy's prostitute, another "Rosie," representative of a "transgressive sexuality" (173). Indeed, Murphy's play *The House* (2000) premiered at the Abbey Theatre and contains a character who returns to Ireland and, it is suggested, is working as a high-class prostitute in London. Moreover, comparisons can be drawn between *Taking Back our Voices* and Deirdre Kinahan's play *Bé Carna (Women of the Flesh)* (1999), originally produced by Tall Tales Theatre Company at Andrews Lane Theatre, which drew on verbatim accounts of prostitution in collaboration with Ruhama.

More recently, Jimmy Fay's revival of James Plunkett's play *The Risen People* in 2013 substituted a prostitute, Lily Maxwell (who is only mentioned in passing in the original text) for the character of Mrs Mulhall. Commenting on the era in which the play is set, Fay states that "prostitution was a huge thing at that time when people had to live any which bloody way they could ... prostitution is a huge thing in present-day Dublin as well" (Kileen). When *Taking Back Our Voices* was performed in November 2012, it also resonated with another brothel scene in the Abbey's production of Oscar Wilde's *The Picture of Dorian*

Gray which was running at the time. Both Shaw and Kavanagh had also performed in *World's End Lane,* ANU's immersive, site-specific performance which was performed on the streets of the 'Monto' area of Dublin's North inner city in 2011, giving dramatic expression to what was once the largest Red Light District in Dublin. Rather than taking a political standpoint, *World's End Lane* was a "geographical response" to the history of the area that focused on the personal stories of those whom history has forgotten. Shaw and Kavanagh brought their experience devising and performing in this experimental theatre form to bear on *Taking Back Our Voices.*

In the context of the Abbey's historical engagement with the topic of prostitution, Lionel Pilkington spoke in a keynote speech at the Irish Society of Theatre Research conference at Birkbeck University in November 2013 of how O'Casey's play glamourized prostitution, for to diagnose the industry as indicative of society's ills would have been to recognize the inadequacies of post-Independent Ireland. Furthermore, Pilkington questioned why audiences are generally more ethically affected by what we witness in the theatre than what we experience outside it. He queried, for example, why at the time of the première of *The Plough and the Stars*, suburban travellers visited the Abbey Theatre to observe tenement life when tenement life was two blocks away from the theatre. Contrastingly, *Taking Back Our Voices* strove to de-glamourize prostitution and to reclaim the narrative of the realities of prostitution that had, the collaborators felt, been historically misrepresented on the Abbey's stage. The production posed that idealized depictions of prostitution are inadequate and do not portray the realities of the profession.

A De-fetishizing and Deconstructive Repossession of Agency

For seven months in 2012, six theatre artists (Caitríona Ní Mhurchú, Kathy Rose O'Brien, Aoibhinn McGinnity, Sorcha Kenny, Niamh Shaw, and Úna Kavanagh) met with women of a similar age to themselves who had been involved in prostitution. This allowed these professional actors to present first-hand accounts of prostitution in a structured theatrical format. The Abbey was keen, according to Kingston, to emphasize that the intentions of the project were artistic rather than therapeutic, and that although testimony informed the piece, this was not a piece of verbatim theatre, and it may be altered/fictionalized to serve its theatrical purpose. This is a further indication of the Abbey's weariness to espouse a particular political viewpoint, for the narratives that emerged from these meetings were exploited for their artistic

potential. Hence the voices of the marginalized/disenfranchised that emerged were not those of women who had been working as prostitutes but women who were sickened by continuous gender oppression, of which they felt prostitution was a further symbol. Oonagh Murphy had been working as the Abbey Theatre's Resident Assistant Director for almost a year when Kingston approached her about directing the piece, and it offered Murphy the apposite territory with which to address what she refers to as "the lack of female voices–both authorially and representationally–in Irish performance."

Kingston recalls that *Taking Back Our Voices* originated from the theatre's commitment to explore contentious social issues through performance. Initially, the decision to approach women whose lives had been affected by prostitution was motivated by a brothel scene in THISISPOPBABY's *Alice in Funderland* (2012). According to the director of *Taking Back Our Voices*, Oonagh Murphy,

> *Alice in Funderland* was cutting satire about the Ireland we live in today and yet prostitution was a story-telling device, not a topic for critique. I was well versed ... in the way women can be used as ciphers to talk about more important matters. The "prostitute as the ultimate emblem of capitalism" had been done since Marx, since O' Casey.

It seems that Murphy's motives here were not to critique prostitution, but rather to employ women, in particular women's bodies, as a "cipher to talk about more important matters." According to Murphy, the aims of the piece were as follows:

> That we should explore the intersection between how a prostitute experiences life, and how society objectifies women in manifold ways [W]e discussed a lot of the ways that female actors can be treated as sexual objects, how the female at work is always a visual entity examined for her pleasure-giving facilities, how prostitution has an effect across a culture as the baseline of degradation we are content to allow primarily one gender to be subjected to. (Murphy)

Murphy had studied the performance art of Karen Finley, Carolee Schneeman, Marina Abramović and Amanda Coogan and brought her research of how these artists use the female body as a performative tool to this piece. Rather than functioning as a piece of propaganda, Murphy's words suggest that the treatment of prostitution in *Taking Back Our Voices* had the aesthetic purpose of catalyzing debates about female objectification in the workplace and gender inequality. This performance functioned as a de-fetishizing and deconstructive repossession of agency, the title of the piece gesturing towards an active

sense of retrieval. To return to Pilkington's aforementioned contention that theatre can often make more of an impact than real life, *Taking Back Our Voices* would not have had the same impact as a piece of verbatim theatre. Although testimonies were incorporated into the performance, the Abbey did not intend the performance to function as purely a platform for disenfranchised voices.

A study conducted in 2004 by Dr. Melissa Farley of Prostitution Research and Education, San Francisco, and others, drawn from the interviews of 853 people who were working or had recently been working in prostitution found that a

> psychological consequence of long-term prostitution is complex PTSD (CPTSD) which results from chronic traumatic stress, captivity, and totalitarian control. Symptoms of CPTSD include difficulty regulating emotions, altered self-perception (in prostitution: a subordinated sexual self), ... and shifts in beliefs about the nature of the world. (58)

This perception of a "subordinated" alternative sexual self was theatrically realized in *Taking Back Our Voices* by the aesthetic creation of the alternative sexualized prostitute as "Other" (Reilly in dominatrix costume), relating to psychic states of disembodiment and dis-association which had been identified in the conversations with the women that Ruhama had provided. During a post-show discussion of *Taking Back Our Voices* on Friday 16th November 2012, Mia de Faoite spoke passionately from the audience in favour of the criminalization of prostitution. She later recounted her own experience of working as a prostitute to Kate Holmquist in an article for *The Irish Times* on 4th May 2013:

> De Faoite says she was able to prostitute herself only by disconnecting her mind from her body, which she felt didn't belong to her when she was working. She still refers to the prostitute part of herself as "her." When de Faoite put on the wig, the make-up and the clothes that were exclusively the prostitute part of herself, she became a third person with a street name that she prefers not to divulge. "It was disassociation. I saw the person I was at night as a completely separate woman," she says. (qtd. in Holmquist)

The disassociation that de Faoite describes was given visual expression in *Taking Back our Voices* by Reilly's "outfitting" in a PVC dominatrix uniform. According to Kingston, the collaborators had originally intended to borrow some of the costumes from *Alice in Funderland*, in particular a cone-shaped bra made infamous by

Madonna, a Pop-icon whose self-orchestrated identity shifts with chameleon-like alterity. They had intended to don this attire over their own nondescript tracksuits to aesthetically gesture to the ludicrousness of these "fantastical representations" (Kingston) of prostitution.

Reclaiming of the Narrative

The sense of "role-playing" worked in *Taking Back Our Voices* as a reclaiming of narrative since the viewer is rendered complicit in the objectification of the female body by his/her gaze alone. By eyeballing the audience at the end of *Taking Back Our Voices*, the actors made the audience aware of the immobilizing pornographic gaze, made complicit by Reilly-the-prostitute-model. According to Shaw, rehearsals were informed by readings of John Berger's *Ways of Seeing* (1972), which was expanded by Laura Mulvey in her treatise on the male gaze in "Visual Pleasure and Narrative Cinema" (1973). Mulvey's seminal text exposes how narrative cinema operates along the same lines as the reifying male gaze in society, rendering woman the passive object of the gaze and never the owner of it. The actors in *Taking Back Our Voices*, by returning the audience's gaze, reclaimed ownership over our active ocular ingestion of their bodies, and simultaneously shattered fourth wall theatrical conventions. This performance was about sex, but there was nothing sexy about the performance. In this piece, sex is depicted as degrading, grotesque, uncomfortable and painful. It attempted to challenge the trope of the "happy hooker" and shifted the focus from the sexual gratification of the man to the bodies of the women that they penetrate. The representation of the aesthetics of prostitution, laid bare and devoid of the semiotics of prostitution, functioned as a resistance to the form. *Taking Back Our Voices* diffused the potency of the suggested trauma that prostitution, and by extension the sex industry, generates through a direct engagement and defamiliarization of its rhetoric and themes. For, as Cathy Caruth writes,

> trauma ... requires integration both for the sake of testimony and for the sake of cure. But on the other hand, the transformation of the trauma into a narrative memory that allows the story to be verbalized and communicated, to be integrated into one's own, and others', knowledge of the past, may lose both the precision and the force that characterizes traumatic recall ... the capacity to remember is also the capacity to elide or distort and ... may mean the capacity simply to forget. (153-54)

In a theatrical sense, *Taking Back Our Voices* evaded replicating the aesthetics of soft porn through Brechtian alienation techniques and

performative "making strange." Espousing that the theatre of illusion must be broken, Brecht's Epic Theatre was a self-conscious commentary on the material reality of drama itself. *Taking Back Our Voices* was in line with Brecht's beliefs that drama should be acted as a reporting of events, with the actor as demonstrator, though consciously shaped into a dramatic form. Similarly, in this performance, the fact that the female actors read from scripts and self-reflexively referred to themselves as actors (by exhibiting their professional headshots) reflected Brecht's belief that the actor should act as a demonstrator and not an impersonator. Formally, *Taking Back Our Voices* was presented as a series of tableaus Shaw referred to as "pieces of presentation," an episodic form which reflects a Brechtian departmentalization of the aesthetics of theatre. Furthermore, at one stage in the piece, Kavanagh brushes her hair aggressively while repeating the phrase "an artist must be beautiful," signalling an interest in the Surrealist concept of "convulsive beauty," but also Brecht's dramatic theories that challenged the notion that theatre must be aesthetically gratifying.

Conclusion

The aims of *Taking Back Our Voices* were not to give a voice to those whose lives have been affected by prostitution in Ireland, but rather to use the testimonies of those who had been subjected to censure and censorship to create a piece of theatre. This was not an ethically dubious endeavour, for, as Kingston expressed in interview, the performance, from the onset, prioritized the aesthetic artistic credibility of the performance over its cathartic potential. *Taking Back Our Voices* utilized the grotesque and the perverse as a destabilizing mechanism with which to draw attention to our own complicity and investment in the immensely imperious multi-billion-sex industry. This feeds off the sexual degradation and torture of women of which prostitution could be conceived as a pawn. Murphy brought her own research of female performance artists to bear on the performance as further evidence of its aesthetic rather than political purpose. Furthermore, *Taking Back Our Voices* strips prostitution bare, exposing perspectives, informed by testimony, on life in a brothel by presenting us with women, in tracksuits, devoid of the identifiable markers of sexual abandon and licentiousness usually associated with the narrative trope of the "whore." Reilly's claim at the end of *Taking Back Our Voices* that in society's view she is "dirt" or "scum" (Reilly to Shaw: "you're up there, I'm down here") suggested that the defetishized female is redundant. In a similar manner to this crisis of representation of female subjectivity,

Taking Back Our Voices posited that the residual impacts of prostitution are difficult to dispose of. The theatre piece was a performative act of reappropriation. The self-conscious act of re-presenting operated in *Taking Back Our Voices* as a reclaiming of ownership over women's bodies and a new way to negotiate power.

Works Cited

Augustin, Laura. "Sex at the Margins: Migration, Labour Markets, and the Rescue Industry." John Hume Institute for Global Irish Studies, University College Dublin. 4 April 2013. Guest Lecture.

Caruth, Cathy. "Recapturing the Past: Introduction." *Trauma: Explorations in Memory*. Ed. Cathy Caruth. Maryland: John Hopkins UP, 1995. 151-57. Print.

Farley, Melissa, et al. "Prostitution and Trafficking in Nine Countries." *Journal of Trauma Practice* 2.3-4 (2003): 33-74. Print.

Holmquist, Kate. "The Sex Trade: Safe or Sordid?" *The Irish Times* 4 May 2013: <http://www.irishtimes.com/news/crime-and-law/the-sex-trade-safe-or-sordid-1.1382024> Web.

Killeen, Padraic. "Plunkett's Play *The Risen People* Returns to the Abbey Theatre." *The Irish Examiner* 29 November 2013: <http://www.irishexaminer.com/lifestyle/artsfilmtv/plunketts-play-the-risen-people-returns-to-the-abbey-theatre-251059.html> Web.

Kingston, Phil. Personal Interview. 25 Oct. 2013. Unpublished.

Mulvey, Laura. "Visual Pleasure and Narrative Cinema." *Screen* 16.3 (1975): 6-18. Print.

Murphy, Oonagh. "Re: Taking Back our Voices." Message to the author. 27 Oct. 2013. E-mail.

Murray, Christopher. *Twentieth Century Irish Drama: Mirror up to Nation*. Syracuse: Syracuse UP, 2000. Print.

Outshoorn, Joyce. "Introduction: Prostitution, Women's Movements and Democratic Politics." *The Politics of Prostitution: Women's Movements, Democratic States and the Globalisation of Sex Commerce*. Ed. Joyce Outshoorn. Cambridge: Cambridge UP, 2004. 1-20. Print.

Pilkington, Lionel. "Theatre and the City." Birkbeck University. Irish Society of Theatre Research Annual Conference. 1 November 2013. Keynote Panel Address.

Reilly, Justine. "Personal Interview." 28 Oct. 2013.

---. http://www.irishmirror.ie/news/irish-news/former-dublin-prostitute-talks-how-2291460 Web.

Shaw, Niamh. Personal Interview. 9 Aug. 2013. Unpublished.

Welch, Robert. *The Abbey Theatre, 1899-1999: Form and Pressure*. New York: Oxford UP, 1999. Print.

8 | "The horror, the horror": Performing "The Dark Continent" in Amanda Coogan's *The Fountain* and Samuel Beckett's *Not I*

Brenda O'Connell

> Out ... into this world ... this world ... tiny little thing ... before its time ... in a godfor- ... what? ... girl? ... yes ... tiny little girl ... into this ... out into this ... before her time ... godforsaken hole... (Beckett, *Not I* 376)

Introduction

Samuel Beckett's drama, and in particular the late plays, are exceptionally reliant on the actor; often there is nothing but a body on stage and sometimes only part of one. Anna McMullan notes that while these disembodied mouths or heads are no longer as disturbing as they once were, the presentation of vulnerable bodies that struggle to appear and to "speak" in his drama continue to present a challenge to contemporary culture and performance (McMullan, *Performing Embodiment* 1). In the twenty-first century, the body has become central to numerous artistic, critical, ethical, scientific and medical discourses and practices. Poststructuralist thinkers such as Michel Foucault inaugurated the contemporary interest in embodiment, albeit in a discursive framework, with the body in his work emerging as a discursively ordered product of institutionalized knowledge and power. The body in Foucault's theory is, according to Bryan S. Turner "that which is signified by biological, physiological, medical and demographic discourses" (231). The emphasis in Foucault's work and post-structuralist theory is, then, on discourse rather on the body itself.

The last two decades have seen a proliferation of theoretical approaches to the body, with a focus on gender, sexuality, textuality and

other bodily constructs. The prominence of theories that challenge Descartes' rationality have played a crucial role in the heightened interest in the body, with some critics suggesting that these theories are reversing the early humanist privileging of the mind. Such renewed interest in the lived body and its sensuous potentiality has manifested in new critical approaches to Beckett's work, whose writing foregrounds the body in both representational and textual ways. Ulrika Maude's study of the body in Beckett's prose, drama and media plays argues for a materialist reading, which can be located "at the intersection of textual, phenomenological and cultural concerns" (1). Trish McTighe argues that Beckett's drama is deeply concerned with acts of touch, a focus which emerges from a "tradition of thinking through touch in art" (qtd. in Maude 1). Beckett's *oeuvre*, and in particular his drama, proves fertile research for a consideration of sensory perception, and the experiences of seeing, hearing and touching.

While the performing body is the primary subject of Beckett's stagecraft, this essay is specifically concerned with the female body in his drama and the ways in which it has been developed as a site of communication in the work of Irish performance artist Amanda Coogan. Her radical corporeal strategies in her art, which involve intense bodily control, endurance and pain, are intertextually connected to Beckett's drama. Her work *The Fountain* (2001), challenges the patriarchal notion of woman by the use of radical corporeal bodily actions. There is a striking similarity between *The Fountain* and Beckett's late play *Not I*, which features Beckett's favoured actress Billie Whitelaw. Both works are themed on the experience of female marginality and abjection, revealing a disconnection and an anxiety around bodily functions, where the body itself poses a threat to the autonomy of its "owner." Drawing on French feminist theory and performance studies, I will argue that in the context of the ongoing controversy over the control of women's bodies in Ireland, Coogan's work produces a kind of *parler femme*, or "woman-speak" in *The Fountain*, one which disrupts and complicates a masculine discourse.

Gabriella Calchi Novati's essay, "Challenging Patriarchal Imagery: Amanda Coogan's Performance Art," argues that Coogan's work directly challenges a "specifically Irish dilemma around the female body turned into a public display of the feminine abject" (180). Novati analyzes performances such as *The Madonna Series* (2001) and *The Fountain* and unravels their meaning in an Irish sociocultural context, referring specifically to the Irish State's attempts to legislate the female body.

Kate Antosik-Parsons, in "Bodily Remembrances: The Performance of Memory in Recent Works by Amanda Coogan" investigates the relationship between memory and identity in contemporary visual art. Antosik-Parsons argues that by engaging with artistic practices of memory, Coogan's performances dispute dominant historical narratives in order to weaken their cultural significance, thus destabilizing dominant representations of the "Irish woman" (7).

Further, I will argue that a feminist reading of the televised version of Beckett's play *Not I* in 1975 reveals an interesting debate about female inscription, where Mouth is revealed on screen as resembling a gaping vagina (fig.2). The association of the feminine with abjection and disorder is analogous with Freud's theory that the sexual life of a girl child is so obscure and faded with time that one would have to dig deep into the recesses of civilization in order to gain some insight into woman's sexuality, the "Dark Continent" (Freud 212).

The Corporeal Body as Site and Sign

Coogan is an established Irish performance artist, living and working in Dublin. Born hearing to deaf parents, her first language is Irish Sign Language, a manual-visual language, spoken by approximately only 5,000 people worldwide. Growing up in such a manual-visual milieu, she explains that "everything was expressed through the body and received through the eyes: love, pain, happiness, sadness, hunger, satiation" (*Profile: Amanda Coogan* 8). Coogan's mentor and trainer is the renowned performance artist Marina Abramović. Abramović was born in Belgrade in 1946, and she deals with what she calls the "true reality" in her art, often subjecting herself to great physical pain at a psychological cost: performances have included her stabbing her own hand and slicing her skin with razor blades. Her notoriety reached a new level recently with two high profile works: *The Artist is Present*, a 700 hour silent performance at the Museum of Modern Art in New York in 2010, which has recently been released as a documentary: *Marina Abramovic: The Artist is Present* and her collaboration with Robert Wilson (American playwright, director and producer) in *The Life and Death of Marina Abramovic* 2011 (also recently released as a documentary: *Bob Wilson's Life and Death of Marina Abramovic*). Wilson is best known for his avant-garde theatre work and his radical re-working of Beckett's plays *Happy Days* and *Krapp's Last Tape*. *Life and Death* is a lavish play that blends performance art, music and theatre, inspired by the biography of Abramovic's life, in which Coogan features.

One of Coogan's earlier works *Medea* (fig.1) was performed in the Irish Museum of Modern Art in Dublin in 2001 as part of *Marking the Territory* performance event, curated by Abramovic. Over the course of three hours and using Irish Sign Language only, she "tells" the secrets of the Irish Deaf community: stories of oppression, humiliation and sexual abuse. For many years these abuses were invisible, complicated by the absence of a shared language of communication. In this provocative performance, Frances Ruane notes that Coogan manages to move beyond language to communicate with her audience. Although her body is the primary site of communication and her serene image seduces the audience, the scene is subverted by the deliberate placement of her hand on her genitals and the staining of the dress. Her lower body is also placed in a deliberately "physically limiting" position, highlighting the plight of those abused in the deaf community (Ruane 53). The deliberate use of Irish Sign Language draws attention not only to the fact that deaf people have been affected by the same catalogue of abuses as hearing people, but that they are doubly constrained by their inability to "tell" their stories.

Elizabeth Grosz argues that the body is a vehicle for consciousness, where the body is "a two-way conduit: on the one hand, it is a circuit for the transmission of information from outside the organism, conveyed through the sensory apparatus; on the other hand, it is a vehicle for the expression of an otherwise sealed and self-contained, incommunicable psyche" (9). One of Coogan's works, *The Fall* (2009) involved her leaping from a ladder onto a mound, before dragging herself up to start again; this piece was performed over a period of seventeen days, which involved intense bodily control, endurance and pain. This relationship between the body, space and time forces an awareness of physicality in the viewer that questions his/her relationship to the self and other through the tangibility of the performance. Artist Barbara Knezevic noted that there was a sense of a "considered and intellectual control over every movement of her (Coogan's) body; there was an incredible discipline and unnerving mental focus" (3). This has the effect of causing the viewer to pause to consider their own physicality in response to the performance, echoing Grosz's argument that the body is a site for the projection of the "external world" (Knezevic 9).

Coogan's live performances result in an intense relationship between artist and spectator, in what Peggy Phelan refers to as a "maniacally charged present," with the corporeal body at its centre, which is tested to its limits (148). Performance art's referent is always the agonizingly relevant body of the performer, which involves duration and pain.

Pain, as Elaine Scarry notes, is not just a bodily trauma but something that resists or "shatters" language and communication (5). Coogan's performances are silent, durational and involve bodily control and pain, all witnessed by the spectator in a complex relationship of presentness in the staged liminal space of live art. In her work, Coogan displays an ability to condense an idea to its very essence and communicate it through her body.

The development of the female performing body in Beckett's drama has been the focus of much enquiry. There is general consensus in Beckett studies that while the representation of women in his early prose is uncontestedly misogynistic, there is far less agreement about the later work, and this is nowhere more evident than in the often entirely irreconcilable responses to the major late play *Not I*. On the one hand, Mouth is viewed as a resistance and subversion to the patriarchal order, by "birthing" a voice of feminine sexuality. Peter Gidal, approaching the work as a stage play, argues that Mouth's speech is "anti-patriarchal/anti-capitalist language and speech production" (114). Anna McMullan, following Lacan, also interprets Mouth as a "disruptive force which threatens the conceptual stability and fixity established by the Symbolic" (*Theatre on Trial* 76). Shane Weller notes that all of these readings locate the play within the European avant-garde tradition in which, "according to Julia Kristeva, the '*heterogeneousness* to meaning and signification' that characterizes the rhythmic semiotic disrupts the Symbolic Order" (qtd. in Weller 165). On the other hand, Kristeva also argues that Beckett's works reproduce an endless mourning for the father as the maker of meaning, irrespective of the gender of the speaker (the play exists as text for Kristeva, far removed from its medium on the stage). Ann Wilson goes a step further, vehemently arguing that Mouth is "the figure of a woman written in a scene over determined by the Order of the Father ... marked by absence–an absence which is the absence of the phallus" (199).

I suggest that any reading of the play depends on the form of the play under consideration; in this case a reading of the televised version provides an interesting argument on female inscription, thereby opening up new possibilities of analysis. The televised version of the play is one of the few occasions that Beckett allowed a text written for stage to be adapted for television, and in 1975, he gave the BBC permission to film Billie Whitelaw as Mouth, directed by Bill Morton. A feminist reading of this version reveals Mouth as not only grotesque; in the close-up Mouth now resembles a gaping vagina. Linda Ben-Zvi puts it succinctly when she observes that Mouth is "a pulsating orifice

attempting to give birth to the self," where "the image marks an elision of mouth and vagina, the female reduced to genital identification, more blatant but no less familiar than the use of female body parts in this and other consumer media" (247).

On screen, Mouth has the appearance of a large, gaping vagina, spewing out its speech in a blatant genital display and a reduction of the feminine to the mysterious Dark Continent, reduced by the gaze of the camera into the very object whose tale she tells. When Mouth says: "when suddenly she felt ... her lips moving ... imagine! ... her lips moving!" (379), the text reveals a feminist reading of female inscription, as the moving of the lips allude to the possibility of sexual pleasure, and the sensuality of speech. This is the moment that feminine sexuality is inscribed as multiplicity which cannot be accounted for within phallogocentricism, the privileging of the masculine or the phallus in understanding meaning or social relations. I argue here that the televised performance bears a striking resemblance to *The Fountain* and that both performances draw attention to the female birthing body in their refusal to obey the rules of discourse. Mouth's blatant sexuality is reduced to the gaze of the camera and the audience while Coogan's sexuality is reduced to the gaze of the lamp and the audience.

Abject Fmininity in *The Fountain*

When Thai curator, Professor Apinan Poshyananda first came across a photograph of *The Fountain* (fig.3) as an adjudicator for *EVA 2002*, he describes his reaction: "the image of a blond woman seated on the steps, with trails of urine between her legs, stopped me dead in my tracks" (qtd. in *Profile* 11). The act, which requires intense bodily control, is loaded with art historical references such as Bruce Nauman's *Fountain* (1965) and Andres Serrano's *Piss Christ* (1987) (*Profile* 12). However, in an interview with Mike Fitzpatrick, Coogan states that the main influence for the work came from the infamous case of Irish teenager, Ann Lovett who died along with her baby boy shortly after giving birth in a lonely grotto in Granard, Co Westmeath in 1984 (*Profile* 17). The case sent shockwaves through Irish society and inspired an outpouring of creative responses from many artists, including poets Paula Meehan, Nuala Ni Dhomhnaill and singer Christy Moore. Meehan, regarded as Dublin's informal poet laureate, was awarded the prestigious position of the Ireland Professor of Poetry in November 2013. She is acclaimed for giving a voice to people and places traditionally marginalized and forgotten and her poem "The Statue of the Virgin at Granard Speaks" is considered one of the most important

artistic touchstones of social and public life in the late twentieth century.

According to Jody Allen Randolph, Meehan's Irish poetic heritage can be found at "an intersection of countercultural ideas and Irish lyric tradition" (7). Randolph refers to Meehan's poems as "public poems," which are concerned with social and ethical commitments (8). Her "signature" public poem "The Statue of the Virgin at Granard Speaks" is, as Andrew Auge points out, an intervention into the public "cultural crisis of the prior decade, triggered by the fierce legislative battles on contraception, divorce, and abortion" (50).

> On a night like this I remember the child,
> who came with fifteen summers to her name,
> and she lay down alone at my feet
> without midwife or doctor or friend to hold her hand
> and she pushed her secret out into the night.
>
> (Paula Meehan, "The Statue of the Virgin at Granard Speaks" 41)

The significance of Meehan's poem was underlined when, in 2012, Meehan read extracts from it at a protest march organized in Dublin in the wake of the tragic death of Savita Halappanavar, where Ireland's ambiguous abortion laws were a key factor. This confusion put the welfare of Mrs. Halappanavar's unborn foetus above the growing risk to her life and reignited the debate around the control of women's bodies, resulting in major rallies across Ireland in a response of grief and shock. In the aftermath, there was intense pressure on the Irish Government to act immediately and as a result, legislation has now been implemented in 2014 to clarify rules that allow abortion in exceptional cases where doctors deem it necessary to save a woman's life. A report on the case, "Patient Safety Investigation Report published by Health Information and Quality Authority" was published in October 2013. The findings reflected "a failure in the provision of the most basic elements of patient care to Savita Halappanavar" ("Patient Safety" 1). In light of the above, and the thirty year anniversary of Ann Lovett and her baby, it is timely to re-analyze Coogan's work in the context of the ongoing controversy. Where Meehan's poem stresses the paralysis of the Irish state in the face of tragedy, and the helplessness of the woman, Coogan's performance stresses movement and bodily control.

In a recent interview I conducted with Coogan, she told me that she found *The Fountain* shocking and "extraordinarily difficult" to make (Interview 7). She was very reluctant to perform the work in Ireland (she had performed it in Germany) in view of its transgressive nature,

but after attending a rally on the Irish abortion referendum in Dublin in 2001, she decided the time was right to perform the piece. She describes the work:

> It's a very beautiful piece, if you get over the shock. It is a totally black stage, so there is an absolute distance. A light comes on straight into the middle of my legs and I try to hold it ... it should be fountainous. So when the light goes on, it is literally the vagina and the legs and then there is a beautiful spurt and there is a magnificent reflection of the vagina in the liquid and there is a spill of liquid in between the legs; light goes out, bang, that is it. It is about two and a half minutes. The acoustics are really important, that you hear the chamber music. In Joyce's terms "the beautiful chamber music." ("Interview" 8)

The description of the reflection of the vagina in the liquid echoes Irigaray's claim that female sexuality is defined in terms of that which is not solid. In her two major works *Speculum of the Other Woman* (1985) and *This Sex Which Is Not One* (1985), Irigaray's goal is to uncover the absence of a female subject position in both Freud's and Lacan's conceptions of female sexuality as lack. More importantly though, she sets out to disrupt the entire phallocentric order in which their discourses are situated, to uncover the feminine, and in particular a female style of writing, "woman-speak" or *parler femme*, which is *not* determined by phallogocentricism.

In addition to the claim that the feminine has historically been determined as a negative alterity within a masculine discourse, Irigaray makes two further fundamental claims, which determine her own philosophy. Briefly, these can be summarized as follows: firstly, she insists that it is not enough to reverse the phallocentric order, which would just result in a reproduction of the existing order. Secondly, the phallocentric order cannot be challenged from a position beyond its borders, as there is no real possibility of any theoretical discourse outside the phallocentric order. This abstract thinking would seem to negate all possibility of liberation for the feminine position, but this is crucial to Irigaray's thinking of an alternative position. She claims that a different position is possible through a disruption from within discourse, and this could be achieved by the process of mimicry or mimesis. Woman must assume the feminine role deliberately, in order to begin to thwart it. Importantly, mimesis must be accompanied by a laughter that is itself "the first form of liberation from a secular oppression" (Irigaray, *This Sex* 163). The laughter is, however, gendered and this is crucial; women must laugh among themselves in order to

escape from a masculine position and they must not forget to laugh. In mimesis, then, one must assume the feminine role deliberately. Subordination can then be turned into an affirmation, which may begin to disrupt it. While Irigaray's claims are abstract and contested, the notion of deliberately assuming the feminine role is a suitable framework for thinking about the two works under discussion in this essay.

Irigaray discusses the relegation of all things feminine to nature, fluids or unthinking matter. There is disquiet about the fluid, the half-formed and indeterminate that cannot be represented. In her essay, "The 'Mechanics' of Fluids," Irigaray claims that women do not speak the same as men, who are represented as solid and rational; what women emit is "flowing, fluctuating. *Blurring* ... Solid mechanics and rationality have maintained a relationship of very long standing, one against which fluids have never stopped arguing" (*This Sex* 113). Grosz, following Irigaray suggests that Western culture has "inscribed woman's corporeality as a mode of seepage ... they are represented and live themselves as seepage, liquidity" and is therefore a threat to order and stability (203). Although there are little differences in terms of the solidity of bodies across genders, women are still represented as prone to this liquidity because of the permeable borders of the womb. Irigaray urges women to create their own sexuality, arguing that the male organ is singular whereas there is a multiplicity to the female sex organs.

Coogan exploits the use of the female sex organ in *The Fountain* by illuminating her genitalia under a lamp and urinating in a controlled manner, while directly confronting her audience. Although this performance is uncontestedly transgressive, I suggest that, inscribed as it is in the cultural lexicon of the ongoing controversy over the control of women's bodies in Ireland, it produces a kind of *parler femme*, one which disrupts the largely masculinist legal discourse on the regulation of Irish women's reproduction. There is something horrific about the act of public urination by a woman, something forbidden and prohibited but within that, there is an urge to "tell" something about Irish society. Following Irigaray, I suggest that Coogan, along with the multiplicity of her sex, makes multiple references in this piece: the tragedy of Ann Lovett's death, the imposed regulation that has existed (and still exists) around the control of women's bodies in Ireland and the explicit direct confrontation with Freud's "Dark Continent" of female sexuality.

Novati argues that Coogan's public act of urinating in front of the viewer's gaze, while using a light to expose her genitalia plays with Julia

Kristeva's notion of abjection: "that which one cannot bear to look at, one cannot engage with" (Novati 188). In *Powers of Horror: An Essay on Abjection*, Kristeva argues that abjection represents all that is repulsive about the human body "these bodily fluids, this defilement, this shit are what life withstands, hardly, and with difficulty, on the part of death. There, I am at the border of my condition as a living being ... Nothing remains in me and my entire body falls beyond the limit" (3). Coogan's silent act, which makes public what is considered a private bodily function, confronts the audience with bodily fluids, forcing them to consider the isolation and vulnerability of Lovett and the circumstances of her death.

There is an act of witnessing involved in Coogan's silent performances, which complicate the relationship between performer and viewer; her use of transgressive corporeal strategies in *The Fountain* implicates the audience with the shame, humiliation and suffering of Lovett and also the shame of the Irish nation who allowed it to happen. Through her use of silence and the lived body in this radical performance, she interrogates the specific Irish dilemma around the female body: the attempt by the Irish state to control women's reproduction and the limited access to abortion in certain life-threatening circumstances. Furthermore, the idea of a woman publicly urinating in front of a live audience's gaze with a mirror displaying her genitalia echoes Kristeva's view that the abject is "that psychical process that draws me toward the place where meaning collapses" (2). This horror of fluids, which infiltrate and seep are historically associated with the fear of female sexuality, Freud's devouring *vagina dentata*. Abjection does not produce understanding but is an encounter with something that resists signification and throws us into a sense of disgust. The use of such radical corporeal strategies, in a "maniacally charged present" with the audience to highlight the issues around the female body is central to this performance.

"... out ... into this world ...": Bodily Intrusions in *The Fountain* and *Not I*

There is something horrific about Mouth's spewing speech and Coogan's public act of urinating in front of a live audience. *The Fountain* is a radical silent performance which confronts issues around female sexuality, through the public performance of a private bodily function. Similarly, Whitelaw's performance, which has been likened to the female orgasm, mimics Irigaray's representation of femininity as seepage and a disturbance to order. There is a striking similarity in the

theme and performances of both works which centre on the experience of birth and female marginality. Mouth has an urge to tell her story, as she subsequently runs to the nearest lavatory "sudden urge to ... tell ... then rush out stop the first she saw ... nearest lavatory ... start pouring it out ... steady stream" (382). Trish McTighe argues that this urge to run to the lavatory to perform the private act implies a "slippage between the mouth and anus, voice and waste" (66).

Mouth's spewing speech and Coogan's deliberate act of urination *as* speech are transgressive; both refuse to obey the rules of conventional discourse; instead, both performances produce a *parler femme* which disrupts a masculine discourse. Both reveal an uncomfortable alliance between speech and excretion as they expel the "... tiny little thing ... before its time" through a "godforsaken hole ... speechless infant"; then there is the "sudden urge to ... tell ... nearest lavatory ... start pouring it out ... [...] prayer unanswered ... or unheard ... whole body like gone ..." (376, 382). This alliance, with all its inappropriateness, makes Whitelaw's performance and Coogan's performance an affront to the senses, societal convention, and taste. The opening word of *Not I*, "out" is the moment when free will is replaced by the sudden bodily demand of birth, excretion, and in the case of Mouth, speech itself. I concur with Paul Stewart, who argues that "Mouth is herself expelled to then expel the play and the figure of the girl in what amounts to a succession of births: of Mouth, and then, through Mouth, of the play and the 'She' of the text" (184). I suggest that a similar expelling occurs in *The Fountain* through the act of urination, in which Coogan expels herself, spits herself out, abjects herself in order to give birth to her female self, echoing Kristeva's notion of abjection when "I expel *myself*, I spit *myself* out, I abject *myself* within the same motion through which 'I' claim to establish *myself* ... I give birth to myself" (3).

On the one hand, then, the performances of *Not I* and *The Fountain* can be viewed as a reaffirmation of Irigaray's theory of femininity as seepage, irrational and a disturbance to order. On the other hand, however, the radical disruptiveness of the performances is a challenge to thought systems that represent the female body as natural and passive. Both works can be considered as disruptions that attempt to make matter meaningful, and the effect of this on meaning and language itself. There is a striking similarity between both performances where a female organ expels and spits itself out in order to birth female identity. Coogan and Whitelaw must abject themselves in order to claim a *parler femme*. There is a radical, disruptive and transgressive nature to both works, but, within that disruption, a

powerful female corporeal is at work, subverting a patriarchal discourse and taking up a position of resistance.

Coogan's *Fountain*, while radical and transgressive, confronts several issues around female sexuality. By publicly performing an act which is a private bodily function in order to "speak" about the ongoing controversies surrounding women's bodies and lack of choice in Ireland, she makes a choice in doing so. She chooses to expose herself, to abject herself, in order to draw attention to these issues. Similarly, Billy Whitelaw's televised performance of Beckett's *Not I*, which has been compared to female orgasm, mimics the representations of the feminine as fluid, irrational and disturbance. Both performances *parler femme*, talk vaginally to challenge patriarchal systems that represent the female body as natural and passive, and woman as unrepresentable, transgressive and marginal.

Works Cited

Auge, Andrew. "The Apparitions of 'Our Lady of the Facts of Life': Paula Meehan and the Visionary Quotidian." *An Sionnach: A Journal of Literature, Culture, and the Arts* 5 (2009): 50-64. Print.

Beckett, Samuel. *Samuel Beckett: The Complete Dramatic Works*. London: Faber, 2006. Print.

Ben-Zvi, Linda, "*Not I*: Through a Tube Starkly." *Women in Beckett: Performance and Critical Perspectives*. Ed. Linda Ben-Zvi. Illinois: Illini Books, 1992. 243-48. Print.

Coogan, Amanda. Home page. http://www.amandacoogan.com. Web.

---. Interview with Brenda O'Connell. 12 July 2011. Unpublished.

Foucault, Michel. *Discipline and Punish: The Birth of the Prison*. Trans. Alan Sheridan. Harmondsworth: Penguin, 1977. Print.

Freud, Sigmund. "The Question of Lay Analysis." *The Standard Edition Of The Complete Psychological Works of Sigmund Freud. Volume XX* (1925-1926). London: Vintage, 2001. 207-17. Print.

Gidal, Peter. Understanding Beckett: A Study of Monologue and Gesture in the Works of Samuel Beckett. London: Macmillan, 1986. Print.

Grosz, Elizabeth. *Volatile Bodies: Toward a Corporeal Feminism*. Indiana: Indiana UP, 1994. Print.

Irigaray, Luce. *Speculum of the Other Woman*. Trans. Gillian C. Gill. Ithaca, New York: Cornell UP, 1985. Print.

---. *This Sex Which Is Not One*. Trans. Catherine Porter and Carolyn Burke. Ithaca, New York: Cornell UP, 1985. Print.

Knezevic, Barbara. Rev. "Amanda Coogan: *The Fall*, Kevin Kavanagh Gallery, Dublin. 25 June 2009." *Circa: Contemporary Art in Ireland*. Web. 20 May 2011.

Kristeva, Julia. *Powers of Horror: An Essay on Abjection*. Trans. Leon S. Roudiez. New York: Columbia UP, 1982. Print.

Maude, Ulrika. *Beckett, Technology and the Body*. Cambridge: Cambridge UP, 2009. Print.

Meehan, Paula. "The Statue of the Virgin at Granard Speaks." *The Man Who Was Marked By Winter*. Washington: Eastern Washington UP, 1994. 41-42. Print.

McMullan, Anna. *Performing Embodiment in Samuel Beckett's Drama*. London: Routledge, 2010. Print.

---. Theatre on Trial: Samuel Beckett's Later Drama. London: Routledge, 1993. Print.

McTighe, Trish. *The Haptic Aesthetic in Samuel Beckett's Drama*. New York: Palgrave Macmillan, 2013. Print.

Novati, Gabriella Calchi. "Challenging Patriarchal Imagery: Amanda Coogan's Performance Art." *Crossroads: Performance Studies and Irish Culture*. Ed. Sara Brady and Fintan Walsh. Basingstoke: Palgrave Macmillan, 2009. 180-95. Print.

O'Regan, John, ed. *Amanda Coogan: Profile 21*. Cork: Gandon, 2005. Print.

Parsons, Kate Antosik. "Bodily Remembrances: The Performance of Memory in Recent Works by Amanda Coogan." *Artefact: Journal of the Irish Association of Art Historians* 3 (2009): 6-19. Print.

Patient Safety Investigation Report. *Health Information and Quality Authority*. Web. 3 Feb 2014.

Phelan, Peggy. *Unmarked: The Politics of Performance*. London & New York: Routledge, 1993. Print.

Randolph, Jody Allen. "Text and Context: Paula Meehan." *An Sionnach: A Journal of Literature, Culture, and the Arts* 5 (2009): 5-16. Print.

Ruane, Frances. "A Provocative Performance." *Irish Arts Review* 21.2 (2004): 52-53. Print.

Scarry, Elaine. *The Body in Pain: The Making and Unmaking of the World*. New York & Oxford: Oxford UP, 1985. Print.

Stewart, Paul. *Sex and Aesthetics in Samuel Beckett's Work*. New York: Palgrave Macmillan, 2011. Print.

Turner, Bryan. *The Body and Society: Explorations in Social Theory*. 2nd ed. London: Sage, 1996. Print.

Weller, Shane. *Beckett, Literature and the Ethics of Alterity*. Basingstoke: Palgrave Macmillan, 2006. Print.

Wilson, Ann. "'Her Lips Moving': The Castrated Voice of *Not*." Ben-Zvi 190-200. Print.

9 | Blurring Boundaries and Collapsing Genres with Shannon Yee: Immersive Theatre, Pastiche, and Radical Openness in the North

Fiona Coffey

In recent years, many Northern Irish theatre practitioners have embraced experimental and non-traditional theatre techniques, moving away from conventional text-based plays rooted within social realism. Kabosh Theatre Company now specializes in site-specific theatre and installation; Big Telly Theatre Company and Tinderbox Theatre Company have both produced site-specific shows since 2000; and Prime Cut Productions and Skinnybone Theatre produced successful immersive theatre projects in 2012 and 2013 respectively.[19] There is, perhaps, a growing sense among Northern theatre practitioners that social realism, long-embraced in Ireland, can no longer adequately express the fractured identities, complex political status, economic upheaval, and uncertainty about the future that embodies the post-Agreement North.

Much of the theatre produced during the Troubles (1968/9-1998) used social realism to promote realistic and truthful experiences of living within sectarian conflict. These plays tended to have clear and focused stories that reflected the urgency and specificity of Northerners' individual and collective experiences. In contrast, theatre of the post-Agreement North tends to reflect the confusion, ambivalence, and ambiguity that have come with peacetime. This uncertainty has been reflected in complex, experimental play structures that often include

[19] Primecut produced an immersive project called *The Baths* (2012), and Skinnybone Theatre produced *Happy Friday* (2013).

the blurring of genres, non-traditional theatre techniques, and audience interaction. Rather than telling one specific story or trying to engender a particular emotional or intellectual response, experimental post-Agreement theatre tends to promote ambiguity in spectators' experiences and highly individualistic interpretations of the performances.[20]

Adding to this growing trend of interactive and experimental theatre practices is artist Shannon Yee.[21] Yee is a Belfast-based practitioner whose work collapses traditional theatrical boundaries and blurs genres, mixing multimedia, music, dance/movement, sound technology, installation art, and experimental theatre traditions. As a biracial, queer, Chinese-American immigrant playwright with an acquired brain injury, she may epitomize in a single body a new range of diversity and change that has come to the North in the past fifteen years. More importantly, she uses her multiple minority identities to tackle difficult and taboo subjects in non-traditional ways. Her artistic work pushes the boundaries of theatrical form and structure while also advocating for those on the margins of Northern society such as the Lesbian Gay Bisexual Transgender (LGBT) community and those with disabilities. One of her most complex and politicized works combines two taboo subjects in the North (homosexuality and the Troubles) into

[20] Since 2000, a wide variety of experimental theatre projects have been performed in the North. Tinderbox Theatre performed a site-specific piece called *Convictions* (2000) at the Crumlin Road Courthouse in Belfast; audience members were led through different rooms of the historic courthouse while scenes addressed shifting notions of what constitutes justice, punishment, and passing judgment in the post-Agreement North. In 2010, Kabosh staged an interactive theatre piece called *The West Awakes* (2010), which took audience members on a walking tour of west Belfast, playing off the popularity of political tours given to tourists by former Republican prisoners. This production challenged the role of the media in shaping the conflict and in privileging certain narratives of the Troubles. Kabosh also produced *1 in 5* in 2011, which was staged in the Limavady workhouse for the poor in Derry/Londonderry. This production explored the on-going issue of poverty by staging contemporary scenes within the historical framework of the Limavady workhouse (known for enforcing brutal work conditions between 1842-1932). In addition to challenging spectators to experience theatre in a new way, each of these productions addressed complex debates in contemporary Northern society in a manner that promoted complexity and defied a singular interpretation.

[21] Yee's legal last name is Sickles but she writes creatively under the pen name Yee.

a unique genre-bending, immersive theatre experience entitled *Trouble* (2013).[22] Another of Yee's performance pieces, *Recovery* (2012), uses installation and advanced binaural technology to address the sensitive subjects of disability and brain trauma. In 2008, Yee contracted a rare brain infection that left her with mild impairments such as noise sensitivity and the occasional inability to verbalize her thoughts. Both *Trouble* and *Recovery* defy conventional theatrical form, pulling from different artistic traditions and technologies to create pastiche artworks that also directly advocate for those on the margins. With her unique blend of artistic technique and influences, Yee creates individualized and interactive performances for her audience members that place the spectator at the centre of the theatrical experience and engender compassion, empathy, and understanding for those who identify outside of traditional identity politics in the North.

Yee first received funding in 2010 from the Arts Council of Northern Ireland to develop a theatre project, which would eventually become *Trouble*. The "o" in *Trouble* is drawn as a pink triangle with a vertical line next to it, turning the universal symbol for gay pride also into the symbol for the rewind button. The rewind button is about returning to the past and uncovering a history of queer culture that has been ignored and suppressed. Yee views the project as an important documentation of a history that has not been taught to the current generation of young men and women who are growing up with the privileges achieved by the queer activists who came before them. Yee travelled around the North and collected the stories of queer rights advocates who were active during the Troubles. The play, which is still in development, charts how the first generation of Northern gay activists in the 1960s and 1970s fought for and achieved important milestones in the fight for equal rights. The achievements and infrastructure that this first generation realized created a solid foundation for a second generation of prominent activists during the early 1990s. The last decade of the twentieth century was the first time a cohesive queer community developed and chose to stay in the North rather than leave (most often for London). In this project, Yee charts the untold history of queer activism during the height of the Troubles. In her blog, Yee describes the project as:

> A biographical, interview-based play that explores the experiences of a generation of individuals from the LGBT community that realized their sexuality while growing up during the Troubles in

[22] This is a working title.

Northern Ireland. The play interweaves individuals' personal stories of cultural identity, sexuality and coming out, religion, feminism, sectarianism, racism, conversion therapy, paramilitaries, politics, the normalization of violence and the effects of the Troubles on the psyche with important historical moments including the Hunger Strikes, the rise of the social LGBT scene and activism, the IRA ceasefire and Good Friday Agreement, the murder of Darren Bradshaw in the Parliament Bar, and the police raids on gay men which led to the European Court case that decriminalized homosexuality in NI.

Yee is one of the first people in the North to address the intersections between queer identity and the Troubles, and this is the first time the Arts Council has funded such an effort.

Queer theatre in the North has slowly become more visible in recent years. TheatreofPlucK, the North's first publically funded queer theatre company, has performed several shows addressing queer issues such as *Automatic Bastard* (2006/7), *We Always Treat Women Too Well* (2008), *Bison* (2009/10), *Divided, Radical And Gorgeous* (2011/12), and *Lesbyterian MissConceptions* (2012/13). Sole Purpose Productions, based out of Derry/Londonderry, recently performed *Pits and Perverts* as part of the 2013 Derry/Londonderry City of Culture celebrations. The play follows a young gay man who leaves Derry/Londonderry at the height of the Troubles to forge a freer life in London and becomes involved in the gay community's support of the Welsh Miner's strike of 1984/5. In addition, homosexuality has been dramatized in more subtle ways for decades within Northern Irish theatre. For example, celebrated playwright Frank McGuinness often includes characters of ambiguous sexual identity in his plays, and more recently, playwrights Jaki McCarrick and Stacey Gregg have also included gay characters in their work.[23]

In addition to this growing canon of inclusive theatre, the creation and promotion of Outburst, a queer arts festival, has dramatically raised the profile of queer culture and art in Belfast in recent years. Niall Gillespie, Patrick Sanders, Michele Devlin, Ruth McCarthy, and Shannon Yee founded the festival in 2007. The annual event is Ireland's only multi-disciplinary, ten-day arts festival, and it showcases theatre, dance, film, visual art, music, storytelling, readings, stand-up comedy, academic lectures, and writing and performing workshops. The festival

[23] Jaki McCarrick's *Belfast Girls* (2012) and Stacey Gregg's *Lagan* (2011) both have characters struggling with issues of sexuality.

advertizes publically in Belfast and has done a lot to raise the profile of the queer community in the city.

Yee is furthering this growing dialogue about queer culture and art with *Trouble* which she developed with Anna Newell (artistic director of Replay Theatre Company in Belfast) and Niall Rea (set designer and founder of TheatreofPlucK). Newell is known for her site-specific and immersive theatre projects that incorporate music, dance, installation art, and technology. Rea has an astute design aesthetic as well as his own experience working on the intersections between sexual identity politics and sectarian divisions in the North.[24] Together, the three theatre practitioners designed a dynamic, immersive experience that blended technology, art installation, music, dance, and verbatim theatre into a performance that allows each audience member to contribute his own experiences, memories, emotions, and ideas about queer identity and the Troubles.

The dialogue in *Trouble* is composed from the original interviews that Yee conducted and was initially inspired by the verbatim theatre and docudrama style of American playwrights Anna Deavere Smith and Eve Ensler. Verbatim theatre, which is a subset of docudrama, started in the UK during the 1970s.[25] It typically uses taped recordings of interviews and speeches, which are then transcribed and used as the primary (or only) source of dialogue in the performance. Performers of verbatim theatre often try to replicate the natural vernacular speech of the original recordings as closely as they can, replicating breaths, stutters, dialects, and emotion. Furthermore, verbatim drama is often a form of political theatre or social activism, using the stage to publically voice the stories and experiences of an oppressed group. It became increasingly popular during the 1990s buoyed by two of the best-known verbatim practitioners in the United States: Anna Deavere Smith and Eve Ensler. Smith produced two of her most famous pieces, *Twilight: Los Angeles* and *Fires in the Mirror* in the early 1990s; both plays

[24] TheatreofplucK toured *D.R.A.G. – Divided, Radical, And Gorgeous* around the island in 2012 which addressed coming of age as a gay man during the Troubles.

[25] The British documentary film movement of the 1930s and 1940s, the Living Newspaper Theatre of depression era United States, radio drama, Joan Littlewood's Theatre Workshop of the 1950s and 1960s, and the works of Peter Cheeseman and Charles Parker all influenced the rise of verbatim theatre. For more information see Derek Paget's 1987 seminal article in *New Theatre Quarterly*, "Verbatim Theatre: Oral History and Documentary Techniques."

addressed issues of race, identity, and prejudice in America. Ensler is best known for the *Vagina Monologues* (1996), which explores women's sexuality, relationship to their bodies, and pressure to conform to social norms. Smith and Ensler interviewed and recorded conversations with ordinary people and then transcribed (word-for-word) and edited the stories into a compelling series of monologues that comprise their plays.

In the North, this purest form of verbatim theatre has rarely been presented. This is, perhaps, in part due to fatigue felt towards the pervasiveness of the monologue play, which often presents first-person narratives. However, a few theatre companies have recently begun to experiment with verbatim techniques. Replay theatre, which is dedicated to youth audiences, performed *Bulletproof* in 2010; this production used interviews with teens living with mental health issues as the basis for its dialogue.[26] In addition, writer/director Kevin O'Connor created a production in 2012 entitled *Troubled Conversations,* which based its dialogue on interviews with ex-provisional IRA volunteers and victims of sectarian violence.[27] Inspired by the strong verbatim tradition in the United States, Yee decided to use verbatim theatre techniques and combine them with more recent innovations in site-specific and immersive theatre. Immersive theatre, which has become extremely popular in London and New York in the last ten years, grew out of American theatre practitioner Richard Schechner's environmental theatre movement of the 1960s. Environmental theatre worked to erase the traditional boundaries between audience and performer and encouraged interaction between

[26] Playwright Gary Owen interviewed dozens of teenagers who struggle with depression, attention deficit hyperactivity disorder, and manic depression and then built the play around these personal stories.

[27] *Troubled Conversations* was performed by four actors in a short, three-night run that toured community centres in Cavan, Derrylin, and Clones. In addition, other playwrights are starting to experiment with other forms of docudrama such as Owen McCafferty's *Titanic* (2012), which explored the two-month investigation regarding the sinking of the Titanic, pulling language from newspapers and court documents. In addition, Bloody Sunday: Scenes from the Saville Inquiry, which was produced by the London-based Tricycle Theatre, toured Derry/Londonderry and Dublin in 2005. However, this was created by London journalist and playwright Richard Norton-Taylor who used language from the Saville Inquiry, court documents, and newspapers to create a docudrama piece that exposed the corruption of the original investigation.

actors, audience members, and the performance space. Similarly, immersive theatre, which did not emerge in its current form until 2000, encourages audiences to interact with the performance using all five senses. Typically, audience members move through the performance space, exploring their surroundings at will, such as rummaging through the set dressings, opening up drawers, reading letters or books, or unlocking secret boxes. The experience also involves interacting with the performers, often eating/drinking food that is offered, and sometimes smelling scents related to the performance. The goal of the immersive theatre experience is to transform the audience member into an active participant in the show and to break the traditional rules of theatre that require spectators to stay passively and quietly in their seats. Site-specific theatre, which started in the 1970s, was also a natural outgrowth of the environmental theatre movement and is defined by performance in non-traditional theatre spaces (such as a public restroom, a forest, or a historic building).

The influences of verbatim, immersive, and site-specific performance traditions are clearly at work in the most recent version of *Trouble*. During the summer of 2013, Yee launched an invitation-only workshop version of the production which was performed at the Metropolitan Arts Centre (MAC) in Belfast. Individuals were led into the performance space one by one and allowed to wander through several interlinking rooms at their own pace, allowing each audience member a unique and personal experience of the project. Spectators also used flashlights to make their way through the darkened rooms, each of which had a different focus and reflected the different stories told to Yee during her interviews.

In the first room, audience members listened to Yee's recorded voice in which she talked about the origins of the project, her interview process, and the artistic decisions she contemplated in making *Trouble* an immersive theatre experience. In doing so, Yee highlighted her role as the author of the project and made visible the process and goals behind interviewing and constructing the stories of gay identity during the Troubles. Interspersed throughout the other rooms were Yee's recorded observations about the people she had interviewed. Thus the audience members heard a brief description about what the interviewees looked like, how they sounded, their gestures, and their emotions before then hearing an excerpt from the original interview voiced by an actor. Yee's descriptions allowed the audience member to imagine a more comprehensive picture of the person whose story they

were about to hear while still maintaining the anonymity of the interviewees.

In one room, videos of actors' eyes and lips were projected onto the walls as audio recordings of the interviewees' stories were played. The room addressed the complex, fractured, and hybrid identities that lesbian women struggled with during the height of the Troubles. Interviewees' stories described how feminist, sectarian, and lesbian agendas often clashed, preventing Protestant and Catholic women from forming a cohesive community of support and advocacy. The following excerpt which was voiced by an actor for audience members reflects these ideas and also highlights how Yee embraced verbatim theatre traditions by having actors recreate the interviewees' speech patterns and mannerisms in order to replicate the original interviews as closely as possible:

> We were talking about it in the women's movement. It was usually a fairly lively debate. Because Republican women and the women's movement wasn't as blended as it could've been. It should've been a blended thing but I think it was...
>
> (pause; 'let me try again')
>
> There was radical feminism and there was socialist feminism and then there was like, the Republican women and women prisoners and somehow these groups were...
>
> (pause; 'let me try again')
>
> We were such a small country we had to join together, but it was as if there were areas where there was unease, where it was threatening. Problematic. I don't know why. There were different agendas. Different ideas for the step forward. Different ideas for political change. Different priorities. Women in prison, abortion, lesbian rights–I feel those things are all valid and yet, I could never seem to...
>
> (pause; 'let me try again')
>
> Arguments and rows would break out. I couldn't see how any of those issues were different. It's as if one issue was given attention then another section would think, what about ours? It's like there wasn't room to co-exist (Yee, *Trouble*).

The room captured how fractured and divisive the lesbian community often was during the Troubles and also highlighted the complex multiplicity of oppressive forces such as sexism, homophobia, religion, nationality, and colonialism which often created division rather than cohesion for women in the North.

In the middle of another room, two female actors performed meeting each other for the first time at an alternative Belfast nightclub during the 1980s. Audio recordings of actors reciting excerpts from interviews were played over loud speakers. The monologues described the LGBT social scene during the Troubles along with the unspoken rule that sectarian identity was checked at the door when one entered an alternative club. Audience members heard stories that recounted how queer identity often overpowered sectarian identity:

> The gay scene seemed neutral on the surface anyway ... well, they were there to get a shag and get off so they weren't gonna start ... if they were thinking 'Oh, you're Catholic' or 'Oh, you're Protestant' that was put aside for the sake of ... a night's fun. I never heard anything sectarian or felt anything sectarian in the gay scene. I never had a care for who anybody was, or where they were from. I was just in Belfast to find lesbians. I didn't care if they were Catholic or Protestant (Yee, *Trouble)*.

Another monologue described how Belfast City Centre was abandoned at night during the Troubles, which allowed the gay community to socialize at night without much intervention:

> Whenever the Troubles were at their height, the only bars that were open in Belfast City Centre were the gay bars. The Crow's Nest, the Parliament, Delaney's. The only people that didn't give a shit about the Troubles were the gays—we got out there and we partied and we had a good time. Because the city centre was a no-go area, the city centre was the gays' domain at night, there was nobody else about. You didn't have to worry about people seeing you. I guess we were pioneers in a way (Yee, *Trouble)*.

In another room, set in the gay club scene, a disco ball swirled while a lone man sang romantic ballads from the 1980s pop charts. The room evoked the loneliness and isolation of being gay during the Troubles even when present in a busy alternative nightclub. Another room offered a one-on-one experience between actor and spectator. One audience member at a time was allowed to enter a small room where a single actor in his underwear delivered a monologue about Darren Bradshaw. Bradshaw was a Royal Ulster Constabulary (RUC)[28] officer who was killed in the Parliament Bar in Belfast (a well-known gay bar) by the Irish National Liberation Army[29] in 1997. As the actor recited the monologue, he slowly got dressed in his uniform, finally revealing to the

[28] Northern Irish Police Force.

[29] The INLA is a republican paramilitary group that split off from the Irish Republican Army in the early 1970s.

audience member that he is an RUC officer. The monologue explored the repercussions of Bradshaw's killing throughout the gay community and how it ultimately brought Protestant and Catholic men together to support civil and human rights. When the monologue was over, the RUC officer fingerprinted the audience member and gave her a copy of her fingerprints and an excerpt of the interview about Bradshaw before ushering her out of the room.

Another room was filled with small lockers, some of which held notebooks representing all the interviews and stories that Yee had collected in her research. Each notebook included where the interviewee was born, some biographical details, and also contained a selection from his or her interview. Audience members could read the excerpts or go to one of the lockers which had speakers inside and listen to an actor performing an excerpt from the interview. At one particular locker, the audience's gaze was directed out a window and into an alleyway, creating an important moment of site-specific theatre. As they listened to the narrative on the locker's speaker, they heard the story of a closeted gay man who recounted to Yee how he watched one day with envy as another man casually bought a newspaper called the *Gay Times* at the local book store. Listening to the story, the audience member gazed out the window into the alley, imagining the encounter. The spectator was thus transformed into the role of the closeted gay man watching with desire and envy as he saw another man feel confident and proud enough to do the seemingly simple task of buying a newspaper without shame or fear.

Audience members also walked by a room which they could not enter but where they could hear a shower running. This room evoked the difficult experience for young gay students of having to shower publicly with their classmates after sports class, an issue that arose several times in Yee's interviews. As audience members walked by, they constructed the meaning of the room individually based on their own personal experiences. Thus, the sound of the shower running might evoke deeply personal resonances for one audience member while it might not affect another audience member at all.

Most of the rooms at the MAC workshop worked in this manner. Each room evoked ideas, memories, associations, and emotions rather than telling a straight narrative of LGBT experiences during the Troubles. Audience members were invited to construct meaning and impact by adding their own personal memories and feelings to the immersive experience of the show. In doing so, everyone's experience of *Trouble* was profoundly different and deeply personal. *Trouble* was also

unique in that its structure allowed the multiplicity of different reactions, ideas, and emotions that Yee heard in her interviews to overlap, intersect, and meld together. The result was that one narrative, perspective, or character was never allowed to dominate the experience.

Yee's work on *Trouble* is difficult to quantify or categorize. It is ultimately an experimental pastiche that pulls from a variety of different art forms including immersive and site-specific theatre, verbatim theatre and docudrama, installation art as well as dance, text-based drama, and sound and projection technology. Yee describes the project variously as a "quasi-historical archive that's part verbatim theatre," a "living history," and an archive of memory and emotion (Yee, Interview). Another useful way of characterizing Yee's work is as a form of pastiche theatre.

American queer theatre artist Taylor Mac has used the term *pastiche* to describe his own form of theatre which, like Yee, pulls from a variety of different theatrical and artistic traditions. Mac uses influences from musical theatre, camp, drag, disco, glam rock, Japanese Noh drama, vaudeville, puppetry, dance, installation art, film, and popular culture (Edgecomb). In doing so, Mac mixes high and low art forms to create a new cohesive performance that draws from many diverse sources but ultimately creates a unified performance tradition that is complete and whole rather than fractured or divisive (as postmodern theatre tends to be). Mac rejects all forms of social realism as he believes it reinforces heteronormative traditions. In a public speech entitled, "I Believe: A Theater Manifesto by Taylor Mac," which the artist performed at the *Under the Radar Festival* "From Where I Stand Symposium" in New York City on 10 January, 2013, Mac proclaimed, "I believe homophobia, racism, and sexism—in the theatre—often manifests itself through the championing of 'Realism' and 'Quiet' plays" (*Manifesto*). Similarly, theatre artists in the post-Agreement North have been using experimental theatre techniques in part to break with the past and to challenge traditional narratives of history, identity, and territory. *Trouble* and *Recovery* both borrow from multiple influences, creating unique pastiche artworks that take inspiration from technology, media, science, music, audio/sound, storytelling, dance/movement, and theatre. In doing so, they prevent audience members from reflexively interpreting their art through a sectarian lens and challenge spectators to shed their preconceptions and absorb the experience through new, unbiased senses. However, unlike postmodern theatre which tends to create discord, fracture, and disharmony by pulling from multiple artistic, cultural, and technological sources, Yee's performance pieces

tend to promote compassion, empathy, and cohesion even while highlighting difference.

Although the taboo subject matter of *Trouble* arguably puts it on the margins, the core of the project is actually in line with more mainstream goals that the Northern government is currently championing with peace and reconciliation. While the peace process in the North is often narrowly understood to be an effort to create cooperation and peace between Catholics and Protestants, the broader goal is arguably to promote compassion and understanding for those who are different and to find strength in diversity. In line with this ambition, Yee's theatre fosters compassion, empathy, and understanding for differences, and she uses non-traditional forms, structures, and techniques to get these ideas across to her audience members. Yee's larger project could perhaps be characterized as promoting cultural pluralism and hybrid identities. While the North has long enforced essentialist identity politics on its citizens by encouraging a singular identity in line with sectarian affiliation, Yee's artistic work encourages audiences to embrace the multiple identities that come from their gender, religion, profession, and politics and shows how Northern culture can be strengthened by hybrid identity.

In addition to her immersive theatre work with *Trouble*, Yee has also produced an interdisciplinary performance piece based on the severe illness she contracted which left her with permanent brain trauma. In 2008, a sinus infection turned into a subdural empyema, a rare brain infection that required multiple operations and months in the Acute Neurology Ward at Royal Victoria Hospital in Belfast. She turned this harrowing experience into a twelve-minute performance piece entitled *Recovery* which debuted at the 2012 summer Pick n' Mix Festival in Belfast. She designed the piece in conjunction with the Sonic Arts Research Centre at Queens University, which uses 3D-sound and binaural technology. Binaural technology reproduces recorded sound in a manner that is similar to the way that humans naturally hear (with sound coming from above, behind, and below a person); this is in contrast to stereophonic sound that artificially splits sound into right and left speakers to recreate sonic directionality. The effect of a binaural recording is a much more realistic and intimate experience that recreates the sensation of live, unrecorded sound. Yee has had to manage physical and cognitive fatigue and hyperacuity (noise sensitivity) as a result of her brain surgeries, and she wanted to create a performance that would give her audience a sense of the aural experience that she had on a daily basis. Interwoven with the sound

sensations, Yee created a fragmented narrative of her time and recovery in the hospital in an attempt to transport the audience inside her head. Audience members entered a room where they lay down on a hospital bed. An actress dressed as a nurse put an eye mask and earphones on the participant, creating darkness and sensory withdrawal. The nurse then asked questions such as: "Have you or someone you know personally or professionally experienced any of the following: brain tumour, concussion, Multiple Sclerosis, Parkinson's disease ..." Through earphones, each person listened to a series of sounds that took the listener on an aural experience of Yee's diagnosis of brain trauma through the process of her recovery. Using binaural recording techniques, the performance used advanced 3D sound to create a new genre of performance, which Yee calls a "choreography of sound and dramatic narrative" (Yee, Interview). *Recovery* is part art installation, part radio drama, and part visceral auditory experience. A review from *Culture Northern Ireland* wrote, "It is a deeply affecting recreation of the process whereby Yee's brain was disassembled then put back together, 'slightly askew.' A wrap-around soundscape, combined with drama, music and vivid word pictures, marks the first phase of an internal nightmare" (Coyle).

Like *Trouble, Recovery* is based on real-life experiences, and it does not tell or narrate what happened to the audience member but rather places the spectator at the centre of the performance, effectively moving the audience from voyeurs to participants. Each person is asked to experience another's emotional and mental journey and encouraged to find compassion and empathy for the stories they are experiencing. Yee believes that the audience's experience of entering into her brain, thoughts, and emotions has the potential to transform a clinical understanding of brain trauma into a better physical and emotional appreciation of a patient's experiences. This has the potential to transform doctors' care, enhance family empathy, and create better support for the recovery process.

Typically a very private person, Yee states that she was willing to expose her personal struggles and private medical history "for those reasons of trying to bring awareness of brain injury and what that experience is like ... [*Recovery*] is the closest thing to getting inside [not only] what was specific to my experience but also [gaining a better understanding about related issues such as] fatigue, noise sensitivity, and cognitive overwhelm" (Yee, Interview). In exposing such a profoundly personal experience, Yee is practicing what Taylor Mac would describe as radical openness. Mac believes that the more

truthful, exposed, honest, and emotional a performance is, the more the audience will connect to their own humanity. In his mission statement posted on his website, Mac explains, "I believe the more personal risk I take in the work, the more the audience will relate and see the whole of their humanity reflected back at them. So, through art, I try to be as masculine, feminine, ugly, beautiful, intelligent, base, chaotic, graceful, joyful, sorrowful, perfect and flawed as I am in real life" (Artist Statement). Mac regularly practices radical openness by performing biographical shows including one based on his difficult relationship with his father (*The Young Ladies Of*, 2008) and by exposing himself physically and emotionally in all his performances.

Yee also seems to be practicing a form of radical openness in her own work and life. In 2004, Yee and her partner, Gráinne Close, were wed in the UK's first civil partnership ceremony at Belfast City Hall. Although Northern Ireland was the last place in the United Kingdom to decriminalize homosexuality in 1982, it was also the site of the first civil partnership when Yee and Close were legally joined in 2005. Yee allowed filmmakers from the BBC to document her relationship to Close and her marriage as the first civil union in the UK.[30] The documentary was shown on television across the UK in 2005. *Trouble* also engages a form of radical openness by asking Northerners to share stories of their sexuality and by revealing a history of queer activism that until now has largely been overlooked in the North. Although the interviewees are not named in the performance, their stories are deeply personal and honest and are recounted word-for-word in the exact manner they were originally told. In addition, Yee takes care to reveal her research and interview processes with the audience, infusing herself directly into the performance experience and also creating a sense of transparency in how the production was researched and structured. Furthermore, *Recovery* is not simply a form of autobiographical theatre but an intimate look at Yee's private medical history, the inner workings of her traumatized brain, and her emotional and cognitive journey in coming close to death. The North has historically privileged personal privacy as both a cultural preference and a survival mechanism within sectarian conflict. Yee's works, therefore, have perhaps even greater impact and meaning as they are brave examples of a radically open and honest form of artistic communication.

While *Recovery* and *Trouble* are very truthful and realistic in their *content*, each of their dramatic *forms* is very stylized and non-

[30] This documentary was first aired on December 19, 2005 on BBC1.

traditional, and both projects speak to the hybridity of Yee's work and to her identity as an artist. Yee reflects,

> There is a move in entertainment generally towards a blurring of the boundaries. There is this weird blurring of definitions and from that there is a lot of hybridization happening. I think *Recovery* is certainly [hybrid] because it's not a radio drama although you listen to it, it's not specifically only sonic arts because there is a dramatic narrative and through-line, and hopefully it's not just biomedical content (Interview).

As an immigrant with multiple minority identities, Yee has proven to be vitally important in diversifying and regenerating a more inclusive arts sector in the North. Her bravery at tackling taboo or marginalized subject matter, the innovative forms and immersive experience of her performances, the honesty and truthfulness of her work, and her emphasis on engendering better understanding, commonality, compassion and empathy for those on the margins of Northern culture make her work radical, innovative, and vitally important. In addition, putting the audience (rather than actor or text) at the centre of her work and encouraging each spectator to construct his/her own narrative empowers Yee's audiences and connects them to difficult subject matter in an intimate and effective way. Although her multiple minority identities may put Yee on the margins of Northern culture, she proves that it is a fruitful place to be as an artist, and she shows that the most pioneering and inspiring creative work can often come from being an outsider looking in.

Works Cited

Coyle, Jane. "Theatre Review: Pick 'n' Mix Festival." *Culture Northern Ireland.org*. Northern Ireland Tourist Board, 11 June 2012. Web. 11 Aug. 2014.

Edgecomb, Sean. "The Ridiculous Performance of Taylor Mac." *Theatre Journal* 64.4 (Dec 2012): 549-63. Print.

Mac, Taylor. "Artist Statement." *Taylor Mac.net*. n.d. Web. 11 Aug. 2014.

---. "I Believe: A Theater Manifesto by Taylor Mac." *Taylor Mac.net*. 10 Jan. 2013. Web. 11 Aug. 2014.

Paget, Derek. "Verbatim Theatre: Oral History and Documentary Techniques." *New Theatre Quarterly* 3.2 (1987): 317-36. Print.

Yee, Shannon. "Gay & Troubled Synopsis." *ShannonYee*. Wordpress. 22, July 2011. Web. 11 Aug 2014.

---. Skype Interview. 16, Oct. 2013.

---. *Trouble*. MAC workshop version. 2013. TS.

10 | Pain, Rain, and Rhyme: the Role of Rhythm in Stefanie Preissner's Work

Kasia Lech

> When the world is changing
> And one faces difficult times,
> What is the value in expressing
> One's struggles in rhymes?

During the 2012 talk hosted by the Abbey Theatre, "Streets to the Stage: Dublin Stories as Poetry," Dublin hip-hop artist Lethal Dialect said that using rhythmical language to talk about everyday issues allowed him to speak about these issues in his own way. And that the people who listen do not have to agree with him, but can still appreciate the rhythm and, in turn, can appreciate his work. Dialect's comment made within the walls of the Abbey allows one to note two phenomena. Firstly, rhythmical language seems to facilitate well the voices of artists that emerged during the last decade. Secondly, rhythmical language appears to have an increasing appeal for various contemporary audiences. All this is visible in new productions created and performed by the current generation of theatre artists.

During the 2011 and 2012 ABSOLUT Dublin Fringe Festivals audiences encountered four different shows that used verse to speak about the younger generation's identity in the context of history, religion, the economic crisis, and globalization. In 2011 Polish Theatre Ireland used the poetry of the Nobel poet Czesław Miłosz to devise *Chesslaugh Mewash*. The company used verse in six different languages to explore the idea of identity as being unstable and yet imposed and indispensable in a global world obsessed with social networks. Neil Watkins wrote and performed *The Year of Magical Wanking* (2011), directed by Philip McMahon, interrogating his own

identity in the context of abuse, sexuality, HIV, and the Catholic Church, as described by Peter Crawley. Stefanie Preissner both wrote and performed *Our Father* (2011) and *Solpadeine is My Boyfriend* (2012). Both productions explored the individual's response to drastic social and personal changes: economic crisis, emigration, and death in particular.

Watkins's and Preissner's shows, nominated for the ABSOLUT Fringe Awards, also mark the tendency to use verse in semi-autobiographical performances, written and performed by the same person under their own name (as in the case of Watkins) or under a fictional character name (in the case of Preissner). A similar trend seems to exist on non-Irish stages. During the 2012 Dublin Theatre Festival, British company Fuel Theatre and Nigerian Inua Ellams presented *The 14ᵗʰ Tale*. Ellams's autobiographical story in verse is about a young male coming from Nigeria growing up in London and Dublin.

Works by Watkins, Preissner, Ellams, and Polish Theatre Ireland suggest that formal language (verse, rhymed prose, and so on) mixes well with elements of autobiography and exploration of complex issues of identity. Most importantly these works not only deal, to varying degrees, with one's responses to change, they were also created after the 2008 financial crisis, when the rapid economic crisis was translating itself into drastic social changes. It seems that some current artists find rhythmical language particularly appropriate to facilitate their theatrical response to the trauma of instability and change.

Stefanie Preissner, whose work this chapter explores, is a prime example of that. This Irish actor (trained in the Gaiety School of Acting) and playwright was named the Artist in Residence at Axis Ballymun for 2014. As a 26-year-old, Preissner belongs to the generation that, according to numbers, has experienced the most significant social changes during the recession. In 2013 28.6 percent of people between 16 and 25 were unemployed (National Council of Ireland), twice as much as the general Irish unemployment rate (The Economic and Social Research Institute). According to the *Irish Times,* close to 10 percent of people in their twenties have emigrated from Ireland between 2009 and 2013 (Mullally). Research conducted by Irial Glynn, Tomás Kelly, and Piaras MacÉinrí from University College Cork has shown that over seventy percent of people emigrating from Ireland between 2006 and 2013 were in their twenties (34). Preissner recalls that over the last few years there was a time when she was seeing her friends only at "emigration parties." And she adds: "I found myself not

wanting to say goodbye to people because of a childhood reaction and fear of change" (Personal Interview). As the upcoming analysis will show, the fear of change is a running theme in her works.

The social and personal context for Preissner's plays links with her artistic interests. She is interested in works that try to understand the processes of dealing with "difficult moments" in life (Personal Interview). In terms of "rhythmical roots," her writing grows out of her enchantment with Puck's final rhythms from Shakespeare's *A Midsummer Night's Dream*, her fascination with the work of Arthur Riordan, and her encounters with rap and hip-hop. She links her interest in rap with the social reality of post-Celtic Tiger Ireland: "There's an anger that is expressed in the meter of rap that I think is definitely a response to the powerlessness that comes from when the tiger left" (Personal Interview). This seemingly eclectic mix of inspirations is linked through rhythms and rhymes and underlies Preissner's impressive awareness of them in the theatrical context.

The upcoming analysis engages with her two productions performed during ABSOLUT Fringe Festival 2011 and 2012: *Our Father* and *Solpadeine is My Boyfriend*. The former, directed by Tara Derrington, was written and performed by Preissner in rhymed verse. The latter, directed by Gina Moxley, was written and presented by Preissner in the mixture of rhymed verse and rhymed and unrhymed prose. *Our Father* focuses on one's reaction to death of the beloved mother, while *Solpadeine* directly deals with the social reality of post-Celtic Tiger Ireland and various responses to it, including personal depression.

The main aim of this chapter is to use the combination of prosodic and performance analyses to show how the use of rhymes facilitates Preissner's exploration of individuals facing difficult changes. In particular, I will focus on Preissner's performance of rhymes as an escape and her use of rhymes as an expression of pain. In both *Our Father* and *Solpadeine* Preissner uses rhymes as a tool to engage her audiences in explorating their own reaction to change. She also "invites" them to face the pain and fear connected to change. At the same time this chapter explores the links between the theme of change and Preissner's use of rhymes and elements of autobiography to complicate her own identity during the performances. This, as I argue, allows the audience to engage with her productions on multiple levels. The interview with Preissner that this chapter is accompanied by sheds further light on her work.

To provide a theoretical background for my analysis I now turn to Bert O. States's comments on the relationship between the actor and

the persona and to Jerzy Limon's work on the audience's perception of the speech of the actor and the speech of the character. This is important as the relationship between Preissner's use of formal language and her identity as a playwright, actor, and character is at the centre of the upcoming analysis. By using States's work to carry out a semiotic analysis of the role of rhymes in Preissner's work, I also follow his advice to allow a phenomenological angle into a semiotic discussion (7-9).

The Audience Perception of the Actor's Identity

States stresses that the start of any discussion about the actor's performance should be recognition of the ambiguity of the actor's identity on the stage: she/he is to be perceived both as performer and persona (119). One can understand from States's discussion that the stronger the illusion of actuality generated by the performance, the less highlighted is the ambiguity of the actor's identity. Hence the weaker the illusion of actuality generated by the performance, the more "visible" is the ambiguity of the actor's identity. Jerzy Limon, a major Polish theatre critic, claims that the creation of this illusion is strongly linked with the language spoken by the actor under a character's name, called for the purpose of this chapter "scenic speech." Limon argues that illusion in the theatre consists in the audience not distinguishing scenic speech from the speech of the persona: watching *Hamlet* the audience does not remember that Hamlet "speaks" Danish (74-77). Limon stresses that this "overlapping" does not happen when the spectator recognizes that the structure that constructs and organizes the scenic speech, for example the rules of literature, is not similar to everyday speech, as it is the case of verse performance. This lack of overlapping between the speech of the actor and the persona highlights the theatricality of the performance (Limon 76-77).

Therefore, following States's argument regarding the ambiguity of the actor's identity, the revealed artificial structure that organizes the actor's speech highlights the live presence of the actor and absence of the persona. It can also highlight the virtual presence of the author of this artificial structure (for example the playwright). Limon says that heightened theatricality allows the actor to highlight that the reason for his action "is placed outside of him" within a larger structure that he is an element of (55). States's and Limon's arguments highlight three points crucial for the upcoming discussion. First of all, revealing the artificial structure that organizes scenic speech may attach a frame of artificiality to the performance. It can also highlight the double identity

of the actor as the persona and the performer and mark the virtual presence of the playwright.

To open up my analysis I first will shortly outline how the opening of *Our Father* and *Solpadeine is My Boyfriend* introduces the idea of rhymes to audiences. It is worth mentioning that both productions were encountered within small black boxes, Loose End Studio in The Civic Theatre in Dublin (2012) and The Cube in the Project Arts Centre (2012) respectively, with the auditorium directly adjoining the stage.

Introduction of the Rhyming Patterns in *Our Father* and *Solpadeine*

At the beginning of *Our Father* Preissner informs the audience that she (or "Ellie"–the character Preissner performs) cannot tell a story about purple socks, because nothing, except "curple" rhymes with "purple":

> If I had dyed them blue or green or red, I could say true or seen or dead but I didn't. I fucking dyed them purple!
>
> So now I can't tell that story. Or that part of that story.
>
> Look, I'll start at the start, before all this crap, and I'll tell you the story in rhyme and in rap.

This odd statement immediately highlights the issue of rhymes in the upcoming minutes of the performance. Instead of the story about socks, Ellie-Preissner tells the audience about Ellie's struggle and pain, or rather the cause of it. While the story of a young woman who must face the sudden death of her mother is revealed, the audience meets the other "heroes" of her tale: her father Gary (Pat Dolan) and her stepmother Fiona (Gene Rooney). Throughout the performance, language, rhymes in particular, remain the main carriers of meaning as the scenography is minimal and practically limited to the lights and drums. The beat of drums, delivered by Josephine Linehan, additionally intensifies the rhythm of rap-verse. Preissner says that Linehan performs the heartbeats of the characters (Personal Interview).

Solpadeine is My Boyfriend is a one woman show delivered in a first person narration focusing on a young Irish woman living in post-Celtic Tiger Ireland: her relationships, her friends (one by one emigrating), and her addiction to painkillers. The performance opens with a recollection of a train journey from Cork to Dublin; to be more specific, it starts from a description of a co-passenger:

> Passengers for Banteer, Milstreet, Rathmore, Killarney, Farranfore and Tralee.
> "Sorry, em, excuse me, is there someone sitting there?"

> Abercrombie, Chanel perfume, backcombed bleach blonde hair.
> "No, I don't think so" and she goes back to reading *ELLE*.
> I feel like I'm in duty free with the overpowering smell. (Preissner, *Solpadeine*)

Some words are highlighted by rhymes, and may be read as extra-important for this description: there, hair, *Elle*, smell. This helps one to see the co-passenger through the eyes of the Narrator. There is a blond girl wearing expensive clothes and expensive perfumes, who reads a fashion magazine and yet smells. In other words rhymes evoke a contrasting image that works to create a comic effect.

The comicality of the situation may additionally highlight the artificial pattern of rhyming that organizes the scenic speech; it also works towards establishing camaraderie between the Narrator, Preissner, and the audience. F.H. Buckley argues that laughter supports the sense of community by signalling the community's sense of superiority over the butt (186-87). Rhymes may additionally strengthen this community by reminding the audience that what they see is "only" a performance. This may turn the audience's attention to the presence of other audience members and encourage collective responses, as per Susan Bennett's reception studies (124 and 133).

In the case of both productions, such strong introductions of rhyming patterns may from the very beginning highlight the issue of Preissner's multiple identities. This is central for her performance of rhymes as an escape and her use of rhymes as an expression of pain.

Rhymes and Preissner's Multiple Identities

From the very beginning the structure created by rhymes on the one hand highlights the presence of Preissner as an author and performer, which may suggest that she is the narrator of both stories. This links with the lack of specific references to the age of Ellie and the nameless Narrator of *Solpadeine*, which allows the audience to assume that Ellie and the Narrator are of a similar age to Preissner. As Preissner's acting style is quite authentic and she does not mark differences between the performer and the character, all this could attach the frame of autobiography to the experience of *Our Father* and *Solpadeine*.

On the other hand, however, rhymes establish an aesthetic distance from autobiography by attaching a frame of artificiality to the experience of both productions. This frame works against the audience's empathy by facilitating their emotional distance from and encouraging their active engagement with the production, as per Bennett's reading of Brechtian strategies (142). In other words, rhymes

facilitate Preissner's flirtation with autobiography and her multiple identities. They also work against the simple emotional engagement of the audience.

In this sense rhymes also work against the reading of both productions in the frame of confession, which Preissner wants to avoid (Personal Interview). This in turn may complicate the emotional identification of the audience with the narrator(s) of *Our Father* and *Solpadeine* as one can never be sure who the "real" narrator is. In this sense rhymes allow the audience to encounter a story about a death of a mother (*Our Father*) and a story about loneliness and addiction (*Solpadeine*) in a more detached manner and without being charged with too much emotion.

One can also read this as Preissner "hiding" behind the rhymes. These rhymes on the one hand expose her as the author, but on the other hand separate her from the narrator of the stories she tells in both plays. Rhymes facilitate Preissner's continuous oscillating between her identities as a young post-Celtic Tiger adult, a writer, a performer, and a stage persona. Consequently, during the performances, rhyming patterns allow the audience to engage with her productions on multiple levels. Preissner can be simultaneously perceived as the character she performs, as the performer, the writer, and a voice of a young generation of Ireland facing the drastic political, social, and personal changes and desperately looking for predictability. This links with the rhymes in both productions functioning as a form of escape, but also as a sign of pain that cannot be expressed in words.

Rhymes as an Escape and Rhymes as Performance of Pain

In the finale of *Our Father,* Ellie explains why she must rhyme:

> Because then I can breathe and it's not so chaotic ... something something anti-biotic.

> I miss my mother, and I want to go back, to be more understanding and cut her some slack.

> But I don't have that option, no matter how much I pray, I rhyme to fill the silence and then I'm ok.

> There's nothing wrong, I'm fine, I'm fine, I'm going to ... have a glass of wine.

> I do not like the red wine here ... Maybe I will have a beer.

> and as I start to speak in rhyme, my mind stops racing and I slow down time.

I cannot think of anything else except what word will rhyme with else.

And keeping busy is always best, rest, chest,

A clear desperation for a rhyme is evident in this quote. Having an untold story of a purple sock in mind, untold because it did not rhyme, one understands that Ellie escapes from her pain into rhymes; rhymes allow her to "breathe"; rhymes are structured; they create a pattern; they are predictable. The final lines of this quotation also suggest that the rhyme engages her thoughts into looking for a rhyme—it facilitates her emotional distance from her own pain. In rhyme, via her memories, she can go back in time. The rhyme succeeds, where the prayer, "Our Father" or any other, fails. The rhyming pattern takes priority over the sense of the words, in the last line in particular. This helps one to understand the severity of Ellie's pain. In this sense, rhymes express the emotion that cannot be expressed through words.

Rhyming structure also becomes a strategy to create circumstances, when the audience is faced with this pain. The rhyming structure creates a pattern and the audience of *Our Father* can quickly learn to anticipate it. In other words, the production establishes a clear contract that seems certain and secure. This sense of security may be strengthened by the dark auditorium, which, according to Bennett, provides anonymity and reassurance for the audience (133). However suddenly half way through the show, the contracts of rhyming patterns and of the invisibility of the spectator are broken. The rules change suddenly, when Ellie-Preissner stands between the spectators and delivers a speech that Ellie "prepared" for the guests at the funeral: "Am ... thank you all for coming, I eh ... I don't really have anything prepared, I'm Ellie, by the way, most of you will know that. I'm Niamh's daughter" (Preissner, *Our Father*). The audience hears about Ellie's mother's sickness and finds out that Ellie is "more scared" than she has ever been. Cast as the guests at the funeral spectators are asked: "Mam wanted you all to remember her as a happy, strong, fun-loving person. And by all means do. Do that. But for me, all I'm left with is a 7ft box of answers that I can't open" (Preissner, *Our Father*).

This entire speech is in prose without rhymes and the auditorium is lit. The audience has no escape from Ellie-Preissner's pain in the same way that Ellie-Preissner cannot escape from the pain of losing her mother. The trauma of losing her mother is so severe that it is hard to find any escape from it, as one may understand later, when she says: "sometimes it's harder than others to rhyme because the words you

need don't fit with the time" (Preissner, *Our Father*). This disappearance of rhyme, connected with Preissner's presence within the auditorium, works to break the frame of artificiality and security; the issue of the actor's identity becomes irrelevant, and the audience may feel very uncomfortable. One may even become aware of the protective shield that the rhymes provide throughout this show. The idea of rhymes as a potential escape for the audience from pain and an unexpected change that brings this pain to the auditorium may put the spectator in a similar situation to Ellie-Preissner.

When rhymes come back, one may appreciate the sense of security they return with, especially given that the return of rhymes coincides with the darkness enshrouding the auditorium once again. However the end of the production again attempts to unsettle the audience. Father-Dolan asks Fiona-Rooney (stepmother) if Ellie could become a part of their family: "Can I do it Fiona, it won't be full-time, I really believe that it will be fine. / It's something I should've done ages ago? Can I send her a letter inviting her?" (Preissner, *Our Father*). One waits for Fiona-Rooney's answer, however one knows what this answer must be. After a long pause, Fiona-Rooney answers according to the rhyme (and potentially against the audience's hopes): "no"; "no" rhymes with "ago."

This rhyme may be read as the play's (and Preissner's) comment on Fiona's escape from the risk of opening up. It can also be read as a sign of the consequences of the escape into rhymes or an escape in general: because Preissner decided Ellie's story must be told in rhyme, Fiona-Rooney must not say "yes." Such a reading interestingly links with Preissner's reflection on the writing process of *Our Father*. Preissner states that rhymes often guide her narratives. She exemplifies it by saying that in *Our Father* the rhyming scheme "revealed" to her that Fiona did not know about Ellie's existence until the death of Ellie's mother (Personal Interview). In this sense the narrative becomes a consequence of a decision to write in rhyme and Preissner's rhyme between "ago" and "no" can be read as a metaphor of the past impacting on the present.

In *Solpadeine is My Boyfriend* the frame of artificiality, facilitated by the presence of rhymes, again allows the audience to distance themselves from the story of a woman addicted to painkillers and struggling with her relationships. From time to time, one hears about another friend of this woman emigrating. Most of them blame the recession and Irish rain. The Narrator-Preissner connects rhymes and unhappiness: she reveals that the story told cannot be happy, because "happiness never rhymes." Through these words rhymes become a

reaction against "unhappiness." Another reaction is the idea of "emigration":

> Because everyone thinks you can just escape,
> that moving to some tropical bay or cape
> will change the fundamental fact that your life isn't great,
> but it rains in Australia too mate! (Preissner, Solpadeine)

Taking Solpadeine is also marked as a reaction to "unhappiness." The Solpadeine, as the audience is told, numbs the physical pain as well as pain of the heart. Thus the production from the very beginning connects Solpadeine, emigration, and rhymes as possible escapes from "unhappiness."

This is particularly highlighted near the end of the show, when the Narrator-Preissner drinks Solpadeine, but it does not seem to work. "It takes a while to work," she says and then, without a rhyme, lists all the things she is afraid of: "people being far far away," "asking for help," "of not being something to someone," and so on (Preissner, *Solpadeine*). "Why isn't it working yet?", the Narrator-Preissner asks and talks to the audience about lack of security and the pain of broken promises. She appeals to them: "If you are born in Ireland, stay there" (Preissner, *Solpadeine*). All this without a rhyme … The economic, social, and personal insecurities listed by the Narrator-Preissner's are likely to be familiar to the audiences of Ireland. Because of that the bond between the audience and the Narrator-Preissner can grow stronger and has the potential to create a sort of community of pain. The lack of rhymes additionally facilitates this emotional engagement.

Finally rhymes re-appear. The frame of artificiality is re-established to facilitate the emotional distance of the audience. At the same time the Narrator-Preissner says: "It's starting to work" (Preissner, *Solpadeine*). Because this comment directly follows the re-appearance of rhymes, the text works to highlight the similarity between the Narrator-Preissner's escape from pain through Solpadeine and the audience's emotional distance facilitated by rhymes. The text can rhyme again, because the painkillers started working. Thus the text levels rhyming, the over-use of painkillers, alcoholism (that the Narrator-Preissner mentions) and emigration as various forms of escape. This works to encourage the audience to start questioning their own forms of escape and, potentially, to level them with those already mentioned like various forms of addiction, which may be quite unsettling.

This strategy to unsettle the audience is given a point in the finale of the performance delivered in almost unrhymed prose. Preissner stands

downstage centre and talks about humans' reaction to stress. The only pair of rhymes that appear throughout this monologue is repeated several times, alternative of flight or fight, enhanced once with additional "light": "When we are in fight or flight mode, everything is kept light so we can escape" and later "The people who stay are not the flight people. The people who stay are the fight people" (Preissner, *Solpadeine*). The rhymed alternative is reinforced by the scenic space: a punching bag and a beanbag that one may associate with the luggage (as Preissner at the earlier stage of the show uses it as a sign of luggage). The last image one is left with is Preissner punching the bag (fight)—she made her choice. As throughout the performance rhyming patterns both highlight and facilitate the multiple identities between which Preissner oscillates, this finale can also be read as an image of an Irish twenty-something that faces the trauma and pain of growing up during the time of extreme change and yet keeps fighting. The finale becomes a screaming echo of the earlier line: "If you are born in Ireland, stay there." The voice of a young post-Celtic Tiger adult calls audiences of Ireland to fight.

Conclusion

Preissner's work is an example of the potential of rhythmical language in facilitating new theatrical voices and communicating with contemporary audiences. Preissner uses rhymes to express her identity as an Irish twenty-something, a coming of age woman, playwright, performer, and stage persona. These multiple identities create various frames for experiencing both *Our Father* and *Solpadeine is My Boyfriend*. To put it differently, Preissner uses rhyming structures to highlight her constant oscillating between these identities and, by doing so, she offers her spectators multiple levels of engagement.

On each of these levels the rhymes become a sign of the past impacting on the present: rhymes are a sign of escapism (into drugs, denial, emigration), but also a result of this escapism, and a factor that compromises one's freedom. Rhymes, finally, facilitate the performance of the pain that goes beyond any form of verbal expression. Consequently the audience can simultaneously identify with this pain, be wooed by the musicality of Preissner's rhymes, and be engaged into a debate on one's power to break patterns.

In broader terms Preissner's work exhibits some potential of rhyme, and formal artificial structures in general, in theatre in terms of their particular ability to complicate identities, redefine theatrical contracts, facilitate enhanced interactions, and create additional layers of

experience. Perhaps most importantly, this chapter shows some ways in which rhythmical language facilitates the voices of a new generation of artists who are not afraid to use patterns to free their own voices. With the young artists like Preissner, Neil Watkins, or Inua Ellams, there is great hope for the restoration of the bond between forms like verse and rhyme and Theatre, a bond that has been enfeebled by the dominance of prose. And that is why we should, no, we must talk about these forms.

Interview with Stefanie Preissner

KL: Tell me about your work.

SP: My work is about identity and coping mechanisms. It's important for me that I look at my own engagement with those things. I am interested in the truth too. I have mental health issues and for me confronting my struggle with them through my work highlights the stigma and shame that society attaches to it. It's all linked. That's why autobiography is vital in my work. If I don't know who I am and where I have come from, I can't ever know who I could be and where I could go. That's the same analogy for everyone and everything. Like Ireland. If I don't know what is happening right now in this country and how we got to that point, how can I possibly know where we can go?

KL: Why do you write in verse?

SP: There are a couple of reasons. I have to put things in place as a writer for my brain to open up parts of it that I wouldn't always use. I think that verse stops over-sentimentality and it stops things being kind of soppy. When you are dealing with things that are difficult to talk about it is like a runaway train and being in rhyme doesn't let you stop. This kind of relentlessness is very important to *Our Father*. I explain that at the end of the script; that's where it kind of turns the light on me as a writer: this is the only way I could tell that story, which is largely fictional, but semi-autobiographical. There is also something amazing happening during the performance of verse. Because of the rhythm, because of the physiology of it, everybody in the audience is breathing together with you. They speed up when you speed up. In our production of *Our Father*, when the Father asks if Ellie could move in with them and Fiona says "No," this pause could be as long as you want, because of the rhyme everyone knows it will be "no" and everyone hopes it won't. There are moments in the production when we stop breathing and you can feel the audience stop breathing too. I really think verse in theatre crosses the boundaries of the fourth wall. We are on the same track, the same train. It doesn't allow the people to be passive and it

gets them engaged. I think that's magic. We are made of patterns, made of rhythms stuck together. That's why we tell kids nursery rhymes. We experience the world through rhythms. Why would you fight against that?

KL: Can you talk about your own influences in Irish theatre and beyond?

SP: Arthur Riordan who wrote *Improbable Frequency* has really inspired me as a writer. My rhythms are also inspired by the last lines of *A Midsummer Night's Dream*: "If we shadows have offended, / Think but this,–and all is mended." I find it easy to express myself like that. I read poetry and I talk to poets. I don't like poems about nature. I don't want people to describe places, I like to read people trying to figure out people and situations. I like difficult moments described. I listen to a lot of rap and hip-hop. I think it is a really interesting way of speaking, it's very emotive. There's an anger that is expressed in the meter of rap that I think is definitely a response to the powerlessness that comes from when the tiger left. The breathlessness of the fast pace, the emotion that comes with that breathlessness and the ability to be safe behind the form is for many young Irish rappers a huge part of the appeal. It's poetry. But not as we are taught in school. School and the way in which we are forced to be educated damages poetry for many, and rap has the power to undo that damage. It's not all mountains and sheep and Emily Dickinson. Or at least it doesn't have to be …

KL: Tell me about your creative process?

SP: Well, I don't write for a long time. When I decide to write a play I think about it for a long time until I kind of have the shell of the story: the start, the middle and the end. And then I start writing and then things come up because of the rhyme. In *Our Father* there is a part when Fiona finds out that her husband has another daughter. And I didn't know that she didn't know until I wrote:

> One night at dinner, we started to chat about starting a family and decided that
> Both of us wanted it more than the world, I told him I'd always wanted a girl.
> He smiled at me and continued eating

I needed something to rhyme with "eating" and the word is "fleeting." So I went: "What look is fleeting?" Then I realized he hadn't told her yet about the daughter and then the play went from there. So it is about letting the rhyme guide the story, because otherwise it will sound really false.

KL: How long did the process of writing *Our Father* take?

SP: Two years. I wrote it first as a five-minute piece, which ends up being, more or less, the first five minutes of the play. People told me that I should expand it into a full piece. I started to think about it as a one person show and then I realized that it needed other voices. It took me about eight weeks to write it. Then I sent it to Tom Creed and said: "Will you do a rehearsed reading of this with me?" And we did. That was in November 2010. In December 2010 I did it at Project Brand New and the Fringe Festival came to me in January 2011 and said they'd love for the play to be in the Festival. The people from Civic came to see it during the Fringe and they said they wanted it ...

KL: How did you rehearse for *Our Father*?

SP: We rehearsed for four weeks. Josephine [Linehan] who plays the drum in the production is not in the script, there is no beat there. And it was very important for us to have something else. Because the rhythm is such a huge part of the play, the director and I talked about personifying it or realizing it on the stage. We talked about having a DJ. But because I love watching the drums, I love how visceral it is, so we chose a drummer. Josephine was with us for the whole four weeks. We spent a lot of time finding the rhythms of the drums, and heart beats for all characters, when the beat needed to come in, when we had too much of it. It was important for each of these characters to have their own heartbeat, their own rhythm and their own story to tell. Josephine worked with us all individually on finding the rhythms for each character. During the performances she has by far the most work to do—she has to be so precise. Also it took the actors a lot of time to learn the lines, because it had to be precise. It was interesting, because sometimes other actors were finding different rhythms in the lines than I did. But I wasn't forcing my own rhythms and I only helped when they couldn't find the rhythm or a rhyme. We spent a lot of time disturbing rhythms. I don't think you can direct the patterns, I think you can only disturb them. So I spent a lot of time listening to other actors and disturbing their patterns: asking for pause, and so on. And Josephine playing drums was very good with that. It is also very comforting for the actor to have her on the stage playing the drums, because it's not so lonely for those long periods of speaking.

KL: Tell me about writing *Solpadeine is My Boyfriend*.

SP: I wrote it over six weeks in 2012. My house went on fire and the Dublin Fringe Festival gave me a room for myself in the building for six weeks. I wrote all day every day and at the end I had a week of development with Gina Moxley. She helped me get some perspective on the piece in terms of what was interesting for an audience. When you're

working so closely to something you can easily lose sight of the context within which you are making it. Maybe I think the story where I have my first kiss is ground breaking and interesting but an audience don't particularly need to bear witness to my retelling of it.

KL: *Solpadeine is My Boyfriend* expresses very strong opinions about contemporary Ireland. Can you tell me more about your inspiration?

SP: It was inspired by a time where I was meeting my closest friends every weekend at going-away parties. The only time we would all be together was to say goodbye to one of us. I found myself not wanting to say goodbye to people because of a childhood reaction and fear of change. I suppose I felt personally abandoned by people who left. And I really struggled against the fact that the government or ... powers that be ... I suppose the circumstances were against me and my wish to keep everyone close to me at all times. It's hard to grow up in a time that is so far removed from your expectations.

KL: And to what extent has the climate of Post-Celtic Tiger Ireland impacted upon you as an artist?

SP: I was only a student during the Celtic Tiger years. A Celtic Tiger cub they call us, which is a good metaphor I think. Because I think my generation is scared and reluctant to grow up from being cubs until the economic situation is returned to what we were told it was going to be, which inevitably creates huge conflict. As I understand it, it was only a handful of artists who benefited on a grand scale from the boom; the vast majority struggled to get by as has become a norm for artists in general. It's a modest living. So the main impact of the recession then I think is on the consumers of Art. Those theatre goers and painting buyers who no longer have the disposable income to invest in Art. I hate the fact, but it is a fact, that our careers are always at the behest of other people's disposable income. I would hope that the funding cuts don't cause a move towards an acceptance of amateurism in people's artistic practice. This is a huge potential pitfall among many younger artists. It's not helped by the example being given from above in the government; by cutting funding they are seriously reducing the esteem once placed on cultural activities. It's an ongoing struggle to get funding but also to get people to attend. It's not seen as important. We need that to change.

Works Cited

Bennett, Susan. *Theatre Audiences*. London: Routledge, 2003. Print.

Buckley, F. H. *The Morality of Laughter*. Ann Arbor: U of Michigan P, 2003. Print.

Chesslaugh Mewash. By Polish Theatre Ireland. Dir. by Anna Wolf. The Lir. Dublin. Sept. 2011. Performance.

Crawley, Peter. "*The Year of Magical Wanking*." *Irish Theatre Magazine* 11 December 2010. Web. 23 Apr. 2012.

Dialect, Lethal. "Streets to the Stage: Dublin Stories as Poetry." Abbey Theatre. 17 Apr. 2012. Discussion.

Glynn, Irial, Tomás Kelly, and Piaras MacÉinrí. *Emigration in an Age of Austerity*. University College Cork, 2013. Web. 20 Jan. 2014.

Limon, Jerzy. *Piąty Wymiar Teatru*. Gdańsk: słowo/obraz terytoria, 2006. Print.

Mullally, Una. "The disappearance of twenty-somethings in Ireland." *Irish Times* 10 January 2014. Web. 20 Jan. 2014.

National Youth Council of Ireland. *Young people hit hardest by recession*. National Youth Council of Ireland, 12 September 2013. Web. 20 Jan. 2014.

Our Father. By Stefanie Preissner. Dir. Tara Derrington. The Civic Theatre. Dublin. 19 Apr. 2012. Performance.

Preissner, Stefanie. *Our Father*. 2011. TS. Author's private collection.

---. Personal Interview. 20 Apr. 2012 and 20 Dec. 2013.

---. *Solpadeine is My Boyfriend*. 2012. TS. Author's private collection.

Shakespeare, William. *A Midsummer Night's Dream*. Project Gutenberg, 2 July 2003. Web. 20 Jan. 2014.

Solpadeine is My Boyfriend. By Stefanie Preissner. Dir. Gina Moxley. Project Arts Centre. Dublin. 15 Sept. 2012. Performance.

States, Bert O. *Great Reckonings in Little Rooms*. London: U of California P, 1985. Print.

The 14th Tale. By Inua Ellams. Dir. by Thierry Lawson. Project Arts Centre. 4 Oct. 2012. Performance.

Reflections and Interviews with Radical Theatre Makers

11 | Lynne Parker: "Radical" Director. Reflections of a Fellow Director

Charlotte Headrick

Writing about directing is a challenge. If a director does the job well, the direction blends into the rest of the elements on stage. Theatre is a collaborative art and, in the best situations, all the elements of the production, under the sure hand of an able director, combine to create a memorable production. And, since theatre is a most ephemeral art, capturing that direction after the fact can be daunting. There are several collections of interviews with directors and they are useful in examining how individual directors approach their work but, in the end, there is an elusive quality to directing that can be difficult to ascertain in the finished work. Additionally, while a scholar may write about the text of the play and a critic may review a production, identifying the director's artistry in the process is often complex. It may be the actor's brilliance that the audience experiences, but did that moment of brilliance arise from the director's suggestion to that actor?

Despite the complications in writing about a director's work, this paper will attempt to track the remarkable career of director Lynne Parker, and will largely be based on my direct observations of Parker's work as a fellow director. Since I live an ocean and a country away from Dublin and London, secondary sources will support my comments about Parker's direction. Directing is about dealing with humanity, about exploring emotions and, as a director, I cannot deal with a fellow director's work without bringing in those "messy" aspects of research. To write about directing means that one has to write about feelings; it is not enough to analyze the director's choices intellectually.

Lynne Parker's career as a working director and as an artistic director of Rough Magic is radical in the scope of her work, in her

commitment to helping writers (especially women writers), in subverting the audience's expectations, in giving opportunities to young artists, and in continuing to seek new and challenging work, whether a Northern Irish *Macbeth* or a play that requires the audience to go outside a venue, on to the street, and travel to a new venue. For Parker, her work is not about tricks; she is inventive because those inventions are a way to communicate with the audience, or in her words "to turn on" those audiences (Manfull 167). Her generosity of spirit and her passion to tell these stories are revealed in every production she directs and in the larger scope of the work of Rough Magic.

From the beginning of her career as one of the founding members of Dublin's Rough Magic Theatre Company, Lynne Parker's work as a director has been radical and cutting edge. Since the early days of the company, Rough Magic has emphasized new Irish writing (the works of Gina Moxley, Paula Meehan, Morna Regan, Arthur Riordan, Elizabeth Kuti, and Declan Hughes) as well as striking and radical interpretations of classics of the Irish theatre. Although she is the Artistic Director of Rough Magic, Lynne Parker has been able to direct in Dublin at the Abbey and the Gate. Coupled with her artistic vision is her commitment to providing productions for emerging Irish women dramatists. It is because of the commitment to these women that Parker's work is especially significant and radical. Celebrating women directors and women dramatists has not been the norm in Ireland. David Grant, in the 1990s, in speaking of women dramatists, has noted that the "common tendency" is "to exclude women" (qtd. in Roche 286). Parker's work and wide success goes against traditional norms in Ireland.

Parker's work has been seen not only in Dublin, but also all over Ireland, in Northern Ireland, in London, and the United States. Some of those productions include O'Casey's *The Silver Tassie* at the Almeida in London (1995) and her 2012 re-visioning of Shakespeare's *Macbeth* for the new Lyric Theatre in Belfast. She has also directed several of the dramas of her uncle, Stewart Parker, and was an early director for the now legendary Charabanc Theatre Company. For Charabanc, she directed Neil Speers's *Cauterised* (1990), Gillian Plowman's *Me and My Friend* (1991), and Lorca's *House of Bernarda Alba* (1993). Her direction of Stewart Parker's plays include *Nightshade* (1987), *Spokesong* (1989), *Pentecost* (1996 and 2008), *Northern Star* (1996), and *Heavenly Bodies* (2004).

Sara Keating noted that female dramatists have traditionally been underrepresented (n.p. par.1). If women dramatists have been

underrepresented, then the case with women directors is even more severe. Lynne Parker in her capacity as Artistic Director of Rough Magic has made great strides not only to provide more opportunities for women writers but also opportunities for women to develop directing skills. She has done this through the Rough Magic SEEDS program which mentors a number of theatre practitioners including young directors.

In 2011, she gave a tribute to Alice Milligan in which she acknowledged that as women artists, "we are standing on the shoulders of those who have come before" ("Lynne Parker-IWD"). In this speech, Parker remarked that she has directed productions in which the entire artistic staff was comprised of talented women: producers, designers, stage managers, and the director. For many of us in theatre, this in itself is a radical concept. It has been only in recent times that women have taken their rightful place in the long male-dominated world of directing. In 1998, for the first time in the United States, two women finally won Tony Awards as directors: Garry Hynes for her work on McDonagh's *The Beauty Queen of Leenane* and Julie Taymor for her direction of the musical *The Lion King.* Since the beginning of her career with Rough Magic, Lynne Parker has consistently been recognized with glowing reviews and numerous awards for her directing and, without a doubt, she is one of the most important directors of the late twentieth and twenty-first centuries.

As directors, Parker believes that "women are good at this job" (Headrick) and in that belief, she has been instrumental in the SEEDS initiative of Rough Magic whose website states that the

> SEEDS programme is a structured development initiative for emerging theatre practitioners. Now in its twelfth year, the SEEDS Programme has introduced a new generation of Irish theatre-makers to the professional theatre world. Participants have the opportunity to observe and experience Rough Magic's work and to gain exposure to the working methods of international artists through mentoring and placements. The SEEDS artists are encouraged to engage with the company's approach and become part of its process. ("Developing Artists")

Although the Abbey Theatre solicits new scripts and has some education programs, it is Parker and Rough Magic who have created a programme for theatre practitioners: directors, designers, and management.

In 1991, I finally had the opportunity to meet Parker. She was one of two women directors to be interviewed. Although I was able to

interview her as part of a sabbatical project, it was not until the spring of 1992 that I saw her remarkable production of Declan Hughes's *Digging for Fire*. Hughes co-founded Rough Magic with Parker. Since that first experience at the Bush Theatre in London, it has been my good fortune to experience Parker's direction of several plays in London and in Dublin. Parker has been generous to me and to others who have sought interviews with her.

Parker's staging of *Digging for Fire* at the cramped Bush Theatre was impressive; the Bush is one of London's many pub theatres, this one with a long legacy of featuring new Irish writing. *Digging for Fire* revolves around a reunion of a group of college graduates. Reminiscent of the American film *The Big Chill* which also centres on a group of college friends reuniting, Hughes's piece depicts the complicated lives of a group of young thirty-somethings in Dublin. Parker staged the scene change as part of the action, going from the apartment setting to the pub and back to the pub. During the production, the actors executed the scene changes while remaining in character, even Peter Hanley's gay solicitor who refused to move anything and, keeping a drink in his hand, supervised the change.

Later that spring, I saw another Parker directed play. *Love and a Bottle* was a reworking by Declan Hughes of George Farquhar's late Restoration play. It was at the Tricycle Theatre located in the Kilburn neighborhood of London known for its transplanted Irish populace. The Tricycle is often the site of both Irish dramas created at the theatre and touring Irish productions. In his blog, Declan Hughes writes about this production noting that, "All restoration plays are about sex and money; George Farquhar's *Love And A Bottle* combined them in the form of George Roebuck, an impecunious Irish rake cutting a sexual swathe through London society" (par. 6). Keeping true to Hughes's wonderfully raunchy text, Lynne Parker did not shy away from boldly staging the sexuality in the comedy. As the rake George Roebuck, Phelim Drew dripped with testosterone in every scene in which he performed. Parker and her costume designer used many white costumes and wigs that contrasted with the lusty pink flesh throbbing underneath all those white outer coverings—a marvelous visual image of white purity masking all those colorful emotions. This production was a good example of Parker's attitude toward the theatre. In Helen Manfull's *In Other Words: Women Directors Speak*, Lynne Parker is one of the fourteen women directors Manfull interviewed. Parker, in speaking about her approach to directing, says, "I also think that theatre is substantially subversive and is about making mischief and being

naughty. It's more useful to me to regard it as something I was doing, almost blowing off my lessons, in order to be in the theatre and just explore what I wanted to there" (Manfull 6). Certainly, Hughes's play is filled with sexual situations, but Parker's staging was uninhibited, revealing that naughty and subversive streak. Jeremy Kingston compliments both Hughes's writing and Parker's staging, describing the performance as "a zestful and shamelessly saucy evening of amoral fun."

While it is the director who oversees the production, Parker always acknowledges the importance of the designers to her work as a director. In her interview with Manfull, she praises designer Kathy Strachan and how flexible Strachan was on a project. She says of collaboration and her way of working, "So there's no straightforward process. You've just got to allow yourself time to keep working, to keep churning it over. I cannot say I have a process. I just have to let it cook in there until I get the idea. And I can't force it" (Manfull 28).

Parker and Rough Magic have been leaders in encouraging new writing by women. In 1999, they published *Rough Magic: First Plays*–a volume of plays containing an equal number of plays by women as men. Of the six plays in the volume, three are by women: Pom Boyd, Gina Moxley, and Paula Meehan. Up until Cathy Leeney's *Seen and Heard* was published, anthologies of Irish drama, with very few exceptions, might include a play by Lady Gregory. Gender balance was of importance to Parker and Rough Magic. In Parker's introduction to the volume, she writes,

> Two of these plays arose out of a particular initiative. The women's playwriting competition was thought up by Siobhán Bourke (Executive Producer for Rough Magic from 1984-1998) in an attempt to address the gender imbalance in playwriting. Both as a statement and as a mechanism for creating new work it was extremely important. ("Introduction" xii)

Rough Magic is known for its commitment to new writing by women and we can trace that commitment back to Lynne Parker and to Siobhán Burke, another founding member of Rough Magic. Kuti's *The Sugar Wife* won the 2006 Susan Smith Blackburn Award for the best play written by a woman in the English language. Earlier, Parker had directed Kuti's reworking and completion of Frances Sheridan's play *A Trip to Bath* in a new version entitled *The Whisperers* (1999). Parker suggested a Restoration play to Declan Hughes and she suggested the title for Kuti's reworking of the Sheridan play and then directed both productions. The Rough Magic archive says of the play, "Begun by

Frances Sheridan in 1765 and completed by Elizabeth Kuti in 1999, *The Whisperers* combines eighteenth century wickedness and wit with a very modern attitude to the sexual power of money and the market value of sex" ("*The Whisperers*" par. 2).

In 1995, Rough Magic produced *Danti-Dan*, a play written by Gina Moxley and directed by Parker. Although Moxley had been an actor in the company, Parker had an instinct that Moxley had a play in her and notes, "That's why I picked on her" (Manfull 142). Parker writes:

> When Gina Moxley joined the company as an actor we discovered her talent for inventing characters and asked her to try her hand at straight drama. We were prepared for the sharpness and wit of her writing but not for its darkness and compassion. *Danti-Dan* is an astonishing debut, not least in that it treats adolescent sexuality objectively and reverses the gender stereotypes usually associated with stories of aggressive sexuality. ("Introduction" xi-xii)

Parker staged Moxley's play at the Hampstead Theatre. Paul Taylor in *The Independent* writes, "Brought to Hampstead in a winning Rough Magic production by Lynne Parker, the drama is set in an Irish backwater 10 miles from Cork in the summer of 1970, and if you ever needed further proof that a repressed society creates sexual obsessives, this play would be your man" ("*Danti-Dan*" par. 1). Fintan O'Toole speaks of Moxley's integrity in telling such a story about sex and power, noting that "It manages to do justice to the ultimate bleakness of the piece without itself being bleak, and above all [gives] a fine young cast the confidence to take emotional risks" (*Critical Moments* 137). Parker's depiction of adolescent sexuality in this play was unflinching. Parker's encouragement of Moxley and her risk-taking with youthful actors paid off: the play went on to win the New Playwrights' Bursary Award from the Stewart Parker Trust, and it has been anthologized both in *The Dazzling Dark* and in *Rough Magic: First Plays*. As Moxley's work illustrates, Rough Magic is known for launching new writers, particularly women, and this commitment can partly be traced to Parker's respect for writers:

> I know I can't do that [playwriting], and I have great admiration for anybody who can. But I would be very unhappy and sad if the show didn't have something of my personality in it, and it's bound to have just a little style in presentation and something of my trademark upon it. (Manfull 47)

Also in 1995, at the Almeida in London, Parker staged Sean O'Casey's *The Silver Tassie*. If bravery is radical, and in the commercial theatre it is, Parker challenged herself in the Almeida production and

she continues to challenge herself today. O'Casey's play has been challenging for both directors and audiences, as it mixes realism with expressionism. My argument is that it was Parker's vision of the play and her skill as a director and her fearlessness that led to the excellence of the production. *The Silver Tassie* is often described as "rarely produced" and with good cause. It is a difficult play that mixes forms but Parker has never been one to skirt a challenge.

The *Herald Scotland* praises Parker's "unsentimental lyricism," saying the fact the play is not seen more often is a "shame, because judging by this wonderful revival from Dublin's Rough Magic director Lynne Parker, it's the kind of play once seen is likely to leave an impression for life" (n.a.,"*The Silver Tassie*, Almeida" par. 1). In the production, Parker did not shy away from making an overt anti-war statement by evoking the power of the Vietnam Memorial Wall. In one scene, long drapes filled with names were hung over the stage. It also evoked the WWI memorials all over Britain but not in Ireland. The image evoked not only the dead of World War I but also the dead of later wars, and, it could be argued, the wars yet to come. It was a very powerful image on stage. Michael Billington refers to "Lynne Parker's excellent revival" and how she solves some of the problems in the play by "treating the whole play as a piece of twenties expressionism."

One of the characteristics of Parker's work is her range, which can certainly be viewed as radical. Traditionally, many directors find their directing niche and specialize in one genre: musicals, dramas, new work, or comedies. She goes from realism to expressionism, to classics, to the wacky world of a new musical theatre piece. In 2005, Lynne Parker's production of Arthur Riordan's *Improbable Frequency* was staged at the Abbey. In an interview, this is a play which she has described as "bonkers" (Woddis). Reminiscent of Tom Stoppard's *Travesties,* in which Tristan Tzara, James Joyce, and Lenin are all in Zurich at the same time, Riordan imagines what might have happened if the poet John Betjeman, physicist Erwin Schrödinger, and Myles na gCopaleen (satirist Brian O'Nolan's alter persona) met in Dublin (all three were in the city at the same time). Riordan, like Stoppard, excels in word play in *Improbable Frequency*. Parker's staging of the play at the Abbey was as zany and acrobatic in physicality as Riordan's play was in verbiage. At the play's intermission, a confused American tourist asked me, since I had been laughing, if I could explain the musical to her. I couldn't. *Improbable Frequency* had some of the zaniness (stylized movement, makeup, exaggeration) of Parker's staging of *Love and a Bottle* only magnified many times. Caomhan Keane describes it

as a "musical fantasia set during The Emergency" (par. 1). Drawing on music hall traditions, stylized costumes and makeup, Irish history and politics, and over-the-top antics, this was a wonderful night in the theatre. The production showed, again, how fearless Lynne Parker is. *Improbable Frequency* is not a usual musical. *Oklahoma* it isn't. *Improbable Frequency* in its subject matter, storyline and staging is not a traditional formulaic musical like *South Pacific* or *Sound of Music*; it also contains a sampler of musical styles. The play swept the awards for the 2005 *Irish Times* Theatre Awards including a Best Directing prize for Lynne Parker. The company eventually toured with this production, and in 2012, they staged a revival of it.

From the fall of 2012 until the present, Parker has continued to challenge herself as a director. Her *Macbeth* at the Lyric reveals her radical and inventive approach to one of Shakespeare's most popular plays. The actors spoke in their native Northern Irish accents and Parker's approach to the witches was remarkable. Lisa Fitzpatrick describes how Parker's version offers a new perspective on the play:

> Beautifully designed and performed by an excellent cast, this version offers another engaging and challenging interpretation that creates a strong atmosphere of moral and political decay. The horror of Macbeth's rule of Scotland is communicated in the harsh comfortless set and a series of directorial decisions by Parker ... One of these decisions is the visible multi-roling by the three actors playing the weird sisters: Eleanor Methven, Carol Moore, and Claire Rafferty. As witches, they are unsettling figures in long shapeless military parkas with hoods that extend down over their faces. (Par. 1-2)

Fitzpatrick describes how the actresses remove their witches' clothing to reveal other costumes, with the actresses morphing into servants, soldiers, and other minor characters who follow Macbeth: "They are therefore with him all the time, shadowing his movements and inhabiting his household, and making visible and embodied the evil that he embraces in the pursuit of his ambitions" (par. 2). Jane Coyle in her review for *The Stage* also comments on how the three witches dominate the production in "Lynne Parker's fascinating, Northern Ireland-inspired revival ... " (par. 1). As a native of Belfast, Parker was also using not only the accent of Northern Ireland in the speech, but also recalling the violent memories of the city of Belfast echoing the world of one of Shakespeare's most violent plays. Her use of the three actresses who played multiple roles in the production was unusual and

striking. It is not often that one sees the drunken porter played by a woman.

A year after *Macbeth*, Parker directed Sheridan's *The Critic* (2013) with her own unusual twist. Parker changed the setting of the play from London to Sheridan's birthplace Dublin. The play opened in the Culture Box in Temple Bar and the final act played in the Ark about a hundred metres down the street. Peter Daley acted as the "director" and guide and he led the audience from the Culture Box to the Ark carrying a red umbrella. Chris O'Rourke remarks that this is a play with "lofty ambitions ... fully realized with great charm and humour in a towering production that deserves to be a runaway success" (par.1). He continues, "Played in the round and performed across two venues, Lynne Parker's excellent direction kept *The Critic's* many plates spinning successfully" (par. 4). One of Parker's spinning plates featured a cast composed of student actors from the Gaiety School of Acting, University College Dublin Dramsoc, and DU Players of Trinity in the second half of the play. Fintan O'Toole is impressed with the sheer number of actors on stage in Parker's productions. He writes of *The Critic* and The Gate's *Threepenny Opera,* which have sixty-three performers between them, that, "There's something magnificently defiant about all of this. If nothing else, it is a reminder that theatre can be ambitious, extravagant and a little reckless now and then" ("Culture Shock" par. 4). What Parker did with the production of *The Critic* is well outside of the usual parameters of a theatrical production. Of course, other productions have used promenade style and moved audiences around, but the combination of a classic play, newly envisioned, using students alongside professional actors, and moving the audience from one venue to another is very unusual.

Perhaps the best testimonial about Parker as a radical, inventive, and creative director comes from those actors who have worked with her. One of these is filmmaker, actress, and director Carol Moore, one of the founding members of Charabanc Theatre Company. Moore praises Parker as a director who works with her fellow artists, encourages their input into the final vision of a production, and allows actors to explore and experiment however they need to discover a character. This has resulted in productions that subvert the audiences' usual expectations of characters. Of this process, Carol Moore wrote the following about working with Parker:

> I remember well Rough Magic's production of *Pentecost* and wondering why in the early stages of rehearsals, I wasn't being given notes to guide my interpretation of Lily. I only realised much

later that Lynne wanted me to trace Lily's journey and find for myself the pain of having an affair and a baby and keeping that secret until the end of her days. This suppression of complex emotions is the antithesis of her as a ghost, where her sectarianism is chillingly vicious towards the Catholic Marian, because I believe it offers the cause and effect of a life unfulfilled. Similarly in her Lyric Theatre production of *Macbeth*, while Lynne had a very strong sense of the witches infiltrating the Macbeth castle as "other characters", it was very much left to the actors, Eleanor Methven, Claire Rafferty and myself to find what that infiltration looked and sounded like, yet retaining the essence of a witch. It is this organic approach where creative decisions happen moment by moment by her and the actors in the rehearsal room that encourages genuine ownership of the production.

Together with Carol Moore, Eleanor Methven, also a founding member of Charabanc, has worked with Lynne Parker for over a twenty-three year period. During the performance run of *The Critic* in which she played Mrs. Dangle, Eleanor Methven wrote the following:

I see Lynne Parker's "Radicalism" not so much in terms of her Direction of Plays (though she is undoubtedly one of Ireland's foremost Directors), but in her Artistic Direction of Rough Magic: wherein she lives her politics. Lynne's raison d'etre in terms of the Company ethos is the dissemination of resources to the next generation, largely through the foundation of the Rough Magic SEEDS scheme. It is evidence of her fundamental belief in mentorship, empowerment and opportunity as the only foundation for a Living Theatre. This is echoed in her work in rehearsal room, which is deeply collaborative and Playful.

Parker has acknowledged that she learned her trade at Trinity, where she made the friends who would become the foundation of Rough Magic Theatre Company. She has also on numerous occasions spoken of the influence of her uncle, Stewart Parker, and about how much she learned from him and part of her work today is keeping his legacy alive. Additionally, she has acknowledged the influence of the French director Ariane Mnouchkine (who herself is often identified as "radical") whose company Théâtre du Soleil is unlike any other in the contemporary theatre. Like Mnouchkine and Théâtre du Soleil, which is a commune, Parker speaks of her relationship with Rough Magic as being one of family.

Interviewed while directing a new reworking of *Phaedra* (2010), in an Irish setting with music (translator, composer, and director, all women), Parker talks about the challenge of directing, describing how "When you do any play, you bring your whole toolbox to it, everything

that influences you and someway uses you as a conduit but you have to make a selection about what you will actually bring to the specific demands of the show" (Areaman, "Interview").

What makes Parker "radical" as a director? It is that toolbox that she brings with her as a director and as Artistic Director of Rough Magic, which includes her bravery in choosing new work and reworking classic texts for new audiences, her strong commitment to women's writing and to establishing the SEEDS program for new young artists as theatre practitioners, her generosity in opening her world to so many: fellow artists, interviewers, and scholars. As the artistic head of Rough Magic, she has done more than any other artistic head in Ireland to promote writing by women and to open the door for young directors through the SEEDS program. Parker notes that if you look back over the array of Rough Magic productions, "none of the shows look like one another." She says that "you have to go for new territory each time, otherwise you stagnate. For me it's not deliberately looking for the opposite of what you have just done but it really helps if you go into a whole new world or a whole new thread of theatre" (Keane, "Diatribes of a Dilettante"). And as Methven has pointed out, it is Parker's commitment to mentorship and empowerment of young artists, particularly women, that makes her radical. In the commercial world of theatre, this is an unusual stance, a radical position and it is the essence of what makes Parker the skilled director that she is.

Works Cited

Billington, Michael. Rev. of *The Silver Tassie*, dir. Lynne Parker. *Theatre Record* 15.10 (1995): 589. Print.

Bourke, Siobhán, ed. *Rough Magic: First Plays*. London: Methuen, 1999. Print.

Coyle, Jane. Rev. of *Macbeth* dir. Lynne Parker. *The Stage*. The Stage Media Co. Ltd., 26 Oct. 2012. Web. 9 Oct. 2013.

"Developing Artists." *RoughMagic.ie*. Rough Magic Theatre Company, n.d. Web. 25 Jan. 2014.

Fasciati, Diego. "Rough Magic Archive 10." *RoughMagic*. Rough Magic Theatre Company, 26 Oct. 2012. Web. 3 Oct. 2013.

Finkel, David. Rev. of *Improbable Frequency*, dir. Lynne Parker. *TheaterMania*. n.p. 5 Dec. 2008. Web. 11 Oct. 2013.

Fitpatrick, Lisa. Rev. of *Macbeth*, dir. Lynne Parker. *Irish Theatre Magazine*. 25 Oct. 2012. Web. 10 Oct. 2013.

Headrick, Charlotte. "'Women are Good at this Job': Lynne Parker, Director." *Northwest Theatre Review* 6 (1998): 9-17. Print.

Hughes, Declan. "On Not Rewriting Tartuffe." *DeclanHughesBooks*, n.d. Web. 30 Sept. 2013.

Keane, Caomhan. "In Conversation with Lynne Parker: *Improbable Frequency*." *Entertainment.ie*. Entertainment Media Networks Ltd. 17 Feb. 2012. Web. 9 Oct.2013.

---. "Lynne Parker Interview." *Diatribes of a Dilettante* 30 May 2010, Web. 29 Jan. 2014.

Keating, Sara. "Female Voices finally finding a stage" *Irish Time*s 2 March 2011. Web. IrishTimes.com, 14 March 2011.

Kingston, Jeremy. Rev. of *Love and a Bottle*, dir. Lynne Parker. *The Times*, 8 June 1992. n.p. Print.

Leeney, Cathy, ed. *Seen and Heard*. Carysfort Press, 2001. Print.

Manfull, Helen. *In Other Words: Women Directors Speak*. Lyme, NH: Smith and Kraus, 1997. Print.

Methven, Eleanor. Message to the author. 8 Oct. 2013. Email.

Moore, Carol. Message to the author. 13 Oct. 2013. Email.

N.A., "*The Silver Tassie*, Almeida." *Herald Scotland*. Herald and Times Group. 16 May 1995. Web. 11 Oct. 2013.

O'Rourke, Chris. "Dublin Theatre Festival, 2013-Critical Acclaim for a Magical Production." *Tulsa Theater Examiner*. Clarity Media Group, 4 Oct. 2013. Web. 10 October 2013.

O'Toole, Fintan. *Critical Moments: Fintan O'Toole on Modern Irish Theatre*. Ed. Julia Furay, and Redmond O'Hanlon. Dublin: Carysfort, 2003. Print.

---. "Culture Shock: Dublin Theatre Festival: Ambitious, Extravagant and a Little Reckless Theatre." *Irish Times*. The Irish Times Ltd., 10 October 2013. Web. 10 Oct. 2013.

Parker, Lynne. "Introduction." *Rough Magic: First Plays*. Bourke x-xii. Print.

---. "Lynne Parker-IWD." *YouTube*. YouTube, LLC. 8 March 2011. Web. 10 Oct. 2013.

---."Lynne Parker, School of Drama, Film, and Music." Areaman, Areaman Productions 11 January 2011. Web. 29 January 2014.

Roche, Anthony. *Contemporary Irish Drama: From Beckett to McGuinness*. Dublin: Gill and Macmillan, 1994. Print.

Taylor, Paul. Rev. of "*Danti-Dan*, Hampstead Theatre, London." *Independent*, 15 June 1995. Web. 3 October 2013.

"*The Whisperers*." *RoughMagic.ie*. Rough Magic Theatre Company, n.d. Web. 10 Oct. 2013.

Woddis, Carole. "Dublin Theatre Festival: Lynne Parker and Rough Magic." *theatreVOICE*. 8 Oct. 2010. Web. 29 Jan. 2014.

12 | Activism and Responsibility: Women Directing Theatre in Contemporary Northern Ireland

Matt Jennings

Nine of the fifteen producing theatre companies in receipt of annual funding from the Arts Council of Northern Ireland (ACNI) for 2014-2015[31] are led by female executive or artistic directors. All of the established theatre companies in Northern Ireland employ women in senior creative and administrative capacities. This represents a remarkable social and cultural phenomenon in a region still coming to terms with the legacy of conflict after the 1998 Belfast Agreement, where issues of gender equality have generally taken a back seat to questions of national identity. It is particularly notable considering the internationally recognized and increasingly contentious issue of gender disparity in leadership roles within the professional theatre sector in the UK, the USA, and beyond.

A recent UK research report and campaign, led by Sphinx Theatre Company, highlights the figures, "35% of actors, 17% of writers, 23% of directors ... 52% of the population."[32] In the US, the "Women Stage the World" campaign, "Theatre Unbound" (Minnesota) and the "Women's Project Theater" (New York) are some attempts to combat this gender gap. As Lynn Gardner says, "men still dominate the big jobs in performing arts." So why is Northern Ireland so different?

In this interview, conducted on 22 July 2014 in the Belfast offices of Prime Cut Theatre Company, Matt Jennings asks four of Ireland's most successful and innovative theatre directors about their understanding

31 Arts Council Northern Ireland, http://www.artscouncil-ni.org/funding
32 Sphinx Theatre Company, http://www.sphinxtheatre.co.uk/

of radical contemporary theatre practice; the context of creating theatre in Northern Ireland; and the significance of gender in relation to their work.

Actress and director, Paula McFetridge has been Artistic Director of Kabosh Theatre Company (Belfast) since 2006 and was Artistic Director of the Lyric Theatre Belfast from 2001 to 2006. Writer, director and facilitator Zoe Seaton has been the Artistic Director of Big Telly Theatre Company since she founded it in 1987.

Emma Jordan is Executive Director of Prime Cut Theatre Company and has worked as a performer with such renowned companies as Charabanc, Tinderbox, The Lyric Theatre, Replay and Dubbeljoint. Originally from Donegal, Caitriona McLaughlin is a freelance theatre director who has worked extensively in London, New York and Ireland. She is part of the Young Vic Directors Program, Associate Director of The Playground Studio, and worked on secondment at the Royal Court. In 2007 Caitriona received a Clore Fellowship.

MJ: This term "radical contemporary theatre," what does it mean to you and how do you think it might relate to your work, or the work of your peers?

PMF: It's not really a term I would use. You tend to say it about other people's work as opposed to your own. Everybody's work is framed by the context in which they produce work, and therefore by them as individuals. I think it is possibly radical when you're hearing a story that hasn't been told before, or in a form that maybe you personally haven't seen before. Everybody's "radical gauge," for want of a better phrase, is unique to them. I don't overly assess my work in relation to a body or canon of work. I prefer to determine its value by what I think is its relevance to the audience that I want to tell the story to.

EJ: I think about the term "radical" in two different ways: firstly, radical in terms of form, in relation to the tradition of Irish theatre in general, which is the traditional narrative, playwriting theatre form. At the moment we're trying to push some of those boundaries outwards; maybe we're at the start of that kind of journey. Some are more involved than others in that–Zoe and Paula's work has been doing that for quite a long time. So in the context of the Irish tradition, there is an element of radicalism in the work that female artists in Northern Ireland are making, which is about form.

The other way that I think about radicalism is about provoking change. That's about the impact on your society and the connection

between the work that you choose to do and how you make it, even within a traditional form, and how notions of change radiates out in society. That's another area, which is about the relationship between the work we do and our society, specifically Northern Irish society and post-conflict society, and what the connection is. That's how I think about the notion of radicalism.

ZS: For me, "radicalism" is more about content than form. In some ways, I'm more interested in form than content. The way that a story is told interests me consistently. "Radical" always feels political and I don't feel the work that I make is politically driven, so it's rarely been a word that I have associated with my work.

CML: I find it a difficult phrase, because "radical" work depends on the context. For example, to spend a year making a piece of work in Northern Ireland would be quite radical (laughs). It's hard to think of radical theatre in general, because I think that we're very limited by the context in which we have to make work here.

My experience of working in Northern Ireland isn't radical in terms of structure, in terms of a European definition of "radical contemporary theatre." We haven't yet embraced that, but that's partly because of the context that we are forced to make theatre in here. Contemporary theatre, for me, is all the theatre that we make today. Even classical texts produced in a contemporary context for a contemporary audience in a contemporary venue—or not in a venue—is contemporary theatre. So I think that I would need a more specific definition, to be able to articulate it more succinctly.

PMF: Yet although it [theatre in Northern Ireland] could be considered a more conservative form, because it's more narrative driven, when we talk about our creative methodologies—because we all work on new work quite a lot—a lot of European theatre-makers see our process as radical and contemporary. So maybe it's not necessarily about the product, which may not be perceived collectively as radical, but the methodology we use to get to that point. What I've perceived, in my experience in Europe—and it's only in the last few years that I've started doing international work—is that we can teach people a lot, as regards how we put shows together, which I was surprised at.

EJ: I agree with you, Caitriona. The way that we are forced to make work doesn't facilitate radical work, because the system we've made is a product-driven and time-limited system. We are all forced, locally speaking, to make work in a three and a half to four-week rehearsal period, if we are lucky. I don't know if that produces radical artists, or radical work, by necessity. It is very capitalist in that way. If you're

talking about radical as political, then we are working within a very capitalist system of time limitation and product at the end of it. I've been more conscious of this over the past four years or so, working with artists from Bosnia and Slovenia, who make work in such a completely different way. I think that facilitates much more risk-taking, in terms of end product, than is allowed to grow here. It's not qualitative, I'm not making comments in terms of quality–but in terms of process and engagement, and in discovering new radical forms, it does allow for engagement in a deeper way than in the way that we have to make work.

ZS: I don't feel forced to make work in a certain way at all. That doesn't echo how I feel at all. I feel privileged to be regularly funded to make work. I know that's not popular, but I do feel absolutely privileged to be in that position. More time might be good, more time to experiment, but not always. Sometimes, with certain projects, more time can limit experimentation and put more pressure on things, and therefore there can be less risk. Some of my favourite projects are where you've had two days and you have nothing to lose. Some of those are the bravest. Give me ten projects like that, for every one where you've got three years to think about it.

PMF: I would agree with you there. I think there's a real joy and delight in those projects where you turn around like a fish in the water– they just happen when you've got the right people in the room, bouncing off each other's creativity and things just happen. You don't have time to censor your thought process and you don't have time to talk something out of the water. Something just works.

ZS: For me, those projects are where I take the most risks. I feel less cornered in those projects than when I have more time and more expectation.

EJ: I also feel very privileged to be working full-time as a theatre artist in the context of this place. I understand that that is a very lucky and privileged position to be in. What I'm talking about is the notion of ensemble, which is about working in a long-term collective of musicians and artists, the whole collective team that is a composite of theatre in an ensemble context. Some of the most exciting work that I've seen internationally has been made out of that context. That's not a construct that is available here. In fact it's not a construct that is available anywhere else in the world, apart from mainland Europe–and only then in some countries. Some of the most exciting work that I have seen has come out of the idea of the ensemble. I look at that and I wonder "what would that kind of adventure be like?" How amazing

would it be for everybody involved in that kind of long-term, invested exploration?

CML: Coming from a freelance perspective, one of the things that is challenging, in terms of radical choices, is that somebody else is making the choice. You very rarely get the opportunity to make the work that you want to make. Very often, you can't build on it. One of the limiting factors is that artistic directors are often very concerned with who an audience knows and who an audience doesn't know. Just listening to you talk, the three of you have very clear theatrical voices that you have grown over time. Whereas freelancers might feel that they are beholden to the views of an artistic director or a gatekeeper or whatever. So you take fewer risks–or, more often, your less risky choices get more support.

MJ: What do you think is specifically characteristic of or different about working in Northern Ireland? How does the context of Northern Ireland influence the way you work, the kind of work you are trying to do and the kind of work you are interested in?

PMF: 80% of my work looks at dealing with the past, looks at conflict resolution. That probably is because, in a sense, I have control over what I do and because it is a thing that interests me. I see my role as an artist as being an activist in some shape or form. I have the skills whereby I can expose difficult material that will challenge people and make them think differently–whether that's about space, whether that's about narrative, whether that's about self, whether that's about social issues, whatever it is.

In a sense, the polar opposite of that–but which I still see as tied into the work of dealing with the past and conflict resolution–is the work that I do in relation to cultural tourism. Because one of our peace dividends is that more and more people are coming to see the scars of the past. The cultural tourism that we have to offer here is framing the past in an accessible and entertaining manner, staying true to the past and not erasing the past, and that is what visitors want to see. Like Zoe, I completely agree that we are incredibly lucky. I feel very lucky to be running a small company. The difference between running a building and running a small company is a luxury that I don't underestimate. I also think that I'm very lucky to be producing work in the North of Ireland–because if I can't open up spaces and tell stories effectively here, then I would find it very difficult to do it anywhere else. The stories and the narratives and the spaces that we have to expose and give voice to here are completely unique. I see myself as an Irish artist and I see myself within the context of Ireland–but I am Belfast born

and bred. I think the rural/urban divide in the north of Ireland is considerable as well. I think we talk a lot about the role of art within the conflict, but I think we also underestimate the role of art from an urban or a rural perspective–and from a gender perspective, as well.

ZS: In that sense, our work is all very connected to place. My work isn't about the conflict, in Portstewart (all laugh). That isn't the story of rural, regional Ireland. But it *is* about making work and connections which are relevant to those communities and those people, in a similar way.

MJ: For instance? Would you like to talk about any particular projects?

ZS: I just think that we're always looking for relevance. We're always looking forward. It's interesting to not be in an artistic community, where there isn't such a cultural context, or such a cultural cohort. We are constantly looking for ways to get the person that is furthest away from engaging with the arts involved in our work. It is our constant interest and our constant triumph–when that person who would never engage with the arts, does engage in some way. For me, that is my biggest challenge and my biggest success–when people engage, with innovative forms or innovative concepts or whatever, who normally wouldn't. It feels like that's the job to be done there. I think that's because I am not in an artistic community. But I think if I was based in Belfast, I'd be doing a different thing, because there'd be a different job to be done.

MJ: So is it radical in relation to people's previous experience of theatre?

ZS: I suppose it's radical in asking people to redefine what the arts are, to define what the arts are in their context.

MJ: And how does that relate to your understanding of Northern Ireland as a place, in relation to other places that you might have worked?

CML: My experience has been very much based in Derry, which is its own situation. My challenge with working in Derry–and this is going to sound awful, but I'm just going to say it–is that the art of theatre is absent in Derry, in my experience. What I mean by that is that actors aren't respected enough in Derry and are not paid enough. Stage management is not considered an essential artistic role. Space to rehearse is not respected and you're not given privacy. There is such a make-do attitude to making theatre there, that it has robbed itself of the potential for it to be art. It's very, very hard to resolve, because it's become an ingrained habit.

And it's become an ingrained habit because amateur theatre is so popular and invaluable and valued–as it should be. But there should be a clearer distinction between somebody who is interested in the industry and the art of theatre, as opposed to somebody who is doing it as a hobby. I don't know how to make that happen–it's been something I've been working on for ten years. I can't seem to articulate why they should be separate, yet I believe 100% that they should be. In the same way that somebody who paints on a Thursday evening after work–no matter how good they are, no matter how brilliant the end product may be–has a different relationship to the process than somebody who is trying to communicate something with their life.

ZS: I think you've summed Derry up absolutely brilliantly. I think that's certainly my experience of the arts in Derry. It is not valued in any kind of real, integral way. There's a lack of confidence about telling *their* stories and telling them the way they need to be told. It was all about getting the right names–whether they're the right names because they do good work or because they are bankable.

MJ: Are there any other aspects of working in Northern Ireland that you want to discuss, in relation to other international contexts?

CML: Actually, sometimes the limitations, or what we usually see as limitations–in terms of the rural element and the fact that you can't put a show up for more than a couple of days in any one space–those things could potentially be an advantage, if we broke the model that we're currently using. But we need some sort of funding support to do that, because that would mean eliminating the current model of a three-week or two and a half-week rehearsal process.

But there is a real potential to develop a new style of theatre, a new structure here, partly because of the geographic specificity of Northern Ireland. We already use the physical size of Northern Ireland to produce work in three or four different towns in the same week, and we use space differently and create work for smaller audiences, building immersive experiences like "The Baths." We should stop trying to rush traditional proscenium arch shows from theatre to theatre on a daily basis. We should do fewer of them and let them sit in venues for longer. We also need to build more work that moves easily, that can be played in different spaces–the way that you guys are already doing work, in terms of going into shops [to Zoe], going into taxis [to Paula] and going into different kind of venues. We need to show how that work will evolve and give it the space to do so. We can afford to do that more easily if we change the structure of the funding to support it. I think it's potentially really exciting here.

EJ: In relation to your initial question, which was about making work in the context of Northern Ireland, you have to go back to why you're an artist. As an artist, growing up in Northern Ireland and seeing an environment which was completely out of control, and looking for possible mechanisms for change, the only thing within your facility was, in my instance, to be an actor–to effect change in the environment of the theatre. Then, as I developed as a director, I increasingly felt that theatre was the only weapon that I had to effect change. That's a very specific context to grow up in. It's a very specific context in which to place yourself as an artist. I think that if I hadn't gone to school in the Falls Road in the 1980s, I might have been a teacher–and earning a hell of a lot more money than I earn now (laughs)!

Who you are as an artist is affected by where you grow up and then, concurrently, the type of work that you make. In a way, I've never regarded myself as a political artist. But I have more understanding as I get older that I am a political artist, whether that is about social satire–which is about us laughing at ourselves–or whether it is really intense work, like we did with the Chilean trilogy, which was like a mirror from another society looking back at ourselves. That's an understanding that maybe grows and evolves over time. You don't know, initially, why you are drawn to this kind of road, but you understand it in a deeper way–maybe–the older you get.

PMF: I don't regard myself as political.

EJ: That's hilarious.

MJ: But you said you are an activist, though.

PMF: I am an activist because my job is to give voice to unheard stories and to challenge preconceived ideas. That could be at any level. That could be about sexuality, it could be about social housing, it could be about education, it could be about the roads–it could be about whether we need a theatre company in Northern Ireland!

ZS: Go on, do a show about the roads! Go on! (All laugh)

PMF: You know, I actually am looking at it–about potholes, I've always wanted to a show about potholes (laughs).

CML: Actually, we did one about road accidents last year.

PMF: Did you?

MJ: So you mean "activist" in terms of addressing social issues, which is not necessarily the same as being political?

PMF: I think artists, by their very nature, live on the fringes of society–maybe because the rest of society thinks that what we do isn't a proper job; or that we are quirky and bohemian and they can't quite put us in a box. So inevitably, if you're on the outside looking in, there's

something a bit different about you. There is something radical, changing, whatever it is. But I do think that all art, by its very nature, is political—with a small "p." I think that the question is between being active or passive. That's the question that always interests me. I would say to young people that passivity is not something that inspires me or rocks my world. If you choose not to be political, *actively* choose not to be political. Don't just stick your head in the sand.

MJ: How do you think all of this work, all of these ideas and all of these experiences, relate to the experience of gender or issues related to gender?

CML: I think that I work in theatre specifically because I grew up in a very male-dominated environment—in terms of roles, if you know what I mean. Now that might be a personal thing, because I had a very strong father and grew up in rural Ireland. It was a very Catholic, male-orientated society. Definitely, that's why I'm in theatre, because I felt like that's where I could have a voice. I had none anywhere else. (All laugh)

PMF: I don't really consider gender. People sometimes ask me about it, but I don't see myself as a female practitioner. I never have. I don't define myself as a feminist. It so happens that I was born a woman. I was in a very matriarchal family. I suppose that I fell into theatre because the rest of my family were all into sport. I wasn't good enough at sport. I liked the idea of a communal live event.

For me, it's more about who you are—your perspective on the world is from a female perspective. The way you interact with other people is from a female perspective, whatever that is. So consequently, that shapes you—because the only lens through which you can do work is with your own eyes and your own ears.

I don't know if I really think about it. Yet other people would really talk to you about it a lot, specifically when I was running the Lyric [Theatre]. People would say to me, "gosh, it's very unusual for a woman to be running a building." I never thought about it too much in that way. I thought about it more in terms of age and experience—"self," I suppose.

EJ: I think about it now in terms of responsibility—the responsibility that I feel for empowering younger women. That's the only context that I understand, in terms of my "gender role" as an artistic director of a company. Because I think that the trajectory is more difficult for women in this environment, especially for actors and for freelance directors ...

MJ: In Northern Ireland, specifically?

EJ: Anywhere! As a feminist, I would say, generally speaking, that confidence and risk-taking—all of those essential, empowering things—are more difficult for women to reach towards. I feel a responsibility as someone who can create environments that might facilitate releasing that potential. To go back to that feeling of privilege—of being in a privileged position—I feel a responsibility to empower and change and build confidence and say "you can do it and this is how you can do it."

ZS: I suppose that I would consider myself a feminist, you know, running a company with seven full-time women—no man ever gets in that door!

EJ: Actually, I have three women in mine. I was just thinking the same thing! Almost everybody I work with is a woman.

PMF: Same here.

ZS: I don't know if that's because I ... Well, it's because I like working with women. But I do see the Irish theatre tradition—the historical Irish tradition—as male-dominated, in terms of "director as autocrat" and male writers.

I'm not interested in "director as autocrat" and I'm not really focused on writers. I'm interested in a more collaborative, ensemble way of making work, where the words aren't just owned by one person. It doesn't really mean that I don't like working with writers sometimes. But I suppose that I do see myself as working far away from a male-dominated "director as autocrat" model, and where the writer is in charge of all the words. I do feel a responsibility to create and give good work to women. If I had a choice of employing a man or woman for the same acting job—maybe I shouldn't say it—but I would choose a woman!

MJ: Sorry, what was that?

EJ: Delete! Delete!

ZS: But I would! If there was a role that could be either, and it was a good role, I would try and give it to a woman. Absolutely. I would try to give it to somebody from Northern Ireland before I would give it to anyone else, and I would give it to a woman before a man.

PMF: I definitely feel like I have a responsibility to employ people from the north of Ireland. I've always felt that.

ZS: Sometimes it's hard though, because a lot of Northern Irish actors are still stuck in the male-dominated tradition, and I find it hard to find Northern Irish actors who are as playful, spontaneous and risk-taking as I'd like them to be. I struggle with that. I always want to work with them but I sometimes find them "stuck," or very text focused.

EJ: It's also about the lack of drama training–the lack of opportunity for a lot of our actors to have intensive drama training. That's a perennial issue.

CML: It's also really important not to employ them when there are better people for the job. That's really important.

PMF: No, absolutely. I agree with you on that.

ZS: I feel we've always had a real freedom about that, because whoever we're employing doesn't usually live in Portstewart, so we've always had to pay subsistence anyway. It's been much easier for us to employ people wherever they're based, to make it a level playing field, because there's not that financial consideration. That makes you very free in some ways. But I would prefer for Northern Irish people to get the jobs, if I could help it.

CML: I think that gender has an impact on the choice of work, because in the few times that I have been able to choose, I tend to choose a female writer with a substantial female cast, because there is a massive imbalance. I was asked to choose a Restoration comedy and I chose Aphra Benn's *The Rover*–because it's a great play but also because it's got as many good women in it as it has men. I would tend to choose a female writer if I had a choice. And I definitely would lean towards a female in a neutral character, if you know what I mean.

PMF: I'm reluctant to say that there are certain stories that interest a woman more than a man, but there inevitably are. For example, *Belfast by Moonlight* started off as a completely different premise. It was a play that I was going to do in St George's to look at 400 years of Belfast. It was going to be three men and two women and it was about the elders of the city deciding what the city was going to be. It ended up being six ghosts of Belfast over the last 400 years who were all women, who had come back to talk about the lives that they led and how they survived. And we had a female chorus of twelve. So it was hilarious when I looked back at what that started off as–but it was because the narrative that I wanted to tell was always there, that was the story that interested me, and it leapt off from that. It led one way, possibly because I'm a female–it's kind of hard to say. The playwright and composer were male–Carlo Gebler and Neil Martin.

EJ: I don't know whether this is true but I think that, generally speaking, women have a greater sense of responsibility, in a domestic and therefore in a kind of personal way. I wonder how that would filter through, in terms of the choices and priorities within an organization. Perhaps, the choices are different in terms of that heightened sense of responsibility–responsibility in terms of gender, in terms of place and

in terms of the next generation of artists, investing in them and understanding that you need to create a support network for them. I wonder if those ideas are a higher priority from a female perspective.

MJ: Do you think that the situation for women in Northern Ireland is substantially different than it is for other parts of Ireland, the UK or Europe? Does that affect your work? Do you have any idea why there are so few female artistic directors in the UK, the US and Europe, while there are so many here in Northern Ireland?

ZS: Whenever Big Telly started [in 1987], the only other women's company here was Charabanc. And we started the company without the context of there being twenty other theatre companies–no one else wanted to come and make work here, when we started. We didn't start in a fiercely competitive environment at all. I think that's historical. Northern Ireland wasn't where people were going to make their work and people didn't see here as a context to have an artistic future–although Charabanc were blazing a trail. Many of my colleagues and friends thought it was a ridiculous place to come and set up a theatre company. But there wasn't another one, so for me it was a great place.

EJ: The environment is very, very different now. There were the halcyon days when Kabosh was generated, and Tinderbox, and Prime Cut and...

ZS: And we're the first generation of those, clearly. But I think that is quite different from thinking "I want to run Derby Theatre Royal"– and that's a completely different context.

MJ: So there are so many women running theatre companies in Northern Ireland because all the men went elsewhere and nobody else wanted to do it?

ZS: Well, it depends what you were looking for. If you were looking for status–and I think a lot of men are–and you were looking for the kind of linchpin job, you weren't going to get it in Northern Ireland. You weren't going to be perceived as somebody that was going to be successful in the arts. I think there were many, many years–and I don't think I was aware of it at the time–but I don't think it had any status particularly. I was just doing it because it was a place where it was possible to make work. But if you are looking for status, you weren't getting it here. It was a different landscape.

EJ: Also, maybe it's about running buildings. Generally speaking, I think anyone who wants to run a building is insane in the head. But maybe that specific kind of drive, in terms of wanting to run a building, is seen as more masculine ... generally speaking, theatre venues in Irish

cities are run by men—with the notable exception of the MAC. That's pretty accurate, isn't it?

ZS: But when you're a young director, running a building is seen as a career move. Not starting your own company—that's seen as something you wouldn't do until you get to run a building...

PMF: ...The number of people that said to me "isn't it awful that you had to step down from running the Lyric to move to running a wee company?"

MJ: But you'd rather run a wee company?

PMF: I am controlling my own destiny. I'm working with people that I want to work with. I'm not dealing with bureaucracy that takes your mind off the joy of what it is that we do.

ZS: It's about the work.

PMF: Yes, and I can have direct responsibility for what it is that I create or who I work with—maybe not a direct responsibility, but ...

ZS: We're all control freaks! (Laughs)

PMF: But the joy that you get when you introduce someone to theatre for the first time—the delight that you get when you meet a young person, and then you meet them five years later and they are putting a piece of theatre on the stage and they say to you "you're the one that said that thing that made me want to go to drama school"—that is brilliant. There is nothing as satisfying and as joyful—it's an honour.

But also, it was an honour to run the Lyric. Every day I used to pinch myself and worry that somebody was going to come and catch me out. I never underestimated the responsibility of it and the responsibility of carrying the mantle of the woman that founded it—Mary O'Malley ... And there had been no other woman running that building since then.

It's interesting when you look at the desire to run a building or to run a festival. I see the two of those are somehow quite similar. When you look at what's happening in England, when you look at the fact that Rachel O'Riordan is running Cardiff now, and women are running Birmingham theatre, and when you look at the Royal Court—when you look at a lot of what's happening, there are a lot of strong women now running theatres. I think the decision to run a theatre is interesting. Does it come at a certain point in your career as a director? Does it have a permanency? Do you get tired of fighting the battles for ongoing funding? Do you want to create a space whereby you can support those younger women coming through by giving them directing jobs, by giving them writing commissions?

CML: One thing though, that I think can't be underestimated—and I say this as somebody who grew up in Donegal as opposed to in the six

counties–is that the confidence of women in the North is completely different to anywhere else. That's another gross generalization, but it is actually true. I've noticed that women in Northern Ireland have often taken leading roles, particularly in an arts context–whether it is a side-effect of the conflict or not, I don't know. They've had to take a leading role and fight their corner, throughout the conflict–initially in domestic contexts, I suppose, but that behaviour becomes endemic throughout a society, part of its fabric. That isn't the same in the rest of Ireland, or at least not to the same degree. It isn't the same in England. Here, there is a confidence and an authority–and women seem very sure of their voice, in a way that women, too often, aren't in other places. Definitely, confidence is an issue here. Don't you think?

EJ: I've never heard anybody say that before. I think it is a really interesting observation.

PMF: As a society, we are. I've been chairing a discussion–after a lot of our work dealing with the past–and listening to working class women articulating very clearly what they want out of life, how they've survived and what it is they want to achieve. Their command of language, emotion and context never ceases to amaze me. Every time I bring people over here, who are working as artists elsewhere, they always comment on it. I don't think we have necessarily given credit to this strength, not for a very long time.

Works Cited

Gardner, Lynn. "Are Women Getting Any Closer to Equality in Theatre?" *The Guardian*, 6 March 2012. Web.

13 | *HERE & NOW*, There and Then: An Interview with Veronica Dyas

Karen Quigley

Introduction

Veronica Dyas is an Irish freelance artist. On graduating from a Masters in Text and Performance Studies at RADA/King's College London in 2008, Dyas returned to Dublin and initially focused on installed theatre, developing and presenting *YOU* in 2009, a multi-site sound installation focused on public-private spaces including toilets, taxis and photo booths. In 2011, she created and performed *In My Bed*, a one-woman show made in collaboration with Niamh Burke-Kennedy for the Dublin Fringe Festival.[33] This text-based performance piece uses a variety of personal objects to present an intimate autobiographical narrative, articulating Dyas's exploration of sexuality, discussing the sexual paralysis resulting from rape when she was a teenager, and weaving the details of her life with that of her grandmother, Granny Vera. The gentle involvement of the audience in *In My Bed*, seated on or near the bed from which Dyas performs, is indicative of her approach to her practice.[34] Participatory, yet never demanding, revelatory but never indulgent, Dyas' care for her spectators is thoughtful and generous. As Peter Crawley noted in a review, "[i]f this is therapy, it's not for her, but for a society, for history, for us."

In 2012, Dyas began work on *HERE & NOW*, an ongoing practical research project exploring notions of place, homelessness, duration and

[33] *In My Bed* was re-staged for the Forest Fringe at The Lir, Dublin, in December 2012, and for the HOME Festival in Cork in April 2013.

[34] Audience capacity for *In My Bed* was 30 in 2011 at the Dublin Fringe Festival, 75 in 2012 at The Lir, and 20 in 2013 at the HOME Festival.

walking. This multifaceted project has seen Dyas facilitate workshops with Focus Ireland and the Abbey Theatre, walk the Camino de Santiago in northern Spain, give away all but the most basic of possessions, and reflect throughout on the questions of abundance and waste that have been occupying the minds of many Irish artists, particularly in the post Celtic Tiger era (Walsh 1-20). An initial performative presentation of this research, *all that signified me ...*, which combined installation, exhibition and live performance, was presented at Project Arts Centre, Dublin, in January 2013, as part of *THE THEATRE MACHINE TURNS YOU ON: Vol. 3*.[35]

Interview

KQ: Thinking around the notion of "radical" as, perhaps, that which departs from tradition, or changes something fundamentally, could we talk about this idea in relation to your work?

VD: Radical is a hard word, and it feels, from a certain perspective, like a strange compliment. *In My Bed* is a text that has been written and performed, so it is traditional in many ways. And I don't think of the content as radical, but if you look at it from a certain societal perspective, the fact that I am performing a one-woman show in a theatrical context, considering my socio-economic background and so on, then that is radical to an extent. Sometimes, when the work was difficult, I thought about the fact that it presents a total shift within my family context. Starting from my grandmother's lifetime, within two generations I have been able to do a professional theatre piece on my own, a woman in Ireland, and speak about sexuality, about sexual violence. That is radical. Further to that, the first time I performed *In My Bed* was on the site previously occupied by the company my grandmother had to leave because she got married, and there I was in the same space, not married, with no limitations really.

KQ: Considering some of the subject matter in *In My Bed*, then, does the notion of the traumatic or the shocking present another connection (or perhaps mis-connection) to the idea of a radical theatrical practice?

VD: I think we can often confuse radical with shocking, because it is an easy label to put on shocking things, but for me a more subtle process is happening. Obviously I talked about rape, but in the text it is

[35] *THE THEATRE MACHINE TURNS YOU ON: Vol. 3* was co-produced by THEATREclub and Project Arts Centre and presented on 15 and 16 January 2013.

pared back. It is not artistic as such, and not graphic, but you know exactly what's happening. There are some very basic, stripped-back movements, like [demonstrates] "he puts his hand on the left side of my face" (Dyas, *In My Bed*), apart from that it is just speaking, but in very close proximity to the audience. This was a balancing act, because you know it's going to have an effect, even if you haven't had that experience, everybody knows somebody that has. So I had to be careful of myself, and then I had to be careful of what was going to happen to the audience. For example, I knew they were going to come and tell me things, that was part of the point.

KQ: Can you tell me more about those kinds of post-show exchanges?

VD: There were at least three women who told me that me talking about rape had significantly changed how they felt about similar traumas that they had had. There were other people who had never told anyone, who then started to talk to the Rape Crisis Centre, that was significant. I knew it was going to happen. "People need to say their things" (Dyas, *In My Bed*), and I think women in Ireland definitely need to say their things, because too much has gone on behind closed doors. With the Magdalene laundries[36] and the Redress Board,[37] people being paid to stay silent, all of those decisions have caused trauma. The only regret I have is that I did two shows a night, so there was not much time after the first show to talk. Sometimes people weren't ready to tell me the whole story, they would just say something like, "That happened to me, thanks so much for saying it out loud, thanks so much for talking about it in public" and they would leave. Then sometimes it was people I knew and they would tell me more information, and suggest that watching the piece helped them to be braver. So, it came to be about the politics of rape, to an extent.

[36] This refers to state-mandated, Church-operated residential institutions in Ireland to which girls and women were sent (for a myriad of reasons, see "Report of the Inter-Departmental Committee to establish the facts of State involvement with the Magdalene Laundries" iii), and effectively imprisoned. In 1993, when a Catholic order in Dublin sold part of their convent to a property developer, the discovery of the unmarked graves of 155 inmates triggered a public scandal in Ireland.

[37] The Redress Board was set up under the Residential Institutions Redress Act, 2002, in order to "make fair and reasonable awards to persons who, as children, were abused while resident in industrial schools, reformatories and other institutions subject to state regulation or inspection" (rirb.ie).

KQ: The notion of tracing back through generations of your family in *In My Bed* arguably had a lot to do with the specific site you performed in, as well as the content you created.

VD: I was disappointed that audiences did not pick up on the fifty years between the two generations I was looking at. I was exploring the idea of women in Ireland and there were exactly fifty years between my granny and I, she was born in 1927 and I was born in 1977. Of course, it didn't matter because they resonated at an emotional level with my grandmother's story or that aspect of the show. Incidentally, she was quite radical in her own way. For instance, when she got married, she did not tell her employer.[38] She worked for the Norman Typewriter Manufacturing Company, they made carbon paper and things for typewriters. It was a small factory, and it's now a car park at the back of Temple Bar. The little shed in the car park, where I performed *In My Bed*, was similar to a black box space, so that was ideal for the show. Also, it was a very resonant site. I think theatrically the show was better when I did it in The Lir in 2012, but there was something visceral that was extremely special, in that space.

KQ: Can we talk more generally about the evolution of *In My Bed* as a piece? I know it signified quite a change in your practice at the time.

VD: I had described it as a "coming out" show, because it was the first show I had done since I went back to college in 2003. I had previously been working with installed theatre, so in a way I'd separated my voice from the body, and the words from me. It was difficult, to do a one-woman show as my first theatre piece, but for me it was necessary, and I had plenty of support. For example, I had a beautiful timeline on the wall, which my friend Soraya Picado designed. I was working with Niamh Burke-Kennedy, who initially came on board as director, though the relationship evolved and she became a dramaturg. Caitríona Ní Mhurchú and Sorcha Kenny, whom I met during The Next Stage in 2009,[39] Lauren Larkin, Louise Lewis, and Grace [Dyas, Veronica's sister] all watched rehearsals and gave

[38] See Ferriter 421, and McGrath 55, for an explanation of the 1932 marriage ban, whereby women working in the public sector were legally obliged to leave their employment when they married. This legislation permeated the private sector also, exacerbating gender inequality in the workplace throughout Ireland.

[39] The Next Stage is an artist development programme based around the Dublin Theatre Festival, presented in association with Theatre Forum Ireland, and supported by Irish Theatre Trust and the Arts Council Theatre Development Fund.

feedback, which was absolutely essential for my confidence. As a performer, I was very nervous because I'd never exposed myself like that. Róise [Goan, then artistic director of Dublin Fringe Festival] gave me support and encouragement too, and to have those women whom I respected be supportive of the work was invaluable. They also helped me with clarity and so on, because the structure of it is my relationship with my grandmother. Evoking her became the linchpin of all of it, and so sometimes basic structural feedback was helpful to hear. Also, Amy Conroy, whom I also met on The Next Stage, was doing a one-woman show at the same time, so I think we helped each other in that regard. She had been working as a performer for years, but *I (Heart) Alice (Heart) I* was her first written piece in 2010, and she was doing *Eternal Rising of the Sun* in 2011, which was a one-woman show about a young woman who had been abused. So there were many similarities between the pieces we were doing. She was working in a different way, with a fictionalized character, but there were parallels between the stories we were trying to tell, and the reasons we were trying to tell them. It was also a similar impulse, stemming from the fact that these stories had not been told for so long in Ireland. And that same oppression had been stopping any healing from taking place.

KQ: You've mentioned already the notion that "people have to say their things," which is a powerful image, and it seems to me that there is an extent to which opening up in that way is not a particularly Irish characteristic.

VD: For me, it's because a lot of what we had is gone. There were "the boom years," where we did not consider these past traumas as much as we do now. Of course, people had already begun to move away from the Church, and the incidents of clerical abuse came out, and there was a huge impact on people whose whole lives had been subject to the Church, a horrible feeling to realize that this had been going on. I remember my mother stopping going to Mass. We lived next door to a church, she had her own version of Catholicism and I think everyone in Ireland did, but there was huge faith, and to have the structure of that taken away was very significant. Not to mention the economic situation. With *HERE & NOW*, I am trying to talk about that idea that everything we had was removed from us, and so there's an awareness and a knowledge now that we didn't have before. Previously, every time we had our own power we were giving it away, to the Church, to the State, to the banks, and we know now that none of that works. So, we have to say our things, and that was a key point of *In My Bed*. To be honest, to be truthful.

KQ: You seem to put a lot of trust in your audiences, even as you care for them—are you ever concerned that they're not going to come with you on the journey?

VD: Well, you have to strike a balance. With some people, I knew it would be difficult. My father came to see it and he wouldn't make eye contact with me, my brother was the same. I had told all my family about the content before I performed it, which I'd never done before, so it was a significant personal journey to have those conversations. Then, when they came to watch, I directed different parts of the performance towards them. I think each spectator has a certain conversation with themselves, because the performer is offering something, but she's offering only her own experience. As a performer, I am also trying to give them the space to have that conversation with themselves, while the show is happening. I don't think there is another artform that can do that in the same way, it's something about the theatre, and about being human. There is a human being in front of you, you can't turn over the channel or eat your popcorn, it's immediate. If I'm there, talking about being raped, and you're sitting right there, you have to work to stay with me, to offer something or to connect with me. There's no wall. I had to invent a prologue to tell them what was going to happen, in order for them to have the agency not to engage. It was very sparse, "I'm going to talk to you, that's all, I'm going to try and tell you my story as I understand it today, I'm going to talk about sexual paralysis, the body remembers" (Dyas, *In My Bed*). I had to give them the parameters, and I had to do that in order to set a tone, to create an atmosphere of safety for them. But then ethically I had to tell them what I was going to talk about, so that they could make their own decision about where they wanted to sit or whether they wanted to stay.

KQ: Let's talk about *HERE & NOW*, and specifically about *Project Downsize*, a phase of the project in which you decided to downsize all your possessions. Maybe we could relate this to the idea of ownership, a gendered ownership of domestic space, and ultimately home ownership, which you articulated particularly in *all that signified me* ...

VD: The powerlessness I felt when I came back from the Camino de Santiago in Winter 2011 was acute. I was £100,000 in negative equity, and felt completely stuck and trapped. I knew, as a theatremaker, that I was never going to make that sort of money to pay off the debts, it would be impossible. I discovered that it was still unusual to be a single female homeowner, as it had been in 2000 when I bought the house. I decided to start by considering my possessions, as the house was full of stuff, and for me that was a waste. I gave my theatre books and

playtexts to the Dublin Fringe Festival library and to Dublin Youth Theatre, and spare curtains, sheets and clothes to St Vincent de Paul. For me, there was movement in that exchange, it was about waste, and transforming waste into "Abundance."[40] However, when I looked at the house, I realized that the only thing I could do was to become a landlord, even though I did not believe in the concept. It was impossible to try to hand back the house to the bank, doing that would have been complicated and irresponsible. The general reaction was one of confusion, people thought I was mad, and my mother and a friend thought I was suicidal, they were terrified and worried. I think it's because they both like their houses and their stuff, it is very much part of their security.

I also had to make a will when I bought the house originally. I was just twenty-three, and all I had was the house, so the rest of the will was leaving cds to my cousin, that sort of thing, ridiculous. So part of *Project Downsize* was the idea that I could give my things to people now, and tell people how I felt about them, and that became very significant. For example, I gave my godchild the ring my grandmother gave me for my confirmation, and had that moment of, "this is for you." It was very funny when I got a letter around the same time from the solicitors who had my will. It said that if I wanted to update my will it was fifty euro. I rang the solicitor and told him that I did not have any of the things from the original will anymore. He said, "Well, Veronica, the way it works is, if someone bequeaths the *Mona Lisa* in their will and they aren't in possession of it when they die, well, you know?" I thought it was hilarious, so I put that into *all that signified me...*

KQ: Staying with *all that signified me...* for the moment, can we talk about how you used theatrical space in that piece?

VD: *all that signified me...* was interesting for me because it represented a radical change in my performance practice. I mapped the space at Project Arts Centre in a very specific way, which was new for me. I had used technology in some of my installed theatre work, but this had mostly been basic sound equipment, as I had preferred the installations to focus on the text, or the voices I had chosen to work with in different contexts. For example, I had never engaged with audio-visual equipment like live-feed cameras, because I had not been in a theatre space with my own work since RADA in 2008. Even with *In My Bed* in The Lir in 2012 I was in their Factory space, and in Cork in

[40] In relation to *HERE & NOW*, "Abundance" forms part of Dyas' developing conceptual framework of enough for all, without waste.

2013 I was in a gallery space, neither of which are specifically theatre spaces. So *all that signified me...* was significant from that perspective, because I remembered what you could do in a theatre space, and for me that was a radical change. In terms of organizing the space, I used all the letters I had received from the bank for the mortgage arrears to make a spiral. This shape also signified the Camino journey and the spiral of life, a liminal space. However, it is important to note that I mapped out the space, but I did not map out a text. When Ciarán O'Melia, the designer for *THE THEATRE MACHINE TURNS YOU ON*, came in to talk about the design of it with me during a rehearsal, I realized that I did not know how I was going to talk to the audience about this piece, my response to *Project Downsize*. And Ciarán reminded me of the title and ethos of the project, *HERE & NOW*. With that in mind, I knew that I did not need to know what to say in advance, because the piece would take place in the here and now, whenever that was.

Returning to the space, I used my grandmother's chair, as I had done in previous installations, and I liked that resonance, the trace of past work.[41] I had a prayer stool that a friend had left in my house, which he had previously given away as a gift. There was also a white skirt onto which I projected images of my previously-owned possessions, and that ran throughout the whole show, as well as a wall of photographic negatives. A live-feed camera faced into the chair, so sometimes I sat in the chair and you could see my face projected onto the wall behind. I had also made a film which played throughout the show, and my Camino diary, bound. There was text that I'd already written on some of the projections, lines from the Camino and stuff like that, and finally I laid out what I had left after *Project Downsize*, my rucksack and my bag. That was how I used the space during the live show.

KQ: What was the audience's response to the piece?

VD: At the time of *all that signified me...* there were 83, 641 people in mortgage arrears of thirty days or more, and I felt like I was the "1." There had been a significant shift in my life, and my house was not important for me anymore. Neither were my possessions, which is an interesting evolution of practice, because *In My Bed* was full of specific objects. But for those other 83, 640 people, some of whom had perhaps

[41] WERK: "The Unthinkingness Chair," created with Fintan Walsh; The Resembled Self Exhibition: "Born The Year of the Silent Movie," installed by Grace Dyas; "In My Bed" in the Dublin Fringe and The Lir.

been made redundant, many of whom had (and have) families to support, the situation was not the same. Looking at all of the arrears letters from the bank, at one stage I thought it might have been an interesting political act to walk on those letters as part of the piece. But then I realized that to dance on them, and to believe that ritual and dance could make a change equivalent to doing something overtly political, would have equal value spiritually and emotionally. So I invited the audience at *all that signified me…* to join me in that dance as a transformational act for those 83,640 people, and they did. Nearly everybody on the two nights came down and danced, which was a miracle, because I knew that if they didn't get up, I was going to have to dance for ten minutes on my own.

KQ: Let's talk a bit further about some of the support you've had for your work in Ireland, the programmes you've been involved with, like The Next Stage and MAKE in Annaghmakerrig.[42] Has this informed and influenced these changes in your practice over the past few years?

VD: Very much so. The Next Stage changed my life, mostly because I met fellow Irish practitioners who truly support each other's work. When I went to MAKE for the first time in 2009, *In My Bed* didn't exist. I had started writing about my grandparents, and I also had some texts that I had written about all the women in my life, but they were two completely separate pieces of work. I had a big studio space in Annaghmakerrig the first year, so I put up a timeline of photographs of my grandmother and I, from her holding me as a baby outside her caravan to me lighting a candle with her coffin behind me, our whole lives together on the wall. I had that timeline at one end of the space, and at the other end, on an easel, I had the texts about women, which were called *Her Bed*. Vivi Tellas [one of the MAKE mentors] visited the studio, and after I'd talked her through the whole space she stood in the middle of it and said that the pieces were completely connected. She said, "It's your bed." And I said, "It's my bed." That is how *In My Bed* started.

However, MAKE was completely different for *HERE & NOW*. I spent the time sitting in different spots making logs of what happened as time passed, because *HERE & NOW* was initially about the paradox of being homeless and yet occupying space. And Florian Malzacher [another MAKE mentor] was very helpful, encouraging me to create a blog at the

[42] MAKE is a residential laboratory programme for theatre and performance artists, supported by Cork Midsummer Festival, Dublin Fringe Festival, Project Arts Centre and Theatre Forum.

start of the process, and to experiment with different styles of writing. Initially, part of the project was going to be a durational piece during the Dublin Fringe Festival in 2012, where I would stay outside. But the concept of doing that when I owned a house became problematic for me, whereas after *Project Downsize*, it made more sense. Additionally, at that time, I had started volunteer work with Focus Ireland, but I had not worked with them in a theatre capacity yet, and I learned a lot from that process. One of the questions I was asked by Richard Gregory [another mentor] at MAKE was about how to process the whole experience at the time, and how to document the process afterwards, which for me is still a significant question. If I write a book that's an answer, in a way.

KQ: Do you think that writing a book about *HERE & NOW* would allow you to think in a certain way about your performative practice so far?

VD: To an extent, but I'm not sure about the kind of change writing a book would represent.[43] For me, there is still an unresolved question about the difference between radical change and incremental change. For instance, my work with Focus Ireland and SAOL[44] has made me realize that facilitation work is very much a part of my practice when I do something in the theatre. Of course, it's a different practice to my performance work, but it's absolutely vital to me making work. I don't mean in terms of taking stories from that work in order to make something, I am referring to the energy or connection or reality of working with people. For example, sometimes when I came out of workshops with SAOL or Focus Ireland, I was certain that society needed to be completely dismantled in order to start again, that there could only be radical change. I felt that nobody in our society should be suffering, and that if one person was then the society was failing. However, that option is impossible, and you would just end up banging

[43] At the time of the interview, Dyas was interested in an autobiographical, generational structure for this book, looking at home ownership in her grandparents' generation, her parents' generation and finally her own.

[44] The SAOL Project is an educational, rehabilitation programme for women with histories of addiction. In association with Phil Kingston and the Abbey Theatre Community Outreach Department, Dyas delivered a series of workshops alongside the Abbey Theatre's productions of thisispopbaby's *Alice In Funderland* (March-May 2012) and *King Lear* (January-March 2013), culminating in devised pieces performed in-house at SAOL (2012) and at the Abbey Theatre's rehearsal room (2013). The 2013 piece was also re-staged for SAOL's International Women's Day event.

your head on a wall. For me, it is a personal conflict when I am seeing the absolute worst aspects of society and thinking that it shouldn't be that difficult, that with the education and resources available we could at least make it equal for everybody. Of course, then I would remember that not everybody shares my way of thinking, and that a personal change could make a more realistic impact, which leaves me with incremental change. If I am making personal work, and speaking to one person, or to five people, there is value in that. Incremental change does change something.

Conclusion

Focusing primarily on *In My Bed* and *HERE & NOW*, Dyas reflects in the above interview on her practice in relation to the notion of the liberation of female narratives and the perceived radicalism of such a practice. In these conversations with Dyas in September 2013, I found myself reminded more than once of Walter Benjamin's essay "The Storyteller." Written towards the end of the 1930s, it discusses the nineteenth century Russian writer, Nikolai Leskov, and notes that "the art of storytelling is coming to an end" (Benjamin 83). Benjamin articulates a transition from an oral practice of narrative to a written one, and warns us of the decreasing value of storytelling. In particular, he discusses the interconnectedness of the storyteller who travels far away, gathering stories and bringing them back to the homeplace; and the one who stays at home, working with local stories and ways of telling. These two types of storytelling are equally vital to narrative practice, as "the figure of the storyteller gets its full corporeality only for the one who can picture them both" (Benjamin 84).

For me, tracing a line from Benjamin's local storyteller, the "resident master craftsman" (85), to the work under discussion in this interview, Dyas delves into her autobiography to construct fluid and porous pieces of performance, reflection and exhibition that release (frequently) female voices and stories previously suppressed by domestic and social constraints. However, moving beyond the purely local and autobiographical, it is evident that the swirling palimpsest of *In My Bed* traces and retraces histories of abuse and recovery, not just hers, but Ireland's. Similarly, the diverse and international elements of *HERE & NOW*, exploring personal research and performance processes as deeply as the products that could be (have already been, and will be) extracted from such work, touch on a much broader theme of possession and ownership, which is being played out across European society at economic, political and cultural levels in the early decades of

the twenty-first century. Thus, just as Benjamin's "travelling journeyman" (85) always returned home to work in the same room as the resident master craftsman, correspondingly, Dyas continues to relate her personal work to a wider world. The ongoing interplay of the local, the national and the international; the delving inwards and the turning outwards; the exposing of the underbelly and the construction of protective armour—what this amounts to, in many ways, is the telling of stories. Returning to my opening question to Dyas above, and to the exploration of the radical in her work, it may be possible that storytelling in this particular way is in fact the most radical practice of all.

Works Cited

Benjamin, Walter. *Illuminations*. Ed. Hannah Arendt. Trans. Harry Zohn. London: Pimlico, 1999. Print.

Crawley, Peter. "*In My Bed*: Review". *Irish Times*. http://www.irishtimes.com/blogs/festival-hub/2011/09/12/in-my-bed/. 2011. Web. 13 Jan. 2014.

Department of Justice and Equality, "Report of the Inter-Departmental Committee to establish the facts of State involvement with the Magdalen Laundries". http://www.justice.ie/en/JELR/Pages/MagdalenRpt2013. 2013. Web. 7 Oct. 2013.

Dyas, Veronica. *HERE & NOW*. Blogger. http://herenow2012.blogspot.ie/. 2012. Web. 7 Oct. 2013.

---. *In My Bed*. 2011. Unpublished script.

Ferriter, Diarmaid. *The Transformation of Ireland, 1900-2000*. London: Profile, 2004. Print.

McGrath, Aoife. *Dance Theatre in Ireland: Revolutionary Moves*. Basingstoke: Palgrave Macmillan, 2013. Print.

Residential Institutions Redress Board. Webtrade. http://www.rirb.ie/. n.d. Web. 7 Oct. 2013.

SAOL Project. n.p. http://www.saolproject.ie/ n.d. Web. 7 Oct. 2013.
Theatre Forum Ireland. Roomthree Design. http://www.theatreforumireland.com/. 2009. Web. 7 Oct. 2013.

Walsh, Fintan. "Introduction." *"That Was Us": Contemporary Irish Theatre and Performance*. Ed. Fintan Walsh. London: Oberon. 2013. 1-20. Print

14 | The 10kW Girl: An Interview with Aedín Cosgrove

Noelia Ruiz

Introduction

Aedín Cosgrove and Gavin Quinn co-founded Pan Pan Theatre in 1991 after graduating from Trinity College Dublin, in Drama and History of Art and Drama and Classics respectively. The artistic directors met in DU Players, the Trinity College Drama Society, where their first collaboration with Cosgrove as designer and Quinn as director took place. They staged *The Vampire* (1990) by British dramatist J. R. Planché (an adaptation of Charles Nodier's *Le Vampire*, which was a dramatization of John Polidori's novel by the same title). Since then they have created more than twenty-six productions establishing themselves as the longest-running experimental theatre company on Ireland and arguably the most recognized internationally, especially in the festival circuit. Their productions of Beckett's radio plays *All That Fall* (2011) and *Embers* (2012) won the Herald Angel Award at the Edinburgh International Festival 2013. Joyce McMillan's five-star review in *The Scotsman* summarizes the company's ethos:

> Samuel Beckett can always be relied on to push our ideas about theatre to their limit and, in responding to his genius, Pan Pan have created a marriage of theatre and installation that seems to capture the hard, implacable but loving soul of the work, while giving it a new theatrical life.

Initially, Cosgrove and Quinn were both inspired by the avant-garde, particularly symbolism, futurism and the conception of theatre as an art form and the work of art as a unity. Adolphe Appia encapsulates the

attitude of the epoch: "every work of art must contain a harmonious relationship between feeling and form, an ideal balance between the ideas which the artist desires to express, and the means he has for expressing them" (qtd. in Beacham 29). Quinn also acknowledges the French group Cartel des Quatre founded in 1927 in Paris by directors Louis Jouvet, Charles Dullin, Gaston Baty and Georges Pitoëff (Ruiz 121), who intended to revitalize theatre by breaking away from what was known as "Théâtre du boulevard," whose motivation was purely mercantile. For Cosgrove, the most influential innovators in scenography, Appia and Edward Gordon Craig are responsible for her decision to become a lighting designer. Both rejected the idea of scenic illusion and conceived the use of lighting, set and three-dimensional spatial composition—including the human body—as aesthetic elements of a theatrical artwork. Craig and Appia's innovation[45] allowed for a sensual theatrical experience through associative, suggestive

[45] Appia was fascinated by Richard Wagner's work and the idea of artistic unity, which motivated the first investigations of his scenic reform; those led him to abandon "the traditional provision of external historical or fictive locales to illustrate the stories, and sought instead to derive the setting from *within* the work itself" (Beacham 2). Appia advocated simplicity in his suggestive three-dimensional sets in which lighting was a crucial aesthetic component, "a fully expressive medium in its own right" (Beacham 5). His innovations fostered many technical developments such as movable spotlights that allowed for a "fluid dynamic formative light" that "by controlling and modulating the intensity, colour, movement and size of the beams projected by these lamps" allowed for expressive effects and shadowing (Beacham 5). As part of his reform Appia also developed an understanding of the human body as a compositional element to be not only part of but also in interaction with the scenography. He collaborated with Emile Jacques-Dalcroze who had created a system of rhythmic exercises for actors called Eurhythmics, which Appia integrated in his work. This conception of the actor as a "scenographic instrument," that is, part of "a synthetic process in which the actor merely animates a number of the signifying systems in the process of generating meaning" (Gordon 7) was brought a step further by Craig and his radical idea of the Über-marionette: "The actor must go, and in his place comes the inanimate figure–the Über-marionette we may call him, until he has won for himself a better name" (81). Craig's non-representational aesthetic propositions were decidedly influenced by Symbolism conceiving theatre as an interdisciplinary art aimed to create an atmosphere through "action, words, line, colour and rhythm" (138). Craig ideated hinged screens, movable proscenium arches, and experimented with colour using solely overhead lighting instead of traditional side and footlights.

atmospheres in which lighting was "a fully expressive medium in its own right" (Beacham 5), a viewpoint shared by Cosgrove.

This avant-gardist model is at the centre of Pan Pan's productions. Since its inception, they have been at the forefront of experimentalism in Irish theatre, which traditionally has been rooted in the dramatic text. When the company was formed their only antecedent in terms of experimental performance was Operating Theatre, created in 1980 by Olwen Fouéré and Roger Doyle out of the idea of a contemporary music-theatre company. In that sense, touring—which they did from their very first production in 1991, *Negative Act* (Lyon International Student Festival, France)—was crucial in the development of the company's aesthetics, which are in line with cutting-edge, contemporary European trends. Touring not only had an impact on their shows but also led them to create The Pan Pan International Theatre Symposium in 1997. Run biennially until 2003, its commitment was to showcase contemporary ground-breaking theatre and performance work, which since Hans-Thies Lehmann's publication *Postdramatisches Theater* in 1999 is usually labelled as postdramatic, a fluid term still open to critical debate. However, as Liz Tomlin argues, the binary "text-based/dramatic/teleological and non-text-based/postdramatic/deconstructive" (64) proposed by Lehmann is limiting, and problematizes the inclusion of contemporary playwriting in the postdramatic as well as mise-en-scènes dictated by a pre-existing text. Nonetheless, Lehmann offers a theoretical, conceptual and terminological corpus to critically analyze contemporary work and, consequently, can be applied to the discussion of Pan Pan's aesthetics.

Pan Pan's aim has always been to explore and investigate the potential of theatrical language and performance in terms of communicating with an audience. Cosgrove and Quinn regard their last four productions as installations[46] at the heart of which lies the spectator's experience of the artwork, a conceptualization that helps understand much of the company's oeuvre in the past ten years. The conception of the theatrical piece as an installation is also important in terms of the company's modus operandi, as they often collaborate with other artists, particularly with sound designer Jimmy Eadie and sculptor Andrew Clancy. Effectively, Cosgrove considers herself a collaborator whether she is working with Pan Pan or with other companies. However, her role as co-artistic director allows her to experiment further and she has been in the forefront in introducing

[46] As other pieces such as *ONE: Healing with Theatre* (2005).

technological advancement on Irish stages. In 2000, she obtained an M.S. in Multimedia Systems, also from TCD, which, as she reflects upon in this interview, was a step in her career. In the 2000s technology became a common feature of theatre and performance and Cosgrove made full use of its potential in shows like *Mac-Beth 7 (2004)* or *The Crumb Trail* (2009). However, as she observes in this interview that tendency in general faded, perhaps because, as Lyn Gardner argues, more often than not technology became "the show, rather than being in service of the show." Philip Auslander argues that "a new medium will not be developed until a 'supervening social necessity' for it is perceived, and it is selected for investment" (3). Similarly, the necessity, impact and relationship of digital technology with the medium of theatre/performance are still contentious issues in terms of how "they have challenged the very conception of theatre" (Nelson 13). Hence, the use of such technology in mises-en-scènes is an aesthetic and/or dramaturgical choice rather than a feature of theatre and performance per se.

If we can regard Pan Pan as a pioneering contemporary theatre and performance company in Ireland, Cosgrove's innovative designs are the more remarkable if we take into consideration that she is a woman in an area of theatre—the technical side—that has been traditionally quite male-dominated. As lighting designer Sinéad McKenna reflects in her interview with Sara Keating on 30th January 2013: "You'd be more likely to encounter it [sexism] at the administrative or producing end of things, people who would doubt your skills or give you a pat on the back if you get a job."

Similar reflections are made by Cosgrove in this interview and my choice of title attempts to signal, albeit humorously, the resistances she confronted when she began her career—with her innovative ideas—a time when it was far less common for women to take certain roles and even less common to propose designs and approaches that could be considered "radical" in an Irish context. Since then, Cosgrove has established herself as one of the leading lighting and set designers in Ireland, working primarily with Pan Pan but also with other companies such as Corcadorca, Junk Ensemble, Stomach Box and in the Abbey Theatre. In that respect, the interview offers insights in the role of the designer in these different contexts since there are few opportunities for designers to be part of the full creative process. This is partly due to financial restrictions, but also to a traditional model of working, as opposed to contemporary approaches to theatre-making, which are

more bound to their processes and interdisciplinary collaboration, as Pan Pan's work evidences and Cosgrove elucidates.

Aedín Cosgrove currently teaches at The Lir Academy, Ireland's National Academy of Dramatic Art at TCD. Nominations and awards with Pan Pan include *Mac-Beth 7* (nominated for Best Lighting, Irish Times Theatre Awards, 2004), *The Crumb Trail* (nominated for Best Lighting, Irish Times Theatre Awards, 2010), *The Rehearsal Playing the Dane*, at Dublin Theatre Festival 2010 (winner of the Irish Times Theatre Award for Best Set Design & Best Production 2011), *All That Fall* by Samuel Beckett, August 2011 (winner of the Irish Times Theatre Award for Best Lighting Design). Other awards include *Man of Valour* (The Corn Exchange Theatre Company, 2011, Winner Best Overall Design ABSOLUT Fringe 2011, and Best Lighting Design, Irish Times Theatre Awards).

The 10kW Girl: An Interview with Aedín Cosgrove

For the purpose of this interview I met Aedín twice. The first time on a late summer afternoon on 15th August 2013 when she was in the middle of the run of *Embers* in the Samuel Beckett Theatre, which they were bringing to Edinburgh the following week. The second time—resulting in a brief follow-up—took place on 15th October 2013 just after their work-in-progress show in the Dublin Theatre Festival, *Americanitis*.

I have had a relationship with Pan Pan for over two years, since I started my academic research on the company, joining them for the first time in rehearsals in June 2011 as a participant-observer for the purposes of my doctoral research in contemporary creative processes.

Take One—15th August 2013

NR: How did you start as a designer?

AC: Like many people I started in college. We had a class on Gordon Craig and Adolphe Appia and I instantly knew it was the only thing that really made sense for me, and I knew that's where I belonged: the world of stage design and lighting. And it was the only part of the education I was having at the time where I could see a future. Even though it was the avant-garde. But I knew it was something I wanted to explore, especially the ideas of Appia and I would say I am still working on that now. So I started off working with people in college, learning like everybody else. Gavin was in Players as well and we had an idea to do a show … and that was the beginning.

NR: Was that *Negative Act*?

AC: No, it was a show in Players called *The Vampire* by J. R Planché, which was great because it was the beginning of the whole thing. It's a play that has about ten locations and ten times of day and night, and weather and storms. It's an old melodrama and it was really great figuring out the problems of that within my newfound early nineteen-hundreds' avant-garde sensibility. I studied History of Art as well and I guess that was part of the feeling of where I belonged within the world of making theatre. So it also came from the fact that I studied History of Art.

NR: And after *The Vampire* did you decide to form Pan Pan Theatre?

AC: No, that was after *Negative Act*. Gavin also had different streams of interests and he was also very interested in the classics and in the Italian *sintesi*.[47] For us it was all quite exciting and new, especially because when you're in college you think you are the first people that ever opened and read this play.

NR: What was the ethos or aim when you formed Pan Pan Theatre?

AC: I think we had a very clear aim to be different in the beginning, to be very distinct from what was happening in the other theatres, in The Gate, in the Abbey and even in the independent companies. We wanted to make our own identity, kind of like a band: we wanted our own sound.

NR: So thinking in terms of your evolution as a designer, what corners did you have to turn to find your own sound?

AC: What opened up a lot of things was the very beginning. We would go anywhere and do anything, so somebody said "we'll pay your flights to Poland to a festival" and we'd just go, and convince everybody to go and go. And then I saw work over there, particularly Leszek Madzik of Scena Plastyczna Kul,[48] he must be very old now. That was very, very mind-blowing because he was doing everything with tin cans and bulbs in a very low-tech way, but it was incredible image-making in the theatre. And that was a course of possibility because you did not need any money to do that, you just needed the ideas and the purpose,

[47] The Futurists created a series of sintesi—radio and theatre playlets—which experimented with sound, noise and silence with the aim to create a state of tension in the spectators. F.T. Marinetti, E. Settimelli, B. Corra, *The futurist synthetic theatre* (1915).

[48] Polish director, scenographer, and playwright, known for his expressive and unconventional staging, he is regarded as the representative of visual theatre in Poland. He founded the Visual Stage at the Catholic University of Lublin.

and to believe it was possible. So that was very inspiring and it definitely was a page-turner for me. I cannot think of any other plays that had such an impact on me.

NR: And in terms of Pan Pan what was the progression?

AC: I do not really see a progression, everything I have done is just the next step.

NR: So, this Polish show inspired you because of its simplicity, however Pan Pan had a period in which technology became very important in its productions. Why this choice?

AC: Well, you make poor theatre when you are poor and when you have the opportunity to use different materials it seems crazy not to give it a chance. And then the possibilities of technology are inspiring in themselves. Perhaps you do not know it's chicken and egg, which comes first, but I would say the idea comes first and then you realize with a certain type of technology you can achieve it so. Which productions are you thinking of?

NR: I was thinking in particular of *MAC-BETH 7* and *The Crumb Trail*.

AC: I guess *The Crumb Trail* comes after I had completed a Masters in Multimedia Systems. But also, Gina Moxley had written *The Crumb Trail*, which is a term to describe a navigation tool. She was making the connection between life navigation, the Internet and Hansel and Gretel. So that was the beginning of that: the subject matter of the play and its whole world was about technology: the explosion of the internet, YouTube, etc. It was massive.

NR: What motivated you to do a Masters?

AC: I always was and always have been interested in image-making and technology, but especially in image-making in general. And a lot of new art is being made by using technology. There is that new thing happening and a lot of artists are interested in the idea of technology, and I, no less than anyone else, was interested in seeing if I could make that work. Especially because lighting is something that is very technology-based and in order to make the lights work for you, you have to interface through a computer. So that was something I was very comfortable with. And I've always been very interested in technology. In my school, back in the day, we bought one of the very first Apples, and that was the new world, and I wanted to be part of that new world. And I always thought it was something I would go back to one day and the opportunity arose to do that course and I thought "I would quite like to do that and then when I come out I will not be left behind by the new generations running ahead of me knowing how to do everything, I

will also be there." In the technological world you cannot be left behind, it's a way of thinking through computers.

NR: You also work with other companies apart from Pan Pan Theatre. When did you start working with other companies?

AC: Right from the beginning. I worked with Corcadorca, I did their very first show, and I worked on *Disco Pigs* (1996). There was a time when Pat, Enda and I had a very fruitful working period in the early nineties. But I have always worked with other people. It's through collaboration with directors and writers that your own design work progresses.

NR: That makes me think that for the two years I have been in the rehearsal room with Pan Pan I have rarely seen you. And in the last week of the production, when technical rehearsal takes place in the venue, a whole new aspect of the world of the piece is discovered, a new dimension I am always confronted with. I wonder what happens behind the scenes, what am I missing?

AC: I will talk to Gavin every day, especially during rehearsal time to know how things are going and what is happening. He tells me about how things are progressing and we discuss aspects or define them. But I think that by the time it comes to rehearsal most times the design ideas are done and it is just the acting part that needs to be made. In a lot of ways the casting, if you can get the right people, makes the work easier. Now more than previously we work with the same people. For instance we knew Judith [Roddy] was going to be a great Nora [in *A Doll's House,* Pan Pan's adaptation of Ibsen's masterpiece].

NR: How do you decide on a project?

AC: Normally we discuss two or three projects and then we decide what to do as a result of what happens in the discussion. Normally it is the project that creates the most excitement that we go ahead with.

NR: It seems to me that there is a very thorough research in any given project but that intuition also plays a big part.

AC: Yes, there is lots of that. And I do not mean to say that when we get into rehearsal the idea is done, it is the research that is done and the visual ideas are there, but it is during the rehearsal phase that they are implemented. Probably the reason I am not normally in the rehearsal room is because I am very busy implementing those ideas and material for the design and making sure that everything is on track. Four-week rehearsals is such a limited amount of time and it's quite busy to gather everything, furniture, etc. So the visual ideas are there but the real work is done the week you are in production. Only then, when everything comes together you really know if it works, if the audience is going to go

with it and like it. Or whether we like it, whether it's finished to our standard.

NR: Changing the subject—as a woman, have you encountered any obstacles? Because within the world of theatre the technical area was probably the most unlikely place for women twenty years ago.

AC: I think at the start I was quite intimidated by that male world. There were very few women working in lighting when I started. Barbara Bradshaw was one of them and I thought "if she can do it, I can do it." She was brilliant. But I remember feeling intimidated. I did a design in the Abbey when I was twenty-eight and I remember feeling that they might be thinking "what on earth does a twenty-eight year old girl think she's doing?" And I do not know if it would have been as much of a problem for a twenty-eight year old man. I remember when I turned thirty I thought, "nobody can boss me around now, I'm thirty!" But now, in the time I am working, things have completely reversed, most lighting designers are women.

NR: Why do you think that is the case?

AC: I don't know. I am not sure if a job is for men or for women, but back in the late eighties it was still quite a divided society in terms of male and female roles and I really do not think that lighting was a female one.

NR: So you felt there was a gender difference when it came to that role? I mean, it was a reality?

AC: It was a reality. But then, it could well be that I had been thinking that way from my upbringing. Perhaps they weren't thinking that way. I felt it, but maybe I felt it from just growing up in the country and all those old Irish assimilations that I always felt. But perhaps they were not there, it was not true, I don't know. But I know that I was often the only woman in the room and the tech people were all men.

NR: And how was it, as a designer, being in charge of a team of men?

AC: It was very hard because if you made a mistake or you wanted to make a considerable change it was more of a big deal. But again, I do not know if it is about being male or female, younger or older. Maybe it would have been the same for a young man. It is always difficult for everybody to be in charge of a team. And it's always intimidating if you are in charge of a team of the opposite sex. Surely perhaps it would have been the same for a man to be in charge of an all-women costume department, for example. But there was definitely a bit more of an attitude back in the day. It was more difficult to be a woman, a young woman in charge of a team of men.

NR: And how did you deal with that?

AC: I am not sure I dealt with it, I just got on with it. I tried my best. At the end of the day I just wanted the design to be right. And maybe there was a bit of swinging in their respect when they could see that I was really just working on the design and not doing anything else. But again I don't know how much of that was in my head and how much was not. But I know that once it was getting towards somewhere, that I was happy with the lighting or that I felt it was working out, I could relax.

NR: You always got lots of work, so despite the gender dynamics, it was not an obstacle being a woman.

AC: Not at all.

NR: So maybe there was an attitude but doors were not closed for you?

AC: But you had to be pretty fit and strong, because at particular times a man could work faster and get things up in the air quicker. As a young designer generally you have to do the entire rigging, you have to focus everything by yourself, and then sit down and work on the desk. So sometimes I wished I was stronger and had more muscle, it would have been handier. I remember people coming to me and saying: "Do you have a time, Aedín, when you think you will have everything ready?"

NR: Let's go now into another terrain. Do you have the same freedom working for institutions like the Abbey Theatre and working with independent theatre companies?

AC: I do not think there is any difference. The advantage of institutions is that they have the same team, and if the team is good and they have been working together for a while it is a bigger advantage. And they have a very fair way of treating everybody so the rules are very clear and the ideas are very clear. They also have the advantage of having more time and a crew that you are familiar with and they are the same every time you go there, and the advantage of much greater resources.

NR: Then you have complete creative freedom?

AC: I think so. But by the end of the day the director is the person you are collaborating with so you cannot do what you want, you are a collaborator, so you have as much freedom as any other collaborator. I really do not notice any difference between working with independent theatre companies and institutions in that respect. It feels like the exact same job.

NR: And between working with Pan Pan and other companies?

AC: I think I have a little bit more of freedom with Pan Pan in that there is a longer time for things to come together, to work with an idea with the same actors. Also, because I am artistic director of the company I can have more of a say for the aesthetic of the company, not only in terms of the design.

NR: Any difficult moments?

AC: About a thousand million.

NR: I remember you were mentioning the other day that you took a year's break and went away, and when you came back you found it difficult to be back on track.

AC: Yes, I had just finished my masters in Trinity, then I worked for a year and afterwards I decided to go away for a year. Vaguely that type of time scale. When you go back to study, research gives you a lot of things that you want to explore, so when I went back to the same kind of work it didn't feel totally right. I felt I needed to try to do something else, digest what I had learnt and think about all the ideas I had. So I had the great luxury of just thinking for a year, it was marvellous. Then I did an internship in SFMOMA in San Francisco where they have the biggest collection of technological art. I was in the interactive department because around the time when I did the MSc the kind of buzzword was "interactivity" and I was interested in all these ideas of interaction with the audience. Funnily enough, not so much anymore. A little bit but not so much, that trend sort of died.

NR: Still, the concept of interaction or of including the audience in Pan Pan's shows is very specific. How is that relationship approached from a design standpoint?

AC: For me that relationship is created particularly with the lighting. Lighting is the great includer. I always want the audience to know that the lighting understands the play, that it is part of what is giving them the play, giving them the experience. For example, when I was reading *All That Fall*, Maddy was hot and fat and walking and dragging down the road, and the smell of that lovely laburnum ... the lighting in *All That Fall* is that journey, in my mind, of the sun and the laburnum, the fact that it was warm, really warm, and that sticky feeling, hence the hanging bulb lights. It is all about the audience, you are thinking of how the audience are going to respond to the lighting and I'm thinking: "are the colours too cold? When should I let go of the tension? When do I get the lights warm again? When is it just too dark because it needs to be and then when can I let go of that as well and bring the light back in"?

NR: Do you consider that what you do is radical?

AC: No. It is mostly the ideas of Appia.

NR: Pan Pan is regarded as "the experimental company" in Ireland, do you agree with that label?

AC: No. I know we started off trying to have a different voice from what was happening at the time, but that is a different thing. I think there are other people making different kinds of experiments in our days. We wanted to be experimental but I do not really know the answer. I think it is probably very hard to do something nobody has ever, ever thought of before and perhaps that is a different world from what we are doing now, when our focus is the audience. Maybe we had that dream that we were moving things forward. I supposed I always wanted to be progressive, not experimental per se, and make theatre that was a building of the ideas that we were interested in.

NR: What do you have to say about this turn to the aural, that is, Beckett's radio plays? You were talking about *All That Fall* and I am curious about the choice you have made with *Embers* in which the sound and lighting cues are live rather than totally pre-set. How did you conceive the idea and how was the creative process of designing it that way?

AC: Well, initially with *All That Fall* we were focused on giving the communal radio-listening experience, when people used to sit by their fires and listen to the wireless together, which is the first reason why we decided to have a carpet. And it was really great to work on it, getting so deep into that great text and into Beckett's work in general. I have done a lot of Beckett over the years. I love Beckett and I think all his plays are brilliant. He wrote a lot of lighting into his other plays, which is extremely inspiring. Now, he is someone who really moved all that forward. It is interesting to do the plays he has written the lighting into, but it is much more interesting to do the ones he has not written the lighting into because you really do have the freedom to create around his wonderful work. But all the lighting he wrote for *Act Without Words I*, *Rockaby* and *Not I*, which is impossible actually to achieve, was great to have because it was fantastic inspiration for doing *Embers*, but also to try and actually do an opposite kind of thing. In *All That Fall* I was purposely trying to oppose that "Beckett" lighting and in *Embers* I was trying to do that too.

NR: *Embers* seems to be thoroughly thought out in its entirety. For how long did you talk about the project?

AC: Since we did *All That Fall* (2011). It kind of felt like it needed a companion piece. Maybe the job was not finished and maybe it will not be finished until we do a truce or maybe a quad and maybe we can stop!

It needed a companion piece because it felt like it was half: even if we had a great time with *All That Fall* it felt like half of what we could do. And *Embers* was very challenging because the text is extremely difficult.

NR: How did you initially approach the piece?

AC: It took us a while to understand what it was that we liked about it. The rhythm of the writing is very inspiring for the lighting. It has got this wonderful Beckett rhythm that starts and stops and gives so much room to play with.

NR: Did you collaborate with Jimmy Eadie in designing the set, that is, the idea of having around 600 mini-speakers hanging from the ceiling?

AC: 597 I think. That was a collaborative design between me, Jimmy, Andrew (Clancy) and Gavin. Everybody. Because we did a development workshop and Andrew built a sort of skull, which he outlined out of pieces of wood, but it was hollow rather than 3D as in the production. And we sat down and listened to the recording [of the play] and watched the skull and it was very clear that it needed something else. And at the same time, Gavin had done a drawing of speakers flying out above the audience and Jimmy had this idea of using these speakers hanging out, without their boxes, that is, the enclosing of the speakers that brings the sound forward, in some kind of project. And it all just happened out of that. And the inevitable questions of: what about eight of them? What about ten of them? What about six of them? What about this height? What if they were behind? What if they were on the floor? So we eventually ended up with the design we have now.

NR: So how do you feel about *All That Fall* being sold out in Edinburgh since the box office opened two months ago?

AC: It feels great.

Take Two—15ᵗʰ October 2013

NR: After our interview two months ago, we met for a different reason a few days later and you told me that my questions in terms of being a woman in a male-dominated world at the time had made you think. If my memory doesn't fail me, I think you said that back in the day it was maybe harder for a woman to earn the same respect. Am I correct?

AC: I think so. I think it was easier for men. I think they got more assistance in that manly comradely way. It was harder to be that sort of friend where you could ask, get advice and get more help. Immediately

you felt that you'd better know everything you were talking about or you would not have any respect.

NR: So maybe it was more about that camaraderie, that is, it was a matter of men being used to being among their comrades or as you say in Ireland, with the "lads"?

AC: And maybe the personality that I had was not so laddish; I feel that maybe you needed to be a bit more "lady." But I don't know that I can say that with absolute certainty. I can speak only for myself. But I definitely felt, wrongly or rightly, that if I was not female I would be having an easier time.

NR: I also remember that day you told me a story that I really liked, the ten kilowatts story. You were doing a project called *City* in Blackrock Park in 1996 and you went to Dun Laoghaire-Rathdown County Council to tell them the specific needs for the installation.

AC: I suppose we were talking about how I felt about being a woman working in that environment and I used to be very intimidated. So when we were doing the *City* project in Blackrock Park I knew I needed 10kW of power to run what I needed to run to make some kind of impact with the lighting, but no one in the parks department would believe me. The first time I went in, they made me doubt myself so I left and double-checked and then went back to the Council and told them that 10kW was the power required. And from then on they used to call me the 10kW girl: "Oh, here she comes, the 10kW girl. She needs ten kilowatts." Back then we did not have any LED parts or any of the low-voltage things, so it was ten parts and they were 1kW each and I needed ten of them.

NR: And you got them.

AC: And I got them in the end.

Works Cited

Auslander, Philip. "Digital Liveness: A Historico-Philosophical Perspective." *PAJ: A Journal of Performance and Art* 34.3(2012): 3-11. Web. 10 February 2013.

Beacham, Richard C. *Adolphe Appia: Texts on Theatre*. Oxon and New York: Routledge, 1993. Print.

Craig, Edward Gordon. *On the Art of Theatre*. London: Mercury Books, 1962. Print.

Gardner, Lyn. "Modern Theatre Relies too much on Technology" in *Theatre Blog with Lyn Gardner*. Guardian. 17 April 2008. Web. 28 September 2013.

Gordon, Robert. *The Purpose of Playing: Modern Acting Theories in Perspective*. U of Michigan P, 2006. Print.

Keating, Sara. "Women make their way to centre stage in Irish theatre."
 Irish Times 30 January 2013. Web. 3 April 2013.

Lehmann, Hans-Thies. *Postdramatic Theatre*. Trans. Karen Jürs-Munby.
 Oxon: Routledge, 2006. Print.

Marinetti, F.T., E. Settimelli, B. Corra. *The Futurist Synthetic Theatre
 Manifesto*. 18 February 1915. Web. 25 September 2013.

McMillan, Joyce. "Theatre reviews: Embers | Eh Joe." Rev. of *Embers*, dir.
 Gavin Quinn. *Scotsman* 26 August 2013. Web. 28 September. 2013.

Nelson, Robin. "Introduction: Prospective Mapping and Network of
 Terms." *Mapping Intermediality in Performance*. Ed. Sarah Bay-Cheng,
 Chiel Kattenbelt, Andy Lavender & Robin Nelson. Amsterdam UP, 2010.
 13-26. Print.

Ruiz, Noelia. "Positive Acts. The Evolution of Pan Pan Theatre Company."
 No More Drama. Ed. Peter Crawley and Willie White. Dublin:
 Project/Carysfort Press, 2011. 119-37. Print.

Tomlin, Liz. "'And their stories fell apart even as I was telling them':
 Poststructuralist performance and the no-longer-dramatic text."
 Performance Research: A Journal of the Performing Arts 14.1 (2010):
 57-64. Web. 10 Dec. 2012.

15 | Landmark Decisions: An Interview with Anne Clarke

Tanya Dean

In 2011, Landmark Productions received the Judges' Special Award from the Irish Times Irish Theatre Awards, in recognition of its "sustained excellence in programming and for developing imaginative partnerships to bring quality theatre to the Irish and international stage." This was in acknowledgement not only of the consistent artistic merit of Landmark's productions, but also the radical approach that company founder Anne Clarke took to the traditional Irish theatrical production model. When establishing Landmark in 2003, Clarke eschewed the officially-endorsed trend for theatre artists to set up companies in order to qualify for annual grants as Regularly Funded Organisations under the Irish Arts Council. Instead, Clarke forged a production model that focused on two distinct but complementary streams of programming: "art-led" productions that mainly relied on Arts Council Project Funding (one-off grants for specific projects) and commercial productions that could reliably recoup their costs and turn a profit in order to finance the company infrastructure.

Clarke began her theatre career as an administrative assistant for the Dublin Theatre Festival before moving to the Gate Theatre in 1984, where she would go on to serve as deputy director to artistic director Michael Colgan. In 2003, Clarke left the Gate to pursue her own independent theatre work, and Landmark Productions was officially launched in 2004 when Clarke produced David Hare's *Skylight* at Project Arts Centre, Dublin.

Throughout the past decade, Landmark's art-led productions such as *Miss Julie* (2008) and *Misterman* (2011) have received critical

acclaim and multiple awards, and have also toured internationally to New York and London. Landmark has also enjoyed sell-out houses for their commercial productions such as a series of plays based on Paul Howard's popular satirical character Ross O'Carroll-Kelly—*The Last Days of the Celtic Tiger* (2007), *Between Foxrock and a Hard Place* (2010), *Breaking Dad* (2014)—and journalist Fiona Looney's Dublin trilogy—*Dandelions* (2005), *October* (2009), *Greener* (2012). As the Arts Council faced several significant budget cuts following the economic downturn, forcing drastic reductions in Regularly Funded Organisation grants and putting severe strain on Irish theatre companies and even forcing some out of existence, the innovation in the Landmark model is striking in both its prescient business acumen and its artistic fertility. Anne Clarke talks about the path that led her to found Landmark Productions, and how her distinctive production model developed.

TD: Let's start at the beginning of your career, prior to Landmark; how did you get into producing?

AC: I was just out of college when I saw an advertisement for the position as an administrative assistant for the Dublin Theatre Festival in 1983. It was a revelation; I hadn't known that jobs like that existed in the arts. This was like a door opening, that the skills I had at the time could be used in the service of theatre, which was the thing I adored. It's possible for a young person now to conceive of being a producer; nowadays there are lots more opportunities and courses and different ways in. But it wasn't on the agenda when I was growing up. Back when I started, we didn't even have computers! The landscape was completely different. I think there is much more empowerment now, and much more mobility between different positions than before.

So I worked in the Dublin Theatre Festival for one year, and learned a huge amount. And then the festival didn't happen the following year (1984). So then I went from there to the Gate Theatre in Dublin, and came in as an administrative assistant, and I was to stay there for nearly nineteen years.

TD: What were the Gate years like?

AC: The Gate is a beautiful theatre; it's also a remarkably flexible model of production. Everything happened in Number Eight Parnell Square (the name of the offices we were in)—model meetings happened there, creative meetings happened there, sometimes auditions happened there. So even when I had just come in at an administrative level, I still got to be very much involved in all aspects of the life of a

working theatre, not just one narrow little field. So the Gate was an education, an absolutely fantastic place to work.

In the early days, I was doing basic administrative work; running the office, reading unsolicited scripts, looking after the board and company secretarial stuff. The first time the Gate toured was in 1988, and that opened up a whole new vista of other work. Liz Heade (assistant to Michael Colgan, the artistic director of the Gate) left around the late eighties, and then I started to work as Michael's assistant. And at that stage I got much more involved in things like casting, and the more artistic side of things (planning; programming, dealing with directors, designers, actors). In the early nineties, Marie Rooney and I were both made deputy directors; with that came a lot more responsibility.

I used to look at other theatres who had more of a stranglehold on their remit—for example, the Abbey has to do so many plays from the canon, and has to reach so many different kinds of audiences—whereas in the Gate we really did have tremendous freedom to do the work that we wanted to do. And we were very lucky because the audiences historically in the Gate are fantastic; years and years of unbroken full houses. That's an exciting thing, to do work that you know is speaking to your audience. It was a very happy time.

TD: What made you decide to make the jump in 2003 to leave the Gate and set up your own company?

AC: Well, at that stage, I would have had a lot more responsibility, but I didn't have final responsibility. I had a significant birthday, and I thought that if I didn't go then, I would never go, and I would always wonder. Having said that, it wasn't necessarily a foregone conclusion that I would go into producing. There were "three legs to the stool" of what I wanted to pursue professionally: casting, touring, and producing. I cast a couple of shows for the Abbey the year after I left the Gate, before realizing that whilst I enjoyed casting, it wasn't what I wanted to do all the time. The other thing I thought I would do was manage international touring for other companies, so I did a couple of tours for the Abbey and a tour for the Gate. And the third leg was producing. Now for the first couple of years, the three legs of the stool were fairly even. But the casting fell aside after year one, and the touring fell aside after year two, and then it ended up that I was just producing. And that's what I've been doing ever since.

TD: What was the Irish theatre scene like during those years? How was work being programmed and funded, and how did this affect your production model?

AC: The landscape was very different, particularly in terms of funding. There were a lot of independent companies that the Arts Council had encouraged into existence, because the thinking at that stage was that you needed to professionalize, you needed a legal structure, etc. And those companies were more or less all led by artistic directors, and I knew Landmark would be led by a producer rather than an artistic director. It took a little while, honestly, for me to feel comfortable saying, "I'm a producer."

We're coming up to ten years now (in January 2014) since the first Landmark production, which was David Hare's play, *Skylight*, which I produced at the Project Arts Centre in Dublin in 2004. I knew before I left the Gate that I wanted to produce that play, and I knew I could produce it well. At that time there was no funding available; the Arts Council was funding companies on an annual basis and then there was Project Funding, which in those days was a small pot (it still is!) and was really only for experimental work, capped at €25,000. In my innocence, I thought, well, I'm coming out of the Gate, I'm going to produce the Irish premiere of this wonderful play by David Hare, a phenomenal writer acclaimed in Britain and America but whose work had never been seen here. David had even said that he would come to Ireland, that he would take part in rehearsals. We had an amazing cast (Owen Roe, Cathy Belton, Michael Fitzgerald), Michael Barker-Caven was directing, Joe Vaněk was designing, Rupert Murray was lighting; how could the Arts Council not support it? Well, guess what? They didn't. It was too late to back down and I still had to do it. And the people who were incredible were Niamh O'Donnell and Willie White at Project Arts Centre in Dublin. They really stepped up and offered invaluable support. So we got the show up, and it was amazing; it sold out, we broke every box office record in Project.

I had a conversation with the Arts Council afterwards; because, at the end of the day, they are dedicated to supporting the work, and it seemed like there simply wasn't a way for them to support the way that Landmark was going to be working. Although ten years later the Project Funding scheme has been expanded significantly, the issue has raised itself in another way; the funding mechanisms in the Arts Council are not currently geared towards the sort of time frame or scale or ambition that's necessary to develop work with significant artists over a long period of time on an independent basis.

TD: Landmark Productions is considered extremely innovative in the Irish theatre ecology because you manage to combine two separate yet complementary threads of programming; smaller not-for-profit

productions (which you term "art-led") like *Miss Julie* that play in more intimate venues like Project Arts Centre [which can seat a maximum of 220 in its multi-purpose Space Upstairs], and large-scale commercial productions like the Ross O'Carroll-Kelly shows that can sell out the Olympia Theatre in Dublin [which has an audience capacity of up to 1,240]. Can you talk a little bit about the relationship between the two strands, and what led you to develop this business/artistic model?

AC: I use the term "art-led" for the Arts Council-funded projects. After that first experience with *Skylight*, I knew I also wanted to work commercially on a large scale. I had a bit of experience from my time in the Gate, where I would have worked on West End transfers, for example. So I knew how they were put together in terms of the financing. I also didn't want to put all my eggs in the Arts Council's basket; I think that very first short sharp shock [with *Skylight*] made me realize that you're just leaving yourself vulnerable.

It's certainly not about the money; of course, you want a commercial show not just to pay you, but also to make money for the investors; you have a responsibility to them. But I think that's the wrong approach, to think, oh, I must do a big commercial show, what shall it be? I think these things come to you in different ways. I think part of the secret is being open to them when they come. And being able to follow a particular path if you think, oh yes, that might work. It might be an amazing piece of casting that everybody will want to go see. So in terms of the commercially-led productions, I've done Fiona Looney's Dublin trilogy (*Dandelions, October, Greener*), and I'm about to do the third play about Ross O'Carroll-Kelly [Paul Howard's famous satirical rugby fanatic and lothario], *Breaking Dad* [in 2014]. I don't know what the next big Gaiety or Olympia show will be, but I do know that I want to keep working there.

So I knew that I wanted to pursue the two different streams: art-led and commercial. And I still think it's a good model. Each of them has attendant risks and challenges, but I suppose I think at the end of the day what a producer has to do is get work on, however you manage to do it, and whatever is the most appropriate way to get a piece of work to the stage. There are some pieces of work that can only happen in a smaller, more art-led way. And there are others that absolutely can and should "wash their face," that people should pay to see, that don't need subsidy.

TD: "Commercial" is often something of a dirty word in artistic circles, but Landmark's large-scale productions have a sterling reputation for being artistically rigorous. You as a producer seem to

have a gift for bringing together high-end theatre artists to make the show the strongest it can be, whether it be art-led or commercial.

AC: The response from the theatre profession has been very positive. There are Irish companies who produce commercially (e.g. Lane Productions, though they are no longer in existence; and producers like Donal Shiels and Robert C. Kelly, for example); and there are subsidized companies who occasionally present work in the big theatres (e.g. Druid and Rough Magic), but so far there is no other Irish company that is managing to straddle the art-led and commercial worlds simultaneously.

You have to consider what makes a production commercial; is it the play, the casting, where it's done, what happens to the proceeds, all of those things? For example, something like the Ross O'Carroll-Kelly plays have had fantastic actors—Rory Nolan, Susan FitzGerald, Philip O'Sullivan, Lisa Lambe, Rory Keenan, Laurence Kinlan—, none of whom had a particularly high public profile in terms of film or television. But in that particular case, Ross itself is a brand. Those books have been selling for the last fifteen years, and there's an enduring public fascination. Part of the attraction for me is that you can pay people on a commercial basis for work that you do in a big theatre; the levels are better than in an intimate theatre, even with Arts Council funding. That's been an unexpected bonus of being able to work on both scales, which is a wonderful thing both for me and for the people who work with Landmark.

TD: In previous interviews, you've discussed how theatre in Ireland has a limited return because of the small population; for example, even the most successful productions can't extend their runs beyond a certain point because the audience numbers just aren't there. How does that affect your production work?

AC: Because things are hard here and they're getting harder and harder, we are having to open up other avenues to support the work. Over the last couple of years, there's been another string to the Landmark bow, which is international touring. *Misterman* went to St. Ann's Warehouse in New York in 2011 and to the National Theatre in London in 2012. If I can open up a show here that can then travel, then that's creating employment as well as a great artistic opportunity for the people involved in it. Over the next few years, there are a lot of interesting things coming down the tracks. In 2015, I'm going to be doing a new opera with Enda Walsh and Donnacha Dennehy (who composed the music for *Misterman*). I'm also now working on Enda Walsh's new play *Ballyturk*. That will be a three-hander, with Cillian

Murphy, Mikel Murfi, and Stephen Rea. It's a co-production again with Galway Arts Festival for 2014. And because of the avenues that *Misterman* opened up, it'll go to the National and then to St Ann's.

What's interesting is, *everyone* wanted to produce Enda's new play, he could have gone anywhere, but he said, "I'm an Irish playwright, and I want to premiere at home." Which I think is the most extraordinary gift for the people of this country, let alone for me as a producer! I always want to do work at home and start stuff here. Culture Ireland made an investment in showcasing work and bringing people to New York during Under the Radar; I've gone for three years now, and as a direct result, *Howie the Rookie* has been invited to the Brooklyn Academy of Music [in December 2014]. There are huge opportunities there; I think we all have to be mindful of what Culture Ireland has achieved and fight to make sure that they can still do it.

TD: Part of the Landmark production model for commercial plays is to offer opportunities for investors. Can you talk about how you approach that?

AC: I suppose what's slightly different about Landmark is the way it has managed—so far!—to balance the art-led and commercial work. The way it normally works is that you would capitalize a production; so, for example, for a five-week run in the Gaiety you might need to raise €350,000. And that would cover everything including pre-production and running. So the theory goes that I would go and raise, go and sell thirty-five units of €10,000 apiece. Assuming we break even, the investors get 60% of the profits, and 40% goes to the producer. That's the same model as the UK; in the US, the balance is 50/50, so it's more in favour of the producer.

In terms of how I approach investors, there is a pool of people at this stage who have invested in most of Landmark's productions to date, and I would try to expand it with each production, because not everyone will be able to invest in each production. As for who those people are, it is mostly individuals and mostly people who have an interest in, or affiliation with, the arts in general and theatre in particular. In terms of pitching it to them, I prepare a prospectus for each production, this is how it works in the West End and on Broadway. It's a document that has information on the play and on the cast and creative team, and financial information including a production budget and recoupment schedule. All of which comes with a very big health warning, which flags the risks involved in investing in theatre productions. So a potential investor has the information he/she needs to make a judgment about the quality of the proposed production; the

box office figure necessary in order to break even; and the potential return, if the show does well. It is different in Ireland as a relatively small nation; anywhere where there's a reasonable-sized audience potential you have the prospect of making a significant amount of money, and here in Ireland that really isn't the case. However, the advantage to Ireland is that your risk is more limited; I know that if I put on a Ross O'Carroll-Kelly play in the Olympia, there's never the risk that nobody will come: we will find an audience. In New York, I think the statistic is that only two out of every five shows break even. Of the five big shows and four revivals I've done—so nine commercial outings altogether—all but one of them has broken even. And some of them have provided really nice returns for their investors over a short period of time. So the batting average is good, but there are no guarantees.

TD: So what are the nuts and bolts of working as a producer and running a company like Landmark?

AC: People do think that I have this great big organization, and they expect that you would have offices in town. In fact, Landmark Productions is me operating from my spare room at home, with the wonderful Sara Cregan. It is easier now to operate like this; it's much more usual for people to have a laptop and a mobile phone. Ten years ago, I do think there was still an expectation that to be considered legitimate, you need to have your offices somewhere. Of course, it is easier now with email, everything is so quick, so immediate. And I do think there are lots of other producers now who are coming on board, who are doing really fantastic work, and it's interesting just to see the Arts Council engaging with producers now as well as companies, as well as artistic directors. I suppose there is more of an acknowledgement now of the role, and the importance of what a strong creative producer can bring to a project. So hopefully over the next few years we'll have lots of young people coming up as producers and there will be more money for them to do things with.

TD: Since coming into existence in 2003, Landmark Productions has witnessed a seismic shift in Ireland's economic circumstances, from the final days of the boom years to the global recession. Has this had a palpable effect on the work that Landmark produces?

AC: Well, funny you should ask ... the first Ross O'Carroll-Kelly play that I produced was called *The Last Days of the Celtic Tiger*, and I did that in 2008. It was fun, it was a joke. The first run went through the roof, absolutely through the roof; people adored it. So I brought it back in the spring, expecting the same thing to happen, and in those six months, *The Last Days of the Celtic Tiger* suddenly stopped being

funny. So I can pinpoint the exact moment it all changed. People talk about Paul Howard capturing the zeitgeist and he absolutely does. When we did *The Last Days of the Celtic Tiger*, Paul had never written a play before. He'd never even really seen that many plays before. So he wrote it as this series of sketches, basically, and then he and Jimmy Fay the director worked on it together, and created a fantastic show. But Paul was famously standing outside the Olympia and saw this helicopter being loaded in the stage door, and thinking, "oh yeah, that's because I wrote 'a helicopter comes in'" and he had this realization that there are consequences when a playwright writes something like that. Since then he's seen millions of plays, and he goes to see everything. So his next play, *Between Foxrock and a Hard Place* was much more about observing the unities, with a single standing set; but it was also absolutely razor-sharp and kind of angry in some of its political satire in terms of the sort of people and the sort of messy situation the nation was in and the financial situation we were in and how we were dealing with it in 2010. Because Paul is so funny, sometimes people forget that he's also writing "state of the nation" plays.

In terms of how audiences have changed, there is definitely increased price sensitivity—people now don't mind saying that they're going shopping in Lidl or Aldi, where they never would have previously. And equally, now audience members are not afraid to look for a discount when they're going to the theatre. The margins are getting tighter and tighter, and that has been hard. I'm having that debate with myself about where I pitch the ticket prices for Ross, for example, and whether to reduce them from the last time, and if so, by how much. There's no easy answer. I've done shows that have done really well—for example, I did *The Talk of the Town* with Hatch Theatre Company and Dublin Theatre Festival in 2012, which sold out before we opened. So there are always shows that will absolutely just take off, for whatever reason. And then there are those that you struggle with a bit more, and you have to work really hard to try and get the people in. If you have a hit, people will pay. It's more the shows that people go, "hmmm, I'd like to see that" but that aren't "must-sees" that are harder to sell. But I would be hopeful that the recovery is already beginning to start. At the end of the day, if you do believe in something, it's amazing how you can find a way. And also how people rally around when the going gets tough. Particularly here; Dublin is still small and one of the happier developments of the last few years is that people are more likely to support each other, because we're all in it together. If you reach out to somebody, you'll often get a response.

TD: One avenue that Landmark is particularly well known for, it seems, is collaborating with playwrights who are interested in directing their own work; for example, 2011's production of *Misterman* (written and directed by Enda Walsh) and 2013's *Howie the Rookie* (written and directed by Mark O'Rowe). How did these collaborations transpire?

AC: *Misterman* came about because of Cillian Murphy. His agent, Richard Cook, and I had been talking about Cillian doing something onstage. We were talking about a couple of things that didn't come to anything. Then Cillian had the idea to do *Misterman* and he went to Enda about it because they're good friends going back to the days of *Disco Pigs*. I think Enda had more or less put *Misterman* away and wasn't really thinking about it again. And Cillian said, let me read it for you and they went and spent a day reading it. And that's how it came about. And there was never any question that Enda wouldn't direct it. What's interesting is that Enda wanted to go back to it, because it had been a while since he'd written it, and he went back and expanded it. It was such an extraordinary directing job as well—his vision as a writer but also his vision as a director—and he was clear about the sort of environment he wanted. The amazing set that Jamie Vartan designed, the sheer technical scope of it all—the music and sound and all of that—all masterminded by Enda. With Enda, the staging is knitted into the writing; there's pages and pages of stage directions. Sometimes the sound cues are timed to the second. If you had asked me five years ago what I thought about writers directing their own work, I'd have said it's not a good idea, because I've seen other cases where it really wasn't a good idea. But that was so extraordinary.

Howie the Rookie came about because I approached Mark [O'Rowe] about doing it. I had suggested Tom Vaughan-Lawlor for one of the parts. Mark went and met him, and was all excited (as you would be). And we talked about it for a couple of months afterwards, and went back and forth and back and forth, but it became very clear that there wasn't another actor that Mark wanted to put with Tom. He wanted to stage it with just one actor playing both parts. And even if that actor is the most extraordinary actor of his generation, it was such a bold call to make. With *Misterman*, Enda as director threw everything at it; the sound, the set, the props, things flying at you everywhere. Mark is so minimalist; he had that real Beckettian thing, stripping stuff away, no colour, no colour. For example, the design we had—which was absolutely beautiful, sublime in terms of the end result—that lightbox could do so much more, you could have bells and whistles, you could have coloured lights, all sorts of things. And Mark kept saying, "no, no,

no, we can't let anything get in the way." And he did reach this extraordinary communion between the two characters. I don't think anybody other than Mark would have had the courage or the authority to be able to make that call and say that it's artistically valid. Because he was the writer, nobody else was going to second-guess him. That's been very interesting for me in terms of working with strong writers who know exactly what they want to do with their work. Both Enda and Mark see a lot of different kinds of work, they're very plugged in, so they're not writing in isolation in their respective rooms and then coming out to go into a rehearsal room; they know what they like and are clear about what they want. It's been an education and a joy working with them.

TD: Another emerging trademark of Landmark's programming seems to be finding people with a gift (often untapped) for theatre, or allowing artists to work outside their demarcated professional roles (e.g. as playwright). What motivates you to seek out these projects and collaborations?

AC: With Paul Howard, it was a light-bulb moment; I remember the exact spot where I was standing in Eason's [bookstore in Dublin] in front of this bank of Ross O'Carroll-Kelly books. The initial introduction came about because his literary agent, Faith O'Grady, works with the Lisa Richards Agency, and a lot of the cast for *Dandelions*—Pauline McLynn, Deirdre O'Kane, Keith Duffy—were also clients of Lisa Richards. *Dandelions* had been very successful, and it demonstrated that Landmark could do a big commercial show successfully. So I asked for an introduction, and they were able to say this person is worth meeting. We had a lovely meeting and Paul was (is!) the loveliest, loveliest man and was really excited about it. That was all remarkably easy and it went very quickly from the time he said he'd do it till the time that we got it onstage. And we had such a good time that we decided to do another one. I think there's been a reduction in demarcation, where if you're a playwright you write plays, full stop. I do think there's far more cross-over now; Paul was a sports journalist before writing the Ross books, Fiona was a journalist (and still is). And Deirdre Kinahan, whose play *These Halcyon Days* I toured to New York and Edinburgh in 2013, is a playwright who was also an artistic director, and is now writing film scripts, for example. There are other people I've talked to who may not have written for the theatre or are currently writing in another area, but who you think might want to give it a go. For example, the Dublin Theatre Festival commissioned Colm Tóibín (who had written one play before—*Beauty in a Broken*

Place—but is much better known as a novelist) to write *Testament* for the 2011 festival. But on the other hand, I'm also working with Enda Walsh, who's writing an opera, he's written a best-selling musical, is there anything he can't do? And your day is always better when you've had a conversation with Enda.

There are just stories that need telling, and there are different spaces that are right for different stories. And finding the right way to tell the story in the best possible way is what's really exciting. That's the great gift of being an independent producer, of finding something that you feel you absolutely *have* to get on the stage, as opposed to working in a theatre where you have to programme fifty-two weeks of the year, and then you have to make compromises perhaps and you have to cater to different strands of the audience and have different priorities. Whereas each and every show that I do, it's because I really believe that needs to be seen for whatever reason. And that's very fulfilling. And when it works at the end of the day, there is no better feeling. For example, Hatch, Landmark and the Dublin Theatre Festival commissioned Emma Donoghue to write *The Talk of the Town*. Again, Emma wrote plays a long time ago but hadn't written for the theatre recently. That sold out the entire run of the Dublin Theatre Festival, and then we were able to extend it. Being able to push to make sure that something that you're proud of reaches the widest possible audience; that's a happy thing when you can pull it off. So much of it is about trusting your instincts and following them. The road to producing is littered with great ideas and good intentions. So often, you just have to leave them by the wayside and just keep putting one foot in front of the other. You can get a long way down the road by dint of sheer determination. I do think determination is a huge part of producing; that will to never, ever, ever give up.

Biographies

Fiona Coffey holds a BA from Stanford University, an MPhil. in Irish theatre and film from Trinity College Dublin, and a PhD in theatre from Tufts University. Between her masters and doctorate, she worked at the William Morris and Harry Walker agencies in New York City representing playwrights, directors, politicians and celebrities. Her research focuses on women in Irish theatre and theatrical responses to the sectarian conflict in Northern Ireland. She has taught courses on theatre and Irish cultural studies at Tufts University, the University of Connecticut, Quinnipiac University, and the University of Hartford.

Emma Creedon was awarded a PhD from University College Dublin in 2013. She has taught courses on English and Drama at UCD and at NUI Galway. Her monograph, *Sam Shepard and the Aesthetics of Performance*, is published by Palgrave Macmillan (2015). Her research has also been published in the peer-reviewed journals *Word and Text: A Journal of Literary Studies and Linguistics* and the *Journal of Contemporary Drama in English*. Her research interests include Modern American Drama, Surrealism, Modern and Contemporary Irish Drama and European Absurdism.

Tanya Dean is a DFA candidate in Dramaturgy and Dramatic Criticism at Yale School of Drama, where she also received her MFA. Her current research focuses on fairy tales and folktales in European theatre. Her writing has appeared in edited collections such as *The Routledge Companion to Dramaturgy*, *"That Was Us": Contemporary Irish Theatre and Performance*, and *Interactions: Dublin Theatre Festival 1957–2007*; and journals such as *TDR, Theater, Irish Theatre International, Theatre History Studies,* and *Journal of the Fantastic in*

the Arts. Her production work as dramaturg includes *The Yellow Wallpaper* by Charlotte Perkins Gilman (Then This Theatre Company, Dublin) and *The Glass Menagerie* by Tennessee Williams (Long Wharf Theatre, Connecticut), and she served as artistic director for the 2012 Yale Summer Cabaret.

Miriam Haughton is a lecturer in Drama, Theatre and Performance at NUI Galway. Her monograph, *Staging Trauma: Bodies in Shadow*, is forthcoming with the Palgrave MacMillan series, "Contemporary Performance InterActions." With Maria Kurdi, she has co-edited the third edition of ISTR journal *Irish Theatre International*, themed "Perform, or Else" (2014). She has published multiple essays in international journals and edited collections. Miriam is a supporting member of the National Women's Council of Ireland (NWCI), an executive committee member of the Irish Society for Theatre Research (ISTR), and a member of the feminist working group of the International Federation for Theatre Research (IFTR).

Charlotte J. Headrick is a professor of Theatre Arts at Oregon State University. A past President of the American Conference for Irish Studies, West, she has directed numerous premieres and productions of Irish plays all over the United States. She is widely published in the field of Irish drama. A former Moore Visiting Fellow at the National University of Ireland, Galway, she is co-editor of *Irish Women Dramatists 1908-2001* (2014, Syracuse University Press). She is a recipient of the Kennedy Center/American College Theater Festival Medallion for service to that organization and is an Elizabeth P. Ritchie Distinguished Professor at Oregon State.

Shonagh Hill completed her PhD at Queen's University, Belfast, and has published articles on women in Irish theatre in *Theatre Research International* and *Etudes Irlandaises*, as well as contributing to the edited collection *Staging Thought: Essays on Irish Theatre, Scholarship and Practice* (2012). Her current research focuses on neoliberalism, feminism and affect. Hill is a member of the International Federation for Theatre Research's Feminist Working Group.

Matt Jennings is Lecturer in Drama at the University of Ulster. Originally from Sydney, Matt has worked as a performer, writer, director, and facilitator in Australia, Ireland, the UK, Italy, Morocco

and France. He has been based in Northern Ireland since 2001, where his experience of working in conflict transformation, educational drama and community-based theatre informs his research, practice and teaching. In 2010, Matt completed a PhD on the impact of community drama in Northern Ireland after the Good Friday Agreement. From 2010 to 2013, Matt was a Senior Lecturer in Drama at Edge Hill University and Northumbria University.

Jessica Kennedy is a choreographer and dance artist based in Dublin. She is Co-Artistic Director of junk ensemble. Jessica trained in the United States, Dublin and London, completing her degree in Dance and English Literature at Middlesex University, London. She has performed extensively with dance and theatre companies throughout Europe and the UK. In Ireland she collaborates regularly with Brokentalkers (*Frequency 783, The Blue Boy, In Real Time, On this One Night*) and has performed with Blast Theory, Myriad Dance, eX Ensemble, Orla Barry (Belgium) and in productions with The Abbey Theatre, The Ark and The Pavilion Theatre. She created the award winning film *Motion Sickness* in 2012, which has screened across thirty festivals worldwide. Other film credits include *Blind Runner* (Dance Ireland commission 2013/junk ensemble), *The Wake* (Oonagh Kearney 2013), *Dance Emergency* (TG4 2014), *Wonder House* (JDIFF 2012) and *Her Mother's Daughters* (RTE 2010). She has lectured for IT Carlow and also performs in a band. She was awarded Best Female Performer for Dublin Fringe Festival 2006. Jessica was Dancer in Residence at RUA RED Arts Centre 2012/13 where she exhibited *Walking on white lines*. Other choreographic credits include the creation of *Songs from Car Park* (Dublin Fringe 2014) and *Nixon in China* (Wide Open Opera/Bord Gais Theatre 2014).

Megan Kennedy trained at Alvin Ailey Dance Center in New York City and received a BA Honours from Queen Margaret University in Edinburgh. Megan is Co-Artistic Director of multi-award winning junk ensemble. She has performed with Retina Dance Company (UK), Tanz Lange (Germany), Firefly Productions (Belgium), Storytelling Unplugged (Romania), Blast Theory (UK), and in Ireland with CoisCéim Dance Theatre (*Faun, As You Are*), Brokentalkers (*The Blue Boy, On This One Night*), The Abbey Theatre (*Romeo & Juliet*), Mouth on Fire (*Everlasting Voices*), and Bedrock Productions (*Pale Angel*). Performance and choreography for film includes *The Wake* (Invisible Thread 2013), *Blind Runner* (junk ensemble/Dance Ireland

Commission 2013), *Wonder House* (JDIFF 2012), *Her Mother's Daughters* (Winner Best Actress Capalbio Festival Italy 2011/Dance on Camera NYC/RTÉ *Dance on the Box* 2010). Choreography includes Tchaikovsky's *Queen of Spades* Opera (Edinburgh Festival Theatre) and *eX Choral Ensemble* (IRL). Megan is the current Limerick Dance Artist-in-Residence. She is a Director of Dance Ireland and a Fellow of Salzburg Global Seminar. www.junkensemble.com

Mária Kurdi is professor in the Institute of English Studies at the University of Pécs, Hungary. Her main areas of research are Irish literature and theatre, especially women's drama. Her publications include three books on contemporary Irish drama, the most recent one being *Representations of Gender and Female Subjectivity in Contemporary Irish Drama by Women* (Edwin Mellen Press, 2010). She is also author of a collection of interviews with Irish playwrights published in Hungary. Her articles have been published in various journals and scholarly volumes. She has co-edited *Brian Friel's Dramatic Artistry: "The Work Has Value"* with Donald E. Morse and Csilla Bertha (Carysfort Press, 2006), and the 2014 issue of the ISTR journal *Irish Theatre International* with Miriam Haughton.

Kasia Lech is a lecturer in Performing Arts at Canterbury Christ Church University and holds a doctorate from University College Dublin. Her research on the importance of verse structure in theatre was supported by the Irish Research Council. Kasia trained as an actor and completed her MA at the Ludwik Solski State Drama School in Poland. She has continued her acting career in Ireland and UK. Kasia is a co-founder of Polish Theatre Ireland, a multicultural theatre company based in Dublin. Her research interests include verse in performance and translation, actor training, and selected aspects of Polish, Irish, and Spanish theatre.

Cathy Leeney lectures in Drama Studies at University College Dublin. She is director of the MA in Directing for Theatre. Her publications include *Irish Women Playwrights 1900-1939: Gender and Violence on Stage, Seen and Heard: Six New Plays by Irish Women, The Theatre of Marina Carr: "before rules was made,"* and articles on contemporary theatre and performance. She is currently working on a project exploring the roles of director and designer in Irish theatre. She would like to thank Rough Magic Theatre Company, and TheEmergencyRoom

and Olwen Fouéré for their cooperation in researching *Phaedra* and *Sodome, My Love*.

Brenda O'Connell is a third-year PhD researcher in NUI Maynooth. Her four-year research project is funded by the John and Pat Hume Scholarship. Her thesis is entitled "Samuel Beckett's Women: a Re-Evaluation of the Problematic Feminine in Beckett's Work." Her theoretical frameworks are drawn from feminism, queer and gender studies, psychoanalysis and new interpretations of Beckett in the twenty-first century. In 2013, she reviewed the Happy Days Enniskillen International Beckett Festival for The Beckett Circle (www.beckettcircle.org). She is currently working on a review of the 2014 Festival for publication in *The Journal of Beckett Studies* (forthcoming 2015).

Karen Quigley is Lecturer in Theatre at the University of York. Her research interests include contemporary European theatre, site-specific performance, and performance pedagogy. Recent publications include a chapter in *Performance and Ethnography*, edited by Peter Harrop and Dunja Njaradi, and articles and reviews for *Contemporary Theatre Review, Performance Research and Platform*.

Caitriona Mary Reilly is a PhD candidate in Drama Studies, School of Creative Arts at Queen's University Belfast. The working title of her doctoral thesis is "Postfeminist Irish Performance, Theatre and Culture." The thesis will draw on the historiography and dramaturgical analysis of performances and productions by Irish practitioners such as Áine Phillips. The thesis will examine the impact of postfeminist culture within contemporary Irish society whilst also discussing issues relating to girlhood, motherhood, and prostitution. Through the interrogation of contemporary gender issues, the thesis aims to understand what is still at stake for Irish women in the increasingly globalized twenty-first century.

Noelia Ruiz completed doctoral research specializing in creative processes and contemporary European theatre and performance aesthetics, particularly postdramatic approaches to theatre-making, directing, new dramaturgies, and modern acting techniques. For her doctoral dissertation she worked with Pan Pan Theatre and The Performance Corporation. Her career trajectory to date has benefitted from productive interconnections between academic research and

practice. From 2010 to 2011 she convened with Willie White (Director of the Dublin Theatre Festival) a Performance Reading Group in Project Arts Centre. She is currently preparing a monograph on Pan Pan Theatre.

Samuel Yates is a doctoral student at the George Washington University, where he researches the aesthetics of disability and performance in popular culture. He received his M.Phil. in Theatre and Performance Studies from Trinity College Dublin as a Mitchell Scholar, and he is a Humanity in Action Senior Fellow. He has previously worked with the Abbey Theatre, the Eugene O'Neill Theatre Center, The Samuel Beckett Centre, and New Harmony Theatre, among others. Samuel's plays include *Haunted, Beau,* and *grass greener,* and his poetry can be found most recently in *Out of Sequence: The Sonnets Remixed.*

Index

Carysfort Press was formed in the summer of 1998. It receives annual funding from the Arts Council.

The directors believe that drama is playing an ever-increasing role in today's society and that enjoyment of the theatre, both professional and amateur, currently plays a central part in Irish culture.

The Press aims to produce high quality publications which, though written and/or edited by academics, will be made accessible to a general readership. The organisation would also like to provide a forum for critical thinking in the Arts in Ireland, again keeping the needs and interests of the general public in view.

The company publishes contemporary Irish writing for and about the theatre.

Editorial and publishing inquiries to:
Carysfort Press Ltd.,
58 Woodfield,
Scholarstown Road,
Rathfarnham,
Dublin 16,
Republic of Ireland.

T (353 1) 493 7383
F (353 1) 406 9815
E: info@carysfortpress.com
www.carysfortpress.com

HOW TO ORDER

TRADE ORDERS DIRECTLY TO:
Irish Book Distribution
Unit 12, North Park, North Road,
Finglas, Dublin 11.

T: (353 1) 8239580
F: (353 1) 8239599
E: mary@argosybooks.ie
www.argosybooks.ie

INDIVIDUAL ORDERS DIRECTLY TO:
eprint Ltd.
35 Coolmine Industrial Estate,
Blanchardstown, Dublin 15.
T: (353 1) 827 8860
F: (353 1) 827 8804 Order online @
E: books@eprint.ie
www.eprint.ie

FOR SALES IN NORTH AMERICA AND CANADA:
Dufour Editions Inc.,
124 Byers Road,
PO Box 7,
Chester Springs,
PA 19425,
USA

T: 1-610-458-5005
F: 1-610-458-7103

The Theatre of Marie Jones: Telling Stories from the Ground up

Edited by Eugene McNulty and Tom Maguire

Marie Jones is one of the most prolific and popular writers working in Northern Irish theatre today. Her work has achieved local relevance and international recognition. From her earliest work with Charabanc in the early 1980s to the present day, Jones's work has engaged with Irish (and, more often than not, specifically Northern Irish) experience in ways that reveal the extent to which the personal is political in a distinctive form of popular theatre. This volume of essays engages critically with Jones's oeuvre, her reception in Ireland and beyond, and her position in the canon of contemporary drama.

ISBN 78-1-909325-65-4 €20 (Paperback)

Blue Raincoat Theatre Company

By Rhona Trench

Since its foundation in 1991, Blue Raincoat Theatre Company is Ireland's only full-time venue-based professional theatre ensemble and has become renowned for its movement, visual and aural proficiencies and precision. This book explores those signatures from a number of vantage points, conveying the complex challenges faced by Blue Raincoat as they respond to changing aesthetic and economic circumstances. Particular consideration is given to set, costume, sound and lighting design.

ISBN 78-1-909325-67-8 €20 (Paperback)

Across the Boundaries: Talking about Thomas Kilroy

Edited by: Guy Woodward

Thomas Kilroy's long and distinguished career is celebrated in this volume by new essays, panel discussions and an interview, reconsidering the work of one of Ireland's most intellectually ambitious and technically imaginative playwrights. Contributors are drawn from both the academic and theatrical spheres, and include Nicholas Grene, Wayne Jordan, Patrick Mason, Christopher Murray and Lynne Parker.
ISBN 78-1-909325-51-7 €15.00 (Paperback)

Tradition and Craft in Piano-Paying,
by Tilly Fleischmann

Edited by Ruth Fleischmann and John Buckley
DVD Musical examples: Gabriela Mayer

This is a document of considerable historical importance, offering an authoritative account of Liszt's teaching methods as imparted by two of his former students to whom he was particularly close. It contains much valuable information of a kind that is unavailable elsewhere. It records a direct and authentic oral tradition of continental European pianism going back to the nineteenth century.
ISBN 78-1-909325-524 €30 (Paperback)

Wexfour: John Banville, Eoin Colfer, Billy Roche, Colm Toibin

Edited by Ben Barnes
A dedication of four short plays by Wexford writers to celebrate the 40th Anniversary of Wexford Arts Centre.

ISBN 78-1-909325-548 €10

For the Sake of Sanity: Doing things with humour in Irish performance

Edited by Eric Weitz

Humour claims no ideological affiliation – its workings merit inspection in any and every individual case, in light of the who, what, where and when of a joke, including the manner of performance, the socio-cultural context, the dynamic amongst participants, and who knows how many other factors particular to the instance. There as many insights to be gained from the deployment of humour in performance as people to think about it – so herein lie a healthy handful of responses from a variety of perspectives.

For the Sake of Sanity: *Doing things with humour in Irish performance* assembles a range of essays from practitioners, academics, and journalists, all of whom address the attempt to make an audience laugh in various Irish contexts over the past century. With a general emphasis on theatre, the collection also includes essays on film, television and stand-up comedy for those insights into practice, society and culture revealed uniquely through instances of humour in performance.

ISBN 78-1-909-325-56-2 €20

Stanislavski in Ireland: Focus at Fifty

Edited by Brian McAvera and Steven Dedalus Burch

Stanislavski in Ireland: Focus at Fifty is an insight into Ireland's only arthouse theatre from the people who were there. Through interviews, articles, short memoirs and photographs, the book tracks the theatre from its inception, detailing the period under its founder Deirdre O'Connell and then the period following Joe Devlin's arrival as its new artistic director. Many of Ireland's leading theatre and film artists trained and worked at Focus, including Gabriel Byrne, Joan Bergin, Olwen Fouèrè, Brendan Coyle, Rebecca Schull, Johnny Murphy, Sean Campion, Tom Hickey and Mary Elizabeth and Declan Burke-Kennedy. The book comes complete with a chronological list of productions.

ISBN 78-1-909325-43-2 €20

Breaking Boundaries. An Anthology of Original Plays from the Focus Theatre

Edited by Steven Dedalus Burch

Almost from the beginning, since 1970, new plays became part of the Focus's repertory.
Of the seven plays in this anthology, all exhibit a range in styles from Lewis Carroll's fantastical world (*Alice in Wonderland* by Mary Elizabeth Burke-Kennedy), to a couple on the brink of a philandering weekend disaster (*The Day of the Mayfly* by Declan Burke-Kennedy), to a one-man show about Jonathan Swift (*Talking Through His Hat* by Michael Harding), an examination of two shoplifting thieves and the would-be writer who gets in their way (*Pinching For My Soul* by Elizabeth Moynihan), a battle royal between two sides of a world-famous painter (*Francis and Frances* by Brian McAvera), the reactions of multiple New Yorkers to that moment in September, 2011 (*New York Monologues* by Mike Poblete), to the final days of an iconic movie star (*Hollywood Valhalla* by Aidan Harney).

ISBN 78-1-909325-42-5 €20

The Art Of Billy Roche: Wexford As The World

Edited by Kevin Kerrane

Billy Roche – musician, actor, novelist, dramatist, screenwriter – is one of Ireland's most versatile talents. This anthology, the first comprehensive survey of Roche's work, focuses on his portrayal of one Irish town as a microcosm of human life itself, elemental and timeless. Among the contributors are fellow artists (Colm Tóibín, Conor McPherson, Belinda McKeon), theatre professionals (Benedict Nightingale, Dominic Dromgoole, Ingrid Craigie), and scholars on both sides of the Atlantic.

ISBN 78-1-904505-60-0 €20

The Theatre of Conor McPherson: 'Right beside the Beyond'

Edited by Lilian Chambers and Eamonn Jordan

Multiple productions and the international successes of plays like *The Weir* have led to Conor McPherson being regarded by many as one of the finest writers of his generation. McPherson has also been hugely prolific as a theatre director, as a screenwriter and film director, garnering many awards in these different roles. In this collection of essays, commentators from around the world address the substantial range of McPherson's output to date in theatre and film, a body of work written primarily during and in the aftermath of Ireland's Celtic Tiger period. These critics approach the work in challenging and dynamic ways, considering the crucial issues of morality, the rupturing of the real, storytelling, and the significance of space, violence and gender. Explicit considerations are given to comedy and humour, and to theatrical form, especially that of the monologue and to the ways that the otherworldly, the unconscious and supernatural are accommodated dramaturgically, with frequent emphasis placed on the specific aspects of performance in both theatre and film.

ISBN 78 1 904505 61 7 €20

The Story of Barabbas, The Company

Carmen Szabo

Acclaimed by audiences and critics alike for their highly innovative, adventurous and entertaining theatre, Barabbas The Company have created playful, intelligent and dynamic productions for over 17 years. Breaking the mould of Irish theatrical tradition and moving away from a text dominated theatre, Barabbas The Company's productions have established an instantly recognizable performance style influenced by the theatre of clown, circus, mime, puppetry, object manipulation and commedia dell'arte. This is the story of a unique company within the framework of Irish theatre, discussing the influences that shape their performances and establish their position within the history and development of contemporary Irish theatre. This book addresses the overwhelming necessity to reconsider Irish theatre history and to explore, in a language accessible to a wide range of readers, the issues of physicality and movement based theatre in Ireland.

ISBN 78-1-904505-59-4 €25

Irish Drama: Local and Global Perspectives

Edited by Nicholas Grene and Patrick Lonergan

Since the late 1970s there has been a marked internationalization of Irish drama, with individual plays, playwrights, and theatrical companies establishing newly global reputations. This book reflects upon these developments, drawing together leading scholars and playwrights to consider the consequences that arise when Irish theatre travels abroad.

Contributors: Chris Morash, Martine Pelletier, José Lanters, Richard Cave, James Moran, Werner Huber, Rhona Trench, Christopher Murray, Ursula Rani Sarma, Jesse Weaver, Enda Walsh, Elizabeth Kuti

ISBN 78-1-904505-63-1 €20

What Shakespeare Stole From Rome

Edited by Brian Arkins

What Shakespeare Stole From Rome analyses the multiple ways Shakespeare used material from Roman history and Latin poetry in his plays and poems. From the history of the Roman Republic to the tragedies of Seneca; from the Comedies of Platus to Ovid's poetry; this enlightening book examines the important influence of Rome and Greece on Shakespeare's work.

ISBN 78-1-904505-58-7 €20

Polite Forms

Harry White

Polite Forms is a sequence of poems that meditates on family life, remembering and reimagining scenes from childhood and adolescence through the formal composure of the sonnet, so that the uniformity of this framing device promotes a tension. Throughout the collection there is a constant preoccupation with the difference between actual remembrance and the illumination or meaning which poetry can afford. Some of the poems 'rewind the tapes of childhood' across two or three generations, and all of them are akin to pictures at an exhibition which survey individual impressions of childhood and parenthood in a thematically continuous series of portraits drawn from life. This is his first collection of poetry.

Harry White is Professor of Music at University College Dublin.

ISBN 78-1-904505-55-6 €10

Ibsen and Chekhov on the Irish Stage

Edited by Ros Dixon and Irina Ruppo Malone

Ibsen and Chekhov on the Irish Stage presents articles on the theories of translation and adaptation, new insights on the work of Brian Friel, Frank McGuinness, Thomas Kilroy, and Tom Murphy, historical analyses of theatrical productions during the Irish Revival, interviews with contemporary theatre directors, and a round-table discussion with the playwrights, Michael West and Thomas Kilroy.

Ibsen and Chekhov on the Irish Stage challenges the notion that a country's dramatic tradition develops in cultural isolation. It uncovers connections between past productions of plays by Ibsen and Chekhov and contemporary literary adaptations of their works by Irish playwrights, demonstrating the significance of international influence for the formation of national canon.

ISBN 78-1-904505-57-0 €20

Tom Swift Selected Plays

With an introduction by Peter Crawley.

The inaugural production of Performance Corporation in 2002 matched Voltaire's withering assault against the doctrine of optimism with a playful aesthetic and endlessly inventive stagecraft.

Each play in this collection was originally staged by the Performance Corporation and though Swift has explored different avenues ever since, such playfulness is a constant. The writing is precise, but leaves room for the discoveries of rehearsals, the flesh of the theatre. All plays are blueprints for performance, but several of these scripts – many of which are site-specific and all of them slyly topical – are documents for something unrepeatable.

ISBN 78-1-904505-56-3 €20

Synge and His Influences: Centenary Essays from the Synge Summer School

Edited by Patrick Lonergan

The year 2009 was the centenary of the death of John Millington Synge, one of the world's great dramatists. To mark the occasion, this book gathers essays by leading scholars of Irish drama, aiming to explore the writers and movements that shaped Synge, and to consider his enduring legacies. Essays discuss Synge's work in its Irish, European and world contexts – showing his engagement not just with the Irish literary revival but with European politics and culture too. The book also explores Synge's influence on later writers: Irish dramatists such as Brian Friel, Tom Murphy and Marina Carr, as well as international writers like Mustapha Matura and Erisa Kironde. It also considers Synge's place in Ireland today, revealing how *The Playboy of the Western World* has helped to shape Ireland's responses to globalisation and multiculturalism, in celebrated productions by the Abbey Theatre, Druid Theatre, and Pan Pan Theatre Company.

Contributors include Ann Saddlemyer, Ben Levitas, Mary Burke, Paige Reynolds, Eilís Ní Dhuibhne, Mark Phelan, Shaun Richards, Ondřej Pilný, Richard Pine, Alexandra Poulain, Emilie Pine, Melissa Sihra, Sara Keating, Bisi Adigun, Adrian Frazier and Anthony Roche.

ISBN 78-1-904505-50-1 €20.00

Constellations - The Life and Music of John Buckley

Benjamin Dwyer

Benjamin Dwyer provides a long overdue assessment of one of Ireland's most prolific composers of the last decades. He looks at John Buckley's music in the context of his biography and Irish cultural life. This is no hagiography but a critical assessment of Buckley's work, his roots and aesthetics. While looking closely at several of Buckley's compositions, the book is written in a comprehensible style that makes it easily accessible to anybody interested in Irish musical and cultural history. *Wolfgang Marx*

As well as providing a very readable and comprehensive study of the life and music of John Buckley, Constellations also offers an up-to-date and informative catalogue of compositions, a complete discography, translations of set texts and the full libretto of his chamber opera, making this book an essential guide for both students and professional scholars alike.

ISBN 78-1-904505-52-5 €20.00

'Because We Are Poor': Irish Theatre in the 1990s

Victor Merriman

"Victor Merriman's work on Irish theatre is in the vanguard of a whole new paradigm in Irish theatre scholarship, one that is not content to contemplate monuments of past or present achievement, but for which the theatre is a lens that makes visible the hidden malaises in Irish society. That he has been able to do so by focusing on a period when so much else in Irish culture conspired to hide those problems is only testimony to the considerable power of his critical scrutiny." Chris Morash, NUI Maynooth.

ISBN 78-1-904505-51-8 €20.00

Buffoonery and Easy Sentiment':
Popular Irish Plays in the Decade Prior to the Opening of The Abbey Theatre

Christopher Fitz-Simon

In this fascinating reappraisal of the non-literary drama of the late 19th - early 20th century, Christopher Fitz-Simon discloses a unique world of plays, players and producers in metropolitan theatres in Ireland and other countries where Ireland was viewed as a source of extraordinary topics at once contemporary and comfortably remote: revolution, eviction, famine, agrarian agitation, political assassination.

The form was the fashionable one of melodrama, yet Irish melodrama was of a particular kind replete with hidden messages, and the language was far more allusive, colourful and entertaining than that of its English equivalent.

ISBN 78-1-9045505-49-5 €20.00

The Theatre of Tom Mac Intyre: 'Strays from the ether'

Eds. Bernadette Sweeney and Marie Kelly

This long overdue anthology captures the soul of Mac Intyre's dramatic canon – its ethereal qualities, its extraordinary diversity, its emphasis on the poetic and on performance – in an extensive range of visual, journalistic and scholarly contributions from writers, theatre practitioners.

ISBN 78-1-904505-46-4 €25

Irish Appropriation Of Greek Tragedy

Brian Arkins

This book presents an analysis of more than 30 plays written by Irish dramatists and poets that are based on the tragedies of Sophocles, Euripides and Aeschylus. These plays proceed from the time of Yeats and Synge through MacNeice and the Longfords on to many of today's leading writers.

ISBN 78-1-904505-47-1 €20

Alive in Time: The Enduring Drama of Tom Murphy

Ed. Christopher Murray

Almost 50 years after he first hit the headlines as Ireland's most challenging playwright, the 'angry young man' of those times Tom Murphy still commands his place at the pinnacle of Irish theatre. Here 17 new essays by prominent critics and academics, with an introduction by Christopher Murray, survey Murphy's dramatic oeuvre in a concerted attempt to define his greatness and enduring appeal, making this book a significant study of a unique genius.

ISBN 78-1-904505-45-7 €25

Performing Violence in Contemporary Ireland

Edited by Lisa Fitzpatrick

This interdisciplinary collection of fifteen new essays by scholars of theatre, Irish studies, music, design and politics explores aspects of the performance of violence in contemporary Ireland. With chapters on the work of playwrights Martin McDonagh, Martin Lynch, Conor McPherson and Gary Mitchell, on Republican commemorations and the 90th anniversary ceremonies for the Battle of the Somme and the Easter Rising, this book aims to contribute to the ongoing international debate on the performance of violence in contemporary societies.

ISBN 78-1-904505-44-0 €20

Deviant Acts: Essays on Queer Performance

Ed. David Cregan

This book contains an exciting collection of essays focusing on a variety of alternative performances happening in contemporary Ireland. While it highlights the particular representations of gay and lesbian identity it also brings to light how diversity has always been a part of Irish culture and is, in fact, shaping what it means to be Irish today.

ISBN 978-1-904505-42-6 €20

Plays and Controversies: Abbey Theatre Diaries 2000-2005

Ben Barnes

In diaries covering the period of his artistic directorship of the Abbey, Ben Barnes offers a frank, honest, and probing account of a much commented upon and controversial period in the history of the national theatre. These diaries also provide fascinating personal insights into the day-to-day pressures, joys, and frustrations of running one of Ireland's most iconic institutions.

ISBN 78-1-904505-38-9 €25

Interactions: Dublin Theatre Festival 1957-2007. Irish Theatrical Diaspora Series: 3

Eds. Nicholas Grene and Patrick Lonergan with Lilian Chambers

For over 50 years the Dublin Theatre Festival has been one of Ireland's most important cultural events, bringing countless new Irish plays to the world stage, while introducing Irish audiences to the most important international theatre companies and artists. Interactions explores and celebrates the achievements of the renowned Festival since 1957 and includes specially commissioned memoirs from past organizers, offering a unique perspective on the controversies and successes that have marked the event's history. An especially valuable feature of the volume, also, is a complete listing of the shows that have appeared at the Festival from 1957 to 2008.

ISBN 78-1-904505-36-5 €20

Synge: A Celebration

Edited by Colm Tóibín

A collection of essays by some of Ireland's most creative writers on the work of John Millington Synge, featuring Sebastian Barry, Marina Carr, Anthony Cronin, Roddy Doyle, Anne Enright, Hugo Hamilton, Joseph O'Connor, Mary O'Malley, Fintan O'Toole, Colm Toibin, Vincent Woods.

ISBN 978-1-904505-14-3 €15